C20th ADVERTISING

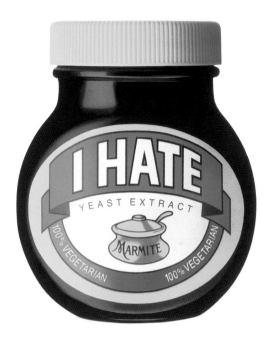

THIS IS A CARLTON BOOK

Design copyright © 1999 Carlton Books Limited
Text copyright © 1999 Dave Saunders

This edition published by Carlton Books Limited 1999
20 St Anne's Court
Wardour Street
London
W1V 3AW

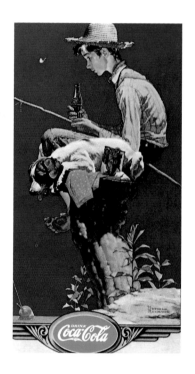

A CIP catalogue for this book is available from the British Library

ISBN 1 85868 520 6

Executive Editor: Sarah Larter
Art Editor: Diane Spender
Design: Michael Spender and Phil Scott
Picture Research: Catherine Costelloe
Production: Alexia Turner

Printed and bound in Spain

DAVE SAUNDERS

FOREWORD BY RUPERT HOWELL
President, Institute of Practioners in Advertising

CARLTON

CONTENTS

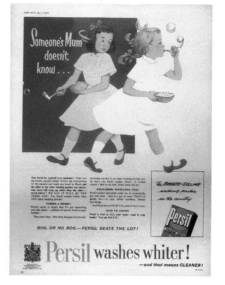
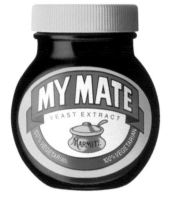
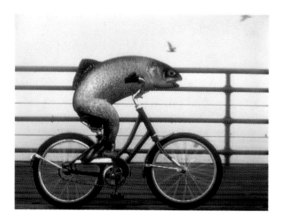

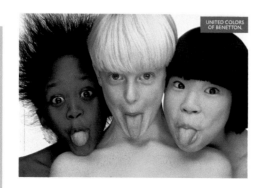
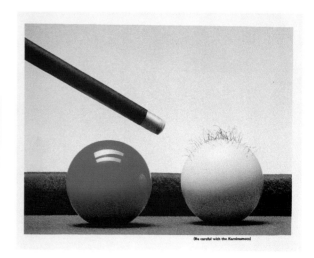

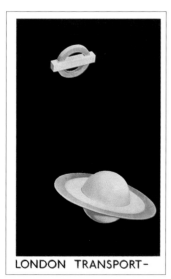

FOREWORD

PEOPLE LOVE ADS. People love talking about them and journalists love writing about them. Everyone thinks they're an expert. Everyone has an opinion.

That's why this book is a treasure trove. For advertising people, it represents a concise history of the very best in advertising – mini case histories from around the world giving the stories of some of the most successful campaigns of all time.

For people outside the industry, it is a fascinating collection of images and stories that will remind them just why they were interested in advertising in the first place.

Twentieth-Century Advertising reveals the changing role and style of advertising over the years, but it also reminds us of the enduring power of the best advertising ideas, icons and images.

Advertising at its best achieves all its commercial objectives, but also enters the popular culture. That has always been true, and will remain true as we enter the digital, interactive age. This book gives an entertaining insight into how that happens and is a constant reminder that it is creative thinking and execution that makes the difference.

Rupert Howell
Chairman HHCL and Partners
President IPA
April 1999

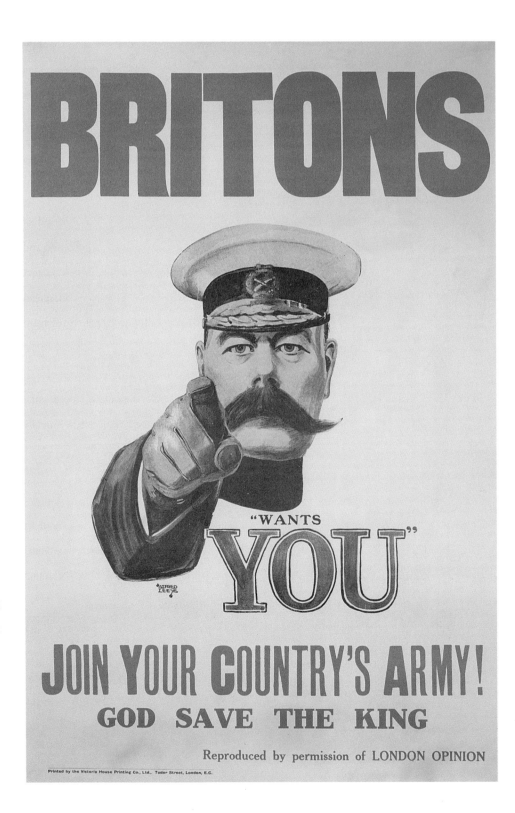

INTRODUCTION

ADVERTISING IS THE WORLD'S most powerful industry. More powerful now than at any time in history. It can help put governments in power, or oust them. It can make a company's – or country's – fortune. And it can change public opinion.

Advertising is not new, but the twentieth century is when it came of age. Crude ads appeared as inscriptions in Egyptian tombs around 3000 BC. The Greeks engraved theatre ads in stone in about 500 BC. And signs were hand painted on the lime-whitened walls of buildings in Rome and Pompeii.

Throughout medieval Europe, town criers called out public notices in the street. They were later hired by merchants to applaud the qualities of their wares and, as such, became forerunners of the radio and television announcers who deliver commercials.

Although the Chinese were printing books using carved wooden blocks from AD 868, print advertising as such made little impact until the invention by Johannes Gutenberg in Germany of the movable type printing press in 1454. The first advertisements in English were written by William Caxton to promote "The Pyes of Salisbury", and offering a prayer book he had printed, with a familiar selling proposition: "good chepe".

Some 150 years later the first magazine ads appeared. In 1761 Louis XV of France ordered that sign-boards must be fixed flat against walls for safety – thus anticipating the hoarding, or billboard. Bills were also attached to wooden roadside posts, positioned to protect pedestrians from the traffic. These became known as "posters". On January 1, 1788, the first ads appeared in *The Times* newspaper in London – two shipping ads with line drawings.

The eighteenth century was a period of economic prosperity, political stability and rapidly increasing populations. These factors combined to create the birth of a widespread consumer society and an accompanying demand for advertising. The Industrial Revolution of the mid-nineteenth century fostered advertising as an essential ingredient of the developing economy.

The invention of lithography – literally drawing on stone – by Austrian playwright Alois Senefelder in 1798 created a cheaper and faster method of producing posters. By 1848 it was possible to print sheets at a rate of 10,000 an hour. In the 1870s techniques in colour – or chromo – lithography made mass production of illustrated colour posters viable and helped fuel the poster boom of the 1880s.

In 1886 Thomas J. Barratt, owner of Pears Soap, paid the English painter Sir John Everett Millais £2,300 for "Bubbles", his classic Victorian painting of his young grandson. Barratt used the image in an ad for Pears Soap, and so created a marriage between art and advertising. This outraged the art world, but proved a great success with the public. From then on it became acceptable for salon painters to accept advertising commissions and apply their talents to creating commercial art in the form of advertising posters.

By the beginning of the twentieth century the larger agencies, such as Lord and Thomas in Chicago, J. Walter Thompson in New York and S.H. Benson in London, were employing or commissioning artists to work to a specific brief, thus producing more integrated and targeted campaigns. During the course of the century some of these advertising messages reached virtually every individual on earth. One estimate claims that American children view an average of 350,000 commercials by the age of 18, so it is not surprising that the modern consumer has evolved into a discerning decoder, automatically filtering out a mass of unwanted information, absorbing only the successful ads – many of which are shown here.

"The historians and archaeologists will one day discover that the advertisements of our time are the richest and most faithful daily reflections that any society ever made of its entire range of activities." (Marshal McLuhan "Understanding Media", 1964.)

Advertising holds up a mirror to our social history, and catches glimpses of the value and aspirations of our culture. Are we happy with what they reveal about us?

FOOD

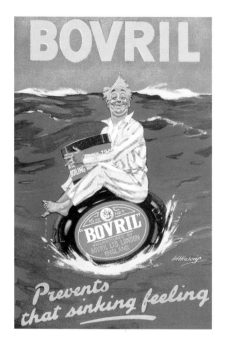

BOVRIL

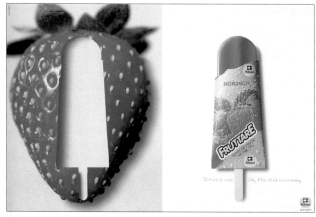

KIBON FRUTTARE

THE NATURE OF ADVERTISING has grown and diversified as the consumer society has become more complex. Yet it would be arrogant to underestimate the achievements of advertising a century ago. Today's ads may be more sophisticated, but they do not necessarily display a greater understanding of the forces that motivate people to buy goods and services.

Advertising is hardly a nineteenth-century invention. The trademark signs erected in front of shops in the sixteenth century were a form of advertising. In the modern sense, the eighteenth-century factories used advertising to inform people about their goods. But it was the nineteenth century that started to turn advertising into an art form, especially in America.

Until the late nineteenth century, everyday foods and household items such as sugar, rice, butter and milk were sold in neighbourhood stores from bulk containers. Then firms began to market packaged goods under brand names, as with Uneeda Biscuits (p.29).

The turn of the century saw the emergence and increasing inventiveness of numerous fledgling companies. Bovril, Colman's, Heinz, Kellogg's and Oxo established their brands so successfully that they long outlived their founders. Advertising provided the public face that such companies presented.

In the early years of the twentieth century, press advertising was widespread, but when newspapers and magazines later found it less easy to fill their ad slots, they commissioned brokers to sell the space. These space-brokers were the first advertising agencies. By the 1920s professional ad agencies had established New York's Madison Avenue as the hub of the industry.

After over a century of monopolizing some of the world's most creative minds, and fuelled by often obscene amounts of money, the advertising industry has explored most possibilities pretty thoroughly. But, rather than being depressed by the dearth of potential new ideas, it is refreshing to discover plenty of brilliant new coats of paint decorating old ideas. The way in which eggs, for example, are promoted is constantly reinterpreted (pp.12–13, p.28). And new life is breathed into other products by using them in unexpected contexts, such as repositioning soup by pouring it into a glass of ice cubes, or by presenting Fruit Gums as a tasty treat for kids, rather than a sophisticated adult sweet.

In the words of Bill Bernbach, architect of the sixties revolution in creative advertising: "Playing it safe is the most dangerous thing in the world, because you're presenting people with an idea they've seen before, and you won't have impact".

A big budget is not a prerequisite for an innovative or breakthrough campaign. Fabio Fernandes, chairman of F/Nazca Saatchi and Saatchi in Sao Paulo believes "The biggest ideas emerge from small budgets, and big budgets often hide weak ideas. The most effective ads are those with a very simple execution." A quote illustrated by the advertisements for both Fruttare (p.16) and Heinz (p.20).

Before showing creative work to clients the agency judges each of their ads according to the acronym "SIMPLES": S–Sympathetic (with the consumer), I–Individual, M–Memorable, P–Pertinent, L–Light/fresh, E–Economic (use of production techniques), S –Surprising (unexpected or unpredictable).

"Tradition and success are strong enemies. In order to think laterally and explore new possibilities we must let go of responsibility and experience, then reclaim them at the end of the day," says Fernandes. Frank Lowe, founder and chairman of the Lowe Group concurs: "Bad advertising tends to be complex advertising. Make it clean and simple. It's the old analogy that if you throw five tennis balls at somebody, they can't catch any of them. But if you throw only one, they can."

America led the world in market research. As early as 1900 the New York agency N.W. Ayer established a business-getting department to investigate the marketing needs of prospective advertisers. Stanley Resor, who became president of J.Walter Thompson in 1916, set up a market research department. In 1932 George W. Gallup joined Young and Rubicam as director of research. Gallup opinion polls are still widely used.

In the mid- to late-1950s Britain followed the USA into more research and measurement techniques with the aim of creating more effectively targeted advertising. The result was that advertising moved away from the simple, direct message and began to introduce sub-texts based on psychological analyses. Motivational research uncovered unconscious impulses that provided a way through people's resistance. "Sex" and "subliminal" became the buzzwords.

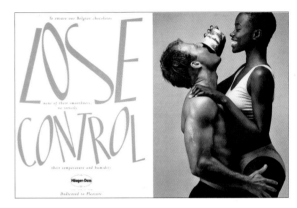

HÄAGEN-DAZS

By the 1970s new buzzwords emerged such as "Relevant Unexpected" and "Unique Selling Proposition", the former encapsulating two main elements of commercial creativity – pertinence and surprise. "Sex" remains in the lexicon, used to sell virtually everything, often without relevance to the product; but "subliminal" has fallen by the wayside, banned in the States since 1958 by the National Association of Broadcasters.

Today, advertising pervades the fabric of society to the extent that it is often seen as intrusive. What, however, has not changed is that it equips people with a sense that they are making informed choices.

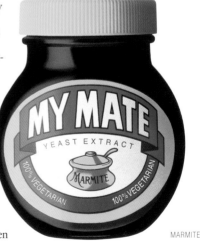

MARMITE

BOVRIL

After the Franco-Prussian war in 1871, when Paris was starved into surrender, the French government was eager to stock up the French forts against future emergencies. A Scotsman named John Lawson Johnston developed a blend of meat extract with caramel, salt and spices to create Johnston's Fluid Beef – a spread to put on bread or to mix with hot water to make a drink.

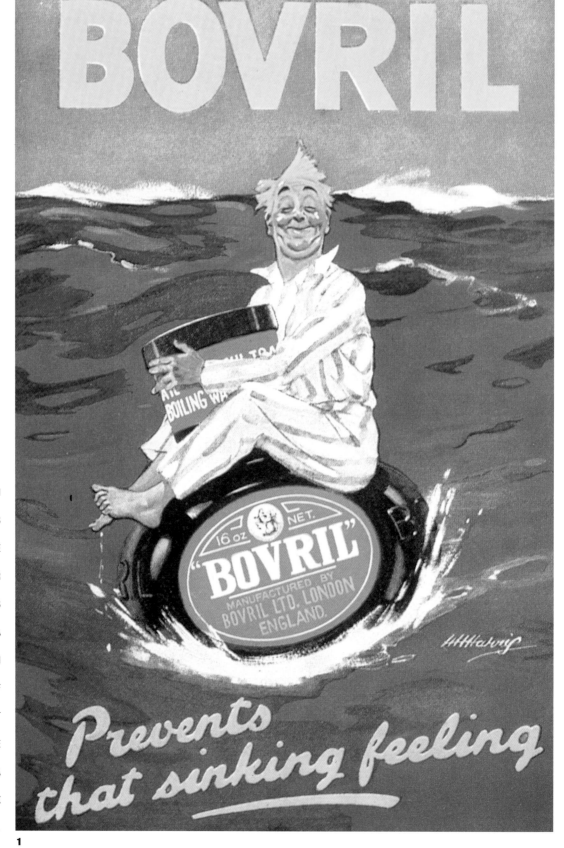

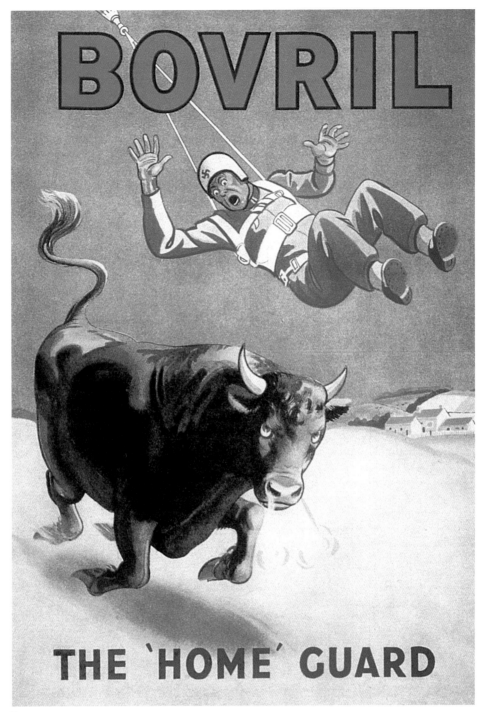

1. DATE: 1920
AGENCY: S.H. Benson, London
ARTIST: H.H. Harris
2. DATE: 1942
AGENCY: S.H. Benson, London

2

Johnston's first factory opened in 1874 in Quebec, Canada. Johnston's Fluid Beef proved so successful that he transferred to a larger manufacturing works in Montreal.

Johnston next set up in London, his product going on sale in Britain in 1886 under the name Bovril: the bo from the Latin for Ox, the vril from Vrilya, the name of the life force in Bulwer Lytton's novel *The Coming Race* (1871). Bovril was perceived as a boost to energy and was marketed as being an ideal addition to soldier's rations in the Boer War and later in World War One and World War Two.

The most famous of all Bovril's posters was drawn by H.H. Harris and first appeared in 1920. The literal, visual interpretation of sinking due to lack of energy reinforced the message. The copyline was thought of before the *Titanic* disaster in 1912, but was withheld for reasons of sensitivity.

The slogan "Prevents that sinking feeling" came from a book, *Golf*, by Horace Hutchinson: "The nerves and muscles must be fed for the work before them otherwise there will ensue a dreadful sinking feeling before the end of the round." The book proceeded to recommend Bovril as a refresher between matches.

The post-war adaptation: "Sinking? Yes, thinking it's time for my Bovril", was followed by the puns of the early sixties: "Glow home with Bovril today" and "Glow to work with Bovril today".

S.H. (Samuel Herbert) Benson was a Bovril employee who set up as an advertisers agent in 1893, with Bovril as his first client. The affiliation continued for some 80 years – one of the longest client-agency relationships on record.

BRITISH EGGS

1. DATE 1999.
2. DATE: 1957.
AGENCY: MATHER AND CROWTHER.
ART DIRECTOR: Ruth Gill.
COPYWRITERS: Fay Weldon and Mary Gowing.
PHOTOGRAPHER: Len Fulford.

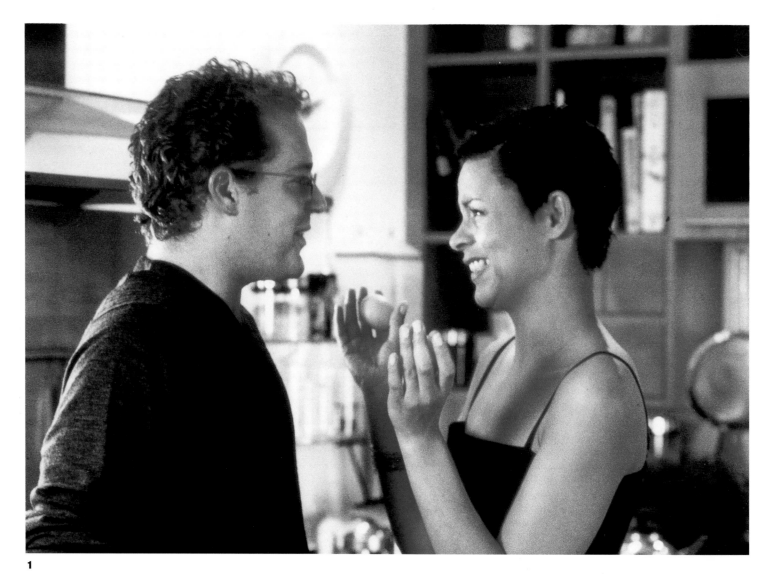

1

ADVERTISING CONTINUALLY REIN-VENTS APPROPRIATE WAYS TO PUT ACROSS THE BENEFITS – BOTH PHYSICAL AND PSYCHOLOGICAL – OF LONG-ESTABLISHED PRODUCTS. EGGS, FOR INSTANCE.

In the Britain of the 1960s, the slogan "Go to work on an egg" became a national catch-phrase, targeting mostly mothers with children and conveying the belief in a "good" start to the day – eggs contain protein, a wide range of other important minerals, including iron and calcium, and most of the vitamins the body needs.

The focus of the advertising evolved with changing social habits, including the disappearance of the weekday cooked breakfast, worries about the effects of cholesterol and the salmonella scare. During the 1970s and 1980s, slogans included "Crack a meal today" and "Go smash an egg".

Then, after a 17 year break from television, a high profile campaign – that also included posters – was launched, emphasizing the nutritional benefits and convenience of eggs: "Fast food and good for you." The first of two 40-second commercials – "Fridge raiders" – showed how easily teenagers could cook scrambled eggs in the microwave. The second – "Apron strings" – combined the seductive charms of a woman and an egg to add passion to the evening. A thirtysomething, nineties man valiantly but unsuccessfully tries to prepare a sophisticated dish for his girlfriend. To salvage the situation, she proposes making a quick omelette – which will leave more time for more important activities later …

Go to work on an egg

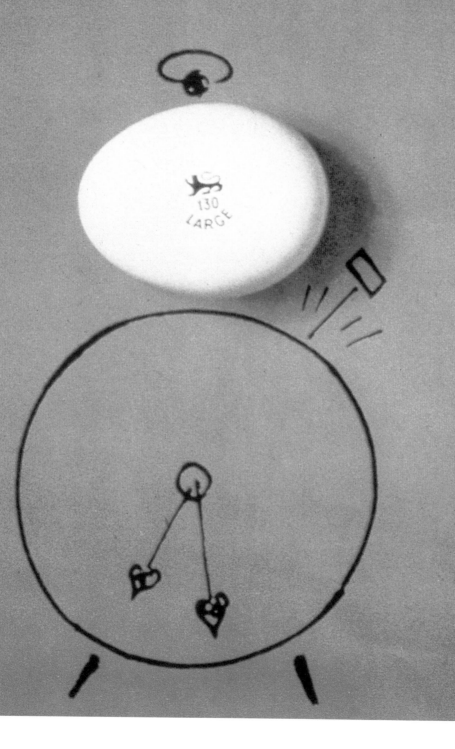

COLMAN'S MUSTARD

DATE: 1910s.

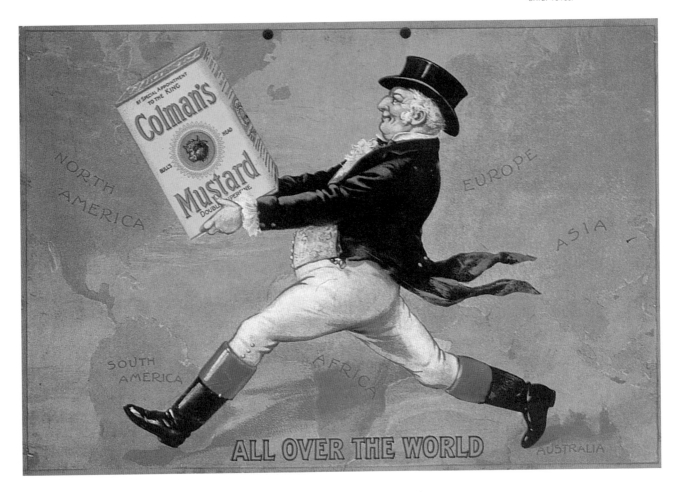

"JEREMIAH COLMAN … RESPECTFULLY INFORMS HIS CUSTOMERS AND THE PUBLIC IN GENERAL THAT HE WILL CONTINUE THE MANUFACTURING OF MUSTARD." SO STATED AN ADVERTISMENT THAT APPEARED IN THE *NORFOLK CHRONICLE* IN 1814.

Colman's was already an experienced flour miller based near Norwich, England when he announced his intentions regarding the production of mustard. In 1823, he went into partnership with his adopted nephew James, forming J and J Colman a business that flourished with a branch that was opened in London in 1836. The Bull's Head became the company's distinctive trademark in 1855, and they were granted a special warrant by Queen Victoria in 1866. By the end of the nineteenth century tins, enamel signs and mustard pots bearing the company's name and logo were being manufactured and in the 1870s and 1880s the firm's printing and advertising departments were set up

and John Hassall was commissioned to produce a series of advertisements. In 1903 Colman's acquired a rival firm, Keen and Son, which was the company that had made mustard a household name and inspired the phrase "keen as mustard".

To create further public interest in mustard, the advertising agency S.H. Benson launched a campaign around the concept of the Mustard Club, which ran from 1926 to 1933; Dorothy L. Sayers, who later became a highly successful detective novelist, acted as copywriter for many of the adverts, while John

Gilroy illustrated them. The activities and adventures of the Club's fictitious officers were popularized through humorous advertisements, songs, books, games and badges. As Colman's now held a virtual monopoly on the sale of mustard, there was no need to include the company name. The agency claimed that the campaign was so successful that 98 percent of the British population had discussed the product at some point. Whether or not the campaign increased mustard sales, it certainly raised public awareness of the product.

CADBURY'S MILK CHOCOLATE

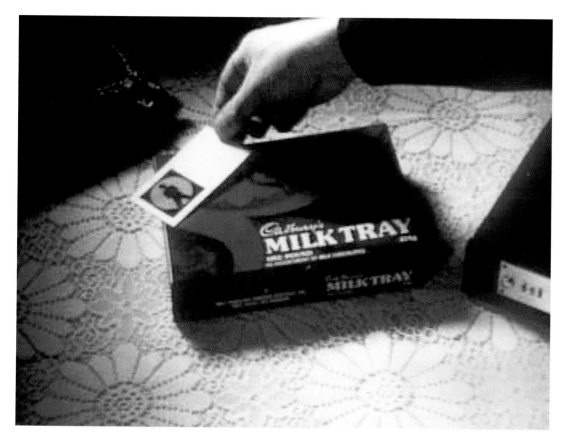

DATE: 1970.

IN THE SEVENTEENTH CENTURY CHOCOLATE WAS A SOPHISTICATED DRINK FOR THE WEALTHY. IT WAS ADVERTISED IN LONDON IN 1657 AS "AN EXCELLENT DRINK CALLED CHOCOLATE". IN 1693, AT ABOUT THE SAME TIME AS COFFEE AND TEA WERE INTRODUCED, WHITE'S CHOCOLATE HOUSE WAS OPENED IN LONDON'S FASHIONABLE ST JAMES STREET. THE DRINKS WERE MADE FROM BLOCKS OF CHOCOLATE IMPORTED FROM SPAIN.

Some of the early cocoa makers were pharmacists interested in the food's supposed medicinal properties. Both Fry's and Terry's were founded by apothecaries, whereas Isaac Rowntree was a grocer before moving into chocolate-making (p.61).

A member of a Quaker family, John Cadbury began his career dealing in tea and coffee at his Birmingham shop. In 1879 his sons, George and Richard, established a chocolate factory in Bourneville. In 1905 they launched a milk chocolate bar that used fresh (rather than powdered) milk, and the basis of their fortune was made – Cadbury's Dairy Milk chocolate. The glass and a half of full cream milk in every half pound created the Cadbury taste, and

Cadbury's Dairy Milk remains the company's flagship brand, with annual sales of £100 million.

Milk Tray, introduced in 1915 in open boxes arranged on wooden trays, reached the height of its popularity half a century later with the spoof James Bond commercials in which the Man in Black performed daring feats in order to deliver the chocolates: "And all because the lady loves Milk Tray."

In 1969, Cadbury merged with Schweppes, and now manufactures confectionary and soft drinks in 68 countries and trades in 120.

KIBON FRUTTARE

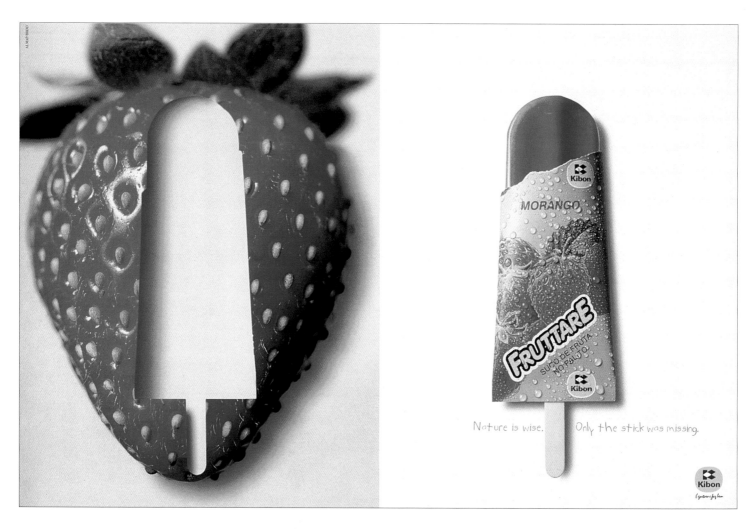

Nature is wise. Only the stick was missing.

BRAZIL IS AT THE VANGUARD OF SOUTH AMERICA'S CREATIVE BOOM AND MARCELLO SERPA IS THE CONTINENT'S LEADING ART DIRECTOR.

Serpa studied visual and graphic arts in Munich and worked in the German agencies R.G. Wiesmeier and GGK before returning to his native Brazil in 1987. After his award-winning advertisements for DPZ Propaganda and DM9 in Sao Paulo, he and copywriter

Alexandre Gama took over the creative helm of the Brazilian office of BBDO. They soon won huge acclaim for their campaign to relaunch the Volkswagen Beetle in Brazil.

"Advertising in Brazil is very strong, but can be very copy-oriented," says Serpa. "I love campaigns with no copy, or very little copy. The art of reduction is as important for the advertising creative as it is for the artist."

Serpa and Gama's campaign for Kibon Fruttare – the ice cream with a 60 percent share of the Brazilian market –

was aimed at the image-conscious 17–23 year old group. The ads have strong visual appeal and illustrate the essence of the product – its fruit content. "Ideas for ads are not inside you, they are out there," adds Gama. "You just have to keep your eyes open for them."

DATE: 1994.
AGENCY: Almap BBDO, Sao Paulo.
ART DIRECTOR: Marcello Serpa.
COPYWRITER: Alexandre Gama.
PHOTOGRAPHER: Freitas.

GENERAL MILLS FLOUR

FOLLOWING A PROMOTION FOR GOLD MEDAL FLOUR IN 1921, THE WASHBURN CROSBY CO. – FORERUNNER OF GENERAL MILLS – WAS INUNDATED WITH ENQUIRIES AND A CORRESPONDENT WAS NEEDED TO HANDLE ALL THE MAIL. THUS BETTY CROCKER, THE WELL-LOVED AND TRUSTED FICTITIOUS KITCHEN EXPERT, WAS BORN.

The name Betty was chosen by advertising manager James A. Quint because it sounded warm and friendly: Crocker was the name of a recently retired director of the company. The Betty Crocker signature was chosen from those produced by the female employees of the time and is still used today. A man answered all the letters until 1936 when Betty was given a face and modelled on a blend of women in the company's home service department.

Betty Crocker became one of the best-known corporate symbols in America and recognized as the "First Lady of Food". Across the decades, Betty Crocker hosted numerous radio and TV cookery shows, and wrote over 200 cook books. As fashion changed, her face was repainted eight times, transforming her from a stiff and stoic older woman to a younger career-minded one, equally capable of managing business and domestic life.

Betty Crocker's image or name now appears on over 200 different products adn General Mills have licensed the name for many kitchen appliances.

1. DATE:1996 (main picture).
DIRECTOR OF ADVERTISING: Samuel C. Gale.

1936	1955	1965	1968	1972	1980	1986

 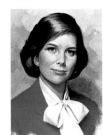

HÄAGEN-DAZS

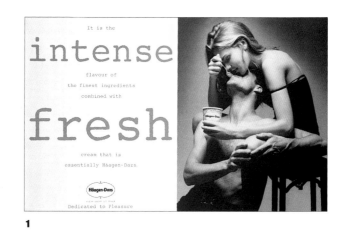

1

2

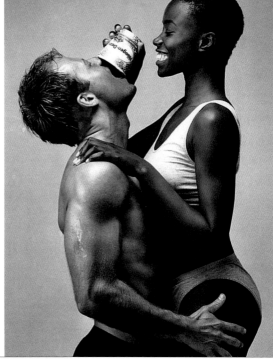

1. DATE: 1991.
AGENCY: Bartle Bogle Hegarty, London.
CREATIVE DIRECTOR: John Hegarty.
ART DIRECTOR: Rooney Carruthers.
COPYWRITER: Larry Barker.
PHOTOGRAPHER: Jeanloup Sieff.

2. DATE: 1992.
AGENCY: Bartle Bogle Hegarty, London.
CREATIVE DIRECTOR: John Hegarty.
ART DIRECTOR: Rooney Carruthers.
COPYWRITER: Larry Barker.
PHOTOGRAPHER: Barry Lategan.

3. DATE: 1993.
AGENCY: Bartle Bogle Hegarty, London.
CREATIVE DIRECTOR: John Hegarty.
ART DIRECTOR: Martin Galton.
COPYWRITER: Will Awdry.
PHOTOGRAPHER: Nadav Kander.

4. DATE: 1996.
AGENCY: J.Walter Thompson, Tokyo.
ART DIRECTOR: Hisa Matsunaga.
COPYWRITER: Eisaku Sekihasi.
PHOTOGRAPHER: Megumu Wada.

ICE CREAM IS FOR KIDS. ISN'T IT? FOR YEARS IN THE UK, ICE CREAM WAS PERCEIVED AND POSITIONED AS A SUMMERTIME DESSERT FOR CHILDREN; ICE CREAM FOR ADULTS WAS FOR RARE FORMAL OCCASIONS, WHEN THE AIM WAS TO IMPRESS GUESTS. MANY TAKE-HOME BRANDS SEEMED MORE CONCERNED WITH THE TYPE OF CONTAINER THAN THE QUALITY OF THE CONTENTS. BY CONTRAST, CONSUMPTION OF ICE CREAM IN THE USA WAS THREE TIMES GREATER, WITH NO PERCEPTION OF IT BEING BASICALLY FOR CHILDREN.

Häagen-Dazs was created in a New York factory in 1959 by Rubin Mattus, who gave it a Danish name to make it sound exotic and get it noticed. By 1984 it had become a subsidiary of the Pillsbury Company (Minneapolis) and commanded 70 percent of the super-premium ice cream market. When it arrived in Europe, the first ice cream to target adults explicitly and the first to open its own shops, its advertising modernized and deformalized the image of ice cream, changing people's preconceptions.

During research, consumers described Häagen-Dazs as "languorous", "sensual" and "dream-like". The agency decided to emphasize the product's richness and creaminess and present eating it as an experience – all the more attractive when sharing it with another in a mood of sensual intimacy.

It was also decided to avoid the traditional television battleground for ice creams. Instead, the agency adopted a quieter approach and built a relationship with the consumer gradually. The first print campaign – oozing flesh and fantasy – was launched in 1991 in the review sections of the quality press, positioning the brand as a luxury adult treat. The ads were seen by the target audience (ABC1, 25 plus, single male or female) and were so successful that they overcame resistance to the almost unpronounceable and unspellable

3

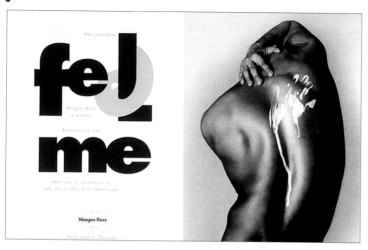

4

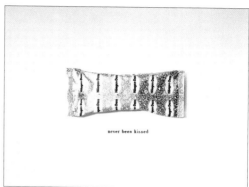

never been kissed

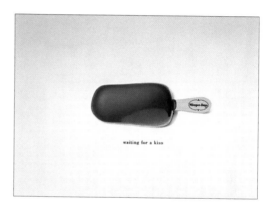

waiting for a kiss

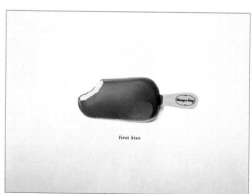

first kiss

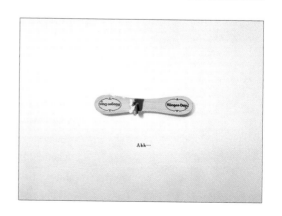

Ahh––

name – as well as convincing people to pay a 50 percent premium.

The photographer used by the agency was Jeanloup Sieff, who made his name in fashion, then enhanced it with his sensuous and erotic black and white nudes. His pictures are the ideal antidote to conventional ice cream images. "Creativity is about breaking laws. Cubism, for example, is just a different way of painting people. It makes you look at the subject afresh," says creative director John Hegarty. "The choice of photographer is important. You're hiring somebody who can not only take a great photograph, but actually understand the thinking behind the idea."

The provocative Häagen-Dazs ads fuelled controversy in the national consumer press, some writers decrying the gratuitous use of sex, others enjoying every opportunity to reprint these effective attention-grabbers.

Any advertising that aims to surprise and impress a core target group often meets a degree of disapproval outside it. But such disapproval can itself be a useful tool in strengthening brand loyalty – those within the target group feel a part of a slightly rebellious club – and with its core consumers as ambassadors, Häagen-Dazs became clear brand leader in its sector, outselling all premium ice cream competitors combined. In the meantime, the mood of intimacy was echoed in the Japanese advertising, "First kiss". It reflected the core message, associating the eating of Häagen-Dazs with "a moment of intense sensual and intimate pleasure", but the treatment was much more subtle. In 1991 sales in the UK rose 398 percent over 1990.

Perhaps the brand's huge success and the millions of column inches devoted to its advertising led to complacency, a dangerous luxury in a competitive arena. By 1995, Ben and Jerry's, the innovative, wacky American brand, was threatening Häagen-Dazs' position. The shock value of the earlier campaign had been spent, and the Häagen-Dazs ads no longer seemed unconventional. It was time for the strategy to move on.

At the end of the century Häagen-Dazs remains the most successful luxury ice cream in the world.

HEINZ

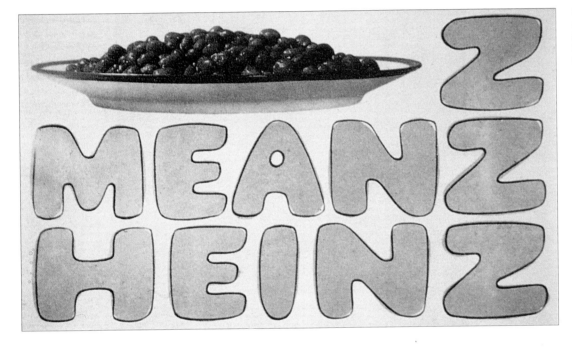

DATE: 1967.
AGENCY: Young and Rubicam, London.
ART DIRECTOR:Jean Bird.
COPYWRITER:Mo Drake.
PHOTOGRAPHER: Tony Copeland.

HENRY JOHN HEINZ AND L.C. NOBLE FOUNDED HEINZ NOBLE AND COMPANY IN PITTSBURGH, PENNSYLVANIA IN 1869. AFTER A FORCED LIQUIDATION DUE TO AN ECONOMIC DEPRESSION, F AND J HEINZ STARTED TRADING IN 1876 WITH THE FINANCIAL BACKING OF HENRY'S BROTHERS FREDERICK AND JOHN. HENRY BOUGHT THEM OUT AGAIN IN 1888 AND FORMED H.J. HEINZ.

Even when Henry conceived the notion of 57 varieties the company was producing over 60, but the number appealed and the slogan has remained ever since. Today Heinz sells over 1,200 products in over 200 countries. Heinz baked beans in tomato sauce first appeared in 1895.

Norman Rockwell's first advertisement for the company, in the 1914 Official Boy Scout manual, was commissioned by H.J. Heinz for Baked Beans – "The best lunches for a hike". Although tomato ketchup is the company's flagship brand and number one ketchup worldwide, in the United Kingdom, where baked beans have been manufactured since 1928, "Beanz Meanz Heinz". The slogan that provided Heinz with one of its most successful and enduring advertisements looks no more than graffiti. It is a quick visual word play, yet it encompasses the spontaneity and familiarity of Heinz in a catchy, memorable phrase that links the product exclusively with the manufacturer. Heinz also benefited from the unsolicited publicity spin-off resulting from Andy Warhol's painting of Heinz baked beans cans.

Like other fast-moving consumer goods, Heinz has had to adapt to changing consumer tastes and demands, especially with the advent of increasing competition from supermarket own-label and discounted brands. The company has done this by introducing new products and altering the tone of its advertising. Some of the television executions strike a particular chord, such as the 1989 commercial set in the 1930s. A mother places a plate of beans on toast in front of her daughter. The girl asks if this will help her become prime minister one day. "It just might, Margaret," says her mother as she whips the plate away realizing the implications. A British audience – bringing their experience and comprehension to the ad – completes the communication, and relishes the understanding of an understated joke.

Heinz has built up many character traits or brand values that contribute to its overall personality – quality, warmth, comfort, childhood, hearth and home. Its successful advertising remains true to this personality, then creates something memorable within that framework.

HOVIS

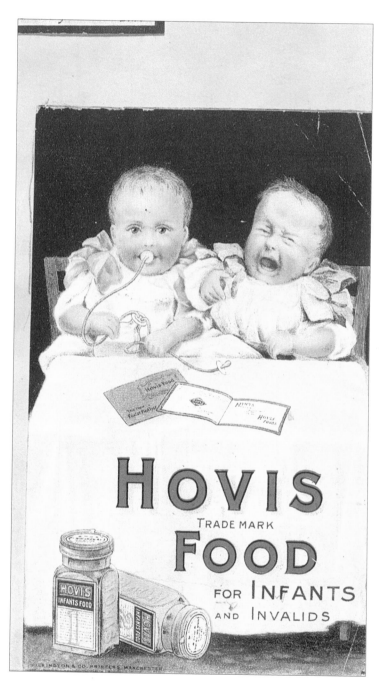

RICHARD "STONEY" SMITH WAS BORN INTO A MILLING FAMILY IN STAFFORDSHIRE. BELIEVING IN THE HEALTH BENEFITS OF THE VITAMIN-RICH WHEATGERM, HE FOUND A WAY OF LIGHTLY COOKING IT IN STEAM TO CONSERVE ITS GOODNESS, THEN RESTORED IT INTO FLOUR IN A GREATER CONCENTRATION THAN IS FOUND NATURALLY.

In 1887 he registered Smith's Patent Germ Flour and marketed it through S. Fitton and Son of Macclesfield. Herbert Grimes, a London student, submitted the name Hovis in response to a competition, for which he won £25. The name was derived from the Latin for "the strength of man" – *hominis vis*. Over the years, Hovis advertising has kept returning to the theme of health and strength.

Most famously, Hovis has been sold on nostalgia. There is something very dependable and comforting about a product that is part of people's heritage and makes them feel good when they buy it. The slice of life commercials, apparently set in the North of England, reassure viewers that Hovis still has many times more wheatgerm than ordinary bread. "It's as good for you today as it's always been."

Successful slogans include "Don't say brown, say Hovis" (1916), "Have you had your Hovis today?" (1936) and "Hovis is the slice of life"(1954). In 1973 the "Boy on the bike" campaign began its 20-year run.

Hovis merged with McDougall Trust in 1957, and then with Joseph Rank in 1962. Despite the popular misconception, Hovis have never made bread. The company simply supplies the flour and the tins in which the bread is baked.

1. DATE: 1900.

2. DATE: 1976.
AGENCY: Collett Dickenson Pearce, London.
DIRECTOR: Ridley Scott.

KELLOGG'S

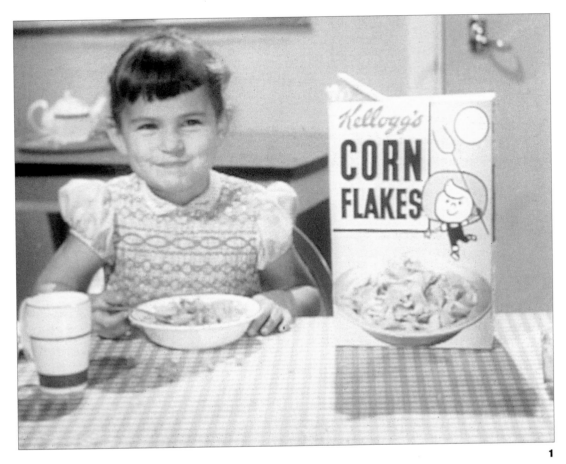

1. DATE: 1960S.
AGENCY: J. Walter Thompson, London.

2. DATE: 1964.
AGENCY: J. Walter Thompson, London.

1

2

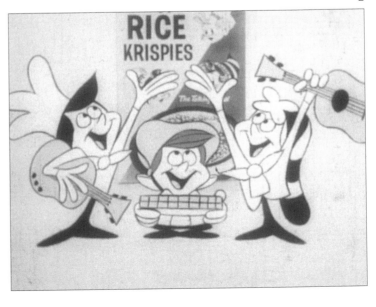

IN THE LATE 1870S PHYSICIAN DR JOHN HARVEY KELLOGG TOOK OVER THE BATTLE CREEK SANITARIUM IN MICHIGAN AND FOR 30 YEARS RAN IT AS A VERY SUCCESSFUL HEALTH SPA.

As the Seventh Adventist Church was the sanitarium's patron, it could serve only vegetarian dishes and in 1878, under the name Sanitas Nut Food Company, Dr Kellogg invented Granola, a mixture of wheat, oatmeal and cornmeal. Later, he boiled, mashed, dried and baked corn to produce corn flakes, which he called Sanitas Toasted Corn Flakes.

The doctor's younger brother William Keith – or W.K. – was an accountant and realized that selling breakfast cereal could be much more lucrative than running a hospital. He persuaded his brother to drop the unappealing name Sanitas and let him have the rights to Corn Flakes. W.K. believed ardently in the value of advertising, and wrote all his own copy. The advertising arena was the battleground on which the many imitators were fought off. In 1906, W.K. established the Battle Creek Toasted Corn Flake Company and placed ads for Corn Flakes in six mid-western newspapers. To counter competition, he included the words "The genuine bears this signature

– W.K. Kellogg – on every carton". Production rose from 33 cases a day to over a million in 1909. By 1911 he was spending $1 million on national advertising.

In 1914 W.K. invented the wax wrapper Waxtite, the seal of quality. First he wrapped the cardboard packs in the wax paper, then put the wrapper inside the box, promoting the freshness of the contents.

The product range began to diversify, extending to over 20 by the end of the century. Constant advertising helped new products and their trademarks become household names. Rice Krispies was introduced in 1928 and, in the 1940s, the Chicago agency Leo Burnett ensured that everyone knew what Snap! Crackle! Pop! signified.

In 1951, Tony the Tiger burst in to launch Sugar Frosted Flakes (later Frosted Flakes), the first sugar-coated cereal. Designed by children's book illustrator Martin Provinsen, Tony was one of four creatures created to promote the cereal. Tony proved more endearing and enduring than Katy the Kangaroo, Newt the Gnu and Elmo the Elephant.

Tony's appearance evolved over time. He stood up from all fours to two paws. He slimmed down and toned up. The introduction of Tony's family was a marketing move to broaden his audience appeal. Tony Jr. was born in 1952, although Mama Tony – his wife – did not appear until the early 1970s, followed by daughter Antoinette in 1974, the Chinese year of the tiger. Throughout the changes, Thurl Ravenscroft's voice-over has enabled Tony to retain his enthusiastic growl: "They're Grrrreat!".

Without the commercial drive of W.K., none of Dr Kellogg's inventions would have been eaten much beyond Battle Creek.

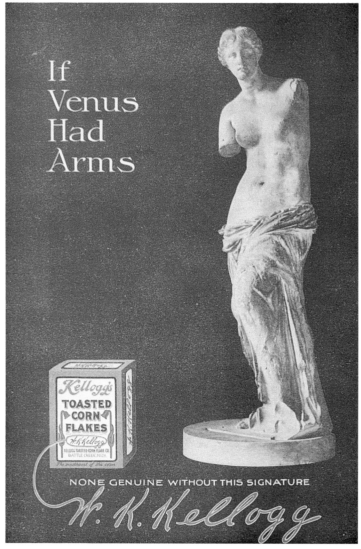

3

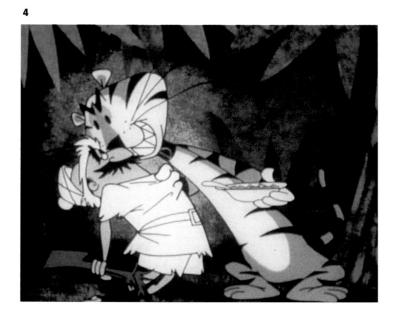

4

3. DATE: 1911.

4. DATE: 1956.
AGENCY: J. Walter Thompson, London.

KIT KAT

DATE: 1970s.
AGENCY: J. Walter Thompson, London.

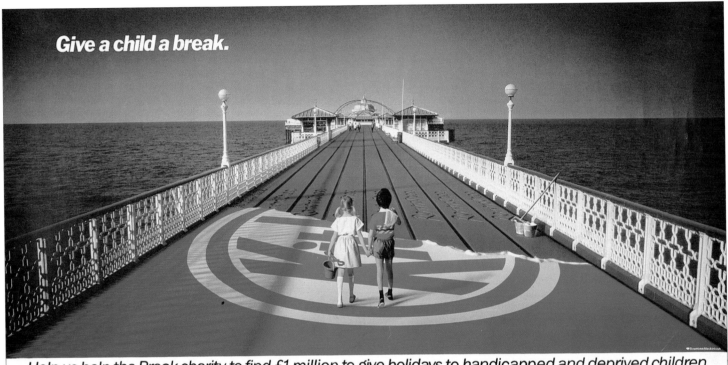

Give a child a break.

Help us help the Break charity to find £1 million to give holidays to handicapped and deprived children.

ROWNTREE'S CHOCOLATE CRISP WAS FIRST PRODUCED IN 1935. IT WAS RENAMED KIT KAT IN 1937, POSSIBLY AFTER THE NOTORIOUS LONDON GAMING CLUB OF THE EIGHTEENTH CENTURY. ITS INNOVATIVE AND DISTINCTIVE RED AND WHITE WRAPPING HAS REMAINED LITTLE CHANGED EVER SINCE.

Early advertising starred Kitty the Kat. The long-running, punning slogan, "Have a break, have a Kit Kat", was launched in the product's 1957 television debut. The word "break" is especially suited to the eminently snappable nature of the chocolate biscuit, as well as carrying implications of a well-earned break from any form of drudgery.

"The term 'Have a break' is Kit Kat, and all the ads have to reflect this ongoing theme," says Dominic Martin, who art directed several Kit Kat ads.

"Beyond that you can do anything." If you have a cracking idea, stay and make a meal of it.

The company retained the essence of the slogan, presenting it in varying forms, often with a new slant on "break". This gave the brand continuity, which was sustained when it was acquired by Nestlé in 1988. The strategy has helped Kit Kat become the UK's best-selling confectionery brand.

"The best advertising comes out of the product – a little truth about the product," says creative director

Billy Malwinney. "The advertising idea should build a bridge between the message and the audience. Creatives must keep going back to the product to make sure the idea is not stuck on with a bit of spit. If you're putting two things together they must fit firmly – as in 'break' and Kit Kat."

MARMITE

DATE: 1996.
AGENCY:BMP/DDB, London.
ART DIRECTOR: Richard Flintham.
COPYWRITER: Andy McLeod.
PHOTOGRAPHER: Andy Baxter.

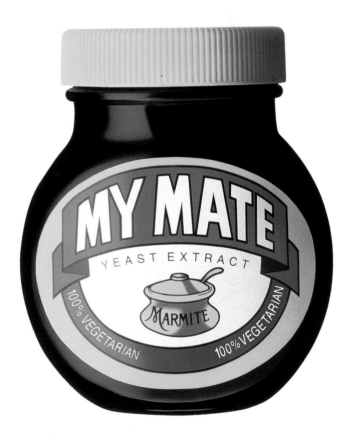
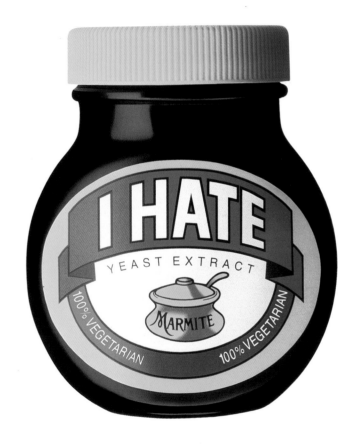

MARMITE IS A CONCENTRATED YEAST PASTE THAT IS 100 PERCENT VEGETARIAN, CONTAINS VIRTUALLY NO FAT OR SUGAR AND IS SUITABLE AS A SPREAD, COOKING INGREDIENT OR A DRINK.

In 1902 the Marmite Food Extract Company rented a disused malthouse in Burton-on-Trent, Staffordshire, the centre of the British brewing industry. The manufacturing process used the spent brewer's yeast.

Following the discovery of vitamins in 1912, the popularity of Marmite – rich in five B vitamins – received a consid-erable boost. Early promotions empha-sized its health-giving properties. During both world wars, Marmite was used by the troops serving overseas to combat beriberi and other deficiency diseases. Early advertising used the phrase "Good for you" – as did Guinness and many other manufacturers keen to exploit people's concerns over health.

A recent awareness-raising campaign used clever wordplay acknowledging that most people either love or hate Marmite.

Until the end of the 1920s, Marmite, which is French for stewpot, was sold in small earthenware pots. When glass jars with metal lids were introduced, a picture of the original bulbous stewpot was retained on the label.

OXO

THE NAME OXO HAS SURVIVED FOR THE DURATION OF THE TWENTIETH CENTURY, YET THE BRAND HAS HAD TO REINVENT ITSELF REPEATEDLY TO REMAIN RELEVANT. THE ORIGINAL FLUID BEEF CONCENTRATE WAS DEVISED BY BARON JUSTUS VON LIEBIG AND LAUNCHED IN 1847 AS AN AID TO HEALTH AND STRENGTH. LIEBIG'S EXTRACT WAS COMMENDED IN SEVERAL MEDICAL JOURNALS AND PRESCRIBED BY DOCTORS. FLORENCE NIGHTINGALE PRAISED ITS RESTORATIVE POWERS AND A JAR OF THE EXTRACT ACCOMPANIED STANLEY ON HIS EXPEDITION TO FIND DR LIVINGSTONE IN 1865.

In 1899 Liebig's Extract was registered as Oxo. To help establish an association with health and endurance, Oxo sponsored athletic events and was the only official caterers at the 1908 London Olympics, when the entire British team endorsed the product. Captain Scott took Oxo on his South Pole expedition in 1911 and an ad in *The Sketch* magazine showed a polar bear sniffing a jar of Oxo, with the headline "One of Scott's Milestones". But it was red faces all round when they realized polar bears do not live in Antarctica. The ad was redrawn with penguins.

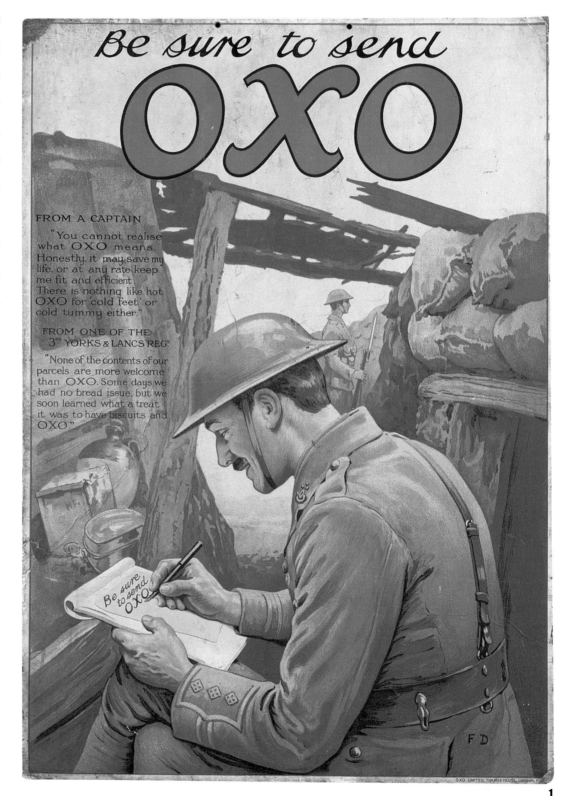

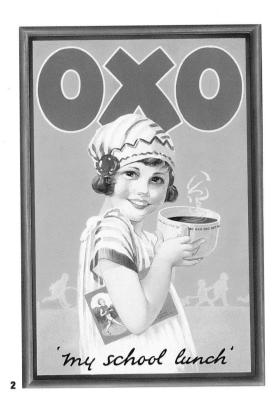

2

'my school lunch'

The Oxo cube itself, with its bright white lettering on a red background, was unveiled in 1910. The cube was cheaper and more convenient to use. Early advertising concentrated on cheerful children and caring adults, ensuring that Oxo was always associated with a reassuring sense of well-being.

Just before World War One, anti-German sentiment was strong and associations with Liebig's name were potentially very damaging. Partly to combat this, Lord Hawke was made chairman of Oxo in 1913. As an aristocrat, sportsman and president of the Middlesex County Cricket Club, he brought with him the ethos of all that is best in traditional British life. The patriotic flavour was further enhanced by the inclusion of tins of Oxo in (almost) every soldier's supplies.

Sales were especially healthy during the two world wars, when Oxo advertising supported the war effort both at home and at the front. The ads emphasized the comforting, familiar and restorative qualities of Oxo, which supplemented the often bland food available.

In the mid-1930s, puns thrived, such as the ad: "Willie B. Hardy? Yes – if he takes Oxo." People became involved with the advertising by working out the word plays, but they also participated more actively by submitting their own slogan suggestions, the best of which were used in ads.

Oxo was one of 23 companies to advertise on the opening night of ITV, the first British commercial television channel on September 22, 1955. Oxo willingly embraced the new medium of television, and within two years was being advertised by Sooty, the most popular glove puppet of the time.

Then, for nearly two decades from 1957, "Katie" became synonymous with Oxo. For 18 years Katie, the star of advertising's first mini-soap, was portrayed by Mary Holland as believable, attractive, interesting and able to cope with a string of kitchen dramas – thanks to the trusty little cube. She helped the brand shake off its post-war image and guide it through great changes in social and eating behaviour.

Katie was the first character in television commercials with a life of her own.

Both men and women responded to the commercials, treating Katie as a real person. In a prototype of interactive advertising, they wrote to her for advice or with details of their own experiences. When her husband, Philip spoke sharply to her in one commercial, all the female staff of an electronics factory came out on strike! Men liked her charm and sex appeal. Women liked her vulnerability and culinary skills. Katie was a sales proposition turned dramatic triumph. Although her treatment would now seem unacceptably sexist, the slogan "Oxo gives a meal man-appeal" endured even after Katie became history.

In the late 1970s research showed that flawless behaviour made real people feel flawed. From 1983 the treatment was

3

very human, funny and fun – at the time a novelty for television commercials. Despite resistance to the warts and all approach, it proved highly successful. In a reincarnation of the Oxo mum, Lynda Bellingham steered a more realistic family through the trials of domestic life, which are invariably improved by the presence of Oxo in the meals.

A recurrent theme throughout Oxo's advertising has been its benefit to children, promoted especially through family cooking. Yet the brand had to fend off competition from convenience food, the decline in home cooking and an increased consumer preference for a greater variety of foreign foods and new cooking methods, such as stir fries and microwaves.

Despite growing external pressures, the volume of Oxo sales was actually slightly higher in the early 1990s than in the early 1950s. The challenge for advertising was to retain the relevance of an essentially unchanging product to a changing society. The only significant change to the cube occurred in 1977 when it was reformulated to give it a "beefier taste" to help combat the challenge from Bovril. Advertising has been the key element in countering an old-fashioned image and continually reframing the product in the light of shifting tastes and cooking habits.

4

SWEDISH EGGS

DATE:1991.
AGENCY: Hall and Cederquist, Stockholm.
ART DIRECTOR: Mats Alinder.
COPYWRITER: Christer Wiklander.
PHOTOGRAPHER: Björn Keller.

URBAN STREETS ARE EVER CHANGING ART GALLERIES WHERE, GENERALLY, A SIMPLE, LARGE, CLEAR IMAGE ATTRACTS THE EYE AND ALSO INSPIRES CONFIDENCE IN THE PRODUCT. IN THIS CASE, THE BRIEF TO THE AGENCY WAS TO PROMPT PEOPLE TO THINK POSITIVELY ABOUT EGGS.

"If you want people to view something in a new way, you have to present it in a new way," says creative director Mats Alinder. "We decided to look at eggs as an ancient symbol of life, and to present them as pieces of art rather than everyday objects in a dramatic, tempting, beautiful way – anything but ordinary."

When enlarged well beyond life size, the resulting six photographs were transformed from product shots to abstract fantasies that increased demand, both for eggs – and for the posters as art.

"Each Scandanavian country has a similar economy and affluent lifestyle," says Jurgen Askelöf, chairman of the Swedish Advertising Association. "The Nordic area also shares much of its culture and tradition. From this stems its appreciation of art and its use of wit and humour in advertising. This differs markedly in style from, for example, German advertising. Our creatives tend to look to the UK for inspiration and technique. Our culture sits more comfortably with British advertising."

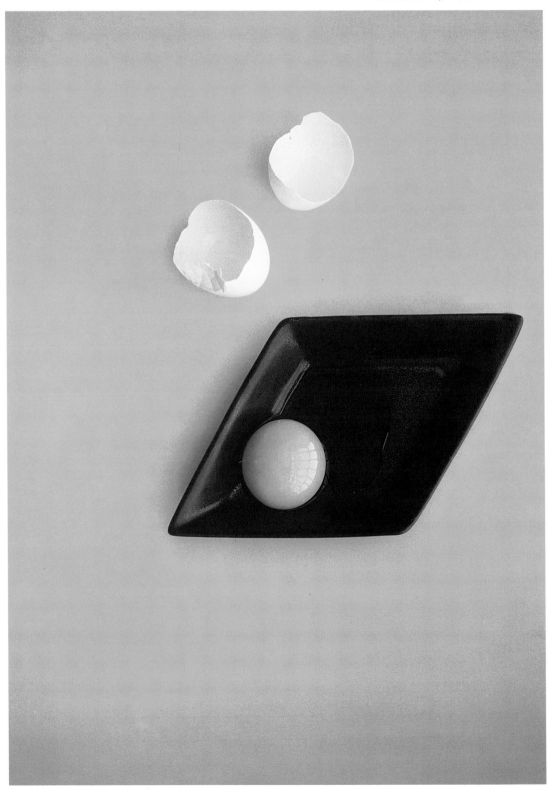

UNEEDA BISCUITS

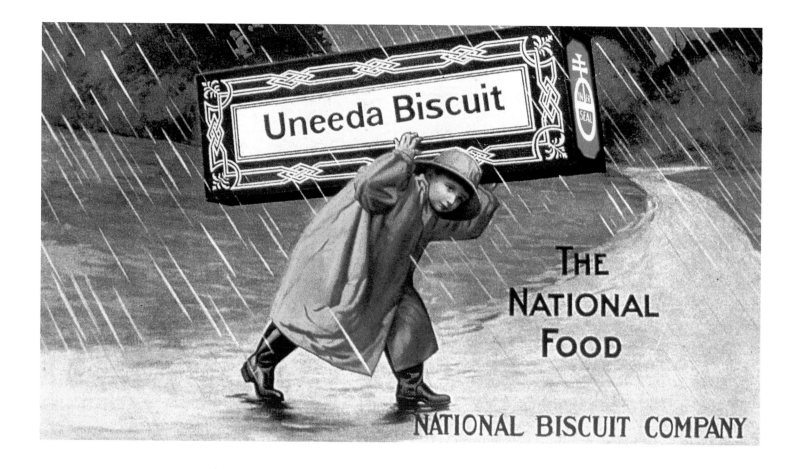

DATE: 1900.
AGENCY: N.W. Ayer and Son, New York.

In the final decade of the nineteenth century, crackers and cookies were produced by hundreds of separate bakers across the USA. They were shipped to retailers in large barrels and square boxes, from which they were sold loose.

In 1898 Chicago lawyer Adolphus Green brought together three big biscuit companies – New York Biscuit, American Biscuit and United States Baking – to form the National Biscuit Company, with 114 bakeries. The company trademark was based on the printer's mark – a Byzantine cross over a circle in white lines on a red field.

Green presented his crackers as a distinct product at a premium price, packaging them in individual boxes with a water-tight lining and selling them under the name Uneeda Biscuits – devised by Henry N. McKinney of N.W. Ayer and Son. The agency was given an unprecedented fee to create the Uneeda Slicker Boy, always walking through driving rain to demonstrate that the wrapper protects the crispness of the crackers. The boy was modelled on Gordon Still, the five-year-old nephew of one of Ayer's copywriters. In 1900, 100 million boxes of Uneeda Biscuits were sold.

In 1941 NBC changed its name to Nabisco.

DRINK

COCA-COLA

DURING THE POSTER boom at the end of the nineteenth century, the streets of Paris burst into life with colourful ads for circus and stage productions. At the time the city was the artistic and cultural centre of Europe and had a well-developed appreciation of the value of posters. The Art Nouveau movement dominated the designs of poster artists led by Jules Chéret and Henri de Toulouse-Lautrec.

As demand grew to promote domestic goods, notably food and drink, established artists responded to the call to create attractive advertisements. Typically, the results resembled their theatrical designs, featuring scantily clad young ladies in striking poses, displaying the products. Invariably the figure was dominant, while lettering and product seemed to be added as an afterthought.

In the meantime, the Arts and Crafts movement in Britain and America had a great influence over advertising until the industry established a language and modus operandi of its own.

The logo or trademark became increasingly recognized as one of the advertiser's most important assets. It was seen as a guarantee of reliability that could be used

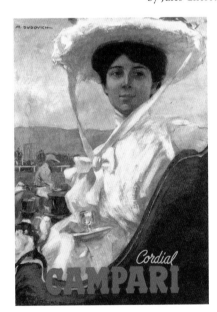

CAMPARI

repeatedly to build on a brand's heritage. Widespread exposure of a consistent symbol helped spread such names as Coca-Cola, Johnnie Walker, Guinness and Sandeman.

"A name is a great property," says John Hegarty, creative director of the London agency Bartle Bogle Hegarty. "People know it. It's solid, reliable and they can trust it. In some cases the job of our advertising is to bring back a name and say to consumers 'We're here, alert and alive to your needs.'"

As many products are very similar and brands are hardly distinguishable from competitors, Steve Henry of HHCL and Partners in London coined the phrase "Unique Selling Persona". Part of an agency's strategy must be to identify an appropriate personality that will make a brand stand out from others. The product personality is enhanced by the borrowed interest of its setting. This in turn defines its market. Campari, for example, is positioned as a society drink in fashionable surroundings. The ad for Campari (p.36) also demonstrates the value that ads can have in providing insights into social paraphernalia of a given time and culture. Compare Campari with Gold Blend (p.43) and Schweppes (p.63).

A product's pedigree provides the bedrock for its personality – although the personality can be largely inde-

pendent of the facts. Sandeman Port (p.62) and Johnnie Walker (p.51) adopted distinctive figures to represent and personify the brand, but they could equally have used very different motifs. Martell is surrounded by a halo of romance and legend, yet this has little logical connection with the product benefits. Coca-Cola is perceived as teenage and vibrant (pp. 38–41), while Guinness is friendly, classless and has a warmth, depth and a sense of humour (pp. 44–7).

While Britain favoured the humorous cartoons of Fougasse (p.246) and Gilroy (pp. 45–6), American advertisers preferred more lifelike illustrations, such as those by Haddon Sundblom (pp. 38–9) and Norman Rockwell (pp. 40, 239).

Besides its use as a part of a brand's character, humour is used in ads to attract attention and empathy and to make people laugh. Humour flatters readers or viewers by crediting them with the intelligence to understand the joke. Bonds of recognition, respect and loyalty to a brand are strengthened through shared jokes (Absolut, pp. 32–3). Several major advertisers have spoofed other ads in an esoteric game that increases visibility and impact. (Heineken pp. 48–49, and Kaliber p. 52)

Off-the-wall humour juggles with fantasy and hyperbole to imprint the brand name on the public consciousness, for example Smirnoff (pp.64–5). During the 1980s and 1990s ads became increasingly bizarre, targeting a sophisticated media-literate market that could appreciate encrypted messages and was becoming more and more sceptical about "straight" product propositions.

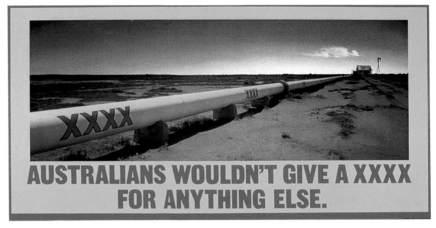

AUSTRALIANS WOULDN'T GIVE A XXXX FOR ANYTHING ELSE.

CASTLEMAINE XXXX

Abrasive, abusive or outrageous humour also found its place, jarring the sensibilities of the uninitiated, but winning approval within the target market, for example Irn Bru (p.50) and Tango (p.66).

Alcoholic drinks have always attracted restrictions, yet these have had irrepressible consequences. When Prohibition became law in America in 1920, alcohol acquired the frisson of forbidden fruit, and speakeasies flourished. During the second half of the century, when social pressure to curb the excesses of alcohol led to restrictions regarding children or as a prerequisite for success, realms of fantasy and surrealism that might otherwise have remained untouched were explored. This also happened in cigarette advertising.

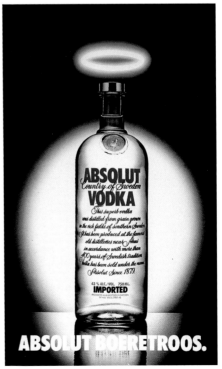

ABSOLUT VODKA

ABSOLUT VODKA

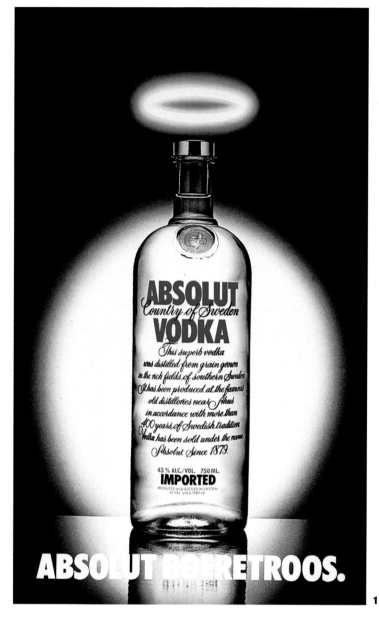

1. DATE: 1980.
AGENCY: TBWA, New York.
CREATIVE DIRECTOR: Arnie Arlow.
ART DIRECTOR: Geoff Hayes.
COPYWRITER: Graham Turner.
PHOTOGRAPHER: Steve Bronstein

2. DATE: 1980s.
AGENCY: TBWA, New York.
CREATIVE DIRECTOR:Arnie Arlow.
ART DIRECTOR: Tom McManus.
COPYWRITER: David Warren.
PHOTOGRAPHER: Steve Bronstein

3. DATE: 1994.
AGENCY: TBWA, New York.
ART DIRECTOR: Pascal Gayraud.
PHOTOGRAPHER: Graham Ford.

WHEN CARILLON IMPORTERS DECIDED TO MARKET THE SWEDISH VODKA, ABSOLUT, IN AMERICA, COMPANY PRESIDENT MICHEL ROUX WAS NOT DETERRED BY UNPROMISING RESEARCH ABOUT THE INNOCUOUS, COLOURLESS BOTTLE. HE INVITED NEW YORK AGENCY TBWA TO PITCH FOR THE ADVERTISING ACCOUNT.

The agency's problem was how to make a new brand of vodka stand out from all the established brands. As Absolut had no US track record, the agency started with a clean slate, looking for a sustainable personality that would make the product distinctive. With no definable advantage, an identity had to be invented.

Three nights before the presentation, the agency's senior vice-president Geoff Hayes doodled a simple visual of the bottle with a halo.

"At that point nobody thought we had a campaign. It was just a single ad," says creative director Arnie Arlow. "Soon we realized a way of expanding the theme until it grew into a campaign.

A momentum developed because we adhered to an important principle of art: unity and variety. The message has remained the same, yet there's tremendous variety in the way it's put across.

"The Absolut campaign is a client's dream: the bottle is centre stage, the product name is in the headline and there isn't too much borrowed interest. But, even

then, it took four or five years before people really started noticing. It takes a lot of advertising to break through public consciousness."

The agency appreciated that the bottle was difficult to photograph and handed Steve Bronstein the task of creating a "look" for it. He did it with back lighting – a soft glow gave the bottle

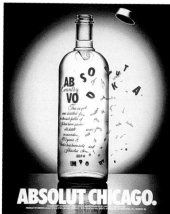

dimension. "I find print work so satisfying because it's finite and it's mostly your own work," says Bronstein, who has since photographed over 70 Absolut ads. "TV doesn't give the same sense of achievement because so many people are involved and your own input gets diluted. But the pay cheque is bigger!"

Early ads featured the bottle in different situations with appropriate visuals. The bottle in chains had the headline "Absolut Security"; "Absolut Definition" placed the bottle inside a dictionary; "Absolut" showed the pure, unadulterated bottle; and "Absolut Déjà Vu" repeated the picture on the following page.

As the shape became more familiar, the campaign dispensed with the bottle and incorporated its shape into different situations. The city series provided a blueprint for a world of possibilities: "Absolut Manhattan" depicted a reshaped Central Park; "Absolut Chicago" – the windy city – had the lettering and bottle top being blown off; "Absolut New Orleans" showed the valves of a trumpet in the distinctive shape of the bottle; and "Absolut Miami" recreated a model of an art deco bottle-building among the hotels of Miami's Collins Avenue.

Sumptuous photography and intelligent thinking behind the long-running, long-punning campaign helped elevate Absolut vodka from obscurity to American brand leader within six years.

3

BODDINGTONS

DATE: 1997.
AGENCY: Bartle Bogle Hegarty, London.
CREATIVE DIRECTORS: Bruce Crouch
and Graham Watson.

ART DIRECTOR: Simon Robinson.
COPYWRITER: Jo Moore.
PHOTOGRAPHER: David Gill.

MOST BEER ADS LEAD WITH TELE-VISION. BODDINGTONS LED WITH PRESS ADS – ALL CLEAN, CRISP AND CLEAR ENOUGH TO BE POSTERS. AND AS THEY DOMINATED THE BACK COVERS OF MAGAZINES, THEY WERE EFFECTIVELY VIEWED AS POSTERS. CONCEPTUALLY, NOT UNLIKE ABSOLUT VODKA (PP. 32–3)

Most beer ads focus on the drinker, not the drink. Boddingtons concentrated solely on a single product attribute - its smoothness. Creaminess was deemed the best evocation of smoothness, and was expressed visually through a series of cream analogies emphasizing the creamy head and translucent golden colour of the beer.

When the agency Bartle Bogle Hegarty was founded in 1982, Whitbread was one of its three founding clients, along with Audi and Levi Strauss. In 1989 Whitbread bought Boddingtons brewery in Manchester. Brewed since 1778, "Boddies" has a solid, accessible and unpretentious personality and is seen as urban and contemporary, but sales were declining.

The advertising campaign aimed to turn Boddingtons into a national brand, without losing sight of its Mancunian roots. Research in the brand's heartland set out to discover the existing appeal of Boddingtons, with the plan to explain this appeal to a wider market.

"All great ideas look wonderfully simple once they're done," says creative director John Hegarty. "But all the way through developing an idea there are moments when you can deviate. And that's the danger area. The deviation might be an improvement, but more often it's a smoke screen."

After two years of press advertising, television was added to bring an extra emotional dimension through the irreverent characters and pasticing of established advertising genres.

The canned beer became market leader within 18 months of the advertising launch. Within six years 84 percent of consumers recognized new "Cream of Manchester" press ads with no logo or branding. As a result, the characteristic yellow strip, logo and brand name were removed in the 1997 campaign and replaced with a discreet sign off "The Cream of Manchester".

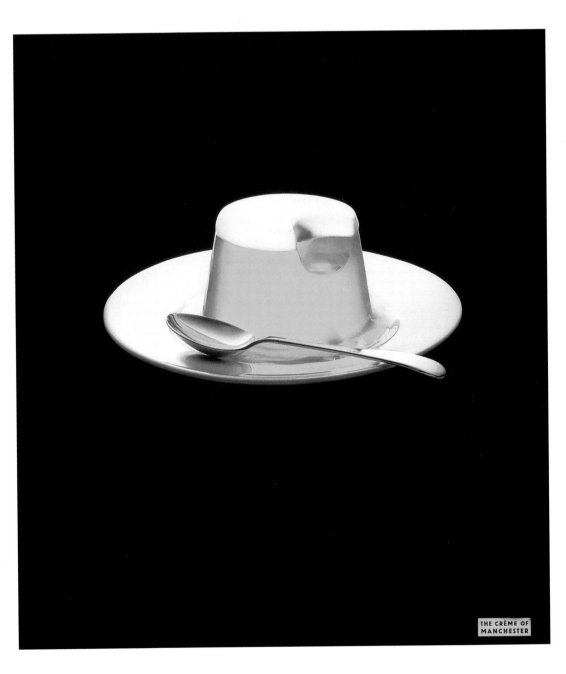

THE CRÈME OF
MANCHESTER

CASTLEMAINE XXXX

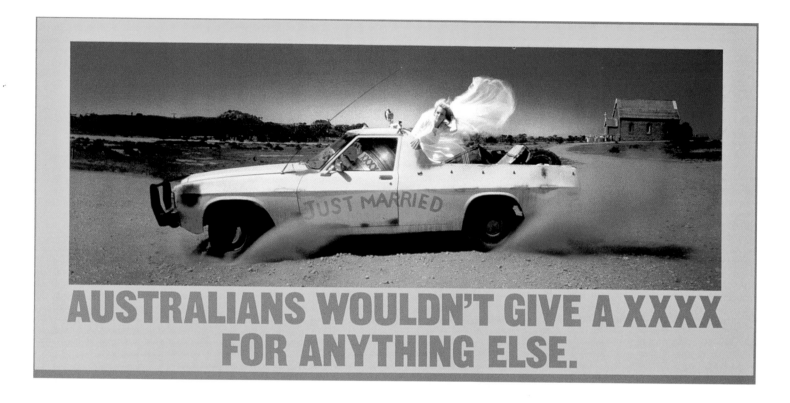

THE LAGER MARKET IN THE UK WAS GROWING AND ALLIED BREWERIES PLANNED TO DOMINATE IT WITH A NEW PRODUCT. RESEARCH SHOWED THAT THE AUSTRALIAN PERSONALITY WAS MOST STRONGLY IDENTIFIED WITH LAGER AMONG LAGER DRINKERS, BUT FOSTERS – LAUNCHED BY COMPETITOR WATNEYS IN 1981 HAD ALREADY SUCCESSFULLY HARNESSED THAT APPROACH. NONETHELESS, THE AGENCY DECIDED TO TAP INTO AUSTRALIAN TERRITORY AS THE SETTING FOR ITS MAJOR CAMPAIGN LAUNCH IN 1984.

The slogan "Australians wouldn't give a Castlemaine XXXX for any other lager" lent itself to a variety of witty treatments, which invariably arose out of relaxed sessions of story-telling. Within three years the brand became one of the top-selling beers in the country and the agency – which reused the popular slogan in a 1999 campaign – claimed XXXXs to be the most successful beer launch ever.

For many of its shoots, the creative team went to the desert near Broken Hill in New South Wales. "It's one of the only places in the world where you can do desert shots without the distraction of planes flying over," says photographer Peter Lavery.

The key target group – young, frequent drinkers – base their brand preferences on a beer's image, which is derived principally from advertising.

The tone must be appropriate for the individual and his peer group, while the advertising must also be sufficiently conspicuous to reassure the consumer of the success and popularity of a product first brewed in Queensland in 1916.

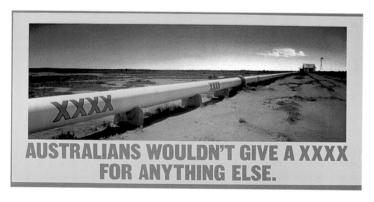

DATE: 1987.
AGENCY: Saatchi and Saatchi, London.
ART DIRECTOR: Peter Gibb.
COPYWRITER: James Lowther.
PHOTOGRAPHER: Peter Lavery.

CAMPARI

1. DATE: 1910.
ARTIST: Marcello Dudovich.
2. DATE: 1921.
ARTIST: Leonetta Cappiello.

1

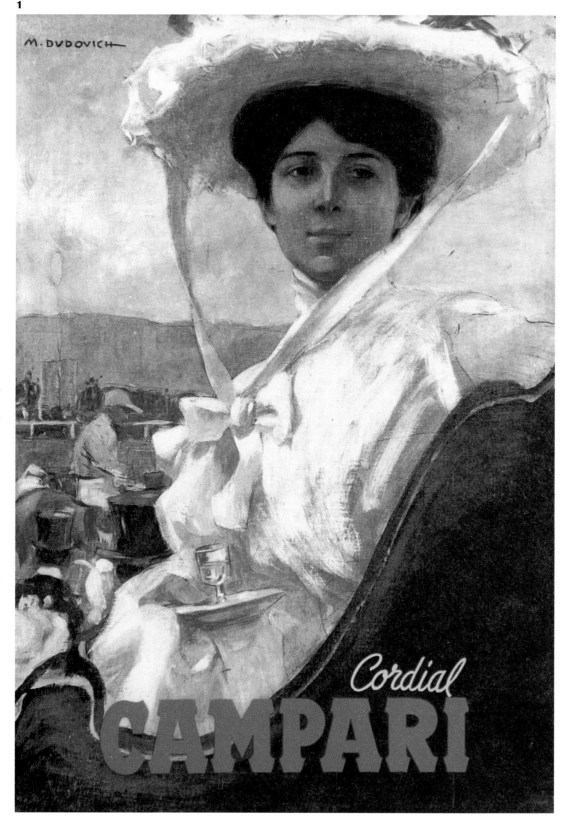

GASPARE CAMPARI CONCOCTED VARIOUS LIQUEURS, CORDIALS AND BITTERS IN THE BASEMENT LABORATORY OF HIS COFFEE-HOUSE IN MILAN, AND RELIED ON WORD-OF-MOUTH PUBLICITY. HIS SON DAVIDE, WHO BEGAN RUNNING THE COMPANY IN 1885 AT THE AGE OF 18, HAD AMBITIONS FOR HIS FATHER'S "BITTER ALL'USO D'HOLLANDA" – LATER SIMPLY CAMPARI – AND SOON EMBRACED THE NOTION OF ADVERTISING. HIS FIRST, MODEST FORAY CAME IN 1889 IN THE FORM OF A PRICE LISTIN A NEWSPAPER.

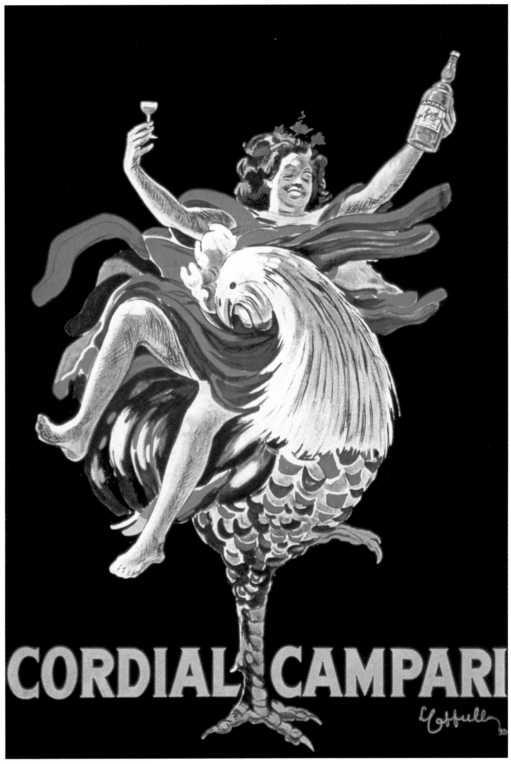

2

The advertising poster was a late starter in Italy – 20 years behind France, Britain and the United States. G. Mora created Campari's first in 1894; but it was not until the twentieth century that Campari posters took flight.

Campari advertising focuses on the name itself and the mood of the image. The drink is woven into the narrative as part of the enjoyment of everyday life, as in the fashionable racecourse scene by the renowned Italian artist Marcello Dudovich. It is neither imposing nor dominant, simply another prop adding to the overall atmosphere of genteel sophistication.

The work of the prolific Italian-born caricaturist and poster designer Leonetta Cappiello addressed a broader class of consumer. Cappiello moved to Paris in 1898 and owed the development of his graphic style to the French school, especially Jules Chéret (p.218). He appreciated the quickening pace of life in the streets and many of his figures stand out dramatically from a dark background.

While most companies jealously guard the accuracy of their logo and trademark, Campari lettering comes in many styles, lacking any continuity. Since Davide Campari launched the publicity machine, the company has always believed that the product speaks for itself.

COCA-COLA

IN 1886, THE YEAR THE STATUE OF LIBERTY WAS UNVEILED, DR JOHN STYTH PEMBERTON CONCOCTED A MIXTURE IN A THREE-LEGGED BRASS POT IN HIS BACK YARD IN ATLANTA, GEORGIA. WHAT THIS PHARMACIST AND INVENTOR OF PROPRIETARY MEDICINES AND BEVERAGES PRODUCED BE-CAME MORE FAMOUS THAN THE STATUE. IT WAS "COCA-COLA", A NAME GIVEN TO THE SYRUP BY PEMBERTON'S BOOKKEEPER, FRANK M. ROBINSON, WHICH HE WROTE IN THE FLOWING SCRIPT THAT DEVELOPED INTO THE COPPERPLATE CURVES RECOGNIZED AROUND THE WORLD.

Pemberton died in 1888. Within three years Asa G. Candler, an astute businessman and owner of a whole-sale/retail drug business, had purchased all rights for a total of $2,300.

The first outdoor advertisement – proclaiming Coca-Cola as "Delicious and Refreshing" – was an oilcloth sign outside Jacobs' Pharmacy, Atlanta, where the drink was sold for five cents a glass as a soda fountain drink. The recipe, which became known as "7X", has remained a closely guarded secret ever since.

A great believer in the power of advertising, Candler promoted the brand using calendars, trays, glasses, fans, wallets, pocket knives, playing

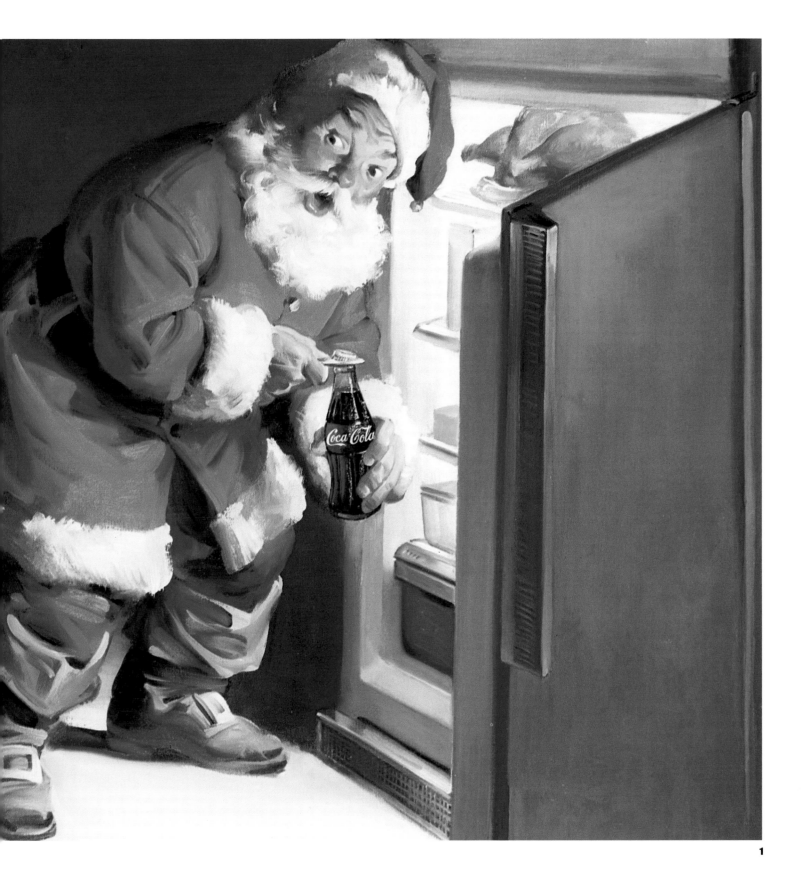

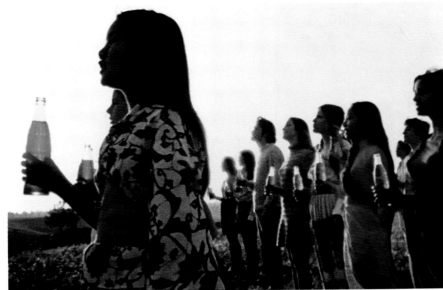

1. DATE: 1959.
ARTIST: Haddon Sundblom.

2. DATE:1935.
AGENCY: D'Arcy and Co.
ARTIST: Norman Rockwell.

3. DATE: 1971

cards, clocks, menus, bookmarks and magazine advertisements. By 1895 he had turned Coca-Cola into a national beverage, drunk in every state and territory in the United States. A major contribution to the brand's success, put in place in 1899, has been the independent bottler system, whereby companies are granted the right to produce, bottle and distribute the drink.

By 1908 the Coca-Cola logo decorated 2.5 million square feet of building facades. Sometimes the logo was simply accompanied by the single word "Drink". You can't have a more direct marketing proposition than that.

Quick to see the value of celebrity endorsement, Candler placed pictures of opera diva Lillian Nordica on various products and in magazine ads. She was followed by Cary Grant, Loretta Young and Jean Harlow, who asserted, "It breaks the stress and strain of shooting scenes over and over".

In 1916 the straight-sided bottle was replaced by the distinctively contoured hobble-skirt bottle which became one of Coca-Cola's trademarks.

As cars began to speed up, outdoor posters grew bigger and simpler. In 1925 the first four-colour billboard ad appeared, featuring a uniformed "Ritz Boy" carrying a tray of frosted Coke, with the headline: "5,000,000 drinks a day".

Between 1928 and 1935, the prolific American artist Norman Rockwell created six scenes for Coca-Coca in his characteristic slice-of-life style.

In a move to increase sales during the cold months of the year, Archie Lee of the D'Arcy advertising agency proposed using Santa Claus to promote Coke at Christmas. In 1930 artist Fred Mizen was commissioned to paint Santa for a magazine ad. It showed a plump, red-suited Santa surrounded by children. But it was the following year that artist Haddon Hubbard "Sunny" Sundblom created the modern image of a warm, friendly, very human Santa Claus, whose suit echoes the colours of Coke's logo. For 33 years Sundblom depicted Santa as a plump jovial man with a hearty laugh and twinkling eyes, enjoying a well-earned "pause that refreshes" – a slogan that first appeared in *The Saturday Evening Post* in 1929. Sundblom's paintings were modelled on a retired salesman named Lou Prentice and later on himself.

Using mostly oils – and either hand – Haddon Sundblom also painted ads for Packard, Ford, Lincoln, Pierce-Arrow and Marmon cars as well as for Cream of Wheat, Nabisco Shredded Wheat and Aunt Jemima; he also created the Quaker Oats man, who bears a striking resemblance to the rosy-cheeked Santa!

Coca-Cola was one of the first American food products to be exported. An early challenge was to translate the name. The company opted for a phonetic spelling in each language with some surprising results - in China the characters for Coca-Cola mean either "make mouth happy" or "delicious refreshing".

Coca-Cola was also quick to spot the potential of television when it arrived and sponsored programmes using actors and existing radio jingles; in the 1950s the brand was identified with over 30 of America's favourite shows. The popular radio jingle "Things go better with Coca-Cola" was recorded in 1963 by The

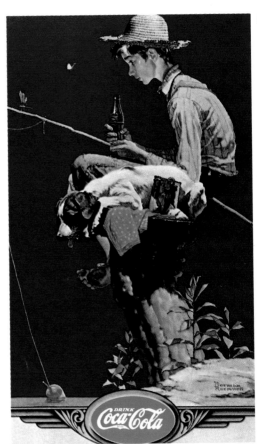

2

4

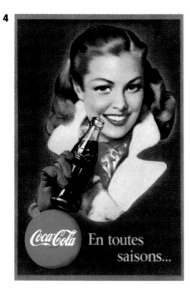

Limelighters, followed by versions by many leading artists including The Supremes, The Four Seasons and The Moody Blues.

A stirring event was staged on an Italian mountainside in 1971 when a Coca-Cola commercial featured young people from 30 countries wearing national dress. In gentle two-part harmony they sang "I'd like to buy the world a home, and furnish it with love; grow apple trees and honey bees and snow-white turtle doves." Coke was not mentioned until the eighth line, but the message was clear, the sentiment in perfect harmony with the zeitgeist of the age – love, not war, and global consciousness. Soon the extravaganza was recognized as one of the century's defining commercials.

Sales of Coca-Cola now average more than 600 million drinks a day and account for nearly half of all soft drinks consumed worldwide in nearly 200 countries.

5

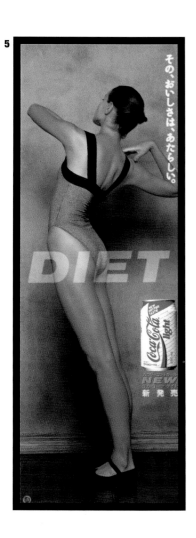

6

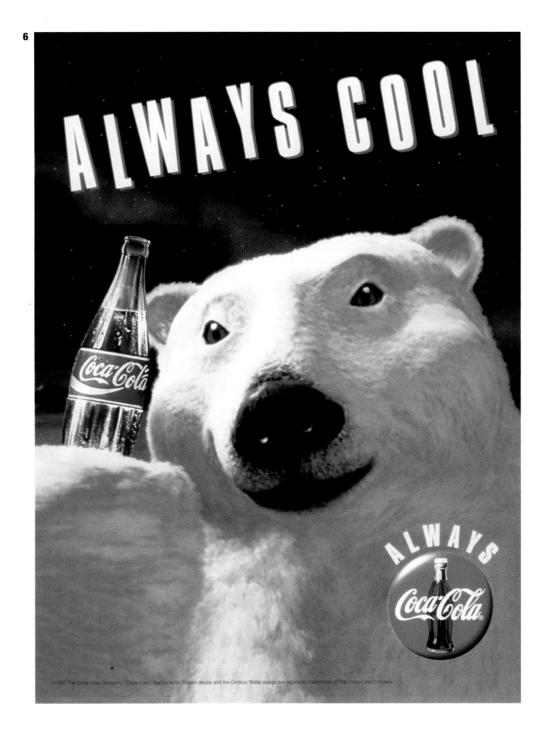

4. Date: 1950s.
France.

5. DATE:1989.
Japan.

6. DATE:1993.

DUBONNET

DATE: 1934.
AGENCY: Alliance Graphique, Paris.
ARTIST: A.M. Cassandre.

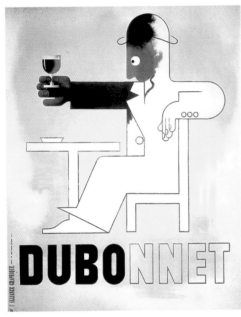
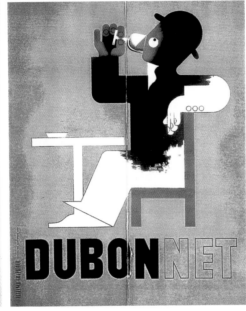
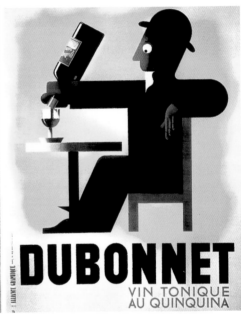

A.M. CASSANDRE WAS AT THE FOREFRONT OF ART DECO POSTER DESIGN IN PARIS IN THE 1920S AND 30S. HIS IMAGES ARE CHARACTERIZED BY THE CLEAN ANGULAR LINES OF PURISM AND THE INTEGRATED USE OF TYPOGRAPHY, WHICH CONTRIBUTE TO THE VISUAL IMPACT (P. 207). HIS MECHANICAL DESIGNS HELPED TO POPULARIZE THE CUBIST MOVEMENT.

Cassandre's ingenious interpretation for Dubonnet expresses movement in much the same way as a film story-board or cartoon strip, showing a developing sequence of events. As the man drinks the Dubonnet, both he and the lettering are suffused by the beverage. Besides being amusing, the depiction conveys a sense of relaxing warmth as the drink spreads through the body. The poster was so successful, it was used for about 20 years.

A founding partner in the advertising agency Alliance Graphique, through which he operated, Cassandre viewed his work as applied art. "A poster is only a means to an end, a means of commu-nication between the dealer and the public, something like a telegraph," he wrote. "The poster designer plays the part of a telegraph official: he does not initi-ate the news, he merely dispenses it. No one asks him for his opinion, he is only required to bring about a clean, good and exact connection."

GOLD BLEND

1. DATE: 1995.
AGENCY: McCann Erickson, London.

2. DATE: 1997.
AGENCY: Dentsu, Tokyo.
CREATIVE DIRECTOR: Yoshihumi Kawai.
COPYWIRITER: Akira Kikuchi.
DIRECTOR: Satoru Fujiuchi.
MODEL: Tetsuya Kumakawa.

1

LAUNCHED IN THE MID-1960S, GOLD BLEND USED THE NEW FREEZE-DRIED TECHNOLOGY TO PRODUCE A SMOOTH, RICH TASTE THAT COULD BE SOLD AT A PREMIUM. ADVERTISING FOR THE BRAND EMBRACED VERY DIFFERENT FLAVOURS IN JAPAN AND THE UK.

For 30 years Gold Blend in Japan has endured as the coffee for those who appreciate high quality. Dentsu began its campaign three decades ago by introducing the market to instant coffee; subsequently it reinforced the calibre of the product by getting the endorsement of novelists, musicians and performers. Each is portrayed as a person who

knows the difference, in this case the ballet dancer Tetsuya Kumakawa. The agency built a solid brand by promoting a consistent concept over an extended period, with music, tone and style remaining constant.

At first, the advertising in the UK concentrated on the product itself, using the mnemonic of a gold bean to suggest superiority. To reach a broader market a shift was made in 1987 towards a more emotive, consumer-orientated approach. The aim was to retain the brand's quality and aspirational image, while making it more accessible.

The agency created an ongoing romantic saga that captured the essence of intrigue, popular in the American TV series, "Moonlighting". The drama was infused with a tantilizing "will they, won't they?" tension. And each episode

ended with a cliffhanger. The couple was brought together through the coffee, but kept apart by events. Media strategy included teaser ads in the TV listings pages that boosted viewing figures.

The first series of commercials was so successful that it ran for 12 instead of

six episodes over five years, culminating in the screening of all episodes and ending with the happy couple disappearing into the sunset. The campaign spawned a book, two CD/cassettes and a video, each successful and profitable in its own right.

2

GUINNESS

EVER SINCE THE FIRST GUINNESS ADS APPEARED IN THE UK NATIONAL DAILY NEWSPAPERS ON 7TH FEBRUARY 1929, THEY HAVE BEEN AT THE FOREFRONT OF INNOVATIVE ADVERTISING.

The immortal slogan "Guinness is good for you" was coined for the company's first ad by art director and copywriter Oswald Greene and junior copywriter Bobby Bevan at the London advertising agency S.H.Benson. The line was used in a variety of forms, from the alliterative "Guinness is good" to "Good for you", which dispensed with the brand name altogether. Stricter regulations in the 1960s rejected the phrases as making false claims, and alternatives kept emerging – "Guinnless isn't good for you", "Good for Guinness", "Pure Genius" and "Not everything in black and white makes sense".

In 1925 John Gilroy, then aged 27, joined S.H.Benson as an in-house artist. He was a skilled draughtsman with populist appeal. He created posters for Bovril and Macleans toothpaste, but is best remembered for his prolific output of Guinness ads – more than 100 over a period of 35 years. Although he left the agency in 1940, he continued to create a menagerie of characters and zoo animals until 1961.

Reflecting the high iron content of the drink, assertions, such as "Guinness for Strength", were seen as acceptable currency in the politically incorrect first half of the century. Gilroy's man carrying an iron girder became such an icon that a pint of Guinness even assumed the nickname "a girder". The drawing has been transposed into different forms and appeared in different countries, including a Nigerian lumberjack carrying away a tree trunk in 1962. While most of the more memorable ads have been generated by successive London agencies, different markets around the world have reinterpreted the advertising strategy to suit local tastes. In 1995 Ammarati Puris Lintas in Canada used the bottle itself as a metaphor for strength, pulling against elephants or bending the bars of dumb bells.

The first poster bearing the line "My Goodness, My Guinness" appeared in 1935 and shows a seal making away with the zoo keeper's Guinness. Gilroy animals were modelled on inmates at London Zoo, while the red-faced zoo keeper was a caricature of himself. The first Guinness TV commercial was broadcast on ITV's inaugural evening in 1955. With actor Charles Naughton as the zoo keeper, it reenacted the seal scenario with a live sea-lion.

Dorothy L. Sayers, later known for her crime fiction, was part of Samuel Benson's writing team from 1922 to 1929. She is credited with conceiving the Guinness toucan, transforming it from the original pelican. Ideal for puns, the toucan became a symbol for Guinness for 25 years, and was reinstated by J.Walter Thompson in 1979 to promote draught Guinness in cans.

Cyril Kenneth Bird, an artist working at the same time as Gilroy, chose the pseudonym Fougasse – French for a small anti-personnel mine used in World War One. His simple sketches accompanied by tongue-in-cheek puns herald a type of humour that infuses much of Guinness advertising. In a 1933 sketch of two people out for a walk in the countryside, one man announces "I feel like a Guinness", and the other replies "I wish you were!" The idea was revived in 1944, with two men painting the side of a ship during World War Two. Fougasse's "Careless Talk Cost Lives" for the Ministry of Home Security in London helped to win the war as much because of their morale boosting qualities as the warning they gave (p.246).

As Guinness ads evolved and the thinking behind them became more complex and sophisticated, the core message remained constant: the brand's uniqueness, quality and strong personality. In 1969 the account moved from S.H. Benson to J. Walter Thompson, in London. The agency made the most of the medium of television by using high profile directors such as Terence Donovan, Lindsay Anderson and Karel Reisz, while the print work, under the guidance of creative director Jeremy Bullmore, focused on quality photography and accessible puns: "Tall, dark and have some" (1972) and "Cool, calm and collect it" (1974).

Allen Brady and Marsh became guardians of the brand's advertising from 1982 until 1984, when they ran the "Guinnless isn't good for you"

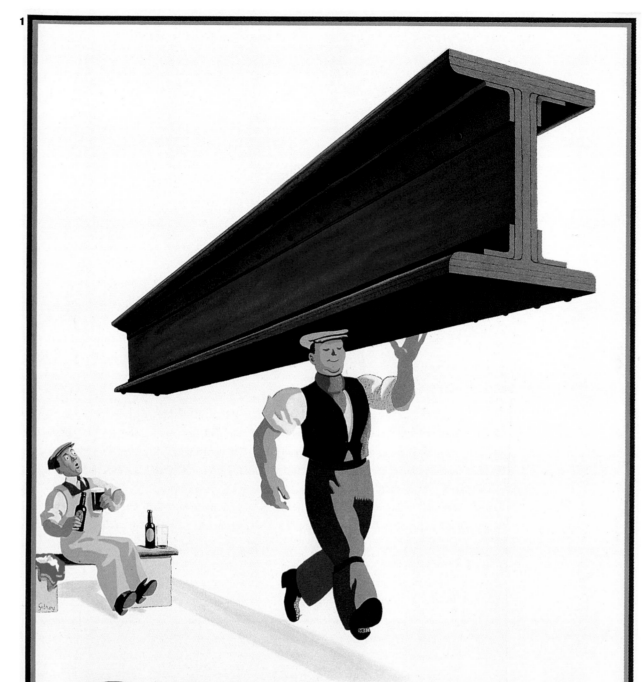

GUINNESS
FOR STRENGTH

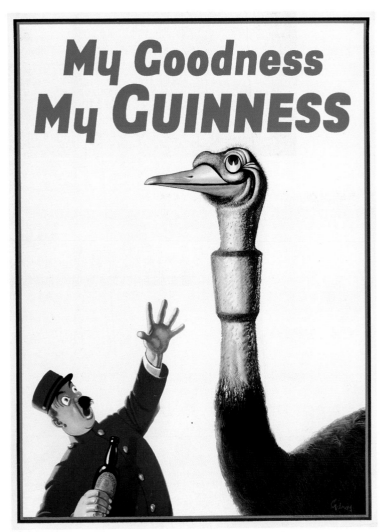

2

campaign. Although the posters and seven commercials reversed a temporary decline in sales, the smart double negative was seen by many as confusing.

In 1984 the account passed to Ogilvy and Mather, an agency that incorporates the original S.H. Benson. The following year Mark Wnek, copywriter with the company, introduced the "Pure Genius" campaign, which attributed the status of genius to both the drink and the drinker. Next came the highly successful "Man with the Guinness" campaign in 1987, featuring Dutch-born actor Rutger Hauer as the enigmatic spokesman personifying the mysterious depths of the product. He mirrors the physical appearance of the drink – dressed in black, with smooth, blond hair – while psychologically he comes across as robust, complex and deep. The 8-year television campaign co-opted such esteemed directors as Hugh Hudson, Barney Edwards, Paul Weiland and Ridley Scott. Awareness of the campaign rose to double that the most other beers, and sales increased significantly. Says Mark Wnek, "(The campaign) seeks to hang on to the impact, originality and intrigue of the past while communicating to today's market."

In Australia Wenanty Nosul played the part of the man with the Guinness – "a little rougher round the edges" than Hauer. In Singapore and Hong Kong, well-established actor George Lam took the role, centred around Chinese proverbs. With the endline "Guinness – a word of wisdom", it was shot in Cantonese, Mandarin and English.

By the mid-1990s, the man with the Guinness appeared too self-assured. Art director Clive Yaxley and copywriter Jerry Gallagher drew on the visual appearance and unexpected character of the product for the "Black and White" campaign, launched in 1996. In contrast to the early light and frivolous Gilroy posters, this was viewed by the uninitiated as bizarre and baffling, while for others it echoed the uncertain spirit of the time.

Appropriately, the endline was "Not everything in black and white makes sense."

Tony Kaye, who directed the second commercial, took his theme from a line of graffiti: "a woman needs a man like a fish needs a bicycle". The commercial shows women engaged in jobs traditionally associated with men – drilling, mining and lorry driving – and ends with a fish riding a bicycle, an image which was transformed into a popular screensaver.

3

2. DATE: 1936.
AGENCY: S.H. Benson, London.
ARTIST: John Gilroy.

3. DATE: 1980.
AGENCY: J. Walter Thompson, London.

4. DATE: 1991.
AGENCY: Ogilvy and Mather, London.
DIRECTOR: Ridley Scott.
MODEL: Rutger Hauer.

5. DATE: 1996.
AGENCY: Ogilvy and Mather, London.
ART DIRECTOR: Clive Yaxley.
COPYWRITER: Jerry Gallaher.
DIRECTOR: Tony Kaye.

4

Characteristically, Guinness was one of the first advertisers to harness the power of the internet. By 1995 over 100,000 people had downloaded a Guinness screensaver.

In 1998 the agency Abbott Mead Vickers/BBDO, London, took over the responsibility of leading this distinctive brand into the next millennium.

Guinness, by far the highest selling stout in the world, is now brewed in 51 markets and sold in over 150. While brand positioning, product strategy and packaging are determined centrally, there has been no global advertising strategy or agency network, and local advertising has been free to respond to local idiosyncrasies.

5

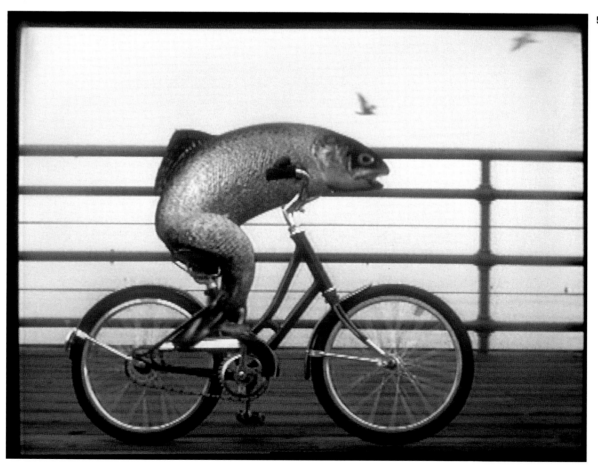

HEINEKEN

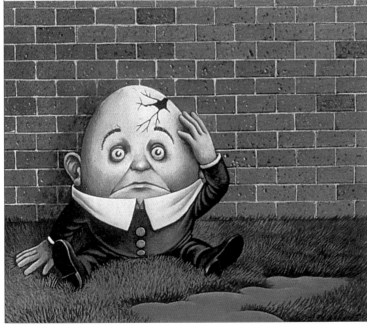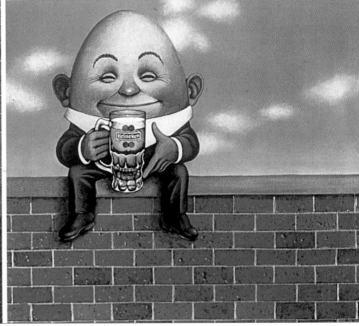

1

IN 1973, STRUGGLING WITH CREATIVE BLOCK, COPYWRITER TERRY LOVELOCK DISAPPEARED TO MARRAKESH IN SEARCH OF INSPIRATION. AT 3AM HE WOKE IN HIS HOTEL ROOM AND SCRIBBLED DOWN THE PHRASE "HEINEKEN REFRESHES THE PARTS OTHER BEERS CANNOT REACH."

The line, memorable because of its quirkiness, its intrigue and its claims to superiority, immediately became a frequently used and adapted catch-phrase, and a bandwagon for witty interpretations.

"Ads should meet the consumer at a point half-way between the printed page or TV screen and the consumers brain," says Frank Lowe, founder and chairman of the Lowe Group. "The consumer knows you're playing a game and he can bring a lot to your ad.

Having done a bit of work on it – like everything else in life – the pleasure of understanding the ad is all the greater."

The subsequent string of television and print ads soon entered the popular idiom in Britain. The word plays became more playful. Heineken ads bounced off other ads in a series of in-jokes. Using the before-and-after formula, a 1977 spoof showed a limp girder carried by the Guinness man (pp. 44–7) transformed into rigidity following suitable refreshment.

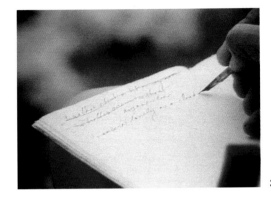

3

Another, in 1981, adapted Elliott Erwitt's classic shot for the French Tourist Board (p. 200), extending the French loaf to traffic-stopping lengths. "That picture has been copied a lot, but this was the one time I was hired to copy my own picture," says Erwitt.

Later, an ingeniously simple parody of the first Silk Cut purple silk ad (pp. 132–33) showed the characteristic cut in the silk apparently completely healed. Then, in place of the government health warning, was the newly refreshed tag-line: "Only Heineken can do this. " In advertising, plagiarism is alive and thriving and, as long as it's a legitimate spoof or so heavily disguised that it is beyond the reach of litigation, it can be enriching rather than enraging.

In the search for a suitable tone for the voice-overs, the agency sought out someone who sounded faintly foreign and whose voice was friendly, persuasive and humorous: Victor Borge.

The Windermere commercial opens with a pen nib scratching on paper and the voice-over: "I walked about a bit on my own …" The nib crosses this out. "I strolled around without anyone else …" The nib crossing this out, too. The sound of a can opening follows, and someone drinking. Back to the nib on the paper. "I wandered lonely as a cloud that floats on high …" Then the voice-over: "Only Heineken can do this because it refreshes the poets other beers cannot reach." The founder, Paddy Heineken, would have found the ads as refreshing as his drink.

1. DATE: 1977.
AGENCY: Collett Dickenson Pearce, London.
CREATIVE DIRECTOR: Frank Lowe.
ART DIRECTOR: Alan Waldie.
COPYWRITER: Mike Cozens.
ILLUSTRATOR: Barry Craddock.

2. DATE: 1977.
AGENCY: Collett Dickenson Pearce, London
Creative Director: Frank Lowe.

3. DATE: 1982. Whitbread.
AGENCY: Lowe Howard-Spink, London.
CREATIVE DIRECTOR: Frank Lowe.

2

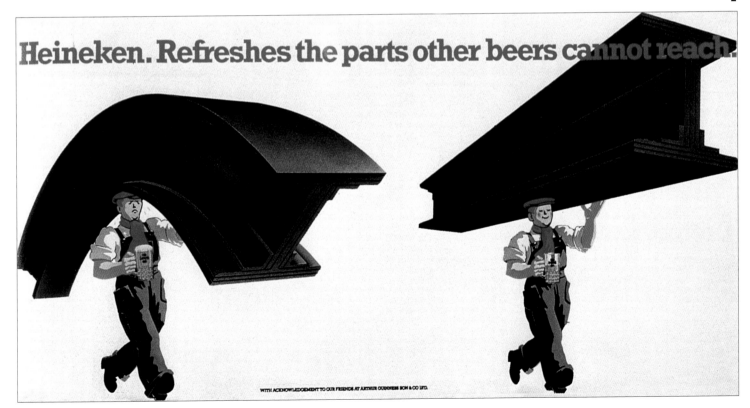

IRN-BRU

IRN-BRU WAS IN TROUBLE. THIS SWEET, FIZZY SOFT DRINK THAT ORIGINATED IN SCOTLAND AT THE BEGINNING OF THE TWENTIETH CENTURY WAS SUFFERING FROM AN OLD IMAGE.

The teenage market did not relate to its existing advertising which stressed product attributes, such as its Scottish origins and the supposition that it contained iron – "Made in Scotland from Girders". Irn-Bru was seen as bleak, grey, industrial and lacking in street credibility – in contrast to the bright, lively, glossy competition.

Yet the competitors' wholesome, energetic advertising gave Irn-Bru the opportunity to take an opposing stance. Through the advertising agency Lowe Howard-Spink, a television campaign lampooned Coke-style advertising with mischievous, anarchic wit, and paved the way for a separate print campaign to boost sales beyond Scotland's borders. The Leith Agency took over the account and assumed a maverick tone in its lateral poster campaign, creating bizarre and often macabre situations to illustrate the apparent effects of drinking Irn-Bru. The radical images reflected the teenage compulsion to rebel against convention. It was a strategy ideally suited both to the target market and the no-nonsense personality of the product.

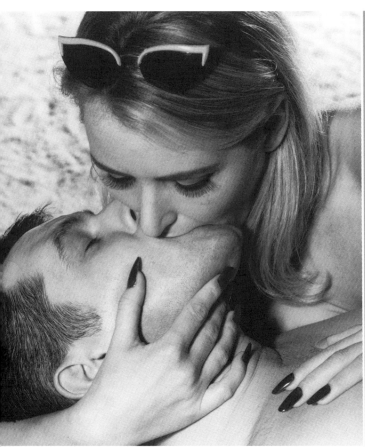

"IF I SUCK HARD ENOUGH, MAYBE I CAN GET MY IRN-BRU BACK."

IRN-BRU

SEE WHAT IRN-BRU CAN DO FOR YOU.

DATE: 1996.
AGENCY: The Leith Agency, Edinburgh.
ART DIRECTOR: Gareth Howells.
COPYWRITER: Dougal Wilson.
PHOTOGRAPHER: Ewan Myles.
CREATIVE DIRECTOR: Gerry Farrell

JOHNNIE WALKER

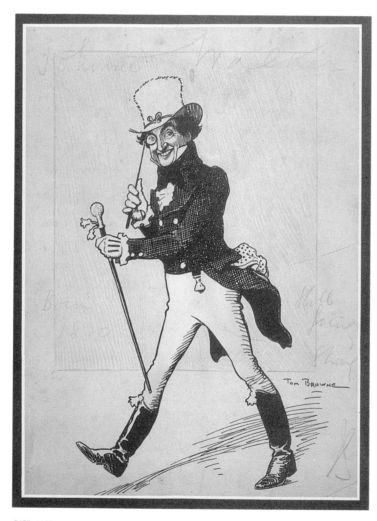

DATE: 1909.
ARTIST: Tom Browne.

WHEN GEORGE AND ALEXANDER WALKER LAUNCHED JOHNNIE WALKER BLACK AND RED LABEL IN 1909 THEY ORGANIZED A COMPETITION TO FIND A LOGO. DESPITE THE MANY ENTRIES, NOTHING SUITABLE EMERGED.

But when the noted cartoonist and humorist Tom Browne was invited to lunch with Lord Stevenson, one of the company's directors, Browne drew on the back of a menu card the distinctive striding man that has since remained the company's logo and global ambassador. The figure wore a top hat, morning coat, white trousers and carried a cane. Browne also drew several other sketches that developed the character and features of the striding man in different social situations.

The following year the slogan was trademarked: "Born in 1820 – still going strong". It reasserted the brand's heritage and fitted the energetic image of the logo. In fact, John Walker had opened a grocery store in Kilmarnock, Ayrshire in Scotland in 1820 but had not trademarked Walker's Old Highland Whisky until 1867. Walker was adept at blending teas and found that the principle of blended whiskies was similar.

Like others, his grocery gave women a way of obtaining spirits without being seen emerging from a bar.

A succession of artists passed on the baton of depicting the striding man. In 1910 *Punch* cartoonist Sir Bernard Partridge drew an equally rakish figure, frequently seen in the company of fashionable women. Next Leo Cheney developed themed situations in which the striding man appeared – travel, old craft, literary spirit and historic spirit – always witty and cosmopolitan. The striding man was invariably dynamic and the centre of activity – a mover and shaker of his time. Gradually, the figure became more rotund and sociable. Wry humour was still an element of the drawings by D. Zinkeisen, though the striding man was radically redrawn. When the brand started using photographs in 1932, striding statuettes were featured. Clive Uptton was the principal artist for Walker ads from 1939 to 1950. The striding man was relegated to the logo on the distinctive square-sided bottle during Uptton's "Good work … Good whisky" campaign. For the "Time marches on" campaign he was returned to centre stage as a symbol of progress that confirms the quality of the product that became the world's leading brand of Scotch whisky.

KALIBER

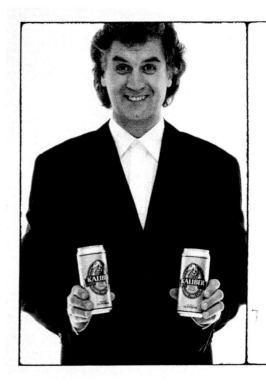

FOR NIGHTS YOU'LL REMEMBER.

LOW-ALCOHOL AND NO-ALCOHOL BEERS HAD AN IMAGE PROBLEM WHEN KALIBER WAS LAUNCHED IN BRITAIN IN THE MID-1980S. PUBLIC OPINION WAS MOVING INCREASINGLY TOWARDS A NO-DRINK-AND-DRIVE CULTURE, REINFORCED BY MORE STRINGENT LAWS, BUT EARLY EXAMPLES OF LOW/NO-ALCOHOLIC DRINKS TASTED DISAPPOINTING AND WERE RIDICULED BY CONSUMERS.

The aim of the campaign for Kaliber no-alcohol lager – the name chosen to evoke an impression of strength and quality – was to reverse these low expectations.

It helped that the beer was produced by Guinness, a company with kudos, but the agency also adopted a novel approach, using Billy Connolly as one of two comedians who declared "No alcohol, no joke", while looking perfectly serious. The choice of Connolly was inspired. The public perceived him either as a hard drinker, and therefore an unexpected front for a no-alcohol beer, or someone who has mellowed with age and still retained the respect of the man-in-the-street. Either way, he commanded high credibility.

Early television advertising established the brand, but it then suffered from the improved competition of low-alcohol rivals. Sales of Kaliber and its market share fell in the opening months of 1994 and the promotions budget was reduced to a fraction of earlier television spends. But Kaliber made the most of two poster sites in the car park of United Distillers, opposite the Hammersmith Odeon where Billy Connolly was appearing for a fortnight on the London leg of a British tour. The agency obtained approval to mimic the hugely popular Playtex Wonderbra "Hello Boys" ad (p.94). The resulting "Hello Girls" poster received considerable media coverage, usually in conjunction with Wonderbra, and the ad was developed into a national campaign that reversed Kaliber's downturn.

DATE: 1994.
AGENCY: Euro RSCG Wnek Gosper, London.
CREATIVE DIRECTOR: Mark Wnek.
ART DIRECTOR: Dexter Ginn.
COPYWRITER: Dominic Gettins.
PHOTOGRAPHER: Dan Tierney.
MODEL: Billy Connolly.

LANSON BLACK LABEL

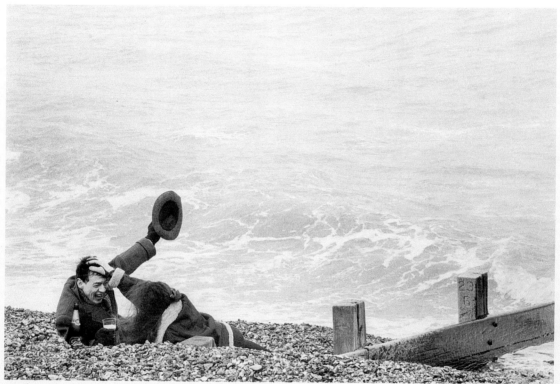

Why not?

Lanson

DATE: 1986. J.R. Phillips and Co.
AGENCY: Saatchi and Saatchi, London.
ART DIRECTOR: Zelda Malan.
COPYWRITER: Tim Mellors.
PHOTOGRAPHER: Andreas Heumann.
HAND TINTING: Dan Tierney.

GOOD STILL LIFE PHOTOGRAPHY CAN MAKE A COOL GLASS OF ANYTHING LOOK MOUTH-WATERING. BUT THIS CHAMPAGNE CAMPAIGN STRETCHES FURTHER – BEYOND A PHYSIOLOGICAL RESPONSE AND INTO OUR EMOTIONS.

When J.R. Phillips was appointed as UK distributor for Lanson Champagne in 1985, sales were no better than "reasonable" and consumer awareness was low. Yet Champagne Lanson is one of the oldest of the Grandes Marques, established in 1760. It is a true champagne, made from grapes grown in the Champagne region of France surrounding Reims and Epernay.

Until 1985, brand support was restricted to trade marketing and some public relations activity. Then, for the first time in its history, advertis-

ing – through magazines, cinema and television – was used to bring Lanson to a broader audience.

"The aim of the campaign was to avoid traditional Champagne imagery reflecting status," says art director Zelda Malan. "We were targeting a new market – people who have the imagination to turn any occasion into a Champagne-drinking occasion."

With inspiration from master reportage photographers such as Henri Cartier-Bresson and Robert Doisneau, the aim was to evoke a natural spon-

taneity. "The images had to be accessible so we used actors rather than models," says Malan. "We gave them a character and a background, then let them improvize the story."

The captured moments look real, with a sense of carefree abandon. "A day's shoot always happens in ten minutes," says photographer Andreas Heumann. "Everything else is thinking and talking."

During the period of the campaign, shipments of Lanson champagne to the United Kingdom almost doubled – from 1 million cases to 1.9 million.

MARTELL

DATE: 1998.
AGENCY: Ogilvy and Mather,
Hong Kong.
MANAGING PARTNER: Tracie Carlson.

A MARTELL AD HAS TO BE SAVOURED, IN MUCH THE SAME WAY AS THE DRINK SHOULD BE SAVOURED. IT IS BEST APPRECIATED AT A LEISURELY PACE, SLOWLY ABSORBING ITS RICHNESS.

Martell is an expensive, quality cognac that has been produced in France since 1715. Now part of Seagram, the company's legacy nevertheless provides part of the appeal of the drink. Legends that make up the Martell story give a face to the product and add to the drinker's feeling of sophistication and sense of history.

The advertising strategy for this campaign was based on the proposition that Martell is the best that money can buy. The agency adopted a confident tone of comfortable superiority, which reinforces Martell's position as brand leader in its category.

"Every other cognac uses trite portrayals of seduction, fast cars and women," says Tracie Carlson, Managing Partner of Ogilvy and Mather in Hong Kong, "No one took the high ground and romanced the drink itself."

The creative team turned to real narratives based on a forgotten – or at least neglected – emblem of the product. "The brand symbol is a swallow that appears on the label," continues Carlson. "We created a legend about the swallow and Martell. This was followed by a series of ads comprising many stories – all true – about the passion Martell puts into perfecting their cognac."

The swallow on the family crest of the Martells may, in fact, be a house martin – or "martinet" in French. Colonies of house martins nest under the eaves of the Martell chateau.

Legend has it that some 300 years ago a migrating swallow drank a little of the cognac on each visit, until gradually it turned to gold. In reality, a little of the cognac is lost through evaporation each year; the cellar men call this "the swallow's share".

Long copy was used intentionally to create the impression that Martell have a lot to say about the care and quality they put into every bottle. The campaign ran on television and as double page spreads in Singapore publications, with the result that image ratings soared.

MILK

In the late 1950s "Drinka Pinta Milka Day" joined the exclusive list of advertising slogans that have passed into the vernacular. It has the immediacy and apparent spontaneity of graffiti, with just enough grammatical anarchy to earn a place in the popular idiom.

The "bath-tub inspiration" of Bertrand Whitehead, the ad was an adaptation of the 1930s slogan "Drink milk daily" which was graphically illustrated by Ashley Havinden of the London ad agency W.S. Crawford. It was the light-hearted embodiment of the National Dairy Council's long-term marketing strategy, yet was criticized by teachers and pedants as "ruining primary education as well as the English language". However, the technique of running words together appealed to the populous and was soon copied by other product names and in other advertising slogans.

A fresh twist came with the line designed to counteract the seasonal decline in milk sales; "Drinka a Winta Pinta" does not even mention the product.

DATE: 1959.
AGENCY: Mather and Crowther, London.
COPYWRITER: Bertrand Whitehead.

PEPSI

1. DATE: 1999.
AGENCY: AMV/BBDO.

2. DATE: 1998.
AGENCY: AMV/BBDO.

3. DATE: 1996.
AGENCY: Almap BBDO, Sao Paulo.
ART DIRECTOR/COPYWRITER: Marcello Serpa.
PHOTOGRAPHERS: J.R. Duran and Cassio Vasconcelos.

1

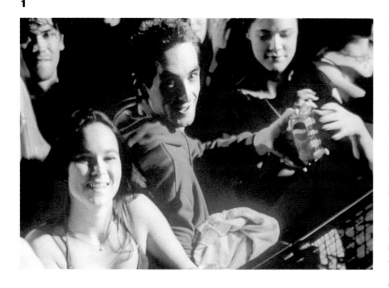

PEPSI-COLA IS THE CHALLENGER. FOR MUCH OF ITS EXISTENCE THE SOFT DRINK HAS LIVED IN THE SHADOW OF ITS LARGER ARCH RIVAL COCA-COLA. BUT, WHILE COCA-COLA MARKETS ITSELF AS THE ORIGINAL AMERICAN COLA, PEPSI'S CONSTANT MISSION HAS BEEN TO SHOW THAT IT IS THE PREFERRED COLA.

Although both recipes are closely guarded secrets, Pepsi's taste differs from Coca-Cola's as Pepsi's citrus flavours are derived from lemons while Coke's come from oranges. Pepsi also purports to contain less caffeine and has never been promoted as having medicinal qualities. It is described as having a lighter, crisper taste and its advertising has promoted its reputation as the cola for discriminating palates.

Pepsi-Cola was invented in 1893 by 31-year-old pharmacist Caleb D. Bradham in New Bern, North Carolina. He concocted a syrup out of kola nut extract, vanilla, pepsin, sugar and rare oils and mixed it with carbonated water. It became known as "Brad's drink". Five years later he renamed the mixture Pepsi after the ingredient pepsin – a fluid that aids digestion.

In 1902 Bradham established the Pepsi-Cola Co. and immediately started advertising in small North Carolina newspapers. By 1908 his bottling network had grown to 250 franchises in 24 states. An early ad for Pepsi-Cola appeared in 1909 featuring the race car driver Barney Oldfield, who endorsed Pepsi as a "bully drink … refreshing, invigorating, a fine bracer before a race."

After World War I Bradham lost a lot of money when the price of his huge sugar stocks dropped. His business collapsed, he returned to his pharmacy and sold the Pepsi-Cola business. In 1931,

after passing through several hands, an 80 percent interest was purchased by Charles C Guth, president of Loft Industries – a candy and fountain store chain – and he installed himself as general manager. Guth declared the original formula unsatisfactory and instructed the chief chemist Richard J. Ritchie to "fix it" and remove pepsin as an ingredient. The brand grew in the mid-30s, eventually becoming a force capable of challenging Coca-Cola's supremacy. During the Second World War Pepsi provided the "quick food energy" for the jingoistic campaign "American energy will win!".

In 1949 Pepsi hired Alfred N. Steele, a disenchanted middle manager from Coca-Cola, to become its new president. He brought with him 15 managers and considerable insight into Coca-Cola's weaknesses. The same year the radio jingle "Pepsi-Cola hits the spot" was played nearly 300,000 times on 469 radio stations.

Steele's wife, the Hollywood star

Joan Crawford, helped change Pepsi's image from "value" to "sophistication and exclusivity". The "So young at heart, so very smart" ad of 1956 shows a refined couple preparing for an evening out, with the endline: "Pepsi-Cola, the light refreshment".

The agency Batten Barton Durstine and Osborne (BBDO) introduced the "Pepsi Generation" campaign in 1963. The young active consumer has been the cornerstone of the advertising ever since. In 1964 a company promotions man handed bottles of Pepsi to each of the Beatles, and then, in a promotions scoop, snapped their picture. Diet Pepsi – the first diet drink – was introduced the same year, accompanied by the "Girl watchers" campaign, targeting fashion-conscious women concerned about high sugar intake.

In 1966, recognizing the product's long-standing appeal to African Americans, Pepsi became one of the first advertisers to use black actors in national advertising. In another

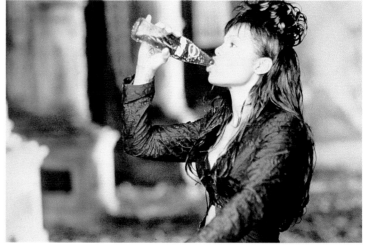

2

3

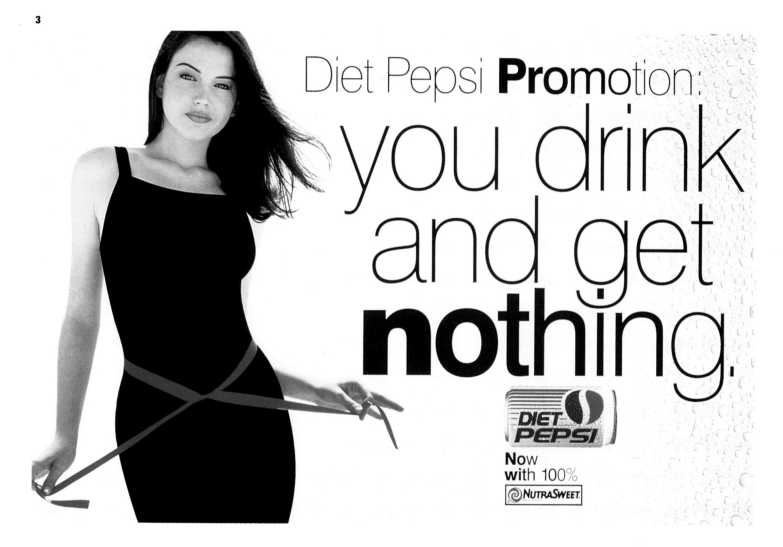

Diet Pepsi **Prom**otion: you drink and get **nothing.**

DIET PEPSI

Now with 100% NUTRASWEET.

coup, Pepsi became the first western consumer product to be introduced to the USSR.

Echoing the 1963 "Pepsi Generation" campaign and reasserting its position in the youth market, the 1984 campaign took the line "Pepsi, the choice of a new generation". Fronted by singer Michael Jackson – whose hair caught fire during filming – the campaign was followed by sponsorship of Jackson's reunion tour with his brothers.

In 1986 Michael Jackson was joined by singer Lionel Ritchie and actor Michael J. Fox as part of the company's entertainment marketing strategy. Blues singer Ray Charles appeared in the campaign "Uh-huh", proclaiming "You got the right one, baby."

Diet Pepsi continued to perform well, but health-conscious men wanting no-sugar drinks steered clear of the feminine image of diet drinks. Pepsi Max sounded suitably masculine to

enable the major 1993 brand to enter new territory, while also attracting Coke drinkers to Pepsi. When supporting the launch of Pepsi Max – the first no-sugar, maximum cola taste brand – London agency AMV/BBDO adapted two commercials originally designed for the American launch of Diet Mountain Dew. The aim was to increase the cola market and swell Pepsi's market share. Sales rocketed, with over 25 percent coming from Coke drinkers and over a

third from new users.

The ornate script of the first Pepsi logo of 1898 was refined several times over the years. The major changes came in 1950 when the script appeared on a blue and red yin-yang swirl bottle cap. And in 1996, in an extraordinarily bold change of branding which dramatically distinquished it from all the other colas on the market, Pepsi changed its livery and packaging from red to royal blue, with the tagline "change the script".

PERRIER

WHEN ST. JOHN HARMSWORTH, A SUAVE ENGLISH GENTLEMAN, VISITED PROVENCE IN THE SOUTH OF FRANCE IN 1903, HE WAS TAKEN TO A NATURAL SPRING IN THE VILLAGE OF VERGEZE BY A DOCTOR PERRIER. SEEING ITS POTENTIAL, HARMSWORTH BOUGHT THE SPRING AND BEGAN TO SELL ITS WATER, NAMING IT AFTER THE DOCTOR. HE MODELLED THE DISTINCTIVE BOTTLE ON THE INDIAN CLUBS HE EXERCISED WITH.

1. DATE: 1980.
AGENCY: Leo Burnett, London.
ART DIRECTOR: Dougie Buntrock.
COPYWRITER: Colin Campbell.
PHOTOGRAPHER: John Turner.

2. DATE: 1979.
AGENCY: Leo Burnett, London.

3. DATE:1978.
AGENCY: Leo Burnett, London.
COPYWRITER AND ART DIRECTOR: Malcolm Gaskin.

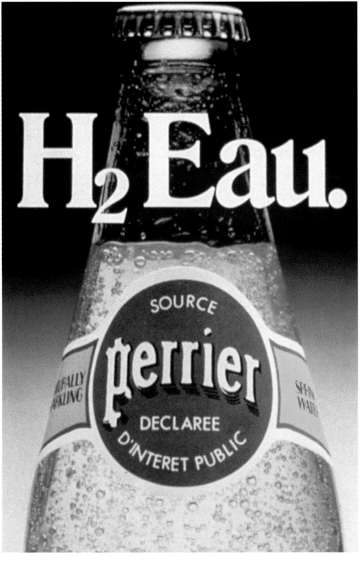

2

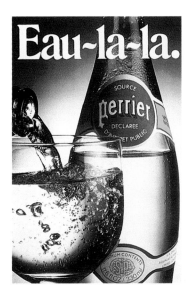

3

Perrier first went on sale in the United Kingdom early in the century, but was confined to a very small, exclusive clientele. Penetration of the British market met considerable resistance from a broader market unimpressed by the notion of paying for water, still or sparkling. It seemed like trying to sell snow to the Eskimos. Yet, within 15 years of the London office of Leo Burnett acquiring the account in 1974, over half the adult population in key areas was drinking mineral water.

The ad agency identified Perrier's "Frenchness" as an important part of its appeal. In 1978 the agency hijacked the French for water, "eau" – its first execution being "Eau-la-la". The agency subtly allied Perrier with France and all its attendant associations with good wine and by implication made it the quintessential mineral water.

Perrier's print advertising features elegantly produced visuals of bilingual puns that embody a chic tone in tune with the cohesive marketing strategy that

has made "Eau" come to mean unique. The permutations on the word seem inexhaustible: "P.T. Eau" "N'Eau contest" and – perhaps the ultimate – manifestation of the light-hearted interplay, "H$_2$ Eau".

With permission, J. Walter Thompson produced a spoof ad for its Polo account in 1994 – "Poleau"– featuring bubble-like Polo mints rising to the surface like fizz in a drink.

While the British have commandeered a French word, the French have

mimicked a famous British ad – "Hello Boys" (p. 94) with a direct Gaelic brashness and the helpful addition of a bottle opener, demonstrating a very different positioning of the brand.

British sales of Perrier in 1974 amounted to half a million bottles; in 1989 it was 152 million – and the premium price had increased. The dominant brand in the bottled water category, Perrier has retained an effervescent personality that is stylish, fashionable and timeless.

PG TIPS

THE YEAR AFTER PG TIPS TEABAGS WERE RELAUNCHED IN 1955, THE BROOKE BOND CHIMPS BECAME CELEBRITIES IN THE UK'S FIRST TV TEA ADVERTISING. WITHIN TWO YEARS PG TIPS HAD RISEN FROM FOURTH POSITION TO BRAND LEADER, MAINTAINING A PRICE PREMIUM.

Legend has it that Rowley Morris, then creative director with Spottiswoode (later Davidson Pearce), saw the crowds at London Zoo enjoying a chimps' tea party. In the bath that evening he reasoned that similar enjoyment could be engendered by a TV commercial.

The chimps Marquis and Rosie starred in the first "tea party" commercial in the elegant setting of a stately home, complete with bone china, tiaras

and a voice-over by the actor Peter Sellers. "The crew simply filmed everything they did," says Tony Toller, one-time copy writer for Davidson Pearce. "But now we have a detailed script and the chimps are rehearsed to do specific tasks. They're placed into situations, with props built two-thirds normal size and clothes designed to fit their big chests, narrow shoulders and non-existent necks.

"They invariably give their best performance when they're happy. The story line is always discussed with the chimp-handler, and the chimps are encouraged with rewards – sultanas, grapes, marshmallows and jelly babies. And they actually do like tea as well –sweet, lukewarm PG Tips!"

The chimps' saga has evolved to reflect a period of rapid social change. In the late 1960s the chimps portrayed a photographer and an artist. In the 1970s they parodied topical events such as the oil crisis. A James Bond spy spoof featured "Bond … Brooke Bond".

Several generations of chimps have enjoyed fresh cuppas in over 130 commercials, taking the campaign into the next century.

There was never a Mr Bond – Arthur Brooke just liked the sound of the name and added it to his when he opened his first tea shops in Manchester in 1869, selling tea, coffee and sugar. Brooke invented the name Pre-Gest-Tea to imply that his tea aided digestion. The brand became known in the trade as PG Tips. The company merged with Oxo in 1968.

DATE: 1956.
AGENCY: Spottiswoode, London.
ART DIRECTOR: Rowley Morris.
MODEL: Rosie.

ROWNTREE'S COCOA

DATE: 1900s.

THE MAYAS OF CENTRAL AMERICA WERE FIRST TO DISCOVER HOW TO USE THE COCOA BEAN AS A BITTER, SPICY DRINK THEY CALLED "CHOCOLATE".

This knowledge was passed on to the Aztecs, then to Europeans when Hernan Cortés took cocoa beans and chocolate-making equipment to Spain in the early sixteenth century. It became a fashionable drink of the Spanish court, but the process was kept a secret for a further 100 years, when it began to spread across Europe into France and Italy.

By the late seventeenth century coffee and chocolate houses were flourishing in London, where chocolate drinks were made from blocks of chocolate imported from Spain. In 1862 Henry Isaac Rowntree, who worked in his family's grocery business, acquired the cocoa and chocolate company and converted a foundry in York into a manufacturing plant. When his brother Joseph joined him as a partner in 1869, the company became H. I. Rowntree and Co. Ten years later they began to make the pastilles and gums for which the company became famous. At the beginning of the twentieth century cocoa was marketed as an revitalizing stimulant, although later it was taken as a soporific bedtime drink.

Other well known and enduring brands were introduced by Rowntree during the twentieth century – Black Magic in 1933, Kit Kat (then called Chocolate Crisp, p.24) and Aero in 1935, Dairy Box in 1936, Smarties in 1937, Polo in 1948 and After Eight in 1962. Rowntree merged with Mackintosh in 1969 and joined Nestlé in 1988, to form the world's largest food company.

SANDEMAN PORT

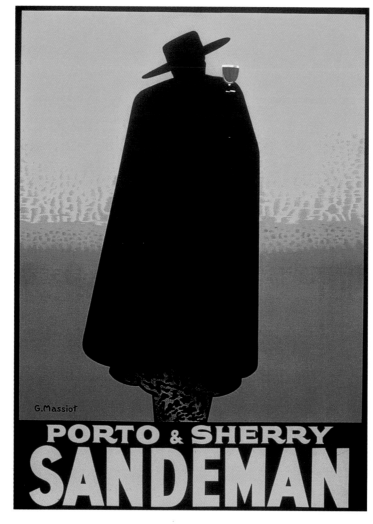

DATE: 1928.
ARTIST: George Massiot-Brown.

IN 1790, WITH A £300 LOAN FROM HIS FATHER, GEORGE SANDEMAN, AN AMBITIOUS AND DETERMINED SCOTSMAN, SET UP HIS BUSINESS AS A WINE MERCHANT SPECIALIZING IN PORT IN A LONDON COFFEE HOUSE.

In 1805, a time when "brands" as such were unheard of, Sandeman started using a fire to brand casks with GSC – George Sandeman Company. The firemark or "crowsfoot" gave the product a name and gave the consumer a guarantee of quality. The mark was registered in 1877, just a year after the registration of trademarks was introduced.

In 1900 the company had a stand at the Great Paris Exhibition, where they conducted their first direct marketing activities.

The mysterious silhouette of the Sandeman Don was drawn in 1928. Representing wines, port and sherry, it was the first wine trade logo, and remains the wine business's most famous logo.

The Don is wearing a Portuguese student's black cape and bears a wide-brimmed Spanish caballero's hat. In 1930 the Sandeman Don was first used in advertising, and was used on bottle labels from 1934. In 1965 the icon was brought to life in a television commercial, famously starring Orson Welles.

In 1990 the Sandeman Don featured in the company's bicentennial global advertising in a young, non-traditional way. And from 1998 the logo has appeared on the company's web page on the Internet, ready to answer consumer's enquiries. This high-profile global image is a far cry from the company's modest beginnings in a rented cellar in the City of London.

In 1980 Sandeman became a part of the international Canadian-based company Seagram, a world leader in the beverage and entertainment sectors.

SCHWEPPES

DATE: 1972.
AGENCY: Mather and Crowther, London.
ART DIRECTOR: Royston Taylor.
MODEL: William Franklyn.

I always think the sipping of a gin and bitter lemon enhances a woman

I like to keep a woman company. When I've poured one bottle of You-Know-Who's Bitter Lemon I always pour another for myself; it's quite the most sociable way to get lemon into gin.

This particular mixture bubbles so freely with the Secret of Schhh... and the fine mist of crushed lemon caught up in its sparkle.

We both feel a lot better for it.

Bitter Lemon by Schhh... You-Know-Who

GERMAN-BORN JEAN JACOB SCHWEPPE MOVED TO GENEVA IN 1765 AS A JEWELLER, BUT BEGAN TO EXPERIMENT WITH THE AERATION OF WATER, GIVING HIS ARTIFICIAL MINERAL WATERS TO LOCAL DOCTORS FOR THEIR POORER PATIENTS. THE DEMAND GREW TO SUCH AN EXTENT THAT HE STARTED BUSINESS COMMERCIALLY IN 1783, MANUFACTURING SELTZER AND SPA WATER.

He moved to England in 1792 where he developed the drink that bears his name. In 1837, after Schweppe's death, Queen Victoria granted a royal warrant of appointment to the firm as purveyors of soda water.

Although the brand name is simply the founder's surname, Schweppes is also onomatopoeic, conveying the fizz and sparkle of the drink. The slogan Schweppervescence was coined in 1946.

David Ogilvy built the brand in America in the early 1950s. For 18 years he used the head of Schweppes, USA, Commander Edward Whitehead, in the advertising, making him the second most famous Englishman in America, after Winston Churchill.

Royston Taylor at Ogilvy's London agency, Mather and Crowther (later Ogilvy and Mather), devised the "Secret of Schhh ... you-know-who" campaign, reflecting the contemporary popular climate which at the time was dominated by James Bond and spy novels. The fact that Schhh ... sounds like a bottle of Schweppes being opened was an unexpected bonus.

SMIRNOFF

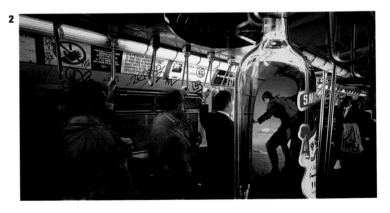

'Accountancy was my life until I discovered Smirnoff.'

The effect is shattering

SMIRNOFF VODKA

1. DATE: 1970.
AGENCY: Young and Rubicam, London.

2. DATE: 1990s.
AGENCY: Lowe Howard-Spink, London.

HAVING FLED THE RUSSIAN REVOLUTION VLADIMIR SMIRNOFF BUILT A DISTILLERY IN PARIS IN THE 1920S; BY THE END OF THE CENTURY THE BRAND WAS VALUED AT OVER US$1 BILLION.

Smirnoff was first marketed in the UK in 1953. After Young and Rubicam were appointed advertising agents in 1969, sales rose at a remarkable rate. The brand rose to a dominant position among vodkas, and was second only to whisky in the spirits sector.

Although its proof strength is slightly lower than whisky or gin, the perceived alcoholic strength of vodka became the platform for the "I used to … until I discovered Smirnoff" campaign. It depicted characters liberated from mundane and limiting activities as a result of drinking Smirnoff.

But then legislation took its toll. Advertisers were no longer allowed to imply that drinking alcohol improves performance or leads to success. In response to new Advertising Standards Authority guidelines, a second – more laissez-faire – campaign was introduced in 1975.

Exploring bizarre realms of improbability, the fantasy campaign (1976–82) became the agency's most successful. Having sipped Smirnoff, beautiful models kept finding themselves in surreal situations: kissing a man-size, cigar-smoking frog; water-skiing behind the Loch Ness Monster; skydiving in a wetsuit; or floating in a life belt marked "S.S. *Titanic*".

The campaign positioned the brand as fashionable, exciting, youthful and individualistic. The tone was witty and adult, addressing those in the know. Unexpected imagery lassoed the attention and lit the blue touchpaper of imagination. The tongue-in-cheek endline – "Well, they said anything could happen" – soon found its way into the vernacular.

Some of the scenarios are more complicated to execute than others, yet as long as the idea coincides perfectly with the strategy, the simplest image often has the greatest impact. The bejewelled lady, apparently adrift in the Atlantic is in fact squatting in a few feet of water close to the shore. Art director Tony Wheeton had seen – in John Thornton's portfolio – a very similar shot

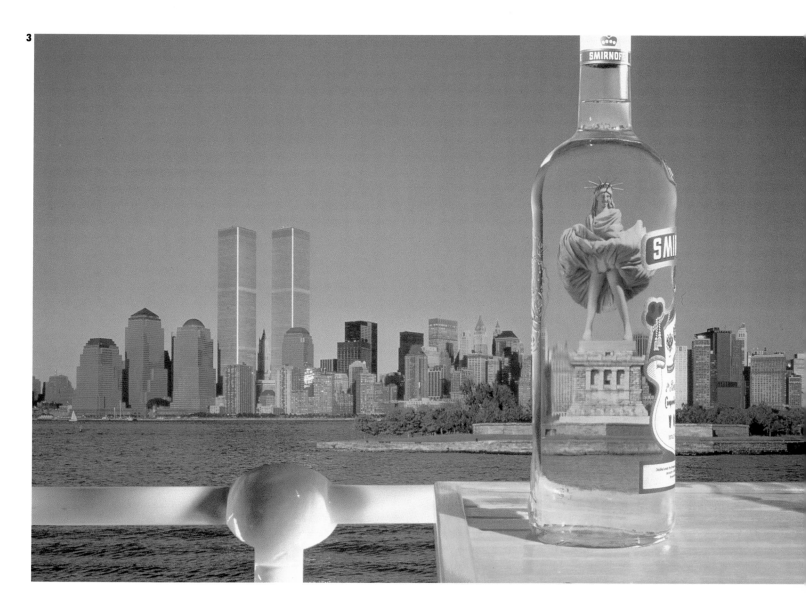

3.DATE: 1990s.
AGENCY: Lowe Howard-Spink, London.
ART DIRECTOR: Jeff Curtis.
COPYWRITER: Adrian Lim.
PHOTOGRAPHER: Alex Buckingham

taken in Majorca. "It was absolutely what we wanted, so we commissioned John to reshoot it, just adding a glass," says Wheeton.

The free fall fantasy is equally arresting, though the reality is almost as prosaic. A scaffolding of steel pipes was erected on a hillside. Duffy photographed the models lying on plates welded to the structure. He then reshot the scene from a slightly different position so that the background hidden by the scaffolding could be stripped in to the final photograph, along with the glass.

Mike Owen, art director on a subsequent Smirnoff campaign, explains the thinking behind the poster campaign. "Our aim was to stand out as contemporary and refreshing. I get tired of seeing posters that are just press

ads. If people react by thinking 'That looks exciting', it doesn't matter if they don't see all the details."

Young and Rubicam purchased all the sides of several three-prism sites, where elements of the hoarding revolve to display three different ads. The Smirnoff ad began with letters "Sm" which unfolded to "Smirn", and finally "Smirnoff", creating the impression of movement from left to right.

The agency held the Smirnoff account from 1962 until 1992, using largely press and poster advertising. The high profile advertising of the 1970s and early 80s led to a dramatic increases in sales, and by 1983 Smirnoff's UK market share was three times larger than any other vodka brand.

When Lowe Howard-Spink took

over the account in 1992, reality again gave way to fantasy as the scenes through the bottle changed in ingeniously inventive ways. While the commercials delivered a streams of mind-expanding transformations, the print ads each focused on a single altered state: a log becomes a crocodile, a line of angels includes one Hell's Angel, a swarm of bees become helicopters, the third china duck on the wall has been shot, one of the Easter Island statues is adorned with headband and headphones .

Over 40 print and poster executions and three extravagant cinema commercials ran in over 40 countries, successfully targeting chic, cosmopolitan and advertising-literate 18–24 year old men and women.

TANGO

1. DATE: 1993.
AGENCY: HHCL and Partners,
London.
2. DATE: 1994.

Born in the 1950s, Tango carbonated drink was advertised only intermittently until after 1986, when it was bought from Beecham's by Britvic Soft Drinks – distributors of Pepsi and 7 Up. After a short spell with the advertising agency Allen Brady Marsh, Britvic joined forces with HHCL and Partners in 1991.

1

Although Tango was universally popular, it lacked a strong personality that the teenage target group could adopt as a social badge. Then, through a series of mould-breaking, multi-media campaigns, Tango exploded into a market dominated by powerful, ubiquitous global brands with strong advertising-led personalities.

Tango soon achieved cult status by recognising a fundamental change in the way consumers were relating to products in the final two decades of the century. Involvement is a key to retaining brand loyalty. The young, in particular, want more from a product than just the product itself. Having bought into a brand membership, they belong to the club and want a broader experience of the brand. It is an interactive relationship increasingly facilitated by technology – telephone, internet and interactive television.

A healthy annual media spend was spread over a range of platforms – television, cinema, press, poster, radio, direct mail and the internet. In a series of launches for the different flavour drinks, the advertising focused on each product, in preference to an image-based approach. In 1991 Orange Tango first hit the public with zany, surreal scenarios involving faces being slapped and a head being blown off. "Have you been Tango'd?"

In a subsequent commercial viewers were invited to telephone for a "free" orange Tango doll – "Gotan". Over 300,000 people made the premium rate call and listened to an engaging six minute dramatized message. Britvic's share of the phone charge covered the cost of the dolls and postage. Within the first year, the Tango telephone lines received 4.5 million calls – an impressive measure of brand loyalty and customer involvement.

The tongue-in-cheek, in-yer-face style of advertising reflected the zeitgeist of the core 13–17 age group while also appealing to the quirky side of the rest of us. The inoffensive belligerence helped catapult the brand from relative obscurity to the nation's third best-selling soft drink after Coca-Cola and Pepsi. Within 15 years its retail value was multiplied 10 times.

Following the successes of the UK launches, Tango made inroads into Europe on MTV, adopting the same basic strategy, on the premise that the teenage audience worldwide responds to similar cues.

2

WHITE HORSE WHISKY

DATE: 1970.
AGENCY: Kingsley Manton Palmer, London.
ART DIRECTOR: Mike Kidd.
PHOTOGRAPHER: Michael Joseph;
MODEL: Pauline Stone.

YOU CAN TAKE A WHITE HORSE ANYWHERE ... AS LONG AS IT IS ELEGANT AND UNEXPECTED.

With a strategy advocating that whisky can be enjoyed in (almost) any situation, the advertising creatives set about visualizing likely venues for a wee dram, that were unlikely places for the white horse. The campaign saw the trusty steed in Venezuela overseeing the laying of an oil pipeline; standing in the front doorway of a stately home ready to greet guests for dinner; outside the window of a boardroom several storeys high; and in a bathroom.

Michael Joseph photographed 23 of the White Horse whisky ads. "From our first session with the horse I knew we'd be in for a hard time," he says. "Although we had a bucket on hand, the horse managed to make a terrible mess on the carpet, which was irritating because we saw it reflected in the mirror on some of the shots. And we had to pay for a new carpet!"

A steam machine hidden behind the bath produced occasional bursts of steam that added to the atmosphere and perked up the horse. If a horse's ears are pressed back against its head, it looks either disinterested or anxious. "A horse pricks up its ears when it hears a different sound, so I carried a bleeper with me to use just before I pressed the shutter," says Joseph.

By linking an animal with the product – especially an animal with positive associations – a Pavlovian reaction is triggered among consumers.

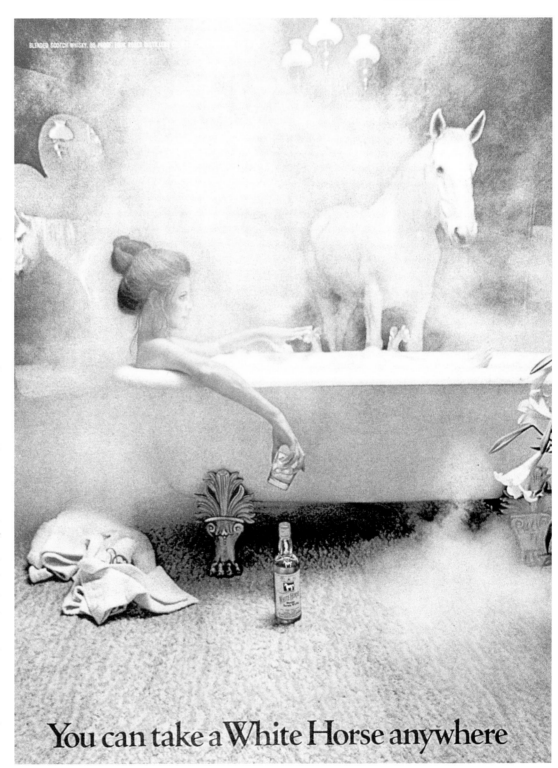

You can take a **White Horse** anywhere

WINDSOR CANADIAN

Fortunately, every day comes with an evening.

YOU'VE BEEN THERE. NOTHING SEEMS TO GO RIGHT. YOU'RE HAVING ONE OF THOSE DAYS. THEN, JUST AS YOU'VE MANAGED TO ACHIEVE A PERFECTLY SMOOTH SURFACE OF WET CONCRETE, A DEAR LITTLE INQUISITIVE DOG TROTS UP TO WATCH WHAT YOU'RE DOING.

There is no point getting upset or blaming anyone. You must find another way out. Such situations of last-straw exasperation fit the strategy for Windsor Canadian, which promises a solution to the day's frustrations. Demonstrating empathy with the victims of misfortune, the campaign offers relief and solace with humour and humanity.

The agency trawled the picture libraries for similar stressful scenarios and commissioned some others to be shot specially. Anyone who has ever had a hard day and said "I need a drink" knows the feeling. The headline resonates as a welcome antidote to the rigours of life.

DATE: 1991.
AGENCY: Fallon McElligott, Minneapolis.
ART DIRECTOR: Tom Litchenheld.
COPYWRITER: John Stingley.
PHOTOGRAPHERS: Craig Perman, Dave Jordano.

X.O. BEER

DATE: 1994.
AGENCY: Ogilvy and Mather, Singapore.
CREATIVE DIRECTOR, ART DIRECTOR
AND COPYWRITER: Neil French.
PHOTOGRAPHER: Hanchew.

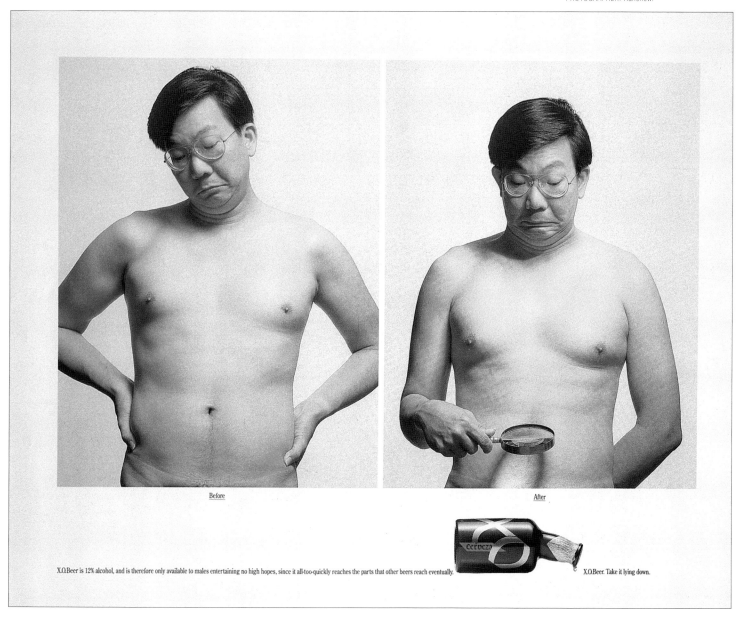

Before

After

X.O.Beer is 12% alcohol, and is therefore only available to males entertaining no high hopes, since it all-too-quickly reaches the parts that other beers reach eventually.

X.O.Beer. Take it lying down.

"THE BEER THAT MAKES YOU DRUNKER QUICKER" WAS THE STRATEGY FOR THIS AD, BUT THE STORY BEHIND THE CAMPAIGN IS EVEN MORE UNEXPECTED.

X.O. Beer did not actually exist as a product when this campaign ran. It was entirely fictitious. The aim was to show advertisers that beer could be effectively sold through newspaper ads. But the huge demand triggered by the potent promise of the ads prompted a small local brewer to start producing a beer of that name.

"For three days there were lines of punters queuing up outside to get the stuff," says Neil French who masterminded the project. "But then the brewery ran out of the stock they thought would last for three weeks. So they decided to brew more of the same, but sell it without the X.O. branding, to avoid paying me the royalty. They went broke within a month. "It's a great story about the power of the brand."

The campaign included two distinct approaches: one with a picture and a pack shot; the other with an extended headline and a larger pack shot. Reader recall reached similar levels for both. One of the before-and-after pictures showing the drooping effect of the brew was banned. "Another excellent way of ensuring the product becomes famous," says French.

FASHION AND CLOTHING

BENETTON

THROUGHOUT THE CENTURY, changes in the social and political climate have been reflected in the chameleon colours of fluctuating fashion. Advertising has alternately set the pace or simply kept pace with the changes, building a comprehensive chronicle of styles.

At the beginning of the century, women wore whalebone corsets from bust to thigh, skirts fell to the ankle and hairstyles were extravagant. In Britain, following the death of Queen Victoria in 1901, the accession of Edward VII heralded an age of refinement and elegance set against troubled atmosphere: the Boer War (1899–1902) was unpopular, there was civil unrest in Ireland and the suffragettes were becoming increasingly politically active.

After World War One had ended, fashions began to change. Newly emancipated, women began to discard their corsets, hobble skirts and 8-button shoes. Within a decade, skirt lengths had crept up to the knee and became as symbolic of the Roaring Twenties as the Charleston and jazz. Women bobbed their hair, wore bright, heavy make-up, plucked their eyebrows, smoked, danced unchaperoned and drove motor cars.

LEVI STRAUSS

It was an exciting time to be rich. But it was also a time of massive unemployment, highlighted by the General Strike in Britain in 1926. By 1927 the pendulum was beginning to swing back. Skirt hems dropped again. The mood became more sombre. The U.S. Stock Market collapsed in 1929, with the Wall Street Crash and the British government's economy measures provoked riots in London and Glasgow. America sank into the Great Depression, despite the end of Prohibition and President Roosevelt's promise of a New Deal in 1933.

In the early decades of the century social status was the peg on which most clothes advertising was hung. In America, Edward Penfield (p.78), Will Bradley and Maxfield Parrish were already designing elegant magazine covers and ads for fashionable clothes, as well as other products – especially bicycles – in which fashion was flaunted.

The Art Deco style of the 1920s and 1930s emerged from the Bauhaus movement, using bold, angular images with simple, dramatic lettering as an integral part of the design. J.C. Leyendecker (p.76) took fashion into the Art Deco period, capturing the sophistication of the cocktail generation. Meanwhile, Coles Phillips (p.81) was flirting with the boundaries of decency, creating some of the first overtly provocative illustrations for hosiery ads.

During World War Two the flowing feminine lines of the mid-1930s were exchanged for utilitarian dress. The hardships of rationing meant that luxury goods such as silk stockings and cosmetics were scarce.

But the war saw women discover an independence, as they took on roles normally seen as masculine and they coped without their menfolk. When the soldiers returned, they were understandably reluctant to relinquish this freedom and this helped fuel great social change. In 1946 *Vogue* magazine even featured jeans for the first time. While bebop dancing was sweeping the USA in the 1940s,

postwar Britain escaped the drabness of battle with Christian Dior-insired "New Look" fashions.

The 1950s welcomed the return of affluence. Advertising had discarded the punchy patriotism of the war and revelled in frivolous pastiches of new-found freedoms. The Maidenform woman released her extrovert tendencies by going shopping in her bra (p.83). It was a decade of promise – an optimistic antidote to the deprivation of war.

The teenager emerged as a defined market group with a significant disposable income for consumer companies to target. The rock and roll rebels gave rise to the anti-hero by the end of the 1950s.

The 1960s was again a time of prosperity. Britain enjoyed almost full employment, and creativity blossomed. Vitality and lateral thinking took precedence over experience and knowledge. Swinging London exploded with Beatlemania, flower power, property booms, mini skirts. Symptomatic of the time was the sexual revolution: the Gay Liberation and feminist movements emerged, accompanied by a changing attitudes towards sex and gender roles. The modern openness towards sexuality gave rise to fashion statements based on themes of androgyny – a merging of gender appearances that Calvin Klein commandeered as its trademark during the 1980s and 1990s (pp. 74–5).

Economic recession at the close of the 1970s encouraged the Punk counter-culture with its anarchic lifestyle, music and fashion. By comparison, the 1980s was a period of affluence and conspicuous consumerism. A boom time for advertising. In the lucrative street footwear market Nike sprinted into the lead (pp. 92–3). Conversely, Benetton jumped off the bandwagon and engineered a controversial counter attack on self-interest, addressing major global issues that bore no relation to the clothes they were promoting (pp. 72–3).

In the final decade of the century consumer values shifted from materialism and individualism to a more considered approach. People sought authenticity and substance, and their purchases signalled their approval of the brand's values. While Levi's promoted the "original jeans" (pp. 88–91), Diesel found scope for a tongue-in-cheek stance that takes nothing at face value (p.77).

Ad agency creatives repeatedly followed tangents in search of attention-grabbing strategies. An eye patch was the eye-catching gimmick or motif that linked together all the Hathaway shirt ads in a quickly recognizable image (p. 79), while Hush Puppies' basset hound provided both continuity and humour to that campaign (p.82).

"Get noticed. Nothing else matters," says Trevor Beattie who helped bring Wonderbra – and Eva Herzigova – to the world's attention (p. 94). Yet some ads teetered between being outstanding or simply outrageous. Benetton's shock tactics demonstrated how to influence people and lose friends.

In order to secure a lucrative share of the lucrative fashion market, manufacturers and retailers use advertising to appeal to much more than people's need for clothes.

PRETTY POLLY

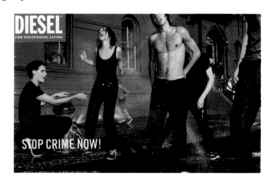

DIESEL JEANS

BENETTON

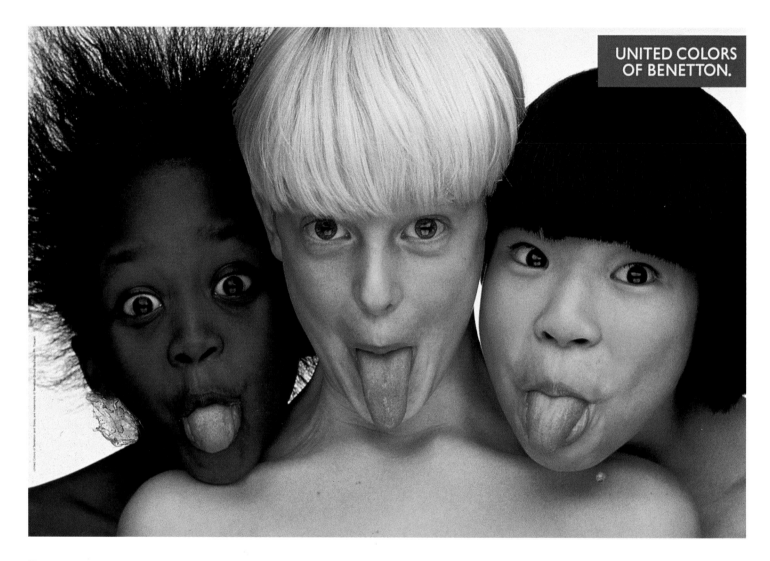

UNITED COLORS OF BENETTON.

BENETTON HAS SUCCESSFULLY ACHIEVED TWO OF ADVERTISING'S PRINCIPAL OBJECTIVES: BE NOTICED AND BE REMEMBERED. BUT IN DOING SO IT HAS NOT ALWAYS STAYED IN A POSITIVE LIGHT.

In the 1950s the Benetton family was impoverished. When his father died in 1945, Luciano Benetton had to leave school, aged 14. He worked in a mate-rial shop while his sister, Giuliana, developed a talent for designing and knitting pullovers. In 1965 the family established its first factory at Ponzano Veneto, a village near Treviso in northern Italy, but it was 20 years before the company name became known around the world.

From 1984, Benetton started adver-tising beyond Italy and France. The first global campaign, which ran in 14 coun-tries, showed multi-racial groups of young people laughing together. Right from this innocuous beginning, Benetton triggered an array of impas-sioned responses – many ads that received awards in some regions were banned in others. In South Africa, publications for whites refused to carry the photos of white and black youths together.

Oliviero Toscani steered the campaigns through a series of universal themes, which he viewed as expressions of the time. In 1985, Benetton ads portrayed pairs of flags of hostile nations, in a plea for co-operation. The following year, billboards showed a young Jew embraced by a young Arab, another plea for harmony instead of conflict.

Benetton's global campaign expanded into 100 countries. After a kaleidoscope of cosmopolitan kids cavorted around in colourful clothes, the campaign again turned serious – and no longer showed the product. As Toscani points out, Benetton has 7,000 stores around the world to display its wares; the company prefers to use its advertising budget to talk to people. In 1989 the focus was on equality between black and

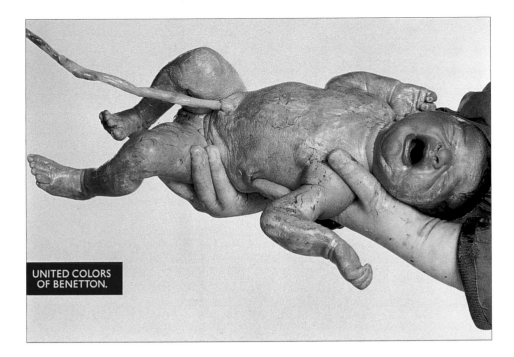

UNITED COLORS
OF BENETTON.

white: a black woman breast-feeding a white baby, two male hands – one black, one white – handcuffed together. The former caused uproar in the USA within the black community, which felt that the ad carried the implication that blacks belonged in a subordinate role.

"We don't imagine that we are able to resolve human problems, but nor do we want to pretend that they don't exist," says Toscani, who steers the campaigns together with Luciano Benetton. "We believe advertising can be used to say something besides selling a product – something more useful."

The picture of three children – black, white and Asian – sticking out their tongues and demonstrating that all our tongues are the same colour, was deemed "pornographic" in Arab countries – where the depiction of an internal organ is prohibited – and withdrawn from display.

The same year the picture of a priest and a nun kissing caused a scandal and the photo of newly born Giusy trailing her uncut umbilical cord sparked unprecedented controversy worldwide. While Benetton claimed the poster to be a wonderful expression of new life, the Advertising Standards Authority in the UK received over 800 complaints that it

was exploitative and immoral. The ad achieved the highest level of spontaneous recall of any in advertising history.

In 1992 the campaign left the studio and used real-life photographs to address real issues: birth, death, poverty, Aids.

Aids sufferer David Kirby's deathbed originally appeared as a black-and-white illustration in the editorial pages of *Life* magazine, where it evoked sympathy and concern. Yet the use of the same picture as an ad was labelled cheap and exploitative.

"We wondered why reality proved so controversial," says Toscani. "When these pictures were published in the media, nobody reacted. These sorts of images are seen every day on television and in newspapers, but as soon as we use them for advertising, everybody gets upset!"

"Why is traditional advertising acceptable with its fake images, yet reality is not? We think we have a duty to talk about such things. I wish some cigarette or car company would devote their incredible budgets to promoting social issues."

The Benetton image of the black man with different coloured eyes was adopted as its symbol by Fabrica, a

school – or factory – at Catena di Villorba near Venice, which is dedicated to seeing into the future. Here, young artists confront such themes as racism, fear and world hunger and challenge the boundaries of traditional communication through new art forms and new uses of technology.

While Benetton's stated aim is to display photographs that help overcome human indifference, many people are more aware of the company's not-so-hidden agenda to extend the range and impact of its advertising by deliberately inviting controversial media attention. The glib tag-line, "United Colors of Benetton", has been

seen as insulting and degrading.

Nonetheless, using large billboard sites, Benetton has forced taboo subjects into the open, challenging the view that real life is only acceptable in advertising if it is sanitized. There may still be vehement resistance to clothing advertising employing shock tactics, but Benetton has made the public confront uncomfortable issues – and thereby redefined advertising's potential role.

1. DATE: 1991.

2. DATE: 1991–2.

3. DATE: 1995–6.

AGENCY: In-house, Italy. CREATIVE DIRECTOR/ PHOTOGRAPHER: Oliviero Toscani.

F A B R I C A UNITED COLORS OF BENETTON.

CALVIN KLEIN

1

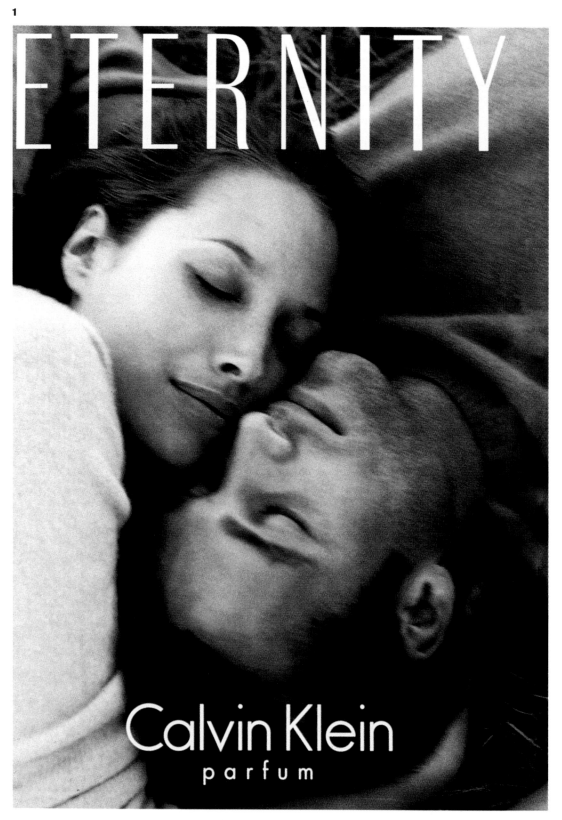

Calvin Klein is one of the more blatant protagonists of sexual explicitness, operating in the vanguard of androgynous chic. The term "shockvertising" surfaced with a vengeance when a 15-year-old Brooke Shields was shown lying on her back wearing tight jeans and murmuring "Nothing comes between me and my Calvins. Nothing". The public outrage generated by the provocative pose and unmistakable double entendre fanned the flames of publicity and helped ensure the company's high profile.

Subsequent ads featuring Joel West were labelled pornographic. Woody Harrelson's billboard bulge raised both eyebrows and hackles. Marky Mark became an instant pin-up after he

2

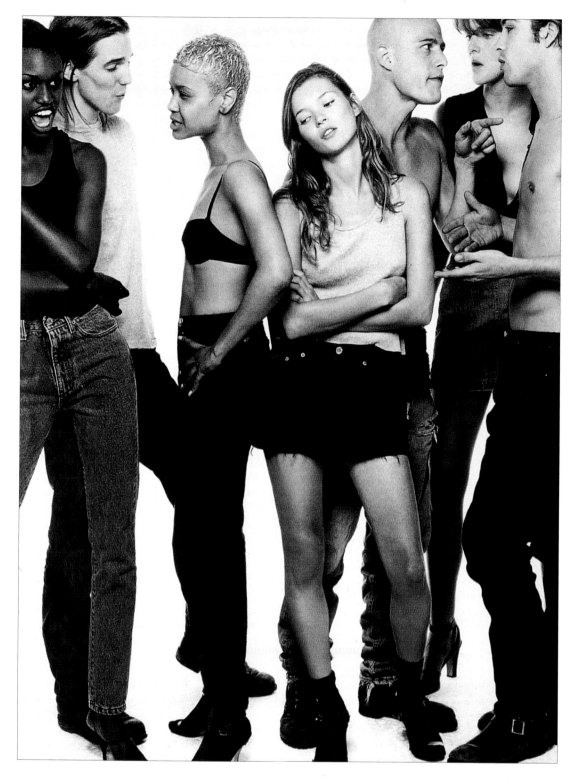

stripped down to his CKs, and super-models Kate Moss and Kirsty Turlington appeared wearing very little. In 1996 a 28 metre (90ft)-high poster of Antonio Sabato Jr in skimpy black CKs went up in Times Square, elevating him from minor soap celebrity to mega sex symbol.

For years Bruce Weber's photographic style was a core part of Calvin Klein's brand image. Then, for the 1997 ad campaign, Craig McDean – one-time assistant to Nick Knight – began photographing CK clothes, accessories and perfume.

When the Obsession range was launched in the 1980s, CK advertising had to confront the challenge of how to convey fragrances. CK's solution was to create print ads and television/cinema commercials that oozed an enigmatic eroticism. By providing no explanation for the situations presented, the mood could be interpreted by viewers to reflect their own experience. The implication was that Obsession was beyond the prosaic world of words and could only be imagined. The approach proved extremely effective and launched a new and unknown brand to the top of its market within months.

ARROW SHIRTS

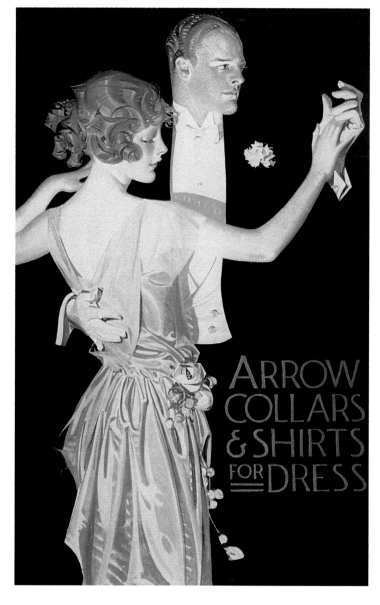

DATE: 1930s.
ARTIST: J. C. Leyendecker.

ARROW STARTED WITH COLLARS IN 1851, AND THAT WAS ALL IT MANUFACTURED FOR 70 YEARS. WHEN GEORGE B. CLUETT BOUGHT THE COMPANY, HE CHANGED ITS NAME TO HIS, BUT FOUR YEARS LATER HE MERGED WITH ANOTHER COLLAR-MAKER, FREDERICK F. PEABODY, WHO BROUGHT WITH HIM THE TRADEMARK "ARROW" AND WHO CONCEIVED THE MASCULINE, TALL, STRAIGHT, SQUARE-JAWED "ARROW COLLAR MAN".

Several leading artists portrayed the image, but it was J.C. Leyendecker's creation that led the rest and provided a blueprint for the style-conscious younger generation. Leyendecker was already well established, having sold his first cover to the *Saturday Evening Post* in 1899.

In response to demand, Arrow started producing its collars with shirts attached in 1921. The 1938 ad, "My friend Joe Holmes is now a horse", created by Young and Rubicam, was particularly successful.

Arrow shirts remained popular. The company was known for its white shirts, especially dress shirts for the older generation, and commanded respect for its good value and quality heritage. But by 1987 Arrow had lost its appeal for the 18–34 age group, its image perceived as staid; not surprisingly, with its roots in the middle of the nineteenth century, it needed a revamp.

When Arrow began producing a colourful range of shirts, ad agency Chiat Day rejuvenated the brand by splashing it across magazines, and then television, reflecting the mood of the times with the end-line: "Arrow shirts, we've loosened our collar."

DIESEL JEANS

DATE: 1995.
AGENCY: Paradiset DDB, Stockholm.
CREATIVE DIRECTOR: Joakim Jonason.

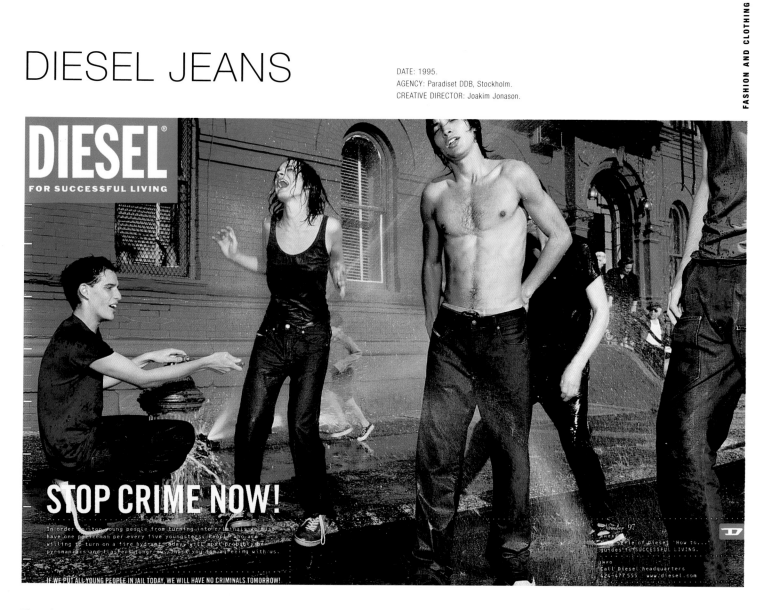

The Italian jeans firm Diesel launched its first global advertising campaign in 1991. Faced with a world dominated by one American jeans giant, the company reasoned that, in an arena with well-defined and established rules, there is actually greater scope for those who dare to go their own way.

Echoing the personality of the founder – and by osmosis the brand – the advertising strategy discarded the accepted assumptions about effective advertising. It rejected the prevailing approaches that implied "if you use our products you will become more successful, smarter, more beautiful, richer and able to get a good-looking partner". Instead, Diesel opted for a more socially aware stance, based on surprising, thought-provoking, entertaining and honest advertising that aimed to establish a friend-relationship between Diesel and their consumers.

Founder and president Renzo Rosso advocates being true to yourself. He started creating innovative clothing when 14 years old, declined the offer of managing his parents' farm and went to the Marconi Technical Institute of Padova. By 22 he was controlling the operation for a product that evolved into the enterprise that Rosso bought out and launched as Diesel in 1985.

The casual and work clothes and accessories reflect Rosso's own personality – perferring honest simplicity, openness and basic values that spurn superficiality. Diesel stands for a state of mind. The wide range of garments are created independently of fashion trends, following instead Rosso's intuition.

The advertising uses irony, satire and humour in a way that is not always read-ily understood. The aim is to highlight facts about our global society that should be questioned and possibly changed. The communication is completed when an intelligent, caring audience draws its own conclusions. Benetton's professed strategy a decade before encompassed a similar philosophy (pp. 72–73, 151). Yet, unlike Benetton, Diesel chose to harness the targeted penetration achieved through MTV. Without direct exposure to this opinion-leading consumer group within the youth market, Diesel would have taken longer to emerge from a niche street brand to a significant global player.

HART SCHAFFNER AND MARX

The solid blocks of colour, especially in his early work, echo the images of the French artist Henri de Toulouse-Lautrec and of Japanese woodcuts. His graphic techniques were straight-forward, dispensing with background detail to focus attention on the name and subject.

Together with Maxfield Parrish and Will Bradley, Penfield was one of the most prominent poster artists in America at the turn of the century. At a time when some artists thought that advertising work tarnished their reputation, they produced a stylish flourish of posters promoting a variety of products, notably bicycles and clothing, as well as working for other publishing houses.

DATE: 1910.
ARTIST: Edward Penfield.

HATHAWAY SHIRTS

DATE: 1962.
AGENCY: Hewitt, Ogilvy, Benson and Mather.
ART DIRECTOR/COPYWRITER: David Ogilvy.

DAVID OGILVY BEGAN HIS CAREER AS A DOOR-TO-DOOR SALESMAN. HE WROTE A MANUAL FOR OTHER SALESMEN – "HOW TO SELL AN AGA" – WHICH LED TO HIS FIRST JOB IN ADVERTISING. AT THE AGE OF 38, HE STARTED HIS OWN ADVERTISING AGENCY, HEWITT OGILVY BENSON AND MATHER, WHICH IN TIME BECAME AN INTERNATIONAL AGENCY NETWORK, THAT GREW TO OVER 140 OFFICES IN OVER 40 COUNTRIES.

"Before I sit down to do an advertising campaign I spend an awful lot of time studying the product and getting to know a lot about it," says Ogilvy. "I do a lot of research. I stuff my conscious mind with information, then unhook my rational thought process and put it out of my mind. You can help this process by taking a hot bath, or a long walk, or by having dinner and drinking half a bottle of claret. I've always found that very helpful. Suddenly I get a telegram from my unconscious that says 'Got an idea for you ... how about this?' It has to be a relevant idea, so my unconscious has to be well-informed. And I've found that a picture with story appeal makes people read the copy, and then they buy the product."

To give story appeal to his ads for Hathaway shirts Ogilvy put an eye patch on a displaced White Russian working as a model baron, George Wrangell. It fuelled intrigue surrounding the character and, within eight years, sales increased from $5 million to $13 million.

"But pictures alone don't sell anything unless you put hard-selling copy underneath them," says Ogilvy. "This was a remarkable idea that lasted for almost 30 years. If an idea works well and is successful, keep using it until it runs dry."

HERMANN SCHERRER

DATE: 1912.
ARTIST: Ludwig Hohlwein.

LUDWIG HOHLWEIN WAS A LEADING POSTER DESIGNER OF THE PERIOD BETWEEN THE ART NOUVEAU FLAMBOYANCE OF THE 1890S AND THE BEGINNING OF FUNCTIONALISM AFTER WORLD WAR ONE. HE WAS A WELL-KNOWN MAN-ABOUT-TOWN IN MUNICH AND A KEEN FOLLOWER OF HUNTING AND HORSE RACING.

Hohlwein's poster for the fashionable tailor Hermann Scherrer has become one of his most famous. The headline is in English to emphasize the fact that the clothes are based on English tailoring and fashion. The posters were highly prized among visiting French and English socialites.

In a 40-year period Hohlwein designed a great variety of posters that were recognizable without being repetitive. His no-formula approach produced a stream of fresh and completely original statements.

Hohlwein viewed the world in terms of tone and colour, and his illustrations create an impression of three dimensions. In his posters, programme covers, trade cards and other ephemera, he decorated reality with an economy of technique that used flat pattern and shadows as an integral part of the design. His work developed the styles of the Beggarstaff Brothers and Henri de Toulouse-Lautrec, and his brand of elegance was admired and appreciated by the general public as well as by artists and sports people.

HOLEPROOF HOSIERY

HOLEPROOF HOSIERY IN MILWAUKEE, WISCONSIN ADVERTISED SINCE THE 1900S, YET IT WAS THE FLIRTATIOUS DRAWINGS OF COLES PHILLIPS THAT FIRST CAPTURED WIDESPREAD ATTENTION. PHILLIPS WORKED BETWEEN 1911 AND THE LATE 1920S, AND IS BEST REMEMBERED FOR HIS IMAGES THAT REFLECTED THE MOOD OF THE ROARING TWENTIES.

He drew dozens of hosiery ads that appeared in many major magazines. Credited with creating the first pin-up girls, his work was considered very risqué. He – more than any of his rivals – extended the boundaries of what was considered acceptable. As standards of respectability fell, hemlines rose and the sale of silk stockings rocketed.

One 1921 advertisement says "In this short-skirted era, Holeproof is becoming as famous for its sheerness, shapeliness and lustrous beauty, as it is for wonderful wearing qualities."

Phillips also produced ads for Community Silver and the Willys-Overland Automobile Co., introducing Art Deco principles to advertising design.

DATE: 1921.
ARTIST: Coles Phillips

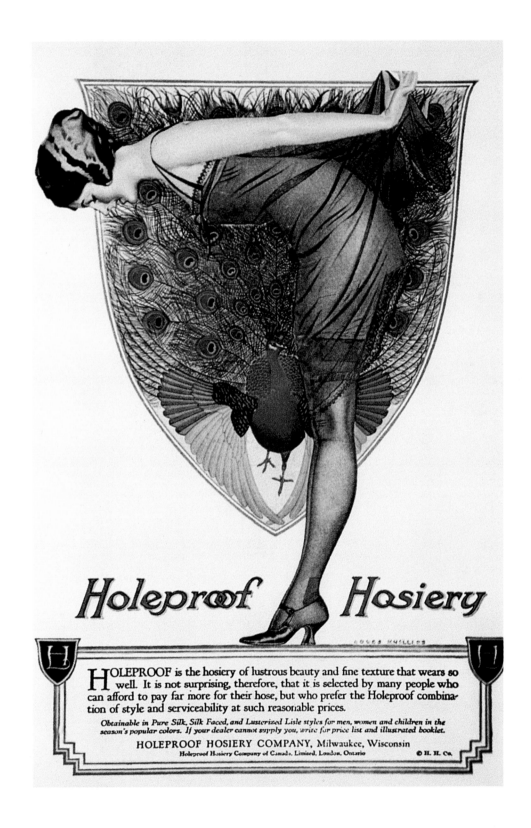

HUSH PUPPIES

DATE: 1998.
AGENCY: Fallon McElligott, Minneapolis.
ART DIRECTOR: Bob Barrie.
COPYWRITER: Jarl Olsen.
PHOTOGRAPHER: Rick Dublin.

Ventilated Hush Puppies.

Will people ever stop panting over these shoes? Cool casuals, in mesh and breathable canvas.

THE US COMPANY WOLVERINE INVENTED THE TECHNOLOGY TO TAN PIGSKIN FOR GOVERNMENT ORDERS DURING THE KOREAN WAR.

In the late 1950s, company chairman Victor Krause used this technology to develop a casual suede oxford shoe.

The name for the product was suggested by Wolverine travelling salesman Jim Muir after he dined with a friend in Tennessee. When his friend's hounds started barking, he tossed them a Southern dish of fried cornmeal balls that were called "Hush Puppies". At the time, feet were called "dogs" and aching feet "barking dogs". What could be a more appropriate name for the new line of comfortable shoes that quietened people's "barking dogs"?

In 1958, long before the advent of designer trainers, Hush Puppies pioneered the branding of shoes and was an immediate success, rising to become the largest selling casual shoe in America, with licences and markets in over 60 countries.

Now inextricably linked to the image of the faithful, dependable Basset Hound with its beseeching eyes, the brand is perceived as being comfortable, well made and conservative. Rather than display its shoes in its advertising, Hush Puppies has used Basset Hound pups in different situations to emphasize specific product attributes. The corporate symbol has been used around the world, needing only a single word translation of "Springy", "Sophisticated" or "Ventilated".

MAIDENFORM

DATE: 1980.
AGENCY: Levine Huntley Vick and Beaver, New York.
PHOTOGRAPHER: Chris Von Wangenheim.

THE FRENCH CLAIM TO HAVE INVENTED THE BRA IN 1889, THOUGH ONE OF THE EARLIEST PATENTS IS CREDITED TO MARY PHELPS JACOB IN 1914, IN THE USA. FRUSTRATED BY HER UNCOMFORTABLE CORSET, SHE DESIGNED A BRA FROM TWO HAND-KERCHIEFS AND NARROW PINK RIBBON, THEN SOLD THE RIGHTS TO WARNER BROS CORSET CO.

Maidenform began in 1921 when dress shop owner Ida Rosenthal advertised frilly uplifting garments to women buying her frocks. It proved popular even in the flat-chested "flapper" era of the 1920s.

Bra advertising emerged from the demure and practical to the brash and glamorous when Maidenform launched the "Dream" campaign in 1949 through the ad agency Norman Craig and Kummel. The designer had heard a psychological test reporting that women had basic exhibitionist tendencies. This gave rise to "I dreamed I went shopping in my Maidenform bra" and a farcical fantasy that ran for 22 years and 163 individual ads.

In 1979, after an eight-year break from high-profile advertising,

THE MAIDENFORM WOMAN. YOU NEVER KNOW WHERE SHE'LL TURN UP.
This time she's making a sensational landing in her Sweet Nothings Demi-Bra. Wide and deep plunging, this feminine front-close bra gives you a high, round, voluptuous look. Definitely executive material in softcup, light fiberfill and underwire too. From $6.50. Demi-bra shown $10.50. Bikini $5. In lots of fashion colors. **Sweet Nothings Demi-Bra by Maidenform**

Maidenform introduced its new woman, striding purposefully around with businesslike confidence. "When 28 million people see your ad, it had better sparkle," says Allan Beaver, who was chief creative officer of the New York agency Levine Huntley Vick and Beaver that handled the account. "In times of recession that's when you should be fantastically creative and talk to the consumer in innovative ways, rather than playing it safe."

WOOL

Founded in 1937, the International Wool Sceretariat (IWS) is a non-profit organization that supports wool growers around the world. It makes nothing and sells nothing. The IWS has branches in 40 countries and is financed by four major producing countries – Australia, New Zealand, South Africa and Uruguay – that represent some 70 percent of internationally traded world production.

Faced with advances in the quality of man-made fibres and increasing costs of growing and transporting wool, the IWS decided that advertising was to be the catalyst to help reverse the decline in sales. The aim was to build a preference for wool products even where they carry a price premium over man-made fibres.

In the mid-1970s photographer Michael Joseph joined a model, a stylist, three shepherds and 600 sheep for an ambitious shoot. "The sheep were on a 60 degree incline and I photographed them from across the valley using a 1,000 mm lens," says Joseph. "The best exposure was in black and white, with the black-faced sheep staring straight at the girl. It lasted for a fraction of a second; in the next negative the black sheep had disappeared into the flock."

In the 1980s the agency launched a campaign specifically for men's knitwear. The rationale behind it was that men with a strong personality no longer distain fashion, but have a highly developed fashion sense. "We had to show there was a contemporary side to wool," says Neil Fazakerley, who conceived the campaign. "The advertising had to look well ahead of the pack. Unusual and confident."

In a fresh look at clothes, the double page spread magazine ads started to play games with the readers. The first few ads in the men's campaign were photographed by John Thornton, whose hard, gritty images emphazied a sense of confrontation. "The danger was that the confrontation would be too

1

1. DATE: 1975.
AGENCY: Davidson Pearce, London.
ART DIRECTOR: Paul Arden.
PHOTOGRAPHER: Michael Joseph.

2. DATE: 1980s.
AGENCY: Davidson Pearce, London.
ART DIRECTOR: Kit Marr.
COPYWRITER: Neil Fazakerley.
PHOTOGRAPHER: Brian Griffin.

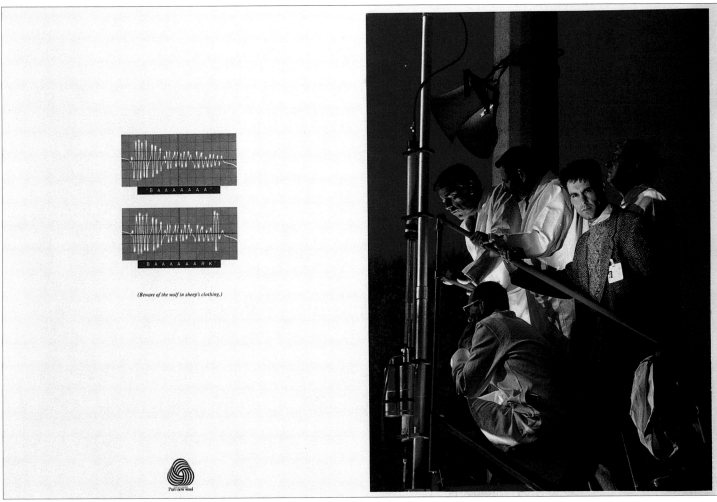

(Beware of the wolf in sheep's clothing.)

2

effective, and readers would find it too threatening, and so turn the page," says Fazakerley.

This is where the graphics on the left hand page came in. The job of this little brain-teaser was to diffuse the menace of the main picture and offer a witty explanation or counterbalance for it. "With photographer Brian Griffin we then developed a greater sympathy between the photograph and the graphic game," says Fazakerley. "My favourite is the voice-prints: one labelled 'B A A A A A', the other 'B A A A A A R K'. The nature of the photograph complements the technical voice-prints."

Brian Griffin had cut his teeth on photographing businessmen for a business magazine. "The photographs had to look punchy, but also have a deeper, more subtle level," says Griffin.

"I prefer to leave some questions unanswered to give the viewer something to think about. In the ad where the man has taken off his white coat and is looking at the camera, it's as though we have intruded on his territory."

Readers who take part in the ads and enter into the game become members of a club; they enjoy the intrigue and so feel positive about the product.

JONATHAN SCEATS

DATE: 1996.
AGENCY: BAM/SSB, Sydney.
ART DIRECTOR: Darryn Devlin.
COPYWRITER: Bobbi Gassy.
PHOTOGRAPHER: Michael Corridore.

JONATHAN SCEATS HAS ALWAYS WANTED TO STAND OUT, AND WAS NOT AVERSE TO USING SHOCK TACTICS TO DO SO. THE PRINT ADVERTISING BEGAN WITH IMAGINTIVE, WITTY, OFTEN ZANY INTERPRETA- TIONS. FOR EXAMPLE, USING PHOTO-MANIPULATION, A PAIR OF SPECTACLES WAS FASHIONED FROM HUMAN FINGERS AND APPEARED WITH THE HEADLINE: "JONATHAN SCEATS SPECTACLES ARE MADE ALMOST TOTALLY BY HAND".

In the early 1990s the advertising became more aggressive, responding to the counter-culture of violence and cynicism. A wave of campaigns during this period tapped into the apparent contempt-for-life attitudes already prevalent on television to some degree, but particularly in movies such as *Pulp Fiction* and *Reservoir Dogs.*

The tenor of the campaign – "Don't be seen dead in anything else" – struck a chord with the target audience of sceptical 18 to 30 year-olds, who view conventional advertising as mundane. They accepted the treatment in the way they perceive the portrayal of murder in the cinema – as make-believe. The ads were entertainment, unlike, for example, Benetton's.

Don't be seen dead in anything else. Jonathan Sceats Sunglasses.

KADU SHORTS

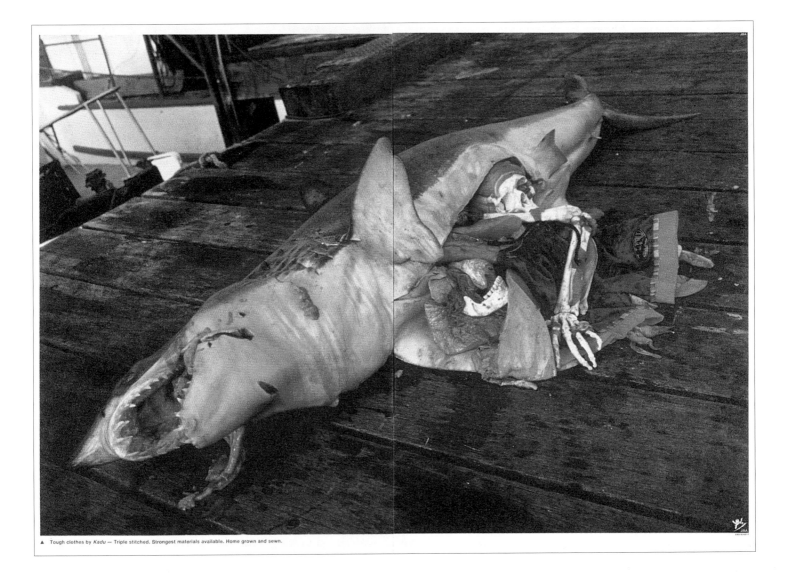

▲ Tough clothes by *Kadu* — Triple stitched. Strongest materials available. Home grown and sewn.

GOING TO EXTREMES IS JUSTIFIABLE WHEN IT MAKES A POINT THAT IS RELEVANT TO THE PRODUCT.

To demonstrate how tough Kadu surfing shorts are, the ad shows them spilling out of a disembowelled shark – still intact. Is this permissible or gratuitous shock? In its defence, art director Ben Nott stresses, "The ad only appeared in specialized media - surfing magazines – rather than being emblazoned across the billboards, like Benetton, with which the Kadu shark has been compared."

One of the strongest human instincts is to want to make sense of what we see. We are intrigued by the unexpected, and don't like being left with a mystery. When presented with an unexplained picture such as this, we are drawn in to solve the visual riddle or to read the copy in search of an explanation. People find shocks – or at least, surprises – more palatable when they are good-humoured as well as appropriate.

At the time the ad appeared, two fatal shark attacks occurred in Australia, increasing the attention given to Kadu – and lending weight to both sides of the argument.

DATE: 1994.
AGENCY: Andromeda, Sydney.
ART DIRECTOR: Ben Nott.
PHOTOGRAPHER: Simon Harsent.

LEVI STRAUSS

As brand leader that defines the product, Levi's are the original and definitive jeans. In the 1850s, Levi's were the choice for hard-wearing work clothes. In the 1950s, when the teenage culture emerged, they became the badge of youth, sex and rebellion and for the next two decades, with Lee and Wrangler, Levi's dominated the market, enjoying mushrooming exports.

But the American triumvirate were being pursued by competition from hundreds of fashion-orientated brands, while other jeans companies stacked high and sold cheap. Facing falling sales and a devalued product, Levi's made an ill-advised foray into men's and youth wear (suits, trainers, children's clothes). By the 1980s the company needed to refocus and re-inject its core values.

During the 1984 Olympics, the company relaunched its 501 line. The "5" denotes the production line in the Battery Street factory, San Francisco, where 501s were first manufactured in 1873. The "01" refers to the Cone Mills fabric still supplied exclusively to Levi's.

The London agency, Bartle Bogle Hegarty (BBH) helped Levi's increase profitability, lower the age profile of the brand's consumer and regain its credibility. In 1986, when Nick Karmen stripped off in a laundrette to wash his 501s, he boosted sales by 800 percent – and gave British advertising a huge shot of adrenalin.

With "Laundrette", BBH imbued the brand with daring, excitement and fun. Within the setting of 1950s America, classic songs evoked an era of cult heroes. Marvin Gaye's "Heard it Through the Grapevine" provided the stirring music track and set the trend for a string of re-released hits: "Wonderful World" (Sam Cooke) reached Number Two, "Stand by me" (Ben E. King) Number One, and "When a Man Loves a Woman" (Percy Sledge) Number Two.

The company's commercials had to be taken off air because revitalized production plants were unable to keep pace with unprecedented demand for 501s. At the same time UK sales of boxer shorts – revealed in "Laundrette" – increased to over two million.

Photographer Richard Avedon's treatment of Levi's in a print campaign was equally strong and resonant with the target audience of 15 to 24 year-olds. Avedon pulled real people off the street and photographed them, warts and all. "We wanted to maintain the integrity of the product and not undermine the loyalty of those who have always worn Levi's," says BBH creative director John Hegarty.

1. DATE: 1992.
AGENCY: McCann Erickson, Milan.
ART DIRECTOR: Stefano Colombo.
COPYWRITER: Alessandro Canale.
PHOTOGRAPHER: Graham Ford.

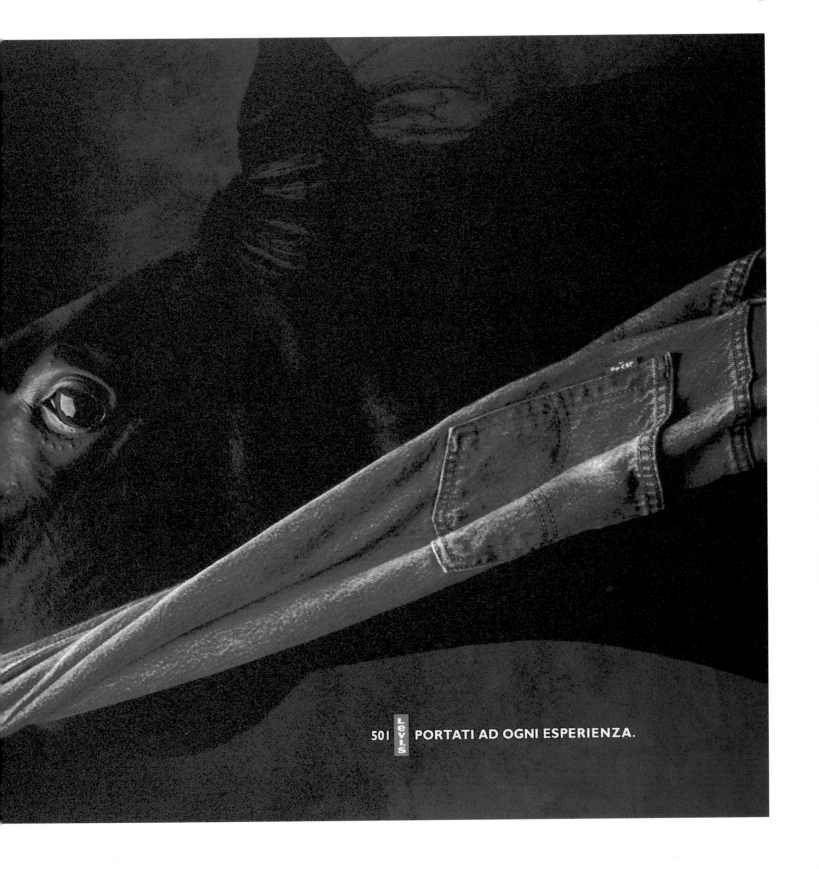

501 Levi's PORTATI AD OGNI ESPERIENZA.

2. DATE: 1985.
AGENCY: Bartle Bogle Hegarty, London.
CREATIVE DIRECTOR: John Hegarty.
ART DIRECTOR: Tim Ashton.
COPYWRITER: John McCabe.
PRODUCTION COMPANY: Passion Pictures.

3. DATE: 1985.
AGENCY: Bartle Bogle Hegarty, London.
ART DIRECTOR: John Hegarty.
COPYWRITER: Barbara Nokes.
MODEL: Nick Kamen.

2

Levi Strauss

At Levi's Milan agency, McCann Erickson, Stefano Colombo art directed a multi-award-winning trilogy of print ads which includes "Turban", "Sumo" and "Horse". "Most jeans ads were fashion-oriented, with American stereotypes - cool kids wearing jeans," says Colombo. "I wanted to try something different. Levi's are so well known, why show them actually being worn? As the copy-line says, '501 - fit for whatever'".

Photographer Graham Ford nearly turned down the commission because the brief about the horse seemed too difficult to achieve convincingly. "The layout gave the impression of a galloping horse, but you also had to be able to see the little Levi's logo," says Ford. "We shot it in stables. The positioning of the horse was critical - within a few inches - but he was all over the place. In the end someone held the jeans on a stick, in line with the mouth."

It would be tempting for the marketing moguls at Levi's San Francisco HQ to dictate how the brand should be projected worldwide – tempting, but short-lived. Rob Holloway, vice-president of global marketing, is global in his approach yet advocates that marketing should be managed locally.

"The old style of thinking involved centralized control. This made for clarity of approach and was great for the ego, but it's fundamentally wrong to believe all good ideas must come from the centre. Conversely, it would be wrong to hand everything away. This would lead to differing regional strategies and a dilution of the brand's identity internationally. It must be agreed interpretation."

BBH created the "Clayman" TV and cinema commercial for the European market, yet its appeal was universal and it enjoyed a much wider reach than originally anticipated, becoming the first truly global campaign. In Singapore, for example, Clayman was adapted simply by changing the endline.

In the fully animated mini-feature, modelling-clay characters act out the classic "damsel in distress" tale. In time with the music – "Boombastic" by Shaggy – the hero removes his belt and throws his 501s over a telephone wire, which he proceeds to use as an aerial runway to rescue the girl.

As John Hegarty says, "Great ideas cross boundaries. A great idea comes out of understanding what makes the brand tick. The first questions that go through your mind are, 'Is it right for the brand? Does it belong? Is it what the brand needs?' Then you ask yourself, 'Is this going to startle people? Will it present information in a way that it hasn't been presented before?' If the answers are yes, there's a chance you've created something memorable. But you still need to ask: 'Does it make the hairs on the back of your neck stand up?'"

In 1997 BBH launched a raunchy 60-second TV and cinema commercial for Levi's 501s. The only product proposition in the brief was to illustrate the theme "shrink to fit" – the jeans must get wet and fit tightly. To the evocative strains of "Underwater Love" by Smoke

3

4. DATE: 1990.
AGENCY: Bartle Bogle Hegarty, London.
ART DIRECTOR: Martin Galton.
COPYWRITER: Will Awdry.
PHOTOGRAPHER: Richard Avedon.
MODEL: Peter Ivan.

5. DATE: 1985.
AGENCY: Foot, Cone and Belding, New York.

6. DATE: 1997.
AGENCY: Bartle Bogle Hegarty, London.
ART DIRECTOR: Steve Hudson.
COPYWRITER: Victoria Fallon.
DIRECTOR: Michel Gondry.
PRODUCTION COMPANY: Partizan Midi Minuit.

7. DATE: 1999.
AGENCY: Bartle Bogle Hegarty, London.
DIRECTOR: Quentin Dupieux.

4

City, a hunky, shipwrecked fisherman wearing baggy jeans is pitched into the sea during a storm and sinks to the seabed. Three mermaids resuscitate him with a sensuous version of mouth-to-mouth, then try to strip off his jeans. Thanks to his shrink-to-fit 501s, he escapes to the surface intact.

The sequence, directed by Michel Gondry, was filmed over five days in marine tanks at Malta's Mediterranean Film Studios. Smoke and wave machines and a water canon created the violent storm that was made even more convincing by a 400-ft cloud-mist which blocked out the Maltese sunshine.

The mist was produced using a Rolls Royce engine to drive a jet stream through a pressurized water ring.

Two months of computer manipulation were needed to make the mermaids "decent" and to add their fins and scales, during which the swimming sequences were combined with underwater footage of herring. "The pressure is really on with a Levi's commercial," says Victoria Fallon, who art directed the ad. "So much has gone before, but you're very conscious that you have to surprise everyone all over again."

Americana, sex and music provide the tone for much of Levi's advertising

Shrink-to-Fit only you.

501 JEANS

which consistently outruns and outshines the competition. Imitators constantly trail behind Levi's, failing to match the strength of the idea, the originality or the high production values. The 1999 campaign featuring Flat Eric was certainly an unexpected departure for Levi's in addition to being another hugely successful campaign.

6

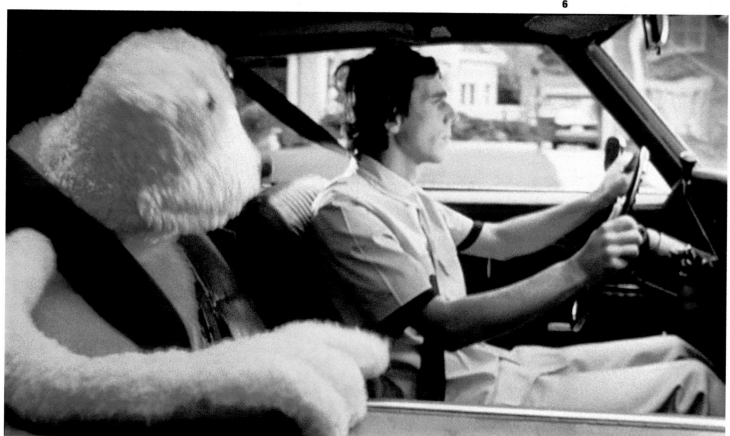

7

NIKE

1. DATE: 1996.
AGENCY: Simons Palmer Denton Clemmons
Johnson, London.
MODEL: Michael Jordan.

2. DATE: 1996.
AGENCY: Simons Palmer Denton Clemmons
Johnson, London.
ART DIRECTOR: Andy McKay.
COPYWRITER: Giles Montgomery.
PHOTOGRAPHER: Stock and Seamus Ryan.
MODEL:Eric Cantona.

1

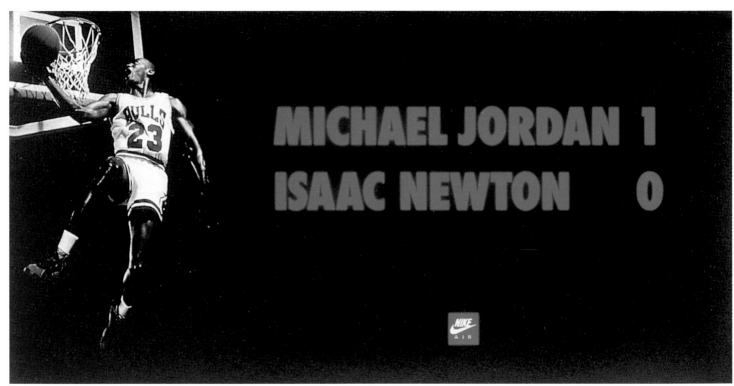

NIKE – THE GODDESS OF VICTORY IN GREEK MYTHOLOGY – WAS LAUNCHED IN 1971, DEVELOPING OUT OF BLUE RIBBON SPORTS, BORN ON THE WEST COAST IN 1964. THE COMPANY FOSTERED AMERICA'S PREOCCUPATION WITH PHYSICAL FITNESS. THROUGH POWERFUL PORTRAITS OF SPORTS HEROES, THE ADVERTISING EMPHASIZED IDEALS OF SELF-RELIANCE AND PERSONAL ACHIEVEMENT, AS WELL AS TECHNOLOGICAL PROGRESS.

Wanting to do something special for the 1984 Los Angeles Olympics, Nike sent a memo to three ad agencies. Chiat/Day's plan was to dominate the billboards in LA so it would look like Nike was sponsoring the Games, which it wasn't.

A no-words campaign evolved, depicting a variety of athletes working at their respective sports. The commercials showed them talking about their attitudes towards their sport. It was simple, direct and cool. And by the time the Olympics began, Nike's "I love LA" commercial turned the song into the unofficial anthem of the Games.

"The creative process starts with gathering all the material and consuming it," says Jay Chiat, who co-founded Chiat/Day in 1968. "You take a break, then revisit it, together with the problem you're trying to solve. Let it gestate for a while – go to a movie or read a book – and let your subconscious work on it. Then you usually come back with an idea."

Michael Jordan attached his name to everything from underwear to tablecloths, from address books to walkie-talkies. But his most lucrative association was with Nike. In 1984 he signed a 5-year, $2.5 million endorsement deal. At the time Nike was struggling

2

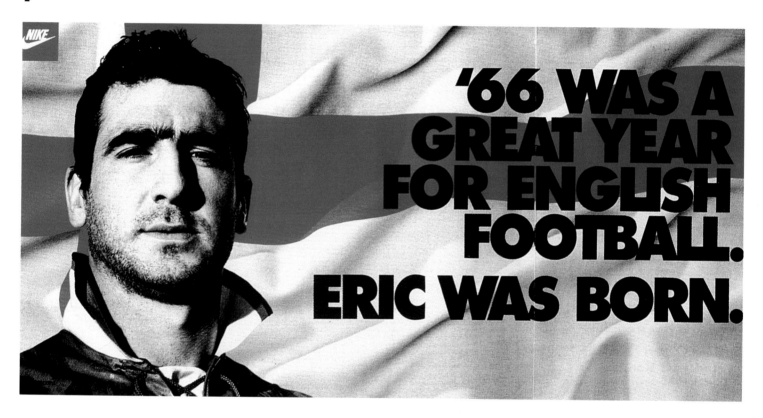

'66 WAS A GREAT YEAR FOR ENGLISH FOOTBALL. ERIC WAS BORN.

financially, but in just one year sold $130 million-worth of Air Jordan shoes.

The Jordan Flight commercial was aired in March 1985 to the roar of aircraft engines: "Who said a man was not meant to fly?" It launched Jordan into the popularity stratosphere, and restored Nike's growth. By the time he retired, Jordan had made over $5.2 billion for Nike.

Dan Wieden, President of Nike's next agency Wieden and Kennedy, suggested thethree syllables "Just Do It" in 1988 during a discussion on the apathetic mood of America during the 1980s. Nike's advertising stemmed from its roots as an authentic athletic brand. By understanding the sweat and sacrifice that goes into being an athlete it has also become associated with personal empowerment. In 1998, when the slogan "Just Do It" was firmly established globally, the company introduced a new slogan – "I can" – taking the concept of positive affirmation even further.

Nike ads have been at times contro-versial and irreverent, but the company and its swoosh (or tick) have come to stand for athletic excellence, determi-nation – and a hip self-awareness. An indication of the success of the corpo-rate branding lies in the fact that the swoosh, alone, is universally recognized as standing for these qualities. Nike has positioned itself as the company that puts athletes before commercialism. And has profited hugely from the strategy.

WONDERBRA

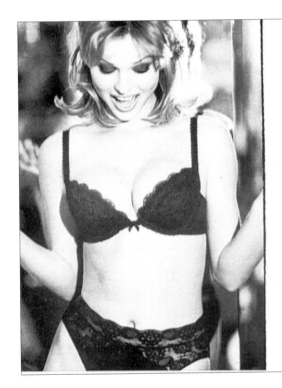

THE ORIGINAL PUSH-UP PLUNGE BRA. AVAILABLE IN SIZES 32-38 ABC.

DATE: 1994.
AGENCY: TBWA, London.
CREATIVE DIRECTOR: Trevor Beattie.

ART DIRECTOR AND COPYWRITER: Nigel Rose.
PHOTOGRAPHER: Ellen Von Unwerth.
MODEL: Eva Herzigova.

IF WONDEBRA HAD REMAINED IN WOMEN'S MAGAZINES, IT WOULD HAVE BEEN JUST ANOTHER BRA. ITS SUCCESS STEMS FROM THE OLDNESS OF ITS POSTERS.

On a tiny budget, with an unknown Czech model and witty headlines, put together with stylish art direction, the campaign was launched in the UK on Valentine's Day in 1994. Wonderbra sales soared from 9,000 to 16,000 a week. When the campaign went global that autumn, the bras were said to have sold at a rate of one every 15 seconds and Playtex could hardly keep pace with demand.

Thirty years earlier, Canadelle, a Canadian lingerie manufacturer, designed and patented the Wonderbra – a push-up, plunge garment that created an impressive cleavage, even with little to work on. In Britain, Courtauld's Textiles distributed the bra through their subsidiary, Gossard. Yet, not until the early 1990s were conditions right for the Wonderbra to supply anything more than a modest niche market. But then fashions welcomed the return of more voluptuous feminine curves, and breasts were once more being thrust to the fore.

In 1993 the licence to sell Wonderbra was transferred to Playtex, while Gossard developed the almost identical Ultrabra. Responding to this threat of competition, Playtex relaunched the Wonderbra with a provocatively upfront campaign.

In the United Kingdom the posters attracted over £20 million-worth of free press coverage. The 15 executions that subsequently appeared in 10 countries also generated huge media interest, further extending the effectiveness of the campaign. Road safety chiefs feared that ogling drivers would cause accidents. Some people felt that the posters exploited women.

Susanna Hailstone, account director at TBWA, was the driving force behind the ideas. She asserts that sex without humour is sexist, whereas sex with humour is not – it's sexy.

The Wonderbra concept is not so much to do with a woman getting her man, as being her own woman. The bra is a morale-boosting accessory, giving women confidence in their sexuality. The image Eva Herzigova presents is neither defensive nor demure.

PRETTY POLLY

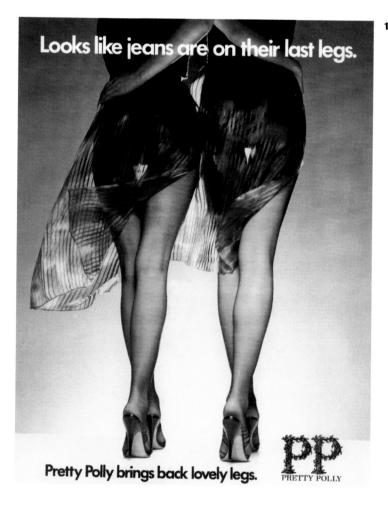

Looks like jeans are on their last legs.

Pretty Polly brings back lovely legs.

PP PRETTY POLLY

1. DATE: 1979.
AGENCY: Collett Dickenson
Pearce, London.
PHOTOGRAPHER: John Swannell.

2. DATE: 1999.
AGENCY: TBWA, London.
PHOTOGRAPHER: Platon.
MODEL: Shebi.

A BOOKMAKER IN STAFFORDSHIRE, ENGLAND WON A FORTUNE IN 1904 WHEN THE FAMOUS FILLY PRETTY POLLY WON THREE OUT OF FIVE ENGLISH CLASSIC RACES, SUBSEQUENTLY THE NAME PRETTY POLLY WAS ADOPTED AS A BRAND NAME BY HIS DAUGHTER FOR HER HOSIERY WHOLESALE BUSINESS.

One of her suppliers was a hosiery manufacturer founded in 1919 by Harry Hibbert and Oswald Buckland. In 1927 Hibbert and Buckland took over the wholesale business and the brand name.

Nylon stockings first appeared in 1939 – two years after nylon was patented by Wallace H. Carothers. After the war, Pretty Polly switched production to nylon and the company expanded rapidly, further boosted by a subsequent string of in-house innovations. Pretty Polly introduced the first non-run seam-free stockings in 1959, and "Holds ups" in 1967, making it brand leader in the UK. By 1976 Pretty Polly was among the top four producers of tights and stockings worldwide. In 1991 Pretty Polly was bought by the US corporation Sara Lee.

Pretty Polly advertising has always had a high profile, with the first television advertising for hosiery in 1980, and print ads with photography by some of the leading names in the business: Richard Avedon, John Swannell and John Claridge.

In 1996 the Long Legs campaign hit the streets and the media headlines with one of the tallest advertisements in history – the 60-ft high legs of German model Shebi, in sheer stockings and high stillettos.

Next, in one of the most traffic-stopping posters ever, a moving billboard dispensed with model Miriam's dress to reveal a pair of tummy-shaping Secret Slimmers. For the 1998 "Drop-dead-gorgeous" campaign the company took on supermodel Eva Herzigova, made famous in the Wonderbra ads created by the same agency (p.94). Attention shifted from her cleavage to her legs as she appeared wearing nothing but a pair of tights.

ROUND THE CLOCK

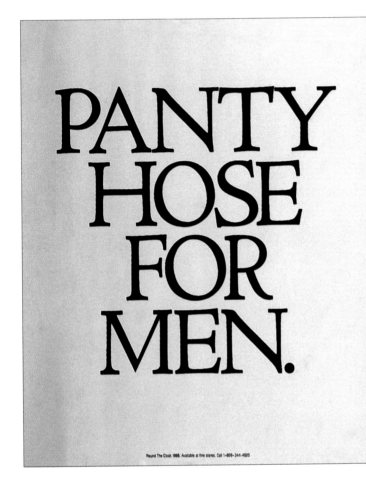

DATE: 1988.
AGENCY: Romann and Tannenholz, New York.
ART DIRECTOR: Denise Derossiers/Terry Whistler.
COPYWRITER: Gad Romann/Gary Tannenholz.
PHOTOGRAPHER: Horst P. Horst.

"NOWADAYS YOU CAN'T PHOTO-GRAPH A GIRL WITHOUT A NAKED BOTTOM," SAYS HORST, YET HE REFRAINED FROM SUCH A REVEALING APPROACH WHEN HE PHOTOGRAPHED A STUNNING PAIR OF LEGS FOR ROUND THE CLOCK PANTYHOSE.

"We wanted Horst for the campaign because his pictures are very stirring, and we knew he could be extremely provocative in black and white," says creative director Gad Romann. "We focused on intangible benefits, stressing the sensuality of the pantyhose. If women view them as a successor to silk stockings, which men find so attractive, they will be willing to pay more for them. So we came up with the line 'Pantyhose for men' as being the most spontaneous way to deliver on this promise."

From 1931 Horst enjoyed six prolific decades working for American and French *Vogue*, *Vanity Fair* and *House and Garden*. "Excellence is a matter of taste, and styles go in and out of vogue," he says. "For me, fashion has always been represented by an attractive woman in an appealing attitude or posture. Sex – in a beautiful, visual way – is most important. In the old days you couldn't take nudes. I had to wait three decades until they became acceptable."

SWATCH

Date: 1990s.
AGENCY: Barbella Gagliardi Saffirio, Milan.
CREATIVE DIRECTOR: Pasquale Barbella.
ART DIRECTOR: Giovanni Porro.
COPYWRITER: Lorenzo De Rit.
ILLUSTRATOR: Nicola Graziani.

SWATCH WAS LAUNCHED IN 1983 IN RESPONSE TO JAPANESE COMPETITION THAT THREATENED SWITZERLAND'S WATCH-MAKING SUPREMACY. RATHER THAN TARGETING THE HIGH-PRICED END OF THE MARKET, SWATCH POPULARIZED WATCHES AS FASHION ACCESSORIES, BASED ON THE INEXPENSIVE QUARTZ WATCH. SWATCHES ARE SHOCKPROOF, WATER-RESISTANT, HAVE A ROT-PROOF STRAP AND COME IN A WIDE RANGE OF COLOURS AND DESIGNS – UNCONVENTIONAL, FUN AND OFTEN ZANY.

When Swatch arrived in the UK, also in 1983, Tony Yeshin, director of the advertising agency Shackle Hanmer and Partners, viewed its watches as being able to withstand the knocks and splashes of rigorous use. "We wanted to show the vibrant appeal of the product and chose vignettes to summarize its various attributes," he says. The commercial used a stream of quick-fire stills, blended together in sequence to provide a unique staccato stop-motion that gave the impression of fast and furious action.

The kaleidoscope of press ads flowing out of Milan are bizarre, sexy, and portray Swatches as lifestyle badges – easy going, active, witty and contemporary.

The Swatch web page talks about Universal Time or Internet Time, representing a new concept of time. The idea is based on a Swatch Beat – a new unit of time that involves no time zones and no geographical boundaries. The virtual and real day is divided into 1,000 "beats". One Swatch Beat is equivalent to one minute 26.4 seconds. The theory is that a New York Internet surfer can make a date for a cyber chat with someone in, say, Rome, using Internet Time, which is the same throughout the world. The system was inaugurated in October 1998, with Biel, Switzerland – home of Swatch – as the new meridian.

TAGHEUER

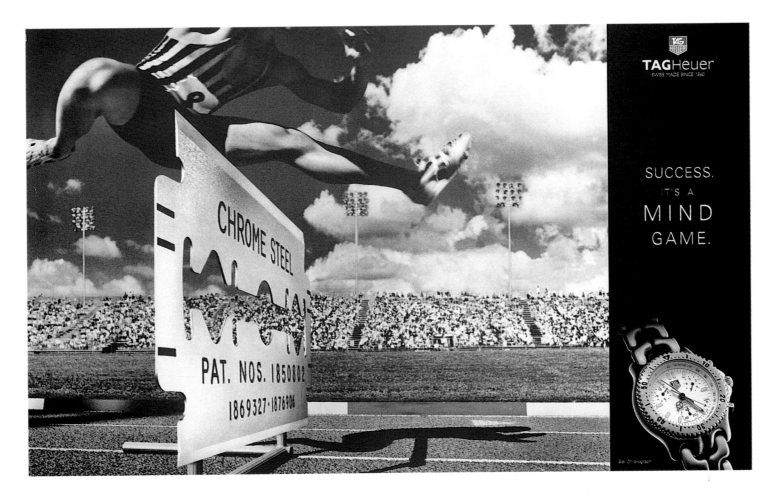

SINCE 1860 THE PERSONALITY AND STYLE OF THIS SWISS WATCH HAS BEEN DEVELOPING. TAGHEUER HAS NURTURED THE PERCEPTION OF IT AS BEING ORIGINAL, UNCONVENTIONAL, BUT RELIABLE — AN ALLIANCE OF SPORT AND PRESTIGE. AT THE CORE OF THE PRODUCT IS THE BELIEF THAT TECHNOLOGY DETERMINES FUNCTION. AND FUNCTION CREATES DESIGN. THIS IS A STYLISH TIMEPIECE THAT IS ALSO VERY FUNCTIONAL. BASED ON THESE ATTRIBUTES, TAGHEUER IDENTIFIED A NICHE MARKET SEGMENT FOR ITS LUXURY WATCHES — YOUNG ACHIEVERS AGED 25-40.

The advertising dramatically illustrates not only the importance of precision accuracy which separates winner from loser, but highlights the energy that goes into every millisecond of sport.

Heuer timekeepers were members of the 1970s Ferrari Formula One team. They developed the first Formula One electronic timekeeping system in 1974, and have been official timekeepers of the sport's World Championship since 1992, as well as being associated with World Cup skiing and the America's Cup yacht race.

TAGHeuer is a world leader in professional sports watches.

DATE:1997.
AGENCY: BDDP, Paris.
ART DIRECTOR: Eric Holden.
COPYWRITER: Rémy Noel.
PHOTOGRAPHER: Guzman.

TIMEX

Date: 1991.
AGENCY: Fallon McElligott, Minneapolis.
ART DIRECTOR: Houman Pirdavari.
COPY WRITER: Bruce Bildsten.
PHOTOGRAPHER: Hiro.
MODEL: Lisa Boyer.

IN THE LATE 1950S, JOURNALIST JOHN CAMERON SWAYZE CAME UP WITH THE SLOGAN "TAKES A LICKING AND KEEPS ON TICKING". THE AD AGENCY W.B. DONNER AND CO PUT THE WATCH THROUGH A SERIES OF "TORTURE" TESTS, AFTER WHICH IT KEPT ON TICKING. SUBSEQUENT CAMPAIGNS REVISITED THE SAME SUCCESSFUL LINE, AND TIMEX BECAME BRAND LEADER IN THE STATES.

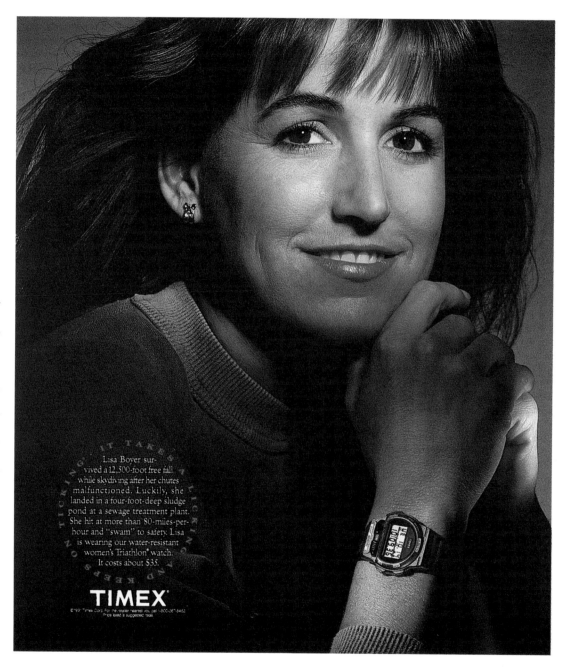

Lisa Boyer survived a 12,500-foot free fall while skydiving after her chutes malfunctioned. Luckily, she landed in a four-foot-deep sludge pond at a sewage treatment plant. She hit at more than 80-miles-per-hour and "swam" to safety. Lisa is wearing our water-resistant women's Triathlon® watch. It costs about $35.

TIMEX

Competition from quartz watches in the mid-1970s led Timex to diversify its range of styles and refocus its advertising towards the sports watch market. Other innovations that keep the brand ticking include the indiglo watch face illumination and the communications link to PCs.

When the company moved its advertising account to Fallon McElligott in 1987, the agency looked at the company's heritage for its print campaign. "We wanted to use the theme 'Takes a licking and keeps on ticking' but we couldn't do torture tests in print," says copywriter Bruce Bildsten. Instead, the focus was put on people who had taken a licking, and pulled through the ordeal. "We are all fascinated by stories of ordinary people who have survived something extraordinary," says Bildsten.

The human stories embodied in the campaign generated huge media interest and a jackpot of publicity that added over a million dollars-worth of value to the advertising spend.

TRIUMPH INTERNATIONAL

1

There are times when you can allow the man in your life to choose your bra.

The bra for the way you are.

Mama-bel nursing bra.

1. DATE: 1993.
AGENCY: Delaney Fletcher Bozell, London.
ART DIRECTOR: Brian Stewart.
COPYWRITER: Greg Delaney.
PHOTOGRAPHER: Pamela Hanson.

2. DATE: 1996.
AGENCY: Delaney Fletcher Bozell, London.
ART DIRECTOR: Brian Stewart.
COPYWRITER: Peter Kew.
PHOTOGRAPHER: Michael Roberts.

MOST CAMPAIGNS ADVERTISING PUSH-UP STYLE BRAS USE MODELS WITH SMALLER BREASTS, IGNORING THE MANY LARGER-BREASTED WOMEN IN THE WORLD AND FORGETTING THAT AVERAGE BRA SIZES ARE ACTUALLY INCREASING. GERMAN-OWNED TRIUMPH INTERNATIONAL'S "THE BRA FOR THE WAY YOU ARE" CAMPAIGN SET OUT TO TALK TO REAL WOMEN IN A REALISTIC WAY.

Photographer Pamela Hanson brings great human feeling to her pictures, capturing the wry smile in a light, true-

to-life manner. People look like they are enjoying themselves – and they just happen to be wearing the product.

"For each ad I gave Pamela a rough sketch, trying to keep it as loose as I could," says art director Brian Stewart. "I would hate it to be so regimented that I was never surprised by the results the photographer achieves. If I art direct photographers I'm limiting them to my imagination." The ad acknowledges the bra as both essential and sensual – personal without being too risqué.

Echoing the strategy used by Round The Clock (p.96), Sloggi suggests we dress for the opposite sex. By making bra ads sexy and fun, they appeal to both men and women.

2

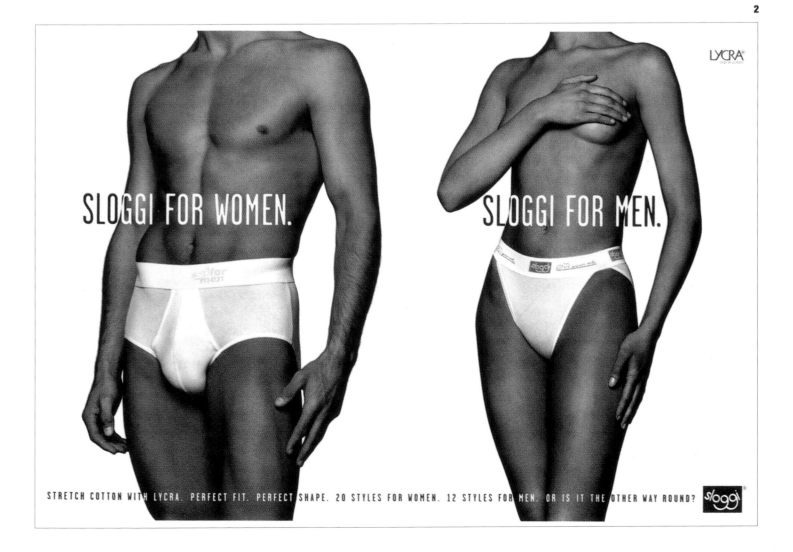

HOUSEHOLD PRODUCTS

A STRING OF INVENTIONS from early in the century gave the advertising industry something to shout about. Domestic gas ovens were installed from 1910 and stainless steel arrived in 1912, paving the way for a surge of timesaving, leisure-enhancing gadgets.

When the Sex Discrimination Removal Act was passed in Britain in 1919, women gained equal rights in certain professions. And as they were released from the strict pre-war morality and conventions, they began to exercise their independence socially, sexually and intellectually. The repercussions were felt not only in their attitudes towards domestic life but in their purchasing patterns.

ARALDITE ADHESIVE

Advertising played an important role in the introduction of the new technology. Ads presented the new machines, demonstrating their relevance to people's lives and showing consumers how to use them. Without explanatory ads, how many people would have picked up a new Kodak Brownie in 1900 (pp. 110–11)? Or found out about new labour-economizing products such as Persil (p.116) or Vim (p.120)? Or the applications of technological breakthroughs such as telephones, radios or gramophones?

In today's overcrowded market where most advances seem to be restricted to computer technology and the communications industry, few ads can present genuine innovations. But in the early decades of the century consumers needed information about new products or novel uses for existing ones.

In America, the prosperity of the 1920s provided the disposable income for consumers to indulge in the new appliances. Most middle-class homes acquired a telephone, electric phonograph, camera and radio. Britain followed America into regular radio broadcasting in 1923; after 1926 when the Central Electricity Board was created in by Act of Parliament, refrigerators and electric lights became common in most kitchens.

Following the 1929 Wall Street Crash, America was plunged into the worst depression in the country's history, with 25 percent of the work-force unemployed. It was a bleak time for manufacturers, and advertising revenues fell from a high of $3.4 billion in 1929 to a low of $1.3 billion in 1933.

In order to justify the need for advertising – and thus to justify its existence – the ad industry turned to market research. George Gallup began polling and selling his results and A.C. Nielson began selling indexes of food and drug sales.

New inventions continued arriving to make life easier, more comfortable or more interesting. The BBC started sending television signals from Alexandra Palace in 1936. Polythene was invented in 1939, then Terylene in 1941 and the long-playing record and transistor in 1948.

While most men were engaged in World War Two, women extended their skills and independence. They worked on production lines and ran offices, as well as looking after the home. After the war everyone looked forward to a better life, but Europe was poor, goods were

in short supply and recovery was slow. Postwar optimism, materialism and consumerism did not gather momentum until the 1950s.

The introduction of advertising on commercial television, which arrived in the 1950s offering unprecedented opportunities for direct advertising and programme sponsorship, dramatically redirected the advertising industry's focus, in many cases sidelining the print media. The first UK commercial break between scheduled programmes, in September 1955, had two 60-second spots, one for Gibb's SR Toothpaste, the other for Cadbury's Drinking Chocolate. Many early commercials were adaptations of press and poster ads that now seem awkward and unpolished. The first Persil commercials, for example, echoed the posters of dancers and sailors in different shades of white.

In a sharp learning curve, the pace quickened, scenes became briefer and links more subtle. TV tie-ins with radio and print advertising developed into consistent, integrated campaigns. Realizing the power of television, advertisers began to spend more per second than was spent on any movie.

Since the 1960s television has been the most dominant advertising medium, although some countries accepted commercial TV much later – Scandinavia did not have independent TV stations until the early 1990s.

During the 1980s and early 1990s small creative agencies prospered on formula-breaking campaigns and a wave of intriguing and involving ads that resisted spelling out every letter of the message. But as budgets had to stretch

further, intuition and creativity were perceived as high-risk indulgences, and clients wanted to spend more on research and testing.

As the century came to a close, the range of media platforms available to advertisers increased and fragmented with the introduction of satellite, cable and digital TV, increasingly specialized magazines and the Internet. Each niche market offers scope for more specific targeting. Interestingly, this proliferation of media has reinstated and strengthened the importance of the poster as an effective advertising medium able to reach a broad audience.

Throughout the century the vast majority of retail purchases have been made by women; some estimates put the figure as high as 80 percent. Today, women have greater equality, self-confidence and freedom to choose their lifestyle, but they continue to be responsible for almost all the shopping, cooking, housework and child-minding – which is why they remain the principal targets for advertisers in those areas. Despite an increasingly media-literate audience, some ads still work by blanket-bombing the consumer into acknowledging and valuing a particular brand.

"Nearly every purchasing decision is made from the heart, not the head – even with washing powders," says Frank Lowe, chairman of the Lowe Group. "People buy Persil because they feel good about Persil. They feel that if they are not using Persil, that somehow they are not using the best."

And everyone's self-image is shaped – at least in part – by their ability to achieve the best.

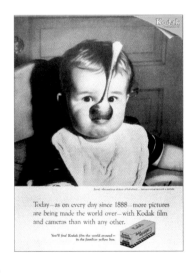

APPLE COMPUTERS 1984

Date: 1984.
AGENCY: Chiat Day, Los Angeles.
ART DIRECTORS: Brent Thomas and Lee Chow.
COPYWRITER: Steve Hayden.
DIRECTOR: Ridley Scott.

JAY CHIAT IS JUSTLY PROUD OF HIS AGENCY'S WORK FOR APPLE. "WHAT EXCITES ME MOST ABOUT ADVERTISING IS DISCOVERING AN UNEXPECTED AD BURIED IN THE EVERYDAY PACK OF MEDIOCRITY. SOME FRESH TWIST, SOME CLICHE TURNED UPSIDE DOWN."

Apple was founded in 1976 by Steve Jobs and Steve Wozniak in California. The company represented an individu- alistic, anti-establishment approach to computer technology.

When Apple wanted to launch the Macintosh computer, it wanted to make a huge impact. This was not just another product – it would change the world. Brent Thomas remembered an unused *Wall Street Journal* ad with the headline "Why 1984 won't be like 1984", originally done by Gary Gussick and Mike Moser.

With this as a basis, the agency came up with something to demonstrate that computers give individuals access to information, thus increasing the democratization of society. The copy- writer proposed satirizing George Orwell's book, highlighting people's fears about Big Brother. Macintosh would be seen to shatter this nightmare. The creative director suggested that a girl could throw a baseball bat at the screen to burst the bubble of totalitarianism.

The concept was ideally suited to the dark, sinister vision of Ridley Scott, English director of *Alien* and *Bladerunner*. Scott changed the bat into a sledgehammer, and Steve Hayden added some jingoistic Marxist phrases "Our Unification of Thought is more powerful a weapon than any fleet or army on earth."

The commercial that emerged shows the Thought Police pursuing the girl into a great hall full of transfixed automatons listening to Big Brother on a huge screen. The girl swings the sledgehammer over her head and hurls it at the video image which explodes. Over a picture of the stunned audience are printed the words: "On January 24th Apple Computer will introduce Macintosh. And you'll see why 1984 won't be like 1984."

The ad was nearly pulled, and was screened at the Superbowl only because the air-time had not been sold and 60 seconds had to be filled with something.

ARALDITE

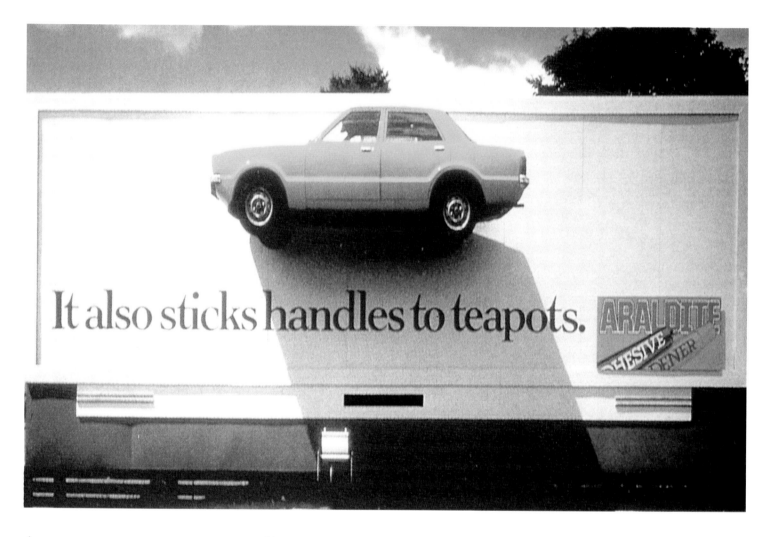

DATE: 1982.
AGENCY: FCO Univas, London.
ART DIRECTORS: Rob Kitchen and Ian Potter.
COPYWRITER: Rob Janowski.

ARALDITE ADHESIVE WAS USED TO STICK A FORD CORTINA TO A 48-SHEET POSTER HOARDING ON CROMWELL ROAD IN WEST LONDON. THIS ADVERTISEMENT WAS FOLLOWED BY "THE TENSION MOUNTS", FEATURING A RED CORTINA ON TOP OF THE YELLOW ONE. AND FINALLY: "HOW DID WE PULL IT OFF?" SHOWING A HUGE RIP OUT OF THE BILLBOARD ITSELF.

Savignac called this approach a "visual scandal" – something so outrageous and unexpected that it is certain to be arresting and a source of public interest. This ad started a craze for 3-D posters, such as cars apparently hanging out to dry and a vacuum cleaner proclaiming its strength by sucking up a passer-by. It was viewed, not as plagiarism, but as perpetrating a shared joke.

Manufactured by Ciba Geigy, Araldite was developed in the 1930s by Aero Research Ltd in Duxford, Cambridgeshire in the United Kingdom. The company was originally known as ARL which probably gave rise to the product name.

BRITISH GAS

DATE: 1990.
AGENCY: Young and Rubicam, London.
ART DIRECTOR: Trevor Melvin.
COPYWRITER: Jeanne Willis.
DIRECTOR: Michael Portelly.
PRODUCTION COMPANY: Halton Roy.
MODELS: Lauren Heston, Billy Zeqiri.

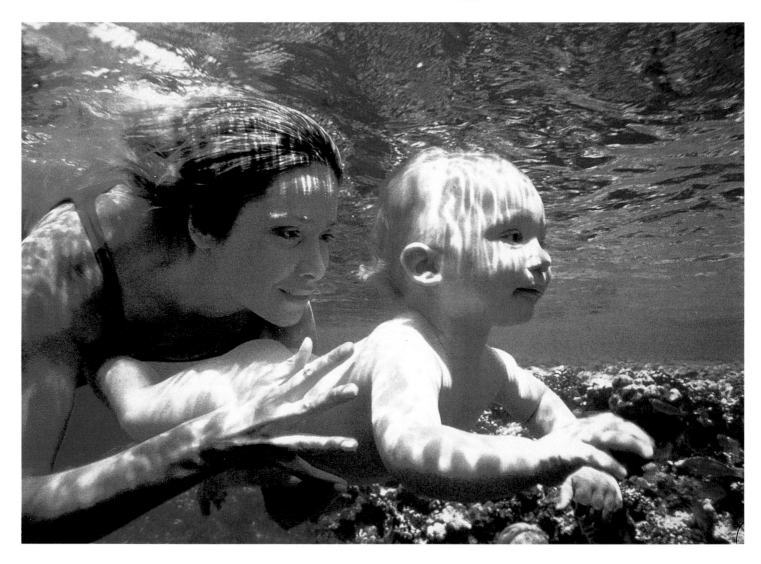

THE BRIEF FROM BRITISH GAS WAS TO PROMOTE GAS AS A CONTROLLABLE FUEL. THE IDEA FOR AN AMBITIOUS, AND POTENTIALLY DANGEROUS, COMMERCIAL CAME FROM A MAGAZINE ARTICLE SHOWING RUSSIAN BABIES SWIMMING UNDERWATER, LOOKING RELAXED AND CONTENTED.

Research revealed that babies have a natural ability to swim underwater at about five months old. During consultations with Michel Odent, the Frenchman who pioneered natural childbirth underwater, the film production company Halton Roy sought reassurance that this shoot was not only possible, but also safe.

Over 50 babies were auditioned and during swimming pool tests they performed naturally what was written on the storyboard. "It wasn't so much

a matter of training the babies as educating the mothers to recognize the innate ability of babies to swim underwater," says Portelly. "That they have this ability isn't really surprising – they've already spent most of their lives underwater inside the micro-ocean of the womb. At five months old they're able to swim underwater without any fear."

Following acclimatization sessions in a saltwater pool, four babies who looked similar were chosen for the

shoot and taken to the Red Sea; each appears in the final cut of the commercial. On the four-day shoot the crew had to be precisely rehearsed for each scene, as each baby was only in the water for three or four minutes at a time, and underwater for up to ten seconds at a time.

"Our first priority was to return from the shoot with four healthy babies and four happy mums," says agency producer Nick Thomson. "The film itself was the second priority."

EVEREADY

EVEREADY – AND ITS MORE RECENT OFFSPRING ENERGIZER – HAS BEEN IN THE VANGUARD OF TECHNOLOGICAL ADVANCE FOR OVER A CENTURY. IN 1896 EVEREADY WAS THE FIRST AMERICAN COMMERCIAL MANUFACTURER OF DRY-CELL BATTERIES. IN 1959 ENERGIZER WAS THE FIRST TO INTRODUCE ALKALINE TECHNOLOGY THAT REVOLUTIONIZED PORTABLE POWER BY SIGNIFICANTLY EXTENDING THE LIFE OF BATTERIES. ENERGIZER WAS ALSO THE FIRST WITH MINIATURE BATTERIES TO REPLACE WINDING WATCHES AND THE FIRST, IN 1995, TO MARKET A NEW SYSTEM OF ON-BATTERY TESTING TO ALLOW THE USER TO CHECK THE POWER LEFT.

The role of advertising has been to put details of the manufacturer's innovations in front of the public – and when competitors introduced similar innovations, to focus on Eveready's supremacy.

The Energizer Bunny was introduced in 1989 by Chiat Day – the development of an idea by DDB Needham Worldwide, for Energizer, which had featured drumming pink bunnies in a spot that was designed to undermine Duracell. The bunny is a manifestation of the batteries' unique selling proposition – their long-lasting properties. It has become such a symbol of longevity, perseverance and determination that it has been used to illustrate the staying power of sports people and politicians.

In a forgivable example of overkill, Chiat Day's commercials began as spoofs for other products, but were then interrupted by the pink bunny going and going and going. And continued going long after its 100th commercial.

The Eveready Battery company is the world's largest manufacturer of dry-cell batteries and flashlights, and global leader in providing portable power. Eveready and Energizer are marketed and sold in more than 160 countries.

DATE: 1989.
AGENCY: Chiat Day, New York.
ART DIRECTOR: Lee Chow.

FEDERAL EXPRESS

DATE: 1982.
AGENCY: Ally and Gargano.
ART DIRECTOR: Michael Tesch.
COPYWRITER: Patrick Kelly.
DIRECTOR: Joe Sëdëlmaier.
PRODUCTION COMPANY: Sëdëlmaier Films.
ACTOR: John Moschitta.

FRED SMITH LAUNCHED FEDERAL EXPRESS IN 1973. HE HAD WRITTEN A COLLEGE THESIS OUTLINING A NEXT-DAY DELIVERY SYSTEM BASED ON A HUB-AND-SPOKES PRINCIPLE. IT FAILED TO IMPRESS HIS TUTORS, BUT DID CONVINCE FINANCIERS, WHO PROVIDED HIM WITH THE BACKING TO ESTABLISH THE NETWORK.

Not wishing to worry the consumer with details of the service provided by Federal Express, the creative team at the ad agency went for humour, using the quick pace of contemporary business life as the backdrop. Seeing John Moschitta Jr on television when he broke the record as the world's fastest-talking human being gave copywriter Patrick Kelly the idea for a fast-talking executive who issues a stream of business clichés – but who is silenced by a soothing voice-over saying: "Aren't you glad there's one company that can keep up with it all? Federal Express." Carl Ally, co-founder of the agency, came up with the end-line: "When it absolutely, positively has to be there overnight."

The advertising could have focused on any number of material benefits: the size of the transport fleet, the number of parcels handled daily, the track-and-trace technology that can locate any package while in transit. Yet the logical attributes are already accepted and expected by consumers. "They don't want to know how it is done. That just makes them nervous because it looks like so much can go wrong," says Philip Huckin, group account director with KHBB in London, the agency responsible for launching Federal Express in Europe in 1988. "Our ads just needed to reassure them by saying 'You can trust us because you're going to like us'. Our aim was to make the potential customer feel warm about the company. And trust it."

FUJI FILM

THE JAPANESE TRADITIONALLY CHERISH NEW YEAR CELEBRATIONS. IT IS A TIME WHEN PEOPLE RETURN TO THEIR HOME TOWNS, AND FRIENDS AND RELATIVES GET TOGETHER AFTER PERIODS OF SEPARATION. IT IS ALSO A TIME WHEN – LITERALLY – MILES OF FILM ARE EXPOSED. FUJI FILM FOCUSES ON THIS SEASONAL TREND.

Ever since the 1960s, Dentsu has run the "Let's take photos of the New Year" campaign, which has grown to become a welcome ingredient of the Japanese New Year.

Each year the country's most popular female personality is chosen to reflect the festive feelings. In 1999 the campaign centres on the young TV star Rena Tanaka, dressed in ancient Japanese attire. In a humorous riot of colour *Shichifukujin* – the seven deities of happiness – embody the vitality and excitement of the occasion.

DATE: 1999.
AGENCY: Dentsu, Tokyo.
CREATIVE DIRECTOR: Shochi Minoura.

DIRECTOR: Shunichiro Miki.
MODEL: Rena Tanaka.

KODAK

1

GEORGE EASTMAN WAS AS INVENTIVE WITH THE NAME OF HIS CAMERA AS HE WAS WITH TECHNOLOGICAL INNOVATIONS.

Today, a new product is often more successful when its name incorporates strong clues as to its use. But Eastman had other criteria. He wanted a name that was short and could not be mispronounced – a word with no other meaning in any language. He also wanted it to start and end with K – he liked the strong, incisive sound of the letter.

Eastman was in his early twenties when he realized he would have to simplify the cumbersome and complicated process of picture-taking, in order to popularize photography. He eliminated the need to mix chemicals and in 1881 started the Eastman Dry Plate and Film Co. He then designed a simple camera to take his film that was based on the newly invented flexible celluloid. The first Kodak was launched in 1888, quickly followed by the first ad for "The Kodak camera. 100 instantaneous pictures!" The ad copy promised "No knowledge of photography necessary", heralding the subsequent line, "You press the button – We do the rest", extracted from copy written by Eastman.

In the early years of the twentieth century the name Kodak began to be used generically for any camera. So Eastman coined the slogan "If it isn't an Eastman, it isn't a Kodak".

2

"Carry a camera with you when you travel" was one of his early themes when foreign travel became more common. A 1905 ad by *Harper's* art director and poster designer Edward Penfield declared: "Bring your vacation home in a Kodak".

The company constantly introduced new technology to keep ahead of the competition. In 1895 came the first folding camera and in 1917 the first flash-bulbs for non-professionals.

Towards the end of the twentieth century, and true to Eastman's passion for innovation, Japanese art director Junichiro Morita ran a campaign illustrating that Kodak professional film is in the forefront of new ideas. "It was our task to show new modes of expression which could be accomplished with Kodak film," says photographer Tetsuro Takai. "We were not so much photographing an object as picturing how we feel about it."

The approach has typified the essence of Kodak for over a century.

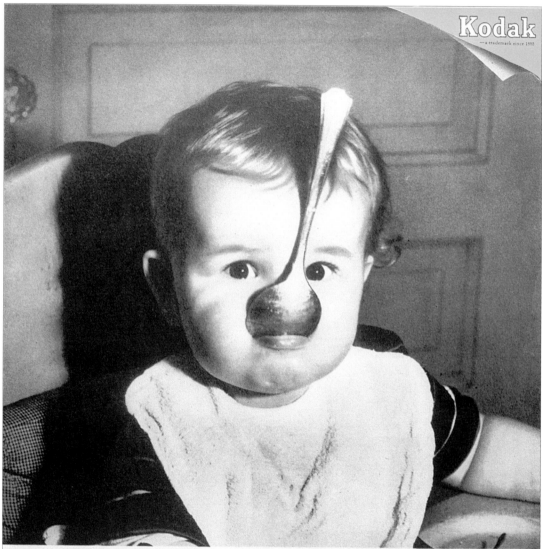

Saved—the precious whimsy of babyhood... because someone took a picture

Today—as on every day since 1888—more pictures are being made the world over—with Kodak film and cameras than with any other.

You'll find Kodak film the world around— in the familiar yellow box.

1. DATE: 1925.
ARTIST: Fred Pegram.

2. DATE: 1950s.

LE CREUSET

DATE: 1989.
AGENCY: Saatchi and Saatchi, London.
CREATIVE DIRECTOR: Paul Arden.
ART DIRECTOR: Antony Easton.
COPYWRITER: Adam Kean.
PHOTOGRAPHER: Sebastião Salgado.

CASSEROLE PROVENCALE:

8 lbs Pig Iron,
2 lbs Sand,
2 lbs Coke,
1 lb Enamel.

Cook in factory for 30 mins
at 800°C (or Gas Mark 24).
Glaze, then enamel. Re-heat.
Leave for three days. Serve.

BLACK AND WHITE IMAGES IMPLY A RETURN TO BASICS. CONSUMERS BELIEVE THAT THE POTS AND PANS ARE MADE OF THE BEST INGREDIENTS BECAUSE THE PICTURES SHOW REAL PEOPLE PHOTOGRAPHED IN A REAL WAY.

"Most photographers go for the heart of a story and don't worry so much about the shape of the pictures," says Paul Arden, creative director at Saatchi's. "But Salgado instinctively produces pictures with form, as well as a story."

During the five days he spent at the factory in north-eastern France, Salgado established a rapport with the men, who were normally suspicious of outsiders. He shot some 3,000 frames of the grimy-faced Algerian and Italian immigrant workers in natural light, using three Leicas. The results were grainy, true-to-life and unpretentious. There was no clear picture of the product – just a sense of product integrity.

"The people working in the factory were intrinsic to the central idea of the campaign," says art director Antony Easton. "We asked Salgado because he has so much humanity in his pictures, as well as the machinery of industry – whether in a steel plant in Belgium or a Brazilian gold mine."

As Kean and Easton were escorted around the factory, the analogy with cooking struck them immediately. Inspiration for the first ad of the campaign – "Recipe" – came from the great vats of molten alloy "cooked" by industrial furnaces.

Targeting 25 to 35 year-old housewives and serious male cooks, the campaign aimed to reinforce the pedigree of this elite-among-saucepans. "We had to give them a reason for spending more on the product than on a stainless steel saucepan," says Kean.

The typeface was integral to the branding – a now defunct metal face from the 1940s, called Sheffield Steel. The distinctive orange border around each of the ads was derived from the "volcanic orange" enamel used by Le Creuset.

LEGO

DATE: 1981.
AGENCY: TBWA, London.
ART DIRECTOR: Graham Watson.

COPYWRITER: Mike Cozens.
DIRECTOR: Ken Turner.
PRODUCTION COMPANY: Clearwater Films.

KIRK CHRISTIANSEN, A CARPENTER IN BILLUND IN JUTLAND, BECAME UNEMPLOYED DURING THE DEPRESSION AND DECIDED TO MAKE ROBUST, QUALITY TOYS THAT HE HOPED WOULD APPEAL TO CHILDREN'S CREATIVE IMAGINATION. HE NAMED THE NEW WOODEN TOYS LEGO, FROM THE DANISH "BEG GODT", MEANING "PLAY WELL". BY COINCIDENCE, LEGO MEANS "I AM JOINING TOGETHER" IN LATIN. CHRISTIANSEN'S COMPANY THRIVED.

After World War Two, Christiansen's son Gotfred devised a system of interlocking bricks that could be assembled, dismantled and reassembled into different objects. Lego was relaunched in Denmark in 1955 and continually diversified its range, becoming increasingly versatile. The theme park, Legoland, opened in 1968 near the factory in Billund, from where 97 percent of this leading European brand is exported to over 100 countries.

Successful Lego advertising taps into the core value conceived by its founder – toys that appeal to the creative imagination. One of the best-remembered commercials was called "Klipper":

"You see, I was standing outside my mousehole …" The manic, quick-talking voice of comedian Tommy Cooper is the voice of the Lego mouse. Along comes a threatening Lego cat – so the mouse turns into a dog – making the cat turn into a dragon … The story continues with the Lego creatures being magically broken down and rebuilt in seconds, showing how easily Lego can create an endless string of new toys, beyond most people's imagination.

MAXELL TAPES

AS THE VOICE-OVER IS SAYING "EVEN AFTER 500 PLAYS ..." IT IS INTERRUPTED BY LOUD MUSIC EXPLODING OUT OF THE SPEAKERS, THE FORCE OF THE SOUND BLOWING BACK THE HAIR AND TIE OF THE YOUNG MAN IN THE LEATHER ARMCHAIR. THE VOICE-OVER RESUMES "...OUR HIGH FIDELITY TAPE STILL DELIVERS HIGH FIDELITY".

By dramatizing a product's attributes, the message hits home more readily and is remembered longer. The problem for Maxell's agency was how to present sound. The answer came from imagining what its effects might look like. This graphic execution, for both a TV commercial and print ad, is the result.

Eight years later the London agency HHCL took the idea further. "Loudness is now a dated proposition," says account director Graham Bednash. "People are looking for sound quality. And different sorts of sound quality depending on what they're listening to."

Research showed that the 16 to 24 age group perceives tapes as a fashion accessory, like Kickers or 501s, so the agency opted to make Maxell a fashionable badge. "Rather than show-ing product virtues, we were suggesting that tapes shouldn't be taken too seriously; they're just fun," says Bednash. In the 30-second commercial a guy gave bizarre new words to Desmond Decker's *Israelites*, then ended with "I think that's what he says, but I need to hear it on a Maxell."

DATE: 1980.
AGENCY: Scali McCabe Sloves, New York.
CREATIVE DIRECTOR: Ed McCabe.
ART DIRECTOR: Lars Anderson.
COPYWRITER: Peter Levathes.
PHOTOGRAPHER: Steve Steigman.

OLYMPUS CAMERAS

1

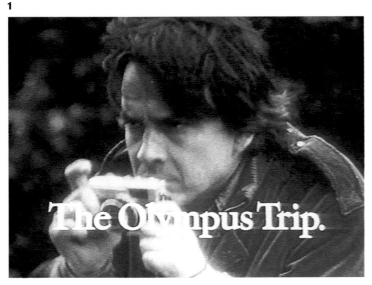

2

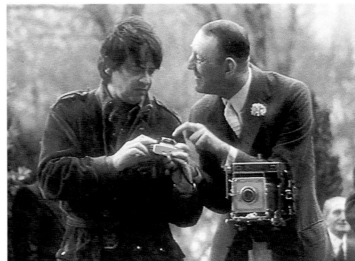

THE ORIGINAL NAME – TAKACHIHO SEISAKUSHO, OR "PLAINS IN THE HIGH HEAVENS" – WAS CONSIDERED TOO UNWIELDY FOR MARKETS BEYOND JAPAN. IN 1921, TWO YEARS AFTER IT WAS FOUNDED, THE COMPANY WAS RENAMED OLYMPUS, AFTER THE HOME OF THE GREEK GODS. IN 1975 OLYMPUS (UK) WAS FORMED. THE COMPANY SOON IDENTIFIED A GAP IN THE MARKET FOR COMPACT CAMERAS AND FILLED IT WITH THE OLYMPUS TRIP.

"Olympus has always believed in the power of advertising and was the first camera manufacturer in this country to use TV advertising," says Peter Cowrie, account manager with Collett Dickenson Pearce. "Our strategy included using professional endorsement, and several professional photographers were drafted in to carry the Olympus banner."

David Bailey was first choice – he had worked with Barry Taylor, now managing director of Olympus (UK), on a promotional film for Polaroid. Although Bailey was extremely well known in the 1960s, a new generation of people probably hadn't heard of him, a fact his first Olympus commercial used to advantage. Bailey is seen taking photos at a wedding. The official photographer with his plate camera scoffs at the little camera Bailey is using. His assistant says, "Do you know who that is? That's David Bailey."

"David Bailey?" the photographer queries. "Who's he?" And a catchphrase was born.

"The TV commercial made it almost impossible for me to take pictures in the street because people keep coming up and saying, 'Ha ha, Bailey. Who's he?' I used to hear that joke 10 times a day," says Bailey.

Patrick Lichfield joined the campaign after his Nikon system was stolen from his studio. "I saw this as a chance to look at other systems," says Lichfield. "In those days Olympus cameras were smaller than anything else and they had a very progressive advertising campaign."

Occasionally, CDP produced tactical ads linked to specific events. They used David Putnam when he won an Oscar, Daley Thompson at the Olympics and Chris Bonnington when he reached the top of Everest in 1985. Olympus soon had 50 percent of the compact camera market with the Trip and XA, and was brand leader in the total 35mm market in the mid-1980s.

A 1998 pastiche of a beauty ad offered a "wrinkle enhancer" to illustrate the sharpness and clarity of the photographs possible with an Olympus digital camera. Appropriately, Bailey took the shot of Quentin Crisp, whose lived-in face and camp make-up were ideal for the tongue-in-cheek press ad.

1 & 2. DATE: 1977.
AGENCY: Collett Dickenson Pearce, London.

PERSIL

DATE: 1953.

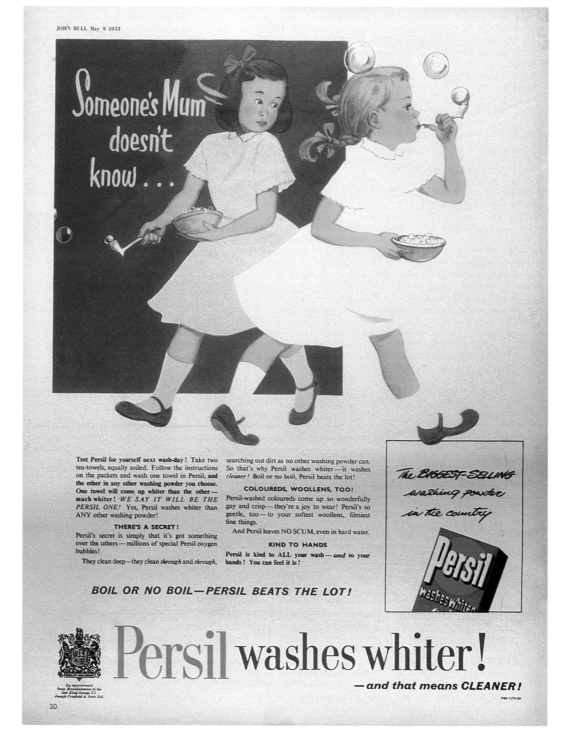

In Stuttgart, Germany, Professor Glessier and Dr Bauer combined a bleaching agent with soap in powder form to produce Persil, named after two of its ingredients — "percarbonate" and "silicate". In 1909 Persil was bought by Crosfields, a competitor of Lever Bros. In 1919 the two companies merged, and ten years later Lever Bros joined the Dutch Margarine Union to form Unilever.

The company is now owned by Unilever in Britain, Ireland, France and the Commonwealth, and by Henkel in most other European countries. Henkel's "white lady" is as powerful an icon on its patch as are the Michelin Man and Betty Crocker on theirs.

The line "Persil Washes Whiter" was introduced early in World War Two. Although simple, the slogan was a powerful selling idea, direct, succinct and memorable. People associated whiteness with cleanliness. The ads made frequent comparisons between the results produced by the Persil Mum and the not-so-happy, off-white results produced by someone using another product.

The advertising strategy continued to combine cleanliness and care but, acknowledging the need to do more than simply gets clothes white – when fewer of our clothes actually are white - the slogan in 1995 became "Persil performs brilliantly … and it shows."

For almost a century Persil advertising has conveyed reliability. The family relies on Mum. And Mum relies on Persil.

RCA VICTOR

THE ENGLISH LANDSCAPE PAINTER FRANCIS BARRAUD OWNED A CYLINDER PHONOGRAPH. HIS FOX TERRIER WAS FASCINATED BY WHERE THE SOUND CAME FROM, AND SAT WITH HIS EAR COCKED IN FRONT OF THE TALKING MACHINE.

In 1895 Barraud painted the dog listening to the horn and called it His Master's Voice. He tried to sell the image to one of the emerging phonograph companies. The Gramophone Company in London wanted to use the idea, but Barraud had to repaint it with a machine that used flat records rather than cylinders.

In 1901, the Victor Talking Machine Company, Philadelphia, acquired the American rights to the painting - which became one of the world's best-known trademarks. It featured in ads for Victrola gramophones, and went on to survive the century.

DATE: 1901.
ARTIST: Francis Barraud.
MODEL: Nipper.

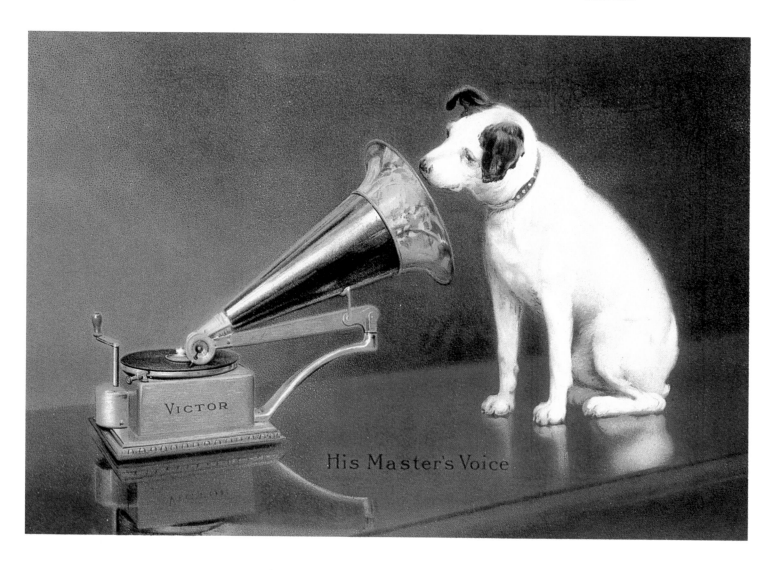

His Master's Voice

STEINWAY

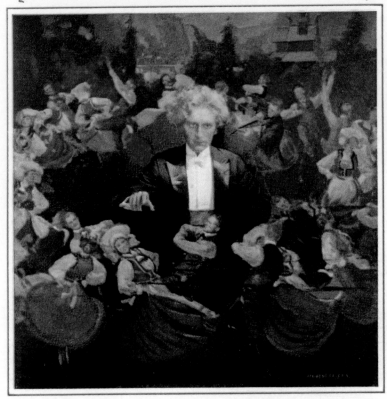

DATE: 1919.
AGENCY: N.W. Ayer and Son, New York.
COPYWRITER: Raymond Rubicam.

RAYMOND RUBICAM, WHO LATER FOUNDED THE AGENCY YOUNG AND RUBICAM, UNDERSTOOD THE POTENTIAL OF REJECTING ACCEPTED WAYS OF PRESENTING PRODUCTS; YOU OPEN THE DOOR TO THE POSSIBILITY OF SOMETHING MORE PERSUASIVE.

Heinrich Steinway emigrated from Germany to Amercia in 1850 and set up a company in New York. His son took over in 1871 and placed ads in the *New York Times* claiming: "the world's finest pianos since 1853". Rubicam was a copywriter with N.W.Ayer in 1919 when he was asked to produce three full page ads for Steinway pianos. Previously Steinway ads depicted attractive ladies at pianos in attractive settings, but failed to convey the company's prestige and heritage. Rubicam turned to the piano's unique selling point – the fact that most of the great pianists and composers played Steinway pianos. From that came the phrase "The instrument of the immortals", which was so successful it was used for the series of ads, although Steinway himself did not like slogans.

Reproduced oil paintings of great masters playing their pianos were not available for advertising, although purchasers of Steinways received a book of the reproductions. The photographer solved the problem by dressing and positioning himself as a composer at the piano. Thanks to the glowing reaction to this ad, the collection of reproductions was released for advertising use. And despite the overall decline in the sales of pianos, Steinway piano sales increased steadily throughout the campaign.

SUPER GLUE-3

1

2

3

A PRACTICAL DEMONSTRATION OF THE EFFECTIVENESS OF A PRODUCT IS ONE OF THE MOST DIRECT AND CONVINCING WAYS TO ADVERTISE.

This approach is especially memorable when it employs a bizarre or extreme theme, as in this French commercial for glue. In a close-up shot, glue is being applied to the soles of a man's shoes while the voice-over says "Look! We are going to show you the incredible bonding efficiency of Super Glue-3." A medium shot then reveals that an inverted man is being stuck to the ceiling by two other men.

As the two men let go and leave the room, the announcer is left hanging upside down from the ceiling, from where he delivers the line: "This sequence was filmed without editing."

The commercial won awards while the glue rose to become brand leader.

Date: 1970s.
AGENCY: Ogilvy and Mather, Paris.

VIM

DATE: 1918.
ARTIST: G. Studdy.

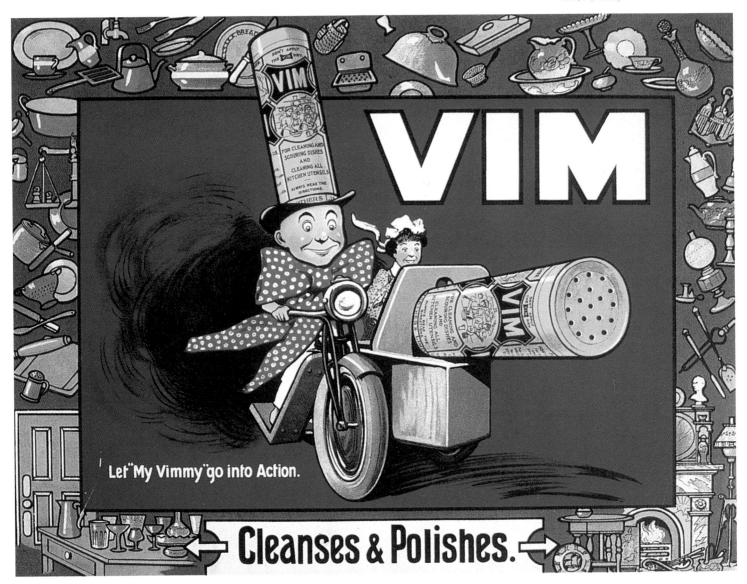

WILLIAM HESKETH LEVER BECAME A PARTNER IN HIS FATHER'S WHOLESALE GROCERY BUSINESS AT THE AGE OF 21, THEN SWITCHED TO PRODUCING SOAP, STARTING WITH SUNLIGHT (1884), THEN LIFEBUOY (1894). VIM WAS INTRODUCED AT THE PORT SUNLIGHT FACTORY IN CHESHIRE IN 1904 AS AN OFFSHOOT OF MONKEY BRAND SCOURING SOAP.

Initially there were reservations about the name which, at the time, was reminiscent of processed meat products, but the more colloquial use of the word seemed ideal for the product. Vim – from the Latin for "force" or "vigour" – suited the active cleaning properties of the household scouring agent.

The spirited little character – Vimmy – appeared in a variety of settings, busily "cleansing and polishing". A later ad drawn by Studdy shows a small industrious band of clockwork Vimmies being wound up and set to work merrily cleaning the kitchenware to "brighten the home and the age".

YELLOW PAGES

It's always there when you need it.

THE CONCEPT OF A GOODS AND SERVICES DIRECTORY ORIGINATED IN THE USA IN THE 1960s. YELLOW PAGES ARE NOW FOUND AROUND THE WORLD, YET THERE IS NO OVER-ALL INTERNATIONAL OWNER. WHEN NYNEX WAS FORMED AS A RESULT OF THE DEREGULATION OF THE TELE-PHONE COMPANY, THE AD AGENCY THAT WON THE ACCOUNT AIMED TO INTRODUCE THE NEW NAME IN TANDEM WITH THE FAMILIAR PRODUCT – YELLOW PAGES, WITH ITS IMAGE AS A FRIENDLY, RELIABLE, AUTHORI-TATIVE SOURCE OF INFORMATION.

The ads needed to say that Nynex is the Yellow Pages – the phone book you have always had, and the only one you will ever need. In the commercial a small boy is unable to reach his food on the table. The endearing narrative demonstrates one of the less obvious benefits provided by the hero – giving the boy a boost. "It's always there when you need it".

The following year, a stream of print ads that was followed by commercials centred on puns on some of the stranger headings found in the Yellow Pages – "Dumbwaiters", "Rock Drills", "Furniture Stripping" – with the end-line "If it's out there, it's in here".

Chiat Day, which handled the Yellow Pages account, was launched in 1968 in Los Angeles by Jay Chiat and Guy Day and became the first nationally successful ad agency outside New York and Chicago.

DATE: 1986.
AGENCY: Chiat Day, New York.
CREATIVE DIRECTOR: Jay Chiat.

TOBACCO

THE TWENTIETH CENTURY was a battlefield. For the first half, the tobacco companies fought for new markets. For the second, they fought against health issues and ensuing restrictions, while also trying to find ways to retain their appeal.

Until the 1850s tobacco was tobacco. As with many food items and household goods, brands did not exist. Then tobacco growers and manufacturers began branding – literally burning the product name on the ends of wooden packing boxes with a hot iron brand. Then the battle of the brands began.

Some manufacturers bypassed wholesalers and retailers and reached the consumer directly through advertising, called "printed salesmanship" by Albert

MARLBORO

Lasker, head of the first major modern ad agency Lord and Thomas that opened in Chicago in 1881 and was responsible for the debut Lucky Strike campaign (p.129).

At the turn of the century pipe-smoking was slowly being displaced by cigarettes, dominated by pungent Turkish tobacco. The three major American tobacco companies at the time – R.J. Reynolds, American Tobacco and Liggett and Myers – then shifted to using tobacco from the eastern states, led by Camel cigarettes in 1915 (p.126).

During the 1920s, when smoking in public became acceptable for women, cigarettes became a fashion accessory – often brandished in long holders. By this time advertising had started to address the largely untapped female market. Lucky Strike opened the new arena with an ad campaign inviting women to "Reach for a Lucky instead of a sweet". In the following decade the cinema glamorized smoking, while advertising claims became ever more fanciful and, in the light of subsequent revelations about the effects on health, indiscriminate: "Smoke as much as you like but keep to Craven 'A' for your throat's sake. As a doctor I am glad to notice more and more Craven 'A' smokers".

BENSON AND HEDGES

MIDDLE TAR as defined by H.M. Government
H.M. Government Health Departments' WARNING: CIGARETTES CAN SERIOUSLY DAMAGE YOUR HEALTH

Sales – and profits – rocketed, enabling unprecedented levels of investment in advertising. The tobacco giants felt invincible and had the financial clout to counter the concerns that began in 1950s, when a connection was first made between smoking and lung cancer. By the mid-1950s a lot of new brands had appeared in the USA, including filter brands such as Marlboro (pp.130–31), not in response to health concerns, but to target women.

By 1964 the American Surgeon General had a report linking smoking with increased mortality rates. From the following year cigarette packs had to include a health warning. A Bill passed by the US Senate prohibiting the broadcast of cigarette advertising on TV or radio came into force in 1972. Britain followed America's lead. As health concerns continued to grow, a succession of further restrictions was imposed on cigarette advertising, in much the same way as alcohol advertising. The ads could not target children or imply that smoking was associated with success or romance. In several countries the ads were not allowed to include people. This posed a particular problem promoting Marlboro without its global icon, the Marlboro Man.

The situation demanded an injection of imagination. "The more stringent the restrictions, the more creative the advertisers became in finding solutions," says Rhoda Marshal, executive director of the Art Director Club in New York. "English advertising developed an off-beat response that was obscure to Americans because our identities and philosophies are different. It's apples and oranges; both are delicious, but they're not the same."

In the many markets, the aura of Marlboro was portrayed through images of Marlboro Country – both mythical and contemporary Midwest. Meanwhile, Benson and Hedges (pp.124–25) took off at a tangent, creating one of the century's most innovative and imitated campaigns, and Silk Cut (pp.132–33) adopted an abstract strategy. In Japan, Dentsu took a different tack for Japan Tobacco, getting mileage out of the government's promotion of peaceful coexistence of smokers and non-smokers with its "Delight" campaign, showing a considerate smoker avoiding inflicting his habit on others and being rewarded with a feeling of well-being.

CHESTERFIELD

Across the century, a variety of forces worked for and against the tobacco companies – which have maintained that advertising does not attract more people to adopt the habit but merely directs them towards a particular brand. By the end of the century, however, mainstream advertising was extinguished in many of its most lucrative markets. In the last month of the century, a complete ban on cigarette advertising, including print, came into force in Britain.

BENSON AND HEDGES

THANKS LARGELY TO RESTRICTIONS ON CIGARETTE ADVERTISING, BENSON AND HEDGES BECAME ONE OF THE BEST-KNOWN CAMPAIGNS IN BRITISH ADVERTISING HISTORY.

The brand was first launched in the UK in 1960. When Gallaher approached the London ad agency Collett Dickenson Pearce, John Pearce rejected the cigarette account on offer and requested instead a little-known brand in a gold box. The subsequent "Pure Gold" campaign ran from 1962 to 1977, conspicuous from the beginning in the recently introduced *Sunday Times* colour supplement.

Avoiding specific product claims, the ads positioned the packs in high-class environments, enhanced by opulent photography. But by 1977, the imagery had become dated and too frequently imitated. More critically, the Advertising Standards Authority, which has to approve every treatment, felt that the up-market associations were too aspirational. Overt claims to sociability or social status were prohibited and cigarette advertising could no longer be linked with success, health, fame or sex.

The agency aimed to sustain the distinctive personality of the brand and retain the visual style and wit of the Pure Gold campaign by striving for greater originality. The idea that developed was based on a visual representation of the gold pack as hero in a surreal setting.

Art director Alan Waldie provided much of the early creative input. "We wanted people to question what was going on. We wanted to educate them to expect more subtle visual ideas," he says.

Waldie launched the first "Surreal" campaign using some of London's most established photographers – Brian Duffy, Adrian Flowers and David Montgomery. "I felt that if they couldn't make it work, we didn't have a campaign. Duffy shot "Mousehole", Flowers "Ducks" and Montgomery "Stonehenge". It was the single most important shift in the way advertising used photography during the late 1970s and early 1980s."

For the photographers, this was the most prestigious, and sought-after, account of the time. "Gold-wrapped cigarettes made more money than gold," says Flowers.

Benson and Hedges' ads frequently borrowed from the art world – notably surrealism – in the manner of Salvador Dali and Rene Magritte (who had himself produced several images for tobacco advertising between 1932 and 1936). While Magritte's "Elective Affinities" depicted a caged egg, one Benson and Hedges ad shows a caged cigarette packet which casts a shadow of a caged bird. The lavish visual games left half the population feeling smug and the rest perplexed.

Neil Godfrey was responsible for the early classic "Pyramids". It is a composition of three separate photographs – the pyramids, the sun and the pack – with the shadows falling on the wrong side. "Sometimes the elements that go together to make an ad are nothing special in themselves. Photography can be purely a technical means to an end," says Godfrey. "In this case the photographer is a cog in the overall process, but the art director puts it all together rather like an artist."

Photographer Jimmy Wormser concurs: "My contribution was to execute Neil's idea. I was the craftsman, not the artist."

Over 90 executions on posters and in the press repeatedly surprised and intrigued an ever-increasing following. "We hit a rich vein and managed to maintain a freshness because of the lack of continuity," says account director Tony Stansfield. "Unless by design, no two consecutive ads look similar in any way. Some are visual jokes, some second-glance jokes and some can be appreciated on different levels. If we gave the campaign more of a direction, it would be in danger of running out of steam."

As a celebration of the first wave of the campaign, the agency ran a special Christmas ad featuring several of their best-known images arranged in a single window.

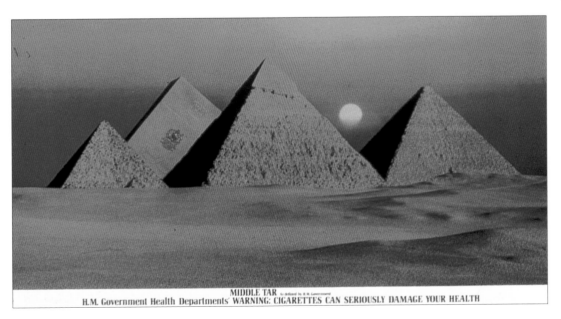

MIDDLE TAR as defined by H.M. Government
H.M. Government Health Departments' WARNING: CIGARETTES CAN SERIOUSLY DAMAGE YOUR HEALTH

2

"You can play games with surrealism; there's an element of wit and a change of logic - the world is not what it seems," says Nigel Rose, who art directed many of the executions. "The pictures must look aspirational and desirable, so long as they are far removed from reality. For "Bees", the photography was very important in enhancing the idea and giving it atmosphere. It had to be very three-dimensional."

Graham Fink was just two years out of college when presented with an opportunity to produce his first Benson and Hedges ad. He took his "Bees" idea to photographer Ed White, and together they spent 16 weeks perfecting it. The 3,500 golden "bees" swarming out of two old-fashioned hives varied in size from a real cigarette pack to a quarter-inch high. Many were held in position by wires attached to the backdrop. "We became

obsessed with it and would find ourselves in the studio at 3 o'clock on a Sunday morning trying to get one small detail right," says Fink.

Each Benson and Hedges ad is sophisticated and credits the public with a high degree of visual literacy. One ad, for example, shows cigarettes raining down on golden umbrellas; there is nothing to say what is being advertised, other than the gold theme. In some cases people have had to look hard to find the cigarette pack in the picture, and to discover the significance of the arrangement of items.

Advertisers take a risk with mysterious ads: people may not bother, or they may give up too quickly. But if the intrigue and imagination are enough to make them persevere, they attach greater value to the image – and the product achieves good brand identification.

1. DATE: 1978.
AGENCY: Collett Dickenson Pearce, London.
CREATIVE DIRECTOR: John Salmon.
ART DIRECTOR: Neil Godfrey.
COPYWRITER: Tony Brignall.
PHOTOGRAPHER: Jimmy Wormser.

2. DATE: 1982.
AGENCY: Collett Dickenson Pearce, London.
ART DIRECTOR: John Merriman.
COPYWRITER: Paul Weinberger.
PHOTOGRAPHER: Graham Ford.

3. DATE: 1983.
AGENCY: Collett Dickenson Pearce, London.
ART DIRECTOR: Graham Fink.
PHOTOGRAPHER: Ed White.
MODEL MAKER: Chris Lovell.

3

MIDDLE TAR
DANGER: H.M. Government Health Departments' WARNING: THINK ABOUT THE HEALTH RISKS BEFORE SMOKING

CAMEL

THE FIRST-EVER BIG BUDGET CIGARETTE CAMPAIGN BEGAN IN 1915 WITH A SERIES OF THREE TEASER ADS THAT APPEARED IN CLEVELAND, OHIO.

"The Camels are coming!" was followed by "Tomorrow there'll be more Camels in this town than in all Asia and Africa combined!" And finally "The Camels are here!" – with an accompanying description of the cigarette.

Having made Prince pipe tobacco a national seller, R.J. Reynolds had then turned to cigarettes. At the beginning of the century, Turkish tobacco was the favoured flavour, with Fatima (Liggett and Myers) being the most popular brand. In 1913, Reynolds bought the name Camel from a small independent company in Philadelphia for $2,500 and gave the ad agency N.W. Ayer the task of introducing it nationally. At the time, different brands of cigarette were sold in different regions of the USA. A national campaign was a bold new approach.

Early pack designs spelled Camel with a "K" to make it sound more exotic (The animal itself was styled on a real dromedary called Old Joe). Despite the Middle Eastern connotations of its name, Camel moved away from the predominantly Turkish taste and introduced a new taste with tobacco mainly from North Carolina, with a sprinkling of Turkish and a rich, saturated flavour of American burley leaves.

The innovation was an immediate success. The teaser ads worked well and were repeated around the country, overcoming regional bias. In five years Camels went from fourth to first position, with 40 percent of the cigarette business. National sales and advertising were subsequently adopted by all Camel's competitors. Legend has it that the 1921 slogan "I'd walk a mile for a Camel" was said to a sign-writer who had just given a passer-by a cigarette.

Subliminally, the statement conjures images of dromedaries soft-footing across the desert towards the reward of an oasis.

Good taste will always discover Camels

© 1929, R. J. Reynolds Tobacco Company, Winston-Salem, N. C.

DATE: 1920s.
AGENCY: N.W.Ayer and Son, New York.

CHESTERFIELD

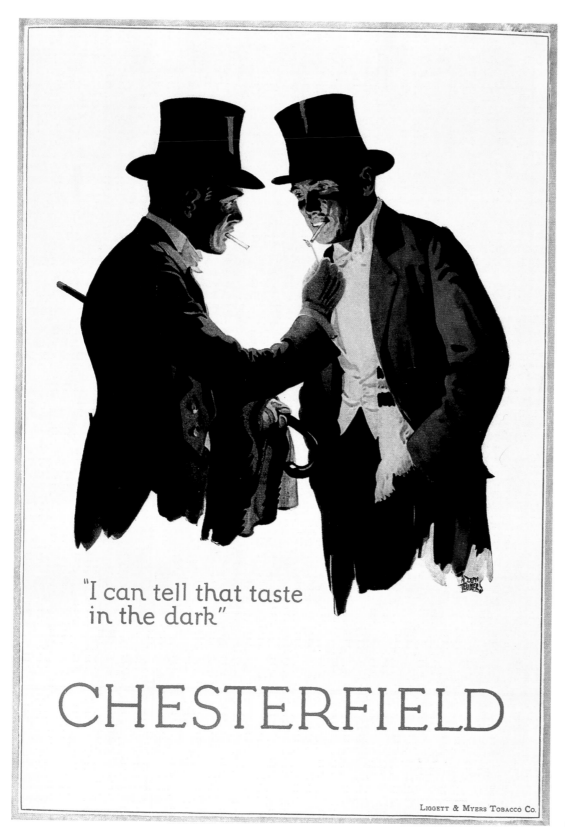

"I can tell that taste in the dark"

CHESTERFIELD

LIGGETT AND MYERS OWNED A MINOR CIGARETTE BRAND CALLED CHESTERFIELD. ITS BLAND BLEND OF VIRGINIA AND MARYLAND TOBACCOS WAS SUITABLY INNOCUOUS TO APPEAL TO A BROAD BAND OF SMOKERS.

Turning something of a negative into a positive, the companys ad agency mounted a campaign emphasizing the aristocratic, smooth and gentle flavour of the cigarettes. The advertising breakthrough came in 1926, when billboards showed a man and woman sitting by a moonlit ocean. As the man lights his cigarette, the woman purrs, Blow some my way. The formula was so successful it was repeated in a variety of venues, taking the catch-phrase into the vernacular.

With Camel and Lucky Strike, Chesterfield dominated the cigarette market in America until after World War Two.

DATE: 1926.
CLIENT: Liggett and Myers.
AGENCY: Newell-Emmett.

HAMLET CIGARS

DATE: 1995.
AGENCY: Collett Dickenson Pearce, London.
ART DIRECTOR: Tim Brookes.
COPYWRITER: Ben Priest.
PHOTOGRAPHER: Paul Bewitt.

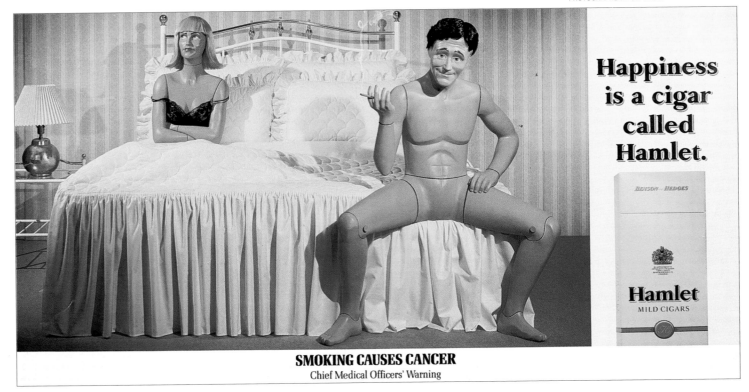

Happiness is a cigar called Hamlet.

Hamlet
MILD CIGARS

SMOKING CAUSES CANCER
Chief Medical Officers' Warning

HAMLET'S DEBUT COMMERCIAL IN 1964 – MAN IN BED WITH A BROKEN LEG – LAUNCHED SEVERAL LEGENDS. IT WAS THE FIRST CAMPAIGN TO USE MUSIC AS AN INTEGRAL ELEMENT OF THE BRAND'S PERSONALITY. SO STRONG WAS THE ASSOCIATION THAT A FEW BARS OF BACH'S AIR ON THE G STRING STILL CONJURES IMAGES OF SMILES OF BLISSFUL RESIGNATION IN THE MINDS OF MILLIONS.

An early commercial featured a man in suit and bowler hat stripping off in a laundrette, then countering any feeling of self-consciousness with the consoling aid of a cigar. The scenario was later re-interpretted by Levi's in another milestone commercial (pp. 88-91).

One Hamlet commercial has often been cited as the best ad of all time. In "Photo Booth" Gregor Fisher tries unconvincingly to cover his bald pate with his few strands of long hair, then is otherwise occupied each time the flash is triggered. Lighting up, followed by a puff of smoke, is accompanied by the voice-over: "Happiness is a cigar called Hamlet. The mild cigar from Benson and Hedges".

Hamlet is also Britain's longest running campaign that has retained its original strategy – solace in the face of adversity – for a total of 100 executions. The final commercial appeared in 1999, just before a total ban on cigarette advertising in the UK.

Many earlier tobacco products were advertised using idealized stereotypes, with whom the smoker could identify. In contrast, Hamlet advertising shows a character in embarrassing or frustrating situations, finding refuge and relief in a quiet smoke. The product doesn't solve the problem, but it makes it a lot easier to bear. The story is not specific to this brand, yet Hamlet has made it their

own. And the strategy is particularly pertinent to the brand because, despite the well-publicized detrimental effects of smoking, it has been proved that it does help to relax the body. This translates into the theme "Don't let your worries get you down".

It is a sentiment that Tom Gallaher would probably have endorsed when, in 1857, he founded a one-man business in Londonderry, Northern Ireland, making and selling Irish rolled piped tobaccos. The company Gallaher is now the largest manufacturer of tobacco for the UK, producing Benson and Hedges (pp.124–125), Silk Cut (pp.132–133), Condor and Old Holborn rolling tobacco.

LUCKY STRIKE

DATE: 1920s.
AGENCY: Lord and Thomas, Chicago.
CREATIVE DIRECTOR: Albert J. Lasker.

THE TURKISH CIGARETTE OMAR WAS AMERICAN TOBACCO'S FLAG-SHIP BRAND UNTIL COMPETITOR J.R. REYNOLDS THREW DOWN THE GAUNTLET WITH THE HIGHLY SUCCESSFUL CAMELS (P.126).

When George Washington Hill, the company head, discovered that the distinctive flavour of Camels was provided by burley leaves, he developed a similar blend. He took the name of a brand his company had bought earlier and designed a red bull's eye on a green background to imply a hit on target. "It's toasted" refers to the drying process that actually applies to all tobacco.

Lucky Strike was launched nationally in 1917 with the most expensive advertising campaign ever seen until then.

When advertising guru Albert J. Lasker, owner of Lord and Thomas, was brought in to boost sales, he decided to target the 51 percent of society largely ignored by cigarette advertising – women. Throughout the 1920s, the slogan "Reach for a Lucky instead of a sweet" appealed to female slimming aspirations. Lasker followed the celebrity endorsement route, co-opting famous opera singers and movie stars to extol the cigarette's virtues, as well as naval leader George Fried and actress Alla Nazimova. The prominent claim was that Lucky Strike was good for you: "No throat irritation – no cough".

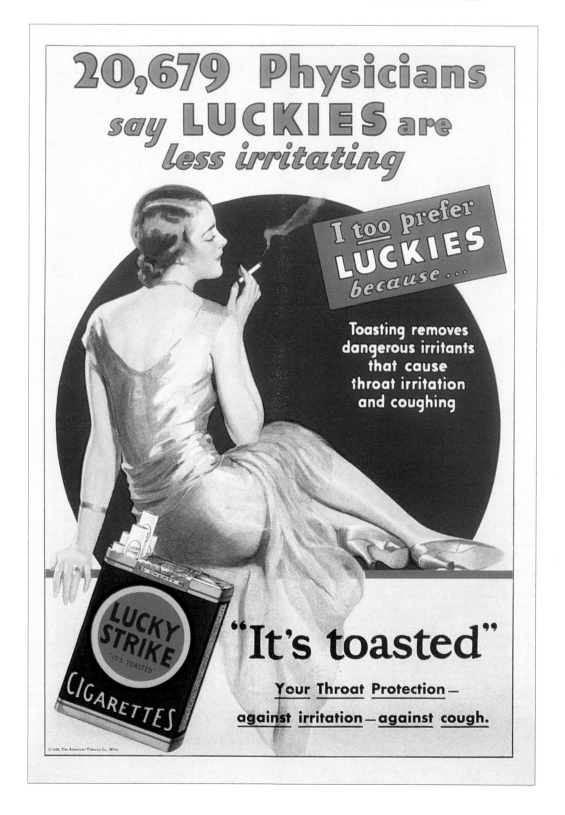

MARLBORO

1

1. DATE: 1997.
AGENCY: TBWA/Gold Greenlees Trott/Simons
Palmer, London.
ART DIRECTOR: Paul Leeves.
PHOTOGRAPHER: Nadav Kander.

2. DATE: 1960s.
AGENCY: Leo Burnett, Chicago.

3. DATE: 1970s.
AGENCY: Leo Burnett, Chicago.

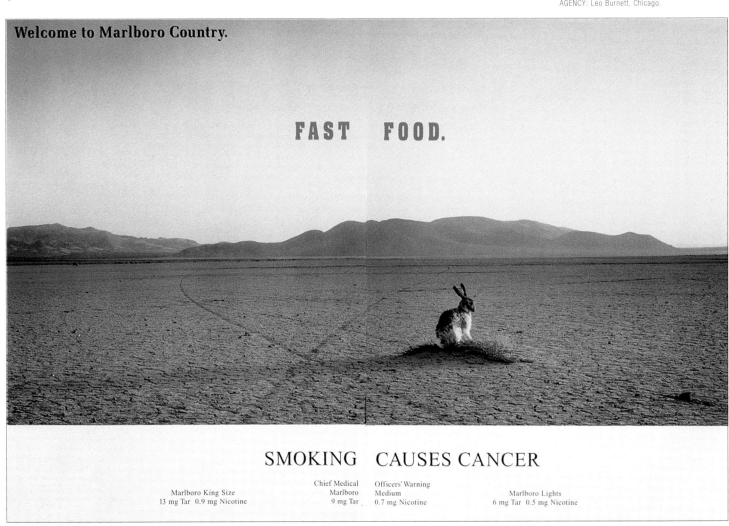

Welcome to Marlboro Country.

FAST FOOD.

SMOKING CAUSES CANCER

Marlboro King Size
13 mg Tar 0.9 mg Nicotine

Chief Medical
Marlboro
9 mg Tar

Officers' Warning
Medium
0.7 mg Nicotine

Marlboro Lights
6 mg Tar 0.5 mg Nicotine

MARLBORO WAS CREATED IN VICTORIAN ENGLAND. AMERICA FIRST EXPERIENCED THE BRAND AS AN UNFILTERED CIGARETTE SOLD IN THE CLASSIER CLUBS AND HOTELS. IT WAS MORE EXPENSIVE THAN EXISTING POPULAR BRANDS AND HAD A SMALL MARKET SHARE, MOSTLY OF SOPHIS-TICATES AND WOMEN. THEN THE ADVERTISING ACCOUNT MOVED TO LEO BURNETT IN CHICAGO AND THE CIGARETTE'S IMAGE WAS TOTALLY REVAMPED WHEN MARLBORO WAS CHOSEN IN 1954 FOR PHILIP MORRIS'S BANNER-WAVING LAUNCH INTO THE FILTER MARKET.

During the 1950s the public was becoming increasingly aware of the possible harmful effects of smoking. The advertising could have addressed these concerns by focusing attention on the filter. It could equally have glorified in the most significant advance in package design for 38 years. Yet the advertising chose to concentrate on the cigarette itself.

With more flavour, a new filter and an innovative crush-proof, flip-top pack with a strong red and white design, Marlboro was heralded as an entirely different kind of cigarette. The aim of the advertising was to portray a strong symbol of masculinity to counter the perception of Marlboro as a mild as May woman's smoke. The message was to be big and bold, clear and confident.

In a concept devised at Leo Burnett by Draper Daniels, William T. Young Jr and Jack OKieffe, a brand personality

emerged: the Marlboro Man – the personification of a red-blooded male with a steadfast, dependable character. The first newspaper ads "delivers the goods on flavor" – hit the spot, and sales soared. Later slogans read: "He gets a lot to like – filter, flavour, flip-top box" (1957), and "The filter cigarette with the unfiltered taste" (1962). The pictures were large, simple and direct and showed the Marlboro Man with a tattoo on one hand, implying a romantic past. Despite some early negative responses to the changes, the agency held its ground and justifiably so.

In 1963 the campaign took the Marlboro Man to Marlboro Country – out on the range with cowboys, horses and Western landscapes – inviting smokers to "Come where the flavour is". Although the Marlboro Man has adopted other successful guises, such as ball player and racing car driver, the cowboy has proved the most potent shorthand symbol for rugged independence.

Even when TV advertising of cigarettes was banned in the USA in 1971, the strong image endured, reinforced by print advertising. The following year Marlboro became the best-selling tobacco brand in the world, available in over 180 countries. Its brand identification and recall are higher than any other brand.

2

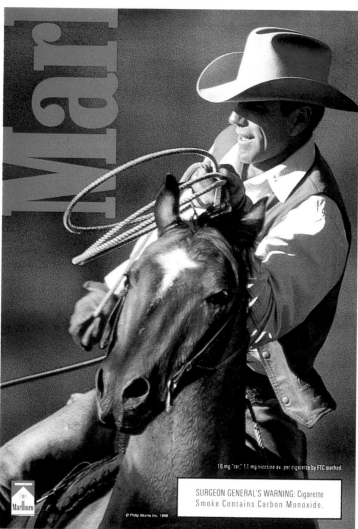

3

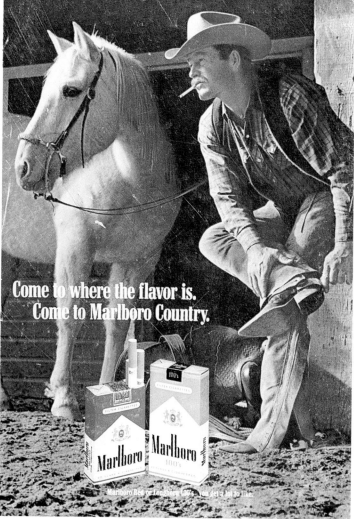

SILK CUT

1. DATE: 1983.
AGENCY: Saatchi and Saatchi, London.
CREATIVE DIRECTOR: Paul Arden.
PHOTOGRAPHER: Graham Ford.

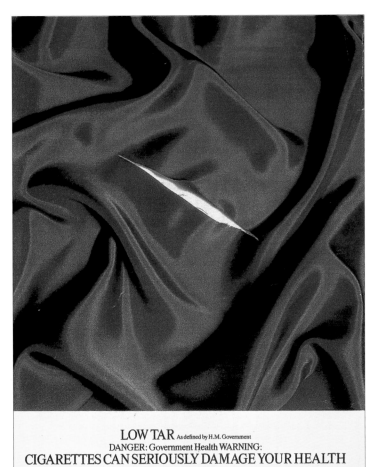

LOW TAR As defined by H.M. Government
DANGER: Government Health WARNING:
CIGARETTES CAN SERIOUSLY DAMAGE YOUR HEALTH

WHEN A MAJOR CAMPAIGN FOR SILK CUT CIGARETTES WAS LAUNCHED IN 1983, IT HAD A HARD ACT TO FOLLOW. THE BENSON AND HEDGES SURREAL CAMPAIGN HAD TAKEN UK ADVERTISING INTO NEW AREAS OF COMMUNICATION AND BECOME THE ENVY OF ADVERTISING CREATIVES AROUND THE WORLD (PP. 124–25).

The London ad agency, Saatchi and Saatchi, founded in 1970 by brothers Charles and Maurice, grew to be the largest in the world – physically, financially and creatively. Having harnessed the visual and artistic strengths of the Benson and Hedges campaign, Paul Arden and Charles Saatchi then originated the Silk Cut concept. It was based simply on the cut and the brand's distinctive colour – and it carved out another unique niche. "It seems easy, but, in fact, it's easy to be boring, and very difficult to be original," says

Arden. "Being creative can be a hazardous route. The gamble is greater, but if it works, the rewards are also greater. As a visual idea, this transcends national boundaries more easily than dialogue, but some great ideas can only be appreciated locally, because other cultures have not been educated to think in a particular way."

The Silk Cut campaign ran in the UK, France, Spain and Greece.

Graham Ford, who photographed the original silk with a cut, does not work to a set formula but prefers to find the most elegant solution to each new problem. "For me, the excitement of photography is to create a controlled environment where an often mundane object can be transformed into an absorbing photographic image."

In the early years, there was a flurry of variations – and Heineken created a delightful spoof poster in which the tear had miraculously disappeared, the endline declaring: "Only Heineken can do this" – pp. 48-49). After that, it was difficult to see how the Silk Cut campaign could progress.

"The subject matter itself should lend itself to great photographic imagery, but there has to be an added level of interest. The ads needed a second level of interpretation," says Matt Ryan, senior art director at Saatchi's. "If the image is too simple – too first level – then interest wanes very quickly."

Teams of hopeful creatives submitted a stream of ideas to Paul Arden, whose waste bin was overflowing.

Then Graham Fink, who had created several of the more powerful Benson & Hedges ads, turned his fertile imagination to Silk Cut. After many rejected ideas, he helped expand the brief into an increasingly sophisticated arena.

"You can't really say anything about beer or cigarettes, so you can have a ball and do really crazy things," says Fink. "To get ideas, I try to view things differently and imagine they are something else. Then, by playing word association, I find a link to the brief."

Similarly, Alexandra Taylor, group head of art, keeps the campaign concept in mind while her imagination fans out in all directions. "Sometimes you see imagery around you that can be adapted for a Silk Cut idea. Sometimes you can give an idea to a photographer and he'll add to it, or make it simpler and help clarify things."

Says art director Carlos: "The most important thing is what people are going to see in their minds, not only what's in the picture." He used the photographer François Gillet "because he paints the background then uses large-format film as an artist uses a canvas."

When the Saatchi brothers set up their new agency in 1995, many of their more prestigious clients came with them – including Gallaher. One of the new breed of ads was created by Nadav Kander, who is equally adept at handling landscapes as studio sets. "On location, the greatest skill is in recognizing a picture, or potential for a picture," says Kander. "I find it harder

2. DATE 1993.
AGENCY: Saatchi and Saatchi, London.
CREATIVE DIRECTORS: Paul Arden and Alexandra Taylor.
ART DIRECTOR: Carlos.
COPYWRITER: Steve Bickel.
PHOTOGRAPHER: Francois Gillet.

3. DATE 1995.
AGENCY: M and C Saatchi, London.
ART DIRECTOR: Martha Reilly.
COPYWRITER: Richard Dean.
PHOTOGRAPHER: Nadav Kander.
MODEL MAKER: Matthew Wurr and Co.

to make a picture than to take one, which is what you do in the studio. I sometimes try to recreate the lighting and composition I see on location, by applying the same rules."

In the final three decades of the century, restrictions on cigarette advertising have led to some of the most innovative and intriguing communication ideas. The inventive imaginations and sumptuous production values invested in the Silk Cut campaign have earned it a place among the world's best.

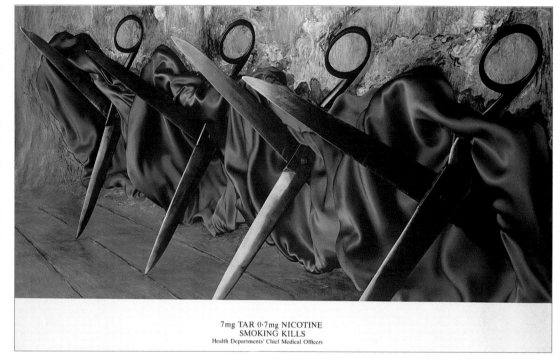

7mg TAR 0·7mg NICOTINE
SMOKING KILLS
Health Departments' Chief Medical Officers

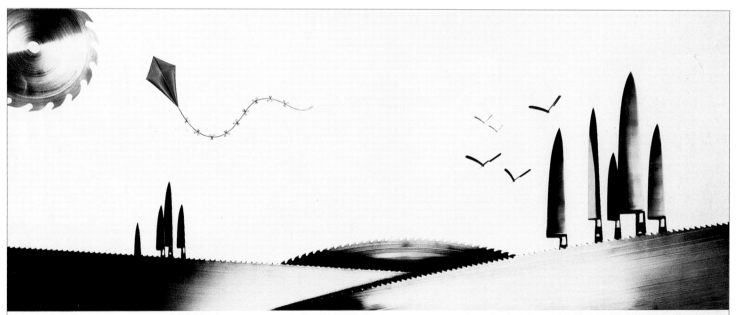

SMOKING CAUSES FATAL DISEASES
Chief Medical Officers' Warning
5mg Tar 0.5mg Nicotine

HEALTH AND BEAUTY

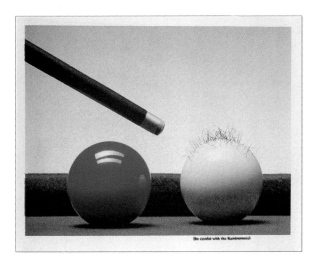

WELLA PACIFIC BEAUTY CARE

LUX SOAP

Of all the bars in all the world

LUX STAR TREATMENT FOR YOUR SKIN

CURES AND COSMETICS, at the beginning of the century, offered enormous scope for outrageous, unsubstantiated claims that remained largely unchecked. Playing on people's anxieties and vanities, ads boasted remedies for gout, bunions and wasting fever. As late as 1953 an ad for Stebbing System announced: "Be taller. Your height increased in 14 days or money back! 2 to 5 inches rapidly gained".

Although in 1991 Kaminomoto was obliged to remove its ads that merely implied – rather than claimed – hair restorative properties (p.147), the proposition did not have to be so discreet or circumspect in 1939: "Going bald? Silvikrin does grow hair."

Many nineteenth-century manufacturers established their names by producing health aids, before abandoning their original *raison d'être* and repositioning themselves to embrace a larger market. Coca Cola started as a medicinal tonic. Early French posters for a drink called Kola or Kola Coca claimed miraculous reparative qualities. Dr Kellogg initially devised his cereals for the patients at his health spa in Battle Creek. Oxo, Bovril and Hovis all focused on the health benefits of their products.

Patent medicines were hugely profitable, especially in the USA when frontier settlers and farmers had to cope without qualified doctors. Such medicines were widely advertised in newspapers and magazines from the late 1870s.

In 1906 the US Congress passed the Pure Food and Drug Act that took an early step in controlling the wilder claims. At the same time the Federal Government clamped down on the more noxious concoctions containing dangerous and habit-forming drugs. The introduction of aspirin just before World War One swept many potions off the shelves.

Medical advertising, when it began, was in the hands of those who understood medicine but had little appreciation of advertising. In the second half of the century mainstream techniques were used, subject to controls and regulations that required advertisements to include prescribing information and detail possible side effects. However, levels of public scepticism have always been high. "I think people should be suspicious of advertising. Advertisers are biased; they are providing selective truth," says Robin Wight, co-founder of WCRS, overseeing Bergasol (p.137).

The "before and after" formula displayed in the Bergasol and Kaminomoto ads is a convincing – and therefore often used – approach, because clear visual "evidence" is hard to dispute. The distribution of free samples to introduce the public to new products is another tried and tested approach – many health and beauty items lend themselves to this sort of integrated advertising approach. From as early as 1911, Colegate distributed samples of its toothpaste as part of an educa-

tion programme that ran in schools throughout the rest of the century (p.138).

There may have been a detectable shift in society from materialism towards deeper concerns for the planet, but society is still largely driven by a search for personal gratification. A lot of advertising works on people's greed or conceit, promising new beauty, allure – or pain relief. As in every sector, humour plays its part. Early Alka-Seltzer ads brought light relief in the form of "Speedy" – the personification of fast-acting remedy (p.136). Kaminomoto's more recent approach invites the audience to work at the ad in order to unravel the symbolism and share in the joke.

Memorable ads are often created by thinking laterally, then depicting an idea literally. This approach produced an effective strategy for the pain-killer Nurofen (p.144) with a dramatic visual portrayal of the sensations of pain.

"All the big spenders do quite pleasant commercials, though they are never outspoken in any way," says Paul Arden, creative director at Saatchi and Saatchi. "They wash over you – even soap ads wash over you – they become part of your life by repetition. Whereas if you do something extraordinary, and it works, the success will be much greater."

Marty Cooke, creative director with Chiat Day,

GILLETTE SAFETY RAZOR COMPANY

agrees: "Advertising is either intrusive or invisible. Subtlety has its place in terms of execution, but because the problems of mental overload are so intense – people receive so many messages – we have to be intrusive."

Personality endorsement – a powerful magnet for consumer attention – comes in a variety of forms. King C. Gillette became something of a celebrity himself by personally underwriting his own safety razors. He wrote his own ads, put his image on every packet and signature on every blade, as a guarantee of quality (p.139). Poster artist Ludwig Hohlwein became so well known that the products he depicted acquired an added kudos just because of his name (p.80, 146). Lux soap has used film star endorsement around the world since the heyday of Hollywood (p.142–43). If this campaign had not been sustained with strong product branding, the celebrities would have been remembered, not the product. The star treatment has been such an enduring feature of Lux advertising that the stars themselves no longer even have to appear.

LYNX BODY SPRAY

ALKA-SELTZER

WHEN STOP-MOTION ANIMATION BROUGHT "SPEEDY" TO LIFE IN 1952, HE DEMONSTRATED THAT A LIGHT-HEARTED APPROACH TO MEDICINES WAS ACCEPTABLE. WITH AN ALKA-SELTZER TABLET FOR A BODY AND ANOTHER FOR A HAT, SPEEDY OFFERED RELIEF FOR TROUBLED STOMACHS. SOMETIMES APPEARING WITH COMEDIAN BUSTER KEATON, SPEEDY OWED HIS DISTINCTIVE PERSONALITY LARGELY TO THE VOICE OF RICHARD BEALS.

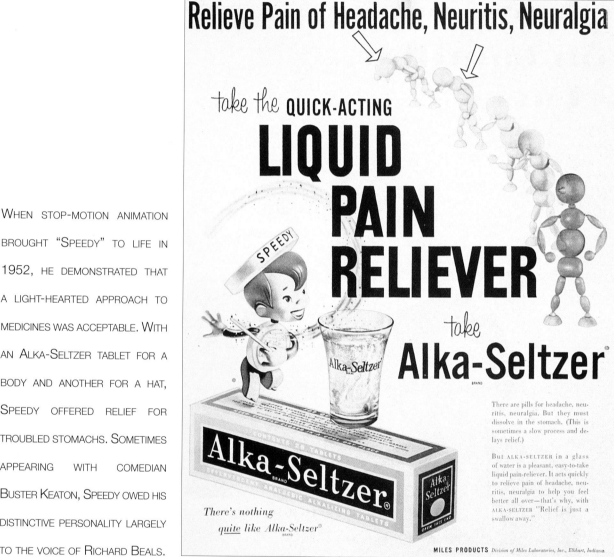

DATE: 1952.
AGENCY: Wade Advertising, Chicago.

Alka-Seltzer enjoyed a succession of successful campaigns from a string of ad agencies – Wade Advertising, Jack Tinker and Partners, Doyle Dane Bernbach and Wells Rich Greene – and during the 1960s and 1970s the product's television commercials pioneered the use of humour in promoting healthcare products.

Speedy was the focal point of the advertising until the account moved to Jack Tinker in New York in 1964. The new agency espoused the creative revolution taking place in advertising, the hard sell and talking heads approach replaced by lateral thinking liberally laced with wit and engaging storylines. "Plink, Plink, Fizz" still brings relief, while the

"Stomachs" montage of 1966 remains a classic, with its theme song "No matter what shape your stomach's in".

The next agency, DDB, was known for its intelligent and endearingly human approach, well illustrated by its commercial "Mama Magadini's meatballs". Bill Bernbach got under the skin of the product by concentrating on how

it related to the consumer and asking what human qualities and emotions came into play. "Nobody counts the number of ads you run; they just remember the impression you make," said Bernbach.

One slogan associated with the product "Try it, you'll like it", from Wells Rich Greene, subsequently entered American popular culture.

BERGASOL

DATE: 1980.
AGENCY: Wight Collins Rutherford Scott, London.
CREATIVE DIRECTOR: Robin Wight.

ART DIRECTOR: Ron Collins.
COPYWRITER: Andrew Rutherford.
PHOTOGRAPHER: Terence Donovan.

NOT ONLY DOES THE GIRL WITH THE PRODUCT HAVE A RICHER TAN, BUT HER HAIR IS FULLER, HER BODY MORE SHAPELY — ALLOWING HER BRIEFS TO BE BRIEFER. THE AD PRESENTS VISIBLE EVIDENCE OF THE PRODUCT'S SUPERIORITY, REINFORCED WITH A GLIB DIG. AND RATHER THAN BEING APOLOGETIC ABOUT THE PRICE PREMIUM, THE AD JUSTIFIES THE COST BY MAKING A VIRTUE OF IT

This quietly stated poster is very European. "American culture expects you to sell to them immediately. British culture expects you to knock first," says Robin Wight, the creative director. "But one problem with print ads, as opposed to television, is that its more difficult to create a sense of involvement with the audience. Here, the back views invite that involvement because you wonder what's happening on the other side. It's a notion I call 'incomplete proposition' – where the mind completes the picture."

The advertisment's photographer, Terence Donovan, said of the medium: "Before I get near an ad, the art directors and copywriters have done a lot of arm-wrestling to get it to that stage. I'm not arrogant enough to think that I know more about what they're doing, when they have spent four months lining it up. So I try to understand what the agency team wants to put across."

The human body was not designed to change colour easily.

Two weeks is not enough for a pale English skin to go a deep gorgeous brown.

Certainly not without help.

The kind of help that Bergasol gives better than any other suntan preparation.

Most suntan lotions offer a degree of protection, so you can stay longer in the sun.

But Bergasol screens out a wider range of the sun's harmful rays, because it has two filters.

One to screen out UVB rays which burn the surface of the skin.

The other to screen out certain UVA rays which damage the cells below the surface.

In fact, even if you were to use two other brands at the same time, they still wouldn't protect you any better than Bergasol.

But though Bergasol stops you burning, it won't, like some suntan lotions, stop you browning. Quite the opposite.

With a range of lotions, creams and oils to choose from, you can carefully control your tanning.

From the day you arrive, pale and wan, till the day you go home beautifully brown.

But even Bergasol isn't perfect.

If you want more protection from the opposite sex it's the last product you should use.

Nothing protects you as well, or tans you better.

COLGATE

DATE: 1960s.
AGENCY: Young and Rubicam, London.

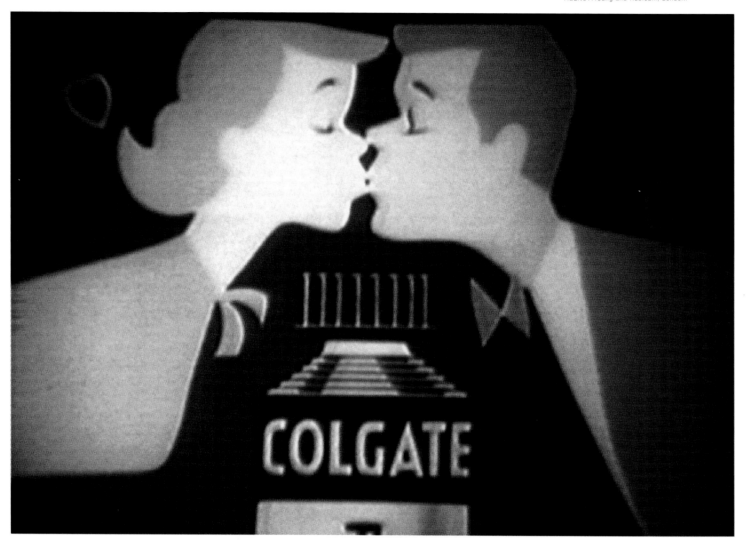

TOOTHPASTE ORIGINATED SEVERAL HUNDRED YEARS AGO WHEN THE INVENTOR OF THE MICROSCOPE — ANTON VAN LEEUWENHOEK — ANALYSED THE WHITE SUBSTANCES FOUND ON TEETH. HE WAS SURPRISED TO DISCOVER MILLIONS OF LIVING ORGANISMS.

Colgate began in 1806 by making soap, candles and cheese in Manhattan. The company introduced a brand of aromatic toothpaste in 1873, made from a mild abrasive, a detergent and mint extracts, which it sold in porcelain jars until 1896 when tubes were introduced. Colgate had already established a good trustworthy reputation with retailers, and found no difficulty distributing its toothpaste along with its other products.

At the time toothpaste was consid-ered a costly luxury. In 1911 and 1912 Colgate issued 2 million free tubes of toothpaste and several thousand tooth-brushes to schools, hoping children would form a teeth-cleaning habit. The school care programme is still practised by Colgate-Palmolive.

Although Colgate promoted dental care, it never claimed medicinal proper-ties for its toothpaste – unlike other products at the time. Colgate simply stated that its toothpaste was a safe cleansing agent that was refreshing, pleasant tasting and economical. The company's honest approach to its adver-tising helped build consumer trust.

Colgate toothpaste has been devel-oped over the years to make teeth more resistent to decay, provide fresher breath and combat gum disease. This overall strategy led to the "Colgate ring of confidence" campaign that has provided consumers with continuing reassurance. The company merged with the Peete Co. in 1927 and with Palmolive in 1928.

GILLETTE

As a travelling hardware salesman, King C. Gillette appreciated the effectiveness of repetitive advertising, especially when introducing a novel concept. His idea for a throwaway razor blade initially met with scepticism by those who saw no problem with the existing reusable blades, but a concerted advertising offensive reaped great dividends.

With a steel blade designed by New England engineer William Emery Nickerson, the first product was launched by the American Safety Razor Company in 1901, which changed its name to the Gillette Safety Razor Co. the following year.

Gillette's early ads were very instructional, demonstrating the innovation through a series of exploded drawings. Ads proclaiming "No stropping, No honing" had appeal because that meant saving time. Sales mushroomed and most of the profits went into further advertising.

The safety razor appeared in 1905 and was sold as a luxury item at a premium price. This memorable depiction of just how safe it was demands attention because of the surprising picture that drives home the unique selling proposition.

Gillette humanized his product by putting his face on every packet and his signature on every blade. His likeness appeared over 100 billion times, his ads projecting the honest, direct personality of someone who addressed prospective buyers personally.

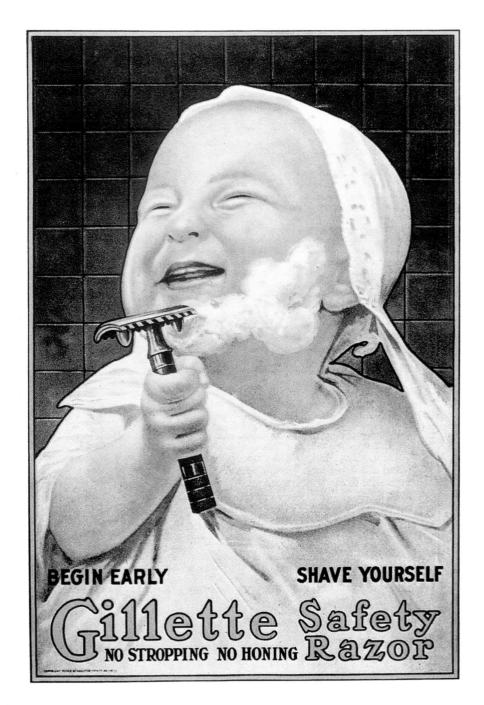

BEGIN EARLY SHAVE YOURSELF

Gillette Safety Razor
NO STROPPING NO HONING

DATE: 1905.
COPYWRITER: King C. Gillette

DEBEERS

DATE: 1988.
AGENCY: N.W. Ayer, New York.
CREATIVE SUPERVISOR: Don Zimmerman.
COPYWRITER: Jeff Odiorne.
PHOTOGRAPHER: Albert Watson.

N.W. AYER IN NEW YORK HANDLED THE DEBEERS' DIAMOND ACCOUNT FOR MANY YEARS, BUILDING A TRUST BETWEEN AGENCY AND CLIENT. "DEBEERS IS INTERESTED IN OUR COMING BACK WITH WHAT THEY SAW ON THE LAYOUTS, BUT THEY ARE ALSO OPEN TO ANYTHING WE THINK MAY BE BETTER THAT DEVELOPS DURING THE SHOOT," SAYS COPYWRITER JEFF ODIORNE.

The advertising budget reflects the stature of the product, allowing the agency to hire the best people for the job.

A series that ran mainly in business and sports publications aimed to justify the high value of diamonds, saying "Sure, they are expensive, but it's worth it for the woman you love". Says Odiorne: "We could have shown pictures of volcanoes erupting to illustrate the melting point of diamonds, but we chose to use a beautiful woman. And that's why we picked Albert Watson, because he can take a very striking picture of a woman."

"Albert has a lot to do with the success of this campaign," says creative supervisor Don Zimmerman. "Some of the best work comes from a very rough

If you were truly an angel you might choose a more modest halo.

Diamonds that shatter all the rules.

For a catalogue of today's leading diamond jewelry designs and designers, call: 800-833-1899.

A diamond is forever.

DATE: 1992.
AGENCY: J. Walter Thompson, Tokyo.
ART DIRECTOR: Daishi Sumi.
COPYWRITER: Emiko Ura.
PHOTOGRAPHER: Tetsuro Takai.

揺らめく輝き。マーキーズ・シェイプ・ダイヤモンド

自然が完成させた、数々の美しいシェイプがある。
そのひとつをかたどったのが、
このマーキーズ・シェイプ・ダイヤモンド。
炎にも似た細かい無数の輝きを、
両の端から放ちながら、煌めいている。
その神秘な美しさを心ゆくまで堪能するために、
カラットは、1カラット以上。
限られた女性だけに許された、この上ない悦び。
カラット ダイヤモンド

Carat Diamond

ダイヤモンドは永遠の輝き

De Beers

掲載商品についてのお問い合わせは、📞0120-41-0002まで。

idea. And some of the great photographers are inhibited by layouts. By improvising you can come up with some wonderful ads."

While appreciating this acknowledgement, Watson is also conscious of his role. Although he spends most of his time shooting for leading fashion magazines in America and Europe, he has photographed over 70 ads for DeBeers. "I feel happier with the results when I'm in control, but no matter what kind of advertising you do, you're still a tradesman, and the photograph has to have a function," he says. "If it doesn't sell a product, then it's a joke.

"Having done 5,000 ads, I'm now more interested in the art end of photography, though I'm very happy if that crosses over and you can sell a product by using it. Some of the things I've shot for the US Virgin Islands come under that heading – and some of those for DeBeers diamonds."

The strategy for one campaign created by J. Walter Thompson in Tokyo picked up on the fact that a diamond is a natural creation. The ads focused on a series of patterns present in nature, such as a shell or a dandelion, and linked them with the shapes of cut diamonds.

"The world of still-life is totally static, and it remains silent until we cause some action, some sense of purpose," says photographer Tetsuro Takai. "We often discover new things in objects if we keep on watching them."

LUX

1. DATE: 1931.
AGENCY: J. Walter Thompson.

2. DATE: 1950s.
AGENCY: J. Walter Thompson.

3. DATE: 1990.
AGENCY: J. Walter Thompson, London.
ART DIRECTOR: Dick Poole.
COPYWRITER: Tim John.
PHOTOGRAPHER: Terence Donovan.

1

2

AT THE AGE OF 33, HAVING GENER-ATED CONSIDERABLE WEALTH AS A PARTNER IN HIS FATHER'S WHOLESALE GROCERY FIRM IN BOLTON, LANCASHIRE, WILLIAM HESKETH LEVER DECIDED TO ENTER THE SOAP TRADE. HE REGISTERED HIS FIRST TRADEMARK – SUNLIGHT – IN 1884 AND DEVELOPED A PRODUCT OF COCONUT OIL, COTTONSEED OIL, RESIN AND TALLOW THAT WENT ON SALE THE FOLLOWING YEAR.

By the mid-1890s he was selling nearly 40,000 tons of soap from his factory, Port Sunlight, in Cheshire. Metal plates at railway stations advertised Sunlight Soap, followed by booklets, diaries and pamphlets that gave health advice. A 1906 ad for Sunlight presented an Equation: Labour Light, Clothes White = Sunlight. The soap's name was soon after changed to Lux, the Latin word for light.

Artist John Hassall created posters for Lux Soap, as well as for Coleman's Mustard and Nestlé Milk, and set up a school of poster artists.

In the early decades of the twentieth century Stanley Resor, head of the advertising agency J. Walter Thompson, strongly favoured celebrity testamonials. He used Hollywood movie stars to promote Lux Toilet Soap. The headline in a 1927 ad read: "9 out of 10 Screen Stars care for their Skin with Lux Toilet Soap". The star endorsement formula continued throughout Hollywood's heyday, and still reappears – although the famous faces now more frequently come from television.

"When we wanted to plug into the nostalgia theme but with a twist," emphasizes art director Dick Poole, the agency brief to the photographer Terence Donovan comprised a videotape of the 1942 movie, *Casablanca*, and some rough ideas involving the use of a bathroom. As there was no bathroom scene in the film, Donovan had to imagine what a bathroom would have looked like.

"Donovan's forté is his marvellous sense of style, his lighting, and his feel for black and white," says Poole. "On one sheet of film he was able to bring together a period room setting and a still-life of the product. Morocco was recreated in a London studio."

"I'm driven by the intrigue of new unsolved projects," says Donovan. "Technically, advertising photography is a phenomenal challenge, but first you must be committed to somebody else's idea. There's no such thing as a simple advertising job; there's always a sting. Photography is about preparation and timing. You assemble the ingredients, then try to turn logistics into magic. It's a tricky sense of timing and an act of theatre. You stand up there and perform, along with the model."

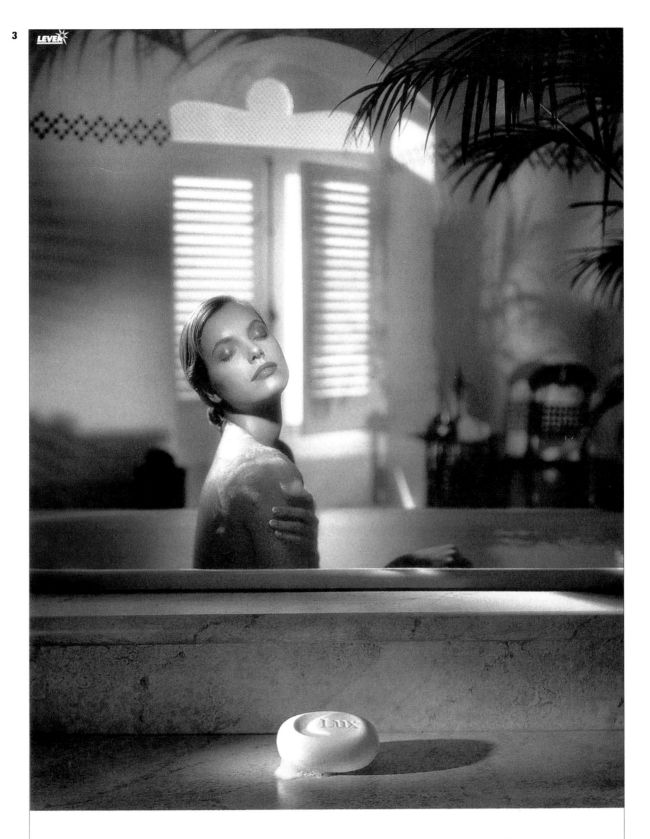

Of all the bars in all the world

LUX. STAR TREATMENT FOR YOUR SKIN.

NUROFEN

DATE: 1989.
AGENCY: Gold Greenlees Trott, London.
ART DIRECTOR: Kate Stanners.
COPYWRITER: Tim Hearn.
PHOTOGRAPHER: Barney Edwards.
HAND TINTING: Dan Tierney

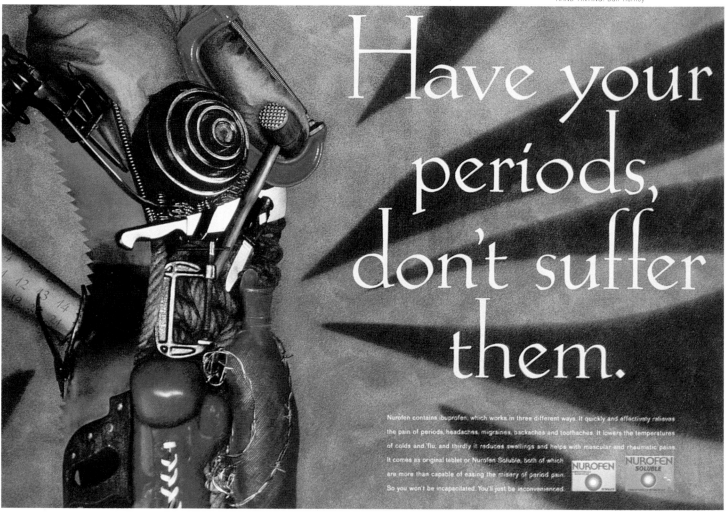

NOT MANY PRODUCTS DOWNPLAY THEIR STRENGTHS. THE PROBLEM WAS THAT NUROFEN – LAUNCHED IN 1983 – WAS PERCEIVED AS BEING SUCH A STRONG PAINKILLER THAT IT WAS ONLY FOR SERIOUS AILMENTS. THE ADVERTISING HAD TO BROADEN THE MARKET BY SHOWING THAT THE DRUG WAS ALSO AN EFFECTIVE GENERAL ANALGESIC FOR HEADACHES, BACK PAIN, PERIOD PAIN, COLDS AND FLU.

Major established brands, such as Anadin, Disprin and Panadol, had built a loyal user base, but Nurofen could be presented as state-of-the-art and superior. While other ads for painkillers stuck to predictable interpretations of the three-stage formula – pain, medication, relief – Nurofen conveyed the same message in a visually innovative and arresting way.

A TV commercial showed individual moving figures soothing and caressing a head, of which they formed a part. Press ads, photographed by Barney Edwards who had directed the commercial, depicted different types of pain within a human figure. "Arcimboldo did it with fruit and vegetables," says Edwards, "but we used uncomfortable objects with sharp, jagged edges to create the feeling of pain. I've always been interested in impressionist and expressionist images that make you feel something. Here, hopefully, the viewer feels pain!" Stabbing pain, sawing pain, thumping, pinching, punching pain – the solution to which is provided by the hero.

Arriving at such ideas usually calls for lateral thinking. "The brain is the best computer in the world; you just feed it information, then step back from it and let your subconscious take over," says Graham Fink, deputy creative director at GGT.

LYNX BODY SPRAY

DATE: 1996.
AGENCY: Bartle Bogle Hegarty, London.
CREATIVE DIRECTOR: John Hegarty.
ART DIRECTOR: Tiger Savage.
COPYWRITER: Paul Silburn.
DIRECTOR: Steven Chase.
MODELS: Daran Norris and Sam Pegg.

WHEN THE AD AGENCY BARTLE BOGLE HEGARTY WON THE ACCOUNT FOR ·LYNX DEODORANT BODY SPRAY, THEY INTENDED TO BREAK THE MOULD OF MEN'S FRAGRANCE ADVERTISING WITH THEIR FIRST TELEVISION AND CINEMA COMMERCIAL.

Existing advertising in this sector took itself very seriously and mirrored all the other brands that blended into bland clones of eachother. Yet most of the ad-literate 16–18 year old male target market rejected these aspirational wear-this-and-be-cool claims, and responded more positively towards a humorous approach.

By lampooning the cliché that the product will transform your life, the "Houseparty" commercial endowed Lynx with credibility: lacking confidence and charisma, one guest at the party awkwardly tries to fit in with the trendy crowd. His bumbling, mumbling attempts to engage an attractive girl in conversation result in his embarrassed retreat to the bathroom where he finds – and uses – a bottle of Lynx body spray. Returning to the party with renewed confidence, he discovers the "Lynx effect" as all attention turns towards him. He sweeps the beautiful girl off her feet and they tango out of the party together. Later that evening the effect wears off and the "hero" clumsily knocks the girl off a ledge as the voice-over warns "The Lynx effect – remember it doesn't last forever."

A sense of fun enabled the Lynx commercial to stand out from the competition. The approach was so successful that further commercials were developed with additional twists – always involving a joke shared with the consumer, ensuring that the product continues to be both acceptable and memorable.

TOCHTERMANN

LUDWIG HOHLWEIN WAS ONE OF THE MOST INFLUENTIAL GERMAN POSTER ARTISTS OF THE TWENTIETH CENTURY. HE TRAINED AS AN ARCHITECT, BUT FROM 1906 CONCENTRATED ON DESIGNING POSTERS. HIS WORK WAS SO POPULAR, AND SO PROLIFIC, THAT *THE STUDIO* MAGAZINE ANNOUNCED IN 1912 THAT HOHLWEIN WAS CONCEIVABLE WITHOUT MUNICH, BUT NOT MUNICH WITHOUT HOHLWEIN.

His forté was to create elegantly composed individuals or small groups of people or animals standing out from the background. His work is characterized by simplicity, with clear geometric lettering. The strength and directness of his designs proved ideal for propaganda posters during World War I and for later appeals for relief help when Germany was in the grip of depression in the early 1930s. His wartime posters depicting veterans, the wounded and prisoners of war showed great conviction and compassion.

Hohlwein was inspired by the work of James Pryde and William Nicholson, better known as the Beggarstaff Brothers – actually brothers-in-law. They led the move towards simple designs and large flat areas of colour. Their work at the end of the nineteenth century involved paper cutouts pasted on to boards. In turn, Hohlwein influenced the styles of other great poster artists, notably E. McKnight Kauffer.

DATE: 1910.
ARTIST: Ludwig Hohlwein.

KAMINOMOTO

DATE: 1991.
AGENCY: The Ball Partnership, Singapore.
CREATIVE DIRECTOR: Robert Speechley.
ART DIRECTOR AND COPYWRITER: Neil French.
PHOTOGRAPHER: Willie Tang.

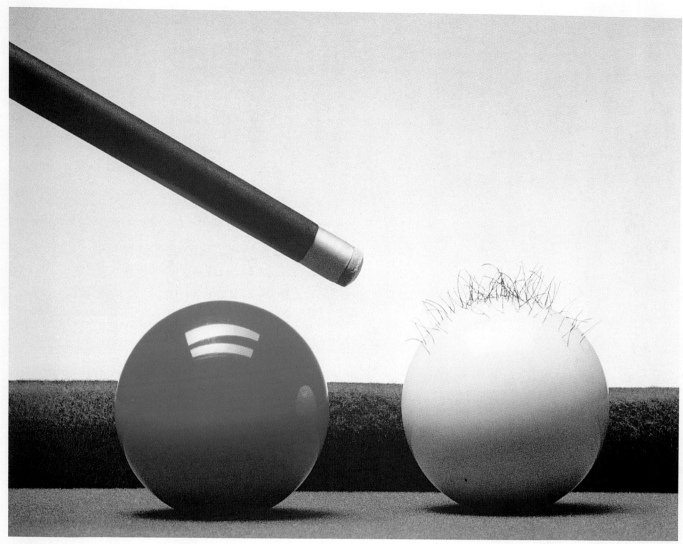

(Be careful with the Kaminomoto)

KAMINOMOTO IS A JAPANESE HAIR TONIC DISTRIBUTED IN SINGAPORE BY WELLA, WHICH, HOWEVER, CANNOT BE CALLED A "HAIR TONIC" BECAUSE OF RESTRICTIONS.

The ads could not show the pack because that stated the purpose of the product. And implying hair restoration with pictures of bald and hairy men was also off limits. The solution was to show bald and hairy eggs, chihuahuas and billiard balls.

"Oddly enough, this made life very easy," says Neil French. "I was determined to use the 'before and after' visual cliché, which would immediately establish the product as a hair restorer. The obvi-ous next step was to use another cliché – 'as bald as a billiard ball' – and add a line which implied that spilling a dash of the product would grow hair on practi-cally anything."

For greatest impact, photographer Willie Tang retained only the bare essen-tials in the picture. "He understands the value of an idea, and realizes how easily it can be buried under heaps of technique," says French. Unfortunately, the monitor-ing authorities thought the implication was so strong that it was tantamount to a false product claim. They pulled the campaign.

Says French: "Our job is not to spend our client's money quietly; our job is to make our clients famous; to sell their prod-ucts; to help make them rich. That way we avoid poverty ourselves."

PUBLIC SAFETY & CHARITY

METROPOLITAN POLICE

NATIONAL CANINE DEFENCE LEAGUE

ADVERTISING HAS BEEN at the forefront of encouraging safe sex, helping people kick the smoking or drug habit, and been a catalyst in the green revolution and the confrontation of Third World debt. Every year, thousands of public service announcements or pro bono ads generate vast sums of money for charitable causes, made for free by the same people who earn megabucks from mainstream advertising.

While some advertising is designed to pamper egos and encourage trivial pursuits and extravagancies, the same sophisticated machinery is employed to highlight starker subjects. These ads have contributed to the success of many worthy causes and have improved many lives.

Times of national crisis, such as war, awaken altruistic sentiments that can be channelled into supportive activities. During World War One the advertising industry developed its role as disseminator of information and appeals for funds, for example the American Red Cross (p.152). During World War Two the War Advertising Council was founded in the USA to support the war effort by selling war bonds and encouraging people to enlist. After the war the name changed to the Advertising Council, which continued as a private non-profit organization supported by American business, including the advertising and communication industries. The tradition of making free space available for good causes continued. All the artwork was contributed free, posters were printed free and ads appeared free in newspapers and magazines. With the arrival of television, the same principles applied, with directors, actors and ad agencies donating their skills and the broadcasters providing the air-time.

"Charity ads usually cost us money, but we like doing them because you can do bright things on them," says Paul Arden, creative director with Saatchi and Saatchi. "Young art directors love them; they can cut their teeth on charity ads and start to make a name for themselves."

Matt Ryan, head of art at Saatchi's adds, "People enjoy working on charity ads because you don't get dragged down into loads of committees and research – and usually you don't have to pull any punches. Charity ads are very strong, very simple and allow you to be very dramatic". Saatchi's "Pregnant Man" (p.155) is a case in point.

Ads that are not "selling anything" can be hard-hitting, uncomfortable or disturbing because the sponsors or lobbyists are usually keen to make their point as forcefully as possible, and do not share the concerns about corporate image that constrain many advertisers. The use of shock tactics is warranted – even unavoidable –when addressing issues such as drug abuse,

debilitating or fatal illness, or cruelty. David Bailey's anti-fur print ad showing a model trailing a bloody fur coat is justifiably shocking (p.158). The link is more direct and evident than in the even more contentious Benetton ads (p.151) widely regarded as a thinly veiled ploy to generate media publicity for commercial rather than altruistic motives.

But how intrusive can an ad be before it begins to be counter-productive and repel even the target market? For example, does the anti-fur lobby's photograph of a skinned fox go too far and trigger a negative response similar to that evoked by the destructive activities of animal rights activists (p. 159)? The approach that aims to shock may well be necessary to penetrate public apathy. When it works, opinions are certainly shaped. A 1975 ad inviting consumers to "Stand out in a crowd in Frank Cooney Fur" would now be more likely to attract vilification than aspiration.

A shocking ad may, in effect, slap people in the face to make them take notice. But then it must deliver the message in a digestible form that clarifies the need for the tactic employed. If it doesn't deliver this – known as "the kiss" – then the portcullis will fall again.

As public sympathy and empathy increase for a particular cause, the role of the advertising is to reinforce an accepted message to the converted, while providing them

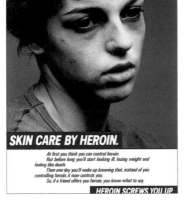

SKIN CARE BY HEROIN.

*At first you think you can control heroin.
But before long you'll start looking ill, losing weight and
feeling like death.
Then one day you'll wake up knowing that, instead of you
controlling heroin, it now controls you.
So, if a friend offers you heroin, you know what to say.*

HEROIN SCREWS YOU UP

ANTI-HEROIN

with the impetus and ammunition to pressurize the unconverted. Anti-drugs campaigns around the world have presented factual information about the dangers and how to avoid them, while also delivering the shocking realities (pp. 157, 163). Drink-driving ads (p.161) have used a similar approach.

When AIDS became a major global concern in the 1980s, safe sex – and condoms – ceased to be taboo topics. While some campaigns focused directly on the terminal effects of careless behaviour, others used humour – an alternative way to challenge entrenched attitudes. Humour reduces tension, delaying the moment of rejection.

Over the last half century, the way in which the media have covered major conflicts and disasters has become more and more graphic. As a consequence, society has been anaesthetised to images of pain and devastation – and ads have had to work harder to breach its barriers. This has required the exercise of power in a responsible way. There is no doubting the power that advertising wields. In this sector, advertising has helped reshape national attitudes and twisted governments' arms.

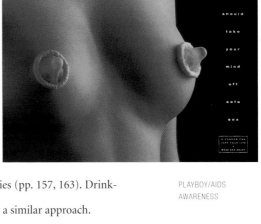

nothing should take your mind off safe sex

A CONDOM CAN SAVE YOUR LIFE & WEAR AND ENJOY

PLAYBOY/AIDS
AWARENESS

AIDS AWARENESS

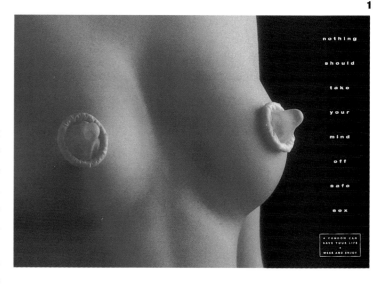

nothing
should
take
your
mind
off
safe
sex

A CONDOM CAN
SAVE YOUR LIFE
•
WEAR AND ENJOY

IN THE MID-1980S AIDS (ACQUIRED IMMUNE DEFICIENCY SYNDROME) BECAME THE WORLD'S MOST SERIOUS HEALTH CONCERN. WITH NO CURE OR VACCINE AVAILABLE, GOVERNMENTS AROUND THE WORLD MOUNTED EDUCATION PROGRAMMES TO RESTRICT THE SPREAD OF THE HUMAN IMMUNODEFICIENCY VIRUS (HIV).

Awareness of the dangers and prevention options rose substantially. A sustained level of concern was maintained both by government information services and other involved groups. While many of the official warnings were apocalyptic in tone, other related organizations often treated the subject with a lighter touch.

As the use of condoms became more important for safe sex, their advertising proliferated, often invoking the enjoyment of the activity rather than agonizing over the alternatives. The advertising for Mates condoms reflected the fresh, dynamic approach of the head of the Virgin Group, Richard Branson, under whose banner the brand was launched.

Playboy magazine in South Africa ran a competition to mark World Aids Day.

This ad was entered by an ad agency featuring a very dedicated account handler who was prepared to keep abreast of the issues. *Playboy*'s aim was to help overcome any reticence about discussing Aids, HIV and condoms, by putting fun back into sex and using humour to help diffuse any tension associated with a formerly taboo topic.

1. DATE: 1990s.
AGENCY: The White House, Cape Town.
CREATIVE DIRECTOR: Ricardo de Carvalho.
ART DIRECTOR: Neil Dawson.
COPYWRITER: Clive Pickering.
PHOTOGRAPHER: Franco Esposito.

2. DATE: 1996.
AGENCY: Knight Leach Delaney, London.
ART DIRECTOR: Andy Wray.
COPYWRITER: Paul Delaney.

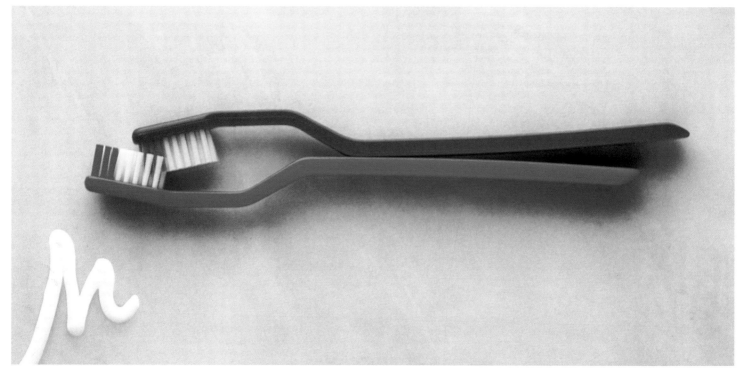

BENETTON

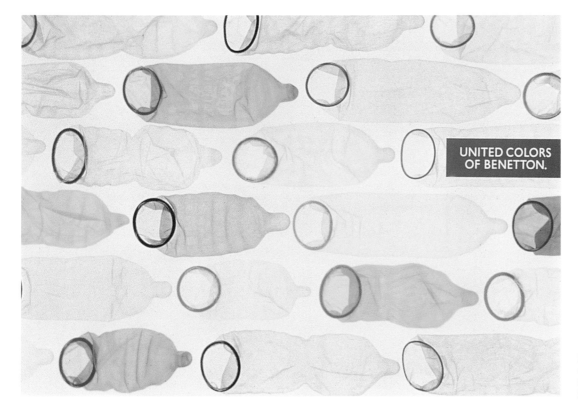

UNITED COLORS
OF BENETTON.

DATE: 1991.
AGENCY: In-house, Italy.
CREATIVE DIRECTOR: Oliviero Toscani.
PHOTOGRAPHER: Oliviero Toscani.

FROM 1983 BENETTON DECIDED TO EXERT A MORE DIRECT HOLD OVER ITS OWN ADVERTISING BY BRINGING IT IN-HOUSE INSTEAD OF USING AN OUTSIDE AGENCY. OLIVIERO TOSCANI, SON OF A PHOTOJOURNALIST FROM MILAN, SHOT MOST OF THE EARLY ADVERTISING PHOTOGRAPHS AND TOOK OVER CREATIVE CONTROL OF THE CAMPAIGNS, TOGETHER WITH COMPANY PRESIDENT LUCIANO BENETTON.

Carefully chosen and presumptuously placed photographs provided the catalyst that projected Benetton into the world's headlines and into the annals of advertising history.

"In traditional advertising you see only the products, but in our market, there is no longer a great difference between one brand and another," says Luciano Benetton. "So we are trying to use our advertising budgets to do something which is a little more useful."

As soon as Benetton began asserting he was doing something other than promoting his clothes, hackles started to rise. Commercialism and altruism, it seems, are hard to reconcile.

When the coloured condom ad appeared to highlight the subject of Aids, the company was helping to fund Aids education programmes around the world and distribute free condoms throughout Europe and the States. In New York the ad was banned at the same time as Benetton was contributing to a prevention programme sponsored by the city's mayor. It was also censored as porno-graphic by some American women's magazines.

People attacked the medium and ignored the message.

AMERICAN RED CROSS

DATE:1918.
AGENCY: Alley and Richards.
COPYWRITER: Courtland N. Smith.
ARTIST: Alonzo Earl Foringer.

THE MADONNA FIGURE HOLDING A WOUNDED AND STRETCHERED SOLDIER AS A BABY IS BOTH CURIOUS AND COMPELLING. THIS WAS ONE OF THE MOST FAMOUS AMERICAN POSTERS OF WORLD WAR ONE AND WAS ADOPTED BY THE RED CROSS AS AN UNOFFICIAL TRADEMARK.

In 1863, Swiss philanthropist Jean Henri Dunant called a conference of representatives from 16 countries to address the humanitarian problem. The following year, 12 nations met in Geneva and signed an international covenant mandating the civilized treatment of the sick, wounded and dead in battle, as well as prisoners of war. To further this humane mission, the convention founded the International Red Cross.

In 1881, Clara Barton – appalled by the callous neglect of the wounded at the beginning of the American Civil War – formed an agency to gather and deliver medical supplies directly to the battle-field. She was instrumental in founding the American Red Cross, and from 1882 to 1904 she was its president. In 1905 the American Red Cross became the official disaster relief arm of the US government. By October 1918, a total of 14,368 nurses had been assigned to the army, 903 to the navy, and 2,454 were awaiting orders.

Foringer – an illustrator and mural painter – was born in Pennsylvania and studied in Pittsburgh and New York. He designed bank notes for European and Canadian banks, but is remembered for this poster, used in the 1918 fund drive and for the Christmas roll-call. He modelled the nurse on Agnes Tait, also an artist, who possessed "a kind of natural languid grace that seemed to fit exactly my conception of the madonna type".

The poster was so successful that it was also used in Britain and brought into service again in World War Two.

AMNESTY INTERNATIONAL

WHEN JBR OPENED ITS DOORS IN THE LATE 1980S ON A TICKET OF HONEST ADVERTISING, IT MADE A POINT OF DEALING WITH THE REAL WORLD. ITS ARTICULATE – OFTEN INCISIVE – ADS CUT THROUGH THE HYPE AND GLOSS OF THE OMNIPRESENT VISUAL MUZAK THAT PASSES AS ADVERTISING.

"We are aware of the great responsibility we have as a part of the most powerful industry in the world," says creative director Ingebrigt Steen Jensen. "We try to use this power to the good."

A former copywriter with Ogilvy and Mather, Jensen has based the agency's creativity on a five-point approach:

1. Break the rules.

2. Treat the audience as people as intelligent as yourself.

3. Go to extremes to get attention.

4. Be aware of the great responsibility you have.

5. Produce advertising that is not only good for the client but also good for the target audience, society and the world.

Each year JBR handles – gratis – a different charity account, such as anti-drugs or anti-drunkenness. The agency frequently uses people who are well-known in Norway to emphasize, personalize or ridicule attitudes and issues. Prominent personalities were featured in the Amnesty International campaign to bring home the plight of

people around the world persecuted for their political beliefs or artistic integrity.

This ad shows the singer Åge Aleksandersen and challenges the reader to imagine that he has been tortured in prison. The headline reads:

"Rebellious musician disabled after torture in a state prison". Other print ads in the series showed a Socialist Party member – "Well-known Socialist leader sentenced to death by military court"; and the leader of the Progressive Party

– "Controversial politician committed to psychiatric care."

DATE: 1986.
AGENCY: JBR, Oslo.
CREATIVE DIRECTOR: Ingebrigt Steen Jensen.
PHOTOGRAPHER: Roger Fredericks.
MODEL: Åge Aleksandersen.

SPANISH CANCER ASSOCIATION

One out of
every two
cancer patients
is cured.
Just one.

†

ASOCIACION ESPAÑOLA CONTRA EL CANCER
JUNTA PROVINCIAL DE BARCELONA

DATE: 1990.
AGENCY: Delvico Bates, Barcelona.
CREATIVE DIRECTORS: Felix Fernadnez and
Toni Segarra.
ART DIRECTOR: Enric Agulera.
COPYWRITER: Toni Segarra.
PHOTOGRAPHER: Ramon Serrano

THE AECC IS AN ASSOCIATION OF VOLUNTEERS AND PROFESSIONALS DEVOTED TO INVESTIGATING AND ADVISING ON CANCER, AS WELL AS SUPPORTING PATIENTS AND THEIR FAMILIES. THE MAJORITY OF ITS FINANCE IS PROVIDED BY DONATIONS.

Through TV, press and posters, the communication strategy focuses on two annual campaigns targeting a broad spectrum of the population. The goal of the collection campaign is to help ensure that as much money as possible is donated on collection day.

The broader awareness campaign informs people of the facts and issues with the aim of preventing the illness through regular screening, changes in lifestyle and stopping smoking. This ad highlights the fact that 50 percent of cancer patients die prematurely.

Fear, guilt, compassion and outrage are all valid targets for issue advertising, and all are capable of motivating people to action. By showing wide-eyed vulnerable children, this billboard campaign aimed a powerful blow to the head and heart, appealing to people's better nature and sense of justice. As with many forms of advertising, it offers the feelgood factor as a reward for those who respond.

FAMILY PLANNING ASSOCIATION

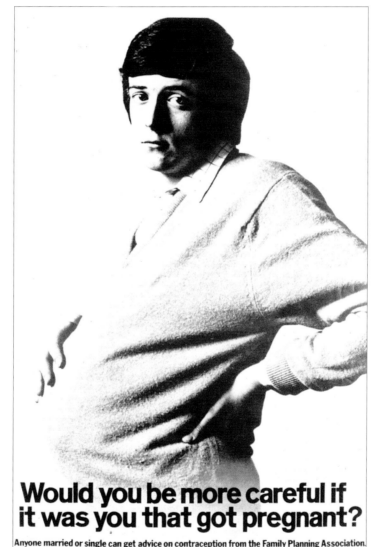

DATE: 1969.
AGENCY: Cramer Saatchi, London;
ART DIRECTOR: Bill Atherton;
COPYWRITER: Jeremy Sinclair;
PHOTOGRAPHER: Alan Brooking.

THE PREGNANT MAN USES THE CLASSIC TECHNIQUE OF TURNING THE RATIONAL WORLD ON ITS HEAD TO DEMAND ATTENTION – IN THIS CASE, THE ATTENTION OF COMPLACENT MALES, ENCOURAGING THEM, LONG BEFORE THE AIDS SCARE, TO PLAY A MORE RESPONSIBLE ROLE IN CONTRACEPTION.

Britain's 1967 National Health Service (Family Planning) Act allowed advertisers to address single people as well as married couples, enabling them to spotlight an increasing problem: in the atmosphere of sexual liberation of the late sixties, premarital sex was becoming more common, but because many young men resisted taking responsibility for birth control, teenage pregnancies were rising.

The lateral approach adopted, laced with wit, has greater effect than a direct command or criticism, which would have been more likely to alienate the target audience than alleviate the problem.

Although the headline is long, the image is sufficiently intriguing to draw the viewer in to understand the message. The words and picture together add up to more than the sum of the parts.

Time magazine featured the ad editorially and made it world famous.

Two decades later the same ad agency used the same photograph to illustrate the impact that *Time* creates, with the headline: "It only took one insertion to make this man world famous" – and a successful clone was born.

HEALTH EDUCATION BOARD FOR SCOTLAND

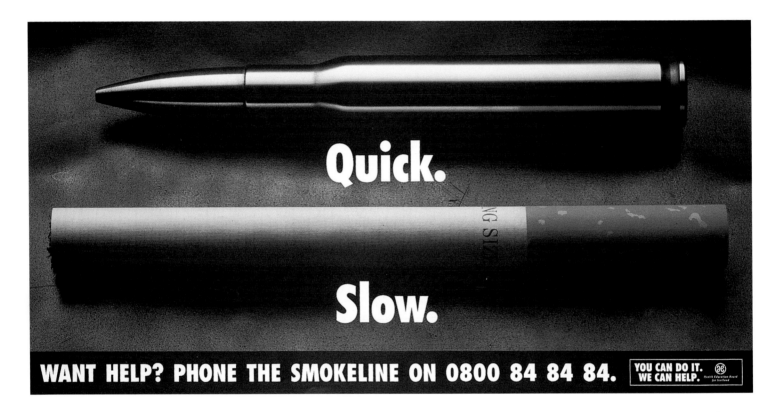

Quick.

Slow.

WANT HELP? PHONE THE SMOKELINE ON 0800 84 84 84. YOU CAN DO IT. WE CAN HELP. Health Education Board for Scotland

SCOTLAND HAS A POOR HEALTH RECORD COMPARED WITH OTHER COUNTRIES IN THE WESTERN WORLD. SMOKING, THE LARGEST SINGLE CAUSE OF ILLNESS AND DEATH, IS JUST ONE OF A WIDE RANGE OF ISSUES TACKLED BY THE SCOTTISH HEALTH EDUCATION BOARD.

The aim of the advertising campaign was to remind adult smokers of the conse-quences of smoking and to motivate them to give up. A "stick and carrot" approach was taken, presenting a blunt and hard-hitting proposition that was followed by the offer of help via a "Smokeline".

The phone-calls made to the stop-smoking counselling helpline were three times the expected level, based on similar campaigns in England and Wales. Six percent of all smokers in Scotland contacted the Smokeline within the first year. A sample survey indicated that a quarter were still not smoking a year later.

DATE: 1993.
AGENCY: The Leith Agency, Edinburgh.
CREATIVE DIRECTOR: Jim Downie.
ART DIRECTOR: Guy Gumm.
COPYWRITER: Gerry Farrell.
PHOTOGRAPHER: Mike Parsons.

DEPARTMENT OF HEALTH AND SOCIAL SECURITY

MANY AD AGENCIES HAVE GRAPPLED WITH DIFFERENT WAYS OF DISCOURAGING DRUG ABUSE. THROUGH BOTH PRESS AND TELEVISION, THIS MID-EIGHTIES CAMPAIGN TARGETED IMPRESSIONABLE YOUNG PEOPLE, ILLUSTRATING THE CONSEQUENCES OF HEROIN ADDICTION ON BODIES AND LIVES. WITH THE ENDLINE "HEROIN SCREWS YOU UP", THE NOW DEFUNCT YELLOWHAMMER AGENCY SET OUT TO USE LANGUAGE THAT THE 15 TO 23 AGE GROUP WOULD UNDERSTAND. RESEARCH HAD CONCLUDED THAT AN AUTHORITATIVE MESSAGE WOULD BE PATRONIZING AND TURN OFF THE INTENDED AUDIENCE.

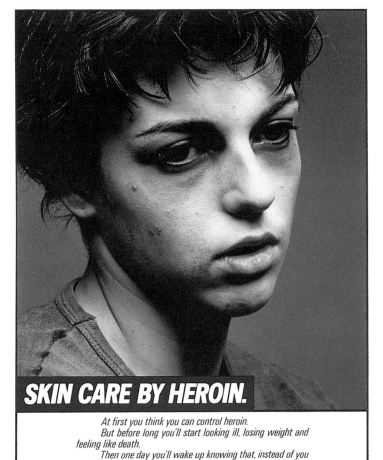

SKIN CARE BY HEROIN.

At first you think you can control heroin.
But before long you'll start looking ill, losing weight and feeling like death.
Then one day you'll wake up knowing that, instead of you controlling heroin, it now controls you.
So, if a friend offers you heroin, you know what to say.

HEROIN SCREWS YOU UP.

DATE: 1986.
AGENCY: Yellowhammer, London.
CREATIVE DIRECTOR: Jeremy Pemberton.
ART DIRECTOR: Andy Cox.
COPYWRITER: Steve Barker.
PHOTOGRAPHER: Clive Arrowsmith.
MAKE-UP: Stephanie Walker.

"The people we used in the ads had to be close enough to the audience's experience to be believable, yet frightening enough to be a deterrent," says former Yellowhammer creative director Jeremy Pemberton. "A lot of teenagers know people who are taking heroin. They know that you don't look too bad in the early stages. We wanted to give kids ammunition to enable them to say 'No.'"

The reality of heroin addiction needed no exaggeration to put the message across but, for the campaign, models with a naturally vulnerable appearance were chosen from several theatrical schools. Photographer Clive Arrowsmith used lighting to create a sense of drama; the black background made his subjects look very isolated and also reproduced well on posters.

"We wanted strong, graphic images that got through to people and stayed with them," says Arrowsmith. "I wanted to create the feeling of Dante's Inferno. The kids had to look ominous, anxious, tragic, like something out of Village of the Damned. We sprayed on glycerine and water for the sweat, and I lit them from above to exaggerate the cheekbones and produce a skull-like look. Although this carried implications of death, the top-lit glow also offered a ray of hope."

"Skin care by Heroin" – a pastiche of cosmetic ads – was run in magazines alongside authentic cosmetic ads.

LYNX

DAVID BAILEY FIRST MADE HIS NAME SHOOTING FASHION FOR *VOGUE*, STARTING IN 1958. "IT ENABLED ME TO PURSUE MY THREE MAIN PASSIONS: PHOTOGRAPHY, WOMEN AND MONEY," HE SAYS. "BUT BEING WELL-KNOWN WORKS AGAINST YOU SOMETIMES.

People think you won't do certain jobs because you're too grand or too busy, but I'm fanatical about taking pictures and am not averse to doing charity ads." Over the years he has actively supported several good causes and was an appropriate choice to direct the commercial and shoot the print ad for the anti-fur campaign.

"We used Bailey for three reasons,"

explains Jeremy Pemberton, former creative director of the now defunct ad agency. "He was likely to make the most of any shot, so we knew we would be assured of a strong image. His name would help make the most of the small budget by attracting additional media exposure. And he was enthusiastic about the campaign – in fact, he refused a fee."

The ad was initiated by Greenpeace, which then withdrew in the face of pressure from the fur trapping communities in Canada. The British team running the campaign decided to continue, and formed the organization Lynx.

In the commercial, a model on the catwalk swirls a fur coat around, splattering blood on the affluent audience. It was designed to run the fine line between being shocking and revolting.

"It was meant to be powerful, without being too horrifying," says Pemberton. "We decided not to have a realistic depiction of an animal suffering, as we might alienate too many people. We wanted to include blood in the picture because this is a bloody subject. We followed the line of thought: 'What is on the inside of an animal's fur?' We imagined the inside of the coat covered with blood. Normally you can't see the inside of a coat, so we had it being pulled along, leaving a trail of blood."

Adds Alan Page, one of the creative team: "The aim was to embarrass people who wore fur. The ad is different from a lot of charity advertising in that it is not asking for money, it is asking people to address an issue."

DATE: 1986.
CLIENT: Lynx.
AGENCY: Yellowhammer, London.
CREATIVE DIRECTOR: Jeremy Pemberton.
COPYWRITER: Bryn Jones.
PHOTOGRAPHER David Bailey.

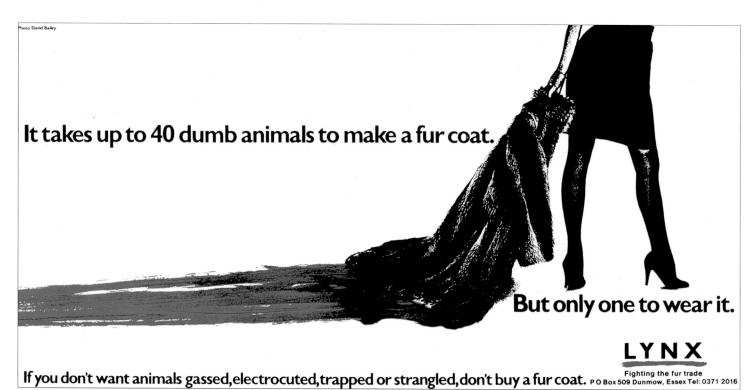

RESPECT FOR ANIMALS

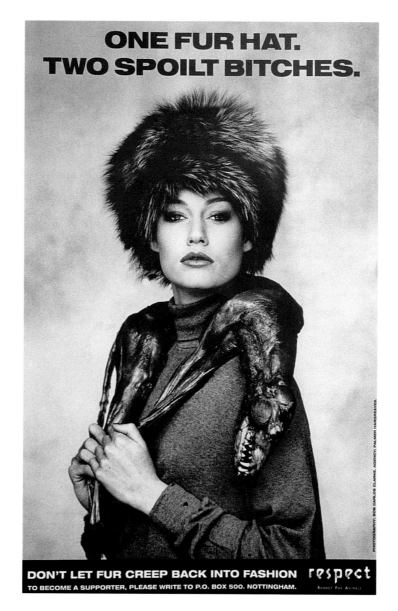

THE FUR TRADE PREDICTABLY REGARDED LYNX AS THEIR PRIME ADVERSARY AND WELCOMED ANY OPPORTUNITY TO SUE THEM. AS LYNX DISSOLVED, RESPECT FOR ANIMALS EMERGED FROM THE ASHES IN 1993.

"We rely on people's goodwill," says Mark Glover, campaign director for Respect for Animals. "Creatives have always been happy to do the work for nothing because they believe in the cause and it provides an opportunity to produce powerful award-winning work."

Their brief has remained the same – getting the majority of people to point the accusing finger at the minority, and invalidate their reason for wearing fur. Unlike most advertising, this is urging people not to buy something. Outdoor advertising is used in order to confront and shame fur coat wearers in the very place where they want to be seen.

"We want them to feel so embarassed that they wish the ground would open up and swallow them," says Glover.

To bring home the reality of wearing fur, Bob Carlos Clarke photographed a model with a skinned fox draped over her shoulders. The smell was so obnoxious she had to disguise it with liberal applications of menthol ointment. The intension was that the visual should be equally repugnant. Given the significant shift in social attitudes since the mid-1980s, and the concurrent reduction of retail outlets selling fur, the shaming campaign has been extremely effective.

DATE: 1990s.
PHOTOGRAPER: Bob Carlos Clarke.

METROPOLITAN POLICE

DATE: 1988.
AGENCY: Collett Dickenson Pearce, London.
ART DIRECTOR: Neil Godfrey.
COPYWRITER: Indra Sinha.
PHOTOGRAPHER: Don McCullin.

COULD YOU TURN THE OTHER CHEEK?

(advertisement body text)

As a police officer, sooner or later you're bound to encounter abuse, threats, provocation, even physical violence. Be careful how you respond. Lose your temper and you could lose your job. **Photograph by Don McCullin**

"You can't go on the attack, whatever the provocation."

"It gets worse. Bottles arc down and burst in showers of flame."

ANTICIPATING A DEMOGRAPHIC TROUGH WHEN RECRUITMENT WOULD BECOME MORE DIFFICULT, THE METROPOLITAN POLICE NEEDED TO INCREASE ITS ATTRACTIVENESS AS A CAREER OPTION.

"The spreads in the press have encouraged people to identify more strongly with the career by posing the challenges and dilemmas a policeman encounters," says Mark Lund, account group head at CDP.

Graham Fink, who art directed the first five in the campaign, chose war photographer Don McCullin to give the ads a gritty editorial feel that portrays the reality of the policeman's lot. "Most photographers concentrate only on the pictures and dont care what the ad is about," says Fink. "But McCullin is a photojournalist who wants to know what the angle is. He keeps asking what

the headline says, and makes the picture work for your ad."

McCullin accepts advertising assignments where he can empathize with the cause, yet he is reluctant to exploit his existing editorial photographs for advertising, feeling they would be tainted.

"The ad shown here was the most confrontational of them all," says Neil Godfrey, who art directed the subsequent executions in the campaign. "It's the ultimate insult, worse than throwing a brick. We used a real policeman, but the spit was a mixture of white chocolate and lemonade. This is a three-part composition because the repeated retakes proved too unpleasant.

"The function of advertising is not to create beautiful photographs but to communicate with a sector of the public – to increase awareness of a product, service or issue. The most important aspect of advertising is to understand the audience you are talking to, and to talk to them as though you are standing beside them."

MOTHERS AGAINST DRINK DRIVING

DATE: 1990.
AGENCY: Clarity Coverdale Fury, Minneapolis.
ART DIRECTOR: Jac Coverdale.
COPYWRITER: Joe Alexander.
PHOTOGRAPHER: Steve Umland.

GUESS WHAT THOUSANDS OF DRUNK DRIVERS AND BUGS HAVE IN COMMON EACH YEAR?

NO BRAINS.

MADD WAS BORN IN THE 1960s AND GREW TO BE ONE OF THE MORE VISIBLE AND POWERFUL GROUPS CAMPAIGNING AGAINST DRINK-DRIVING IN THE USA.

The organization's goal is to raise awareness of the dangers, and to make drink-driving socially unacceptable.

The agency's strategy was to create ads that have an impact on young adults – mostly males. A much higher proportion of men between 20 and 24 have drink-related accidents than any other age group. "We were delivering the same old message, but dressed up in a fresh and unexpected way in the hope of capturing people's attention," says art director and partner Jac Coverdale.

This particular execution is not only graphically explicit, but is also likely to raise a smile of acknowledgement and therefore achieve greater acceptance. To fire the (already dead) bugs on to a piece of glass, the creative team used an airgun hooked up to a compressor. They tried it at different speeds until they achieved just the right effect – at about 40 mph.

A combination of improved enforcement, tougher penalties and extended programmes of hard-hitting advertising has helped change people's attitudes towards drink-driving. However, despite a significant reduction in the problem, there is a continuing need for such campaigns – drink-driving still gets people killed and injured.

TOYS AREN'T US

WHEN HE PHOTOGRAPHED HIS OWN DOG TROTSKY, LEON HAD NO IDEA THE IMAGE WOULD BECOME AN ICON FOR THE NATIONAL CANINE DEFENCE LEAGUE.

This charity attempts to protect all dogs from abuse, cruelty and abandonment and believes that no healthy dog should ever be destroyed. All its advertising is upbeat, celebrating the existence of dogs rather than focusing on the horrors of mistreatment – an approach taken by many other animal welfare organizations.

Many people buy pets as Christmas presents, then find that the novelty wears off. The aim of the "A dog is for life, not just for Christmas" campaign – commissioned by Julia Felthouse of the NCDL – was to make people think, and act responsibly. The pun on the well-known toy store introduces an element of wit that adds to the poignancy of the message. Another endearing ad in the campaign carried the line "Dear Santa. Don't even think about it."

DATE: 1990.
AGENCY: TBWA, London.
ART DIRECTOR: Steve Chetham.
COPYWRITER: Trevor Beattie.
PHOTOGRAPHER: Leon.
MODEL: Trotsky.

PARTNERSHIP FOR
A DRUG-FREE AMERICA

DATE: 1996.
AGENCY: Hill Holliday Connors Cosmopulis, Boston.
CREATIVE DIRECTOR: Fred Bertino.
ART DIRECTOR: Wendy Lewis.
COPYWRITER: Baxter Taylor.
PHOTOGRAPHER: Matt Mahurin.

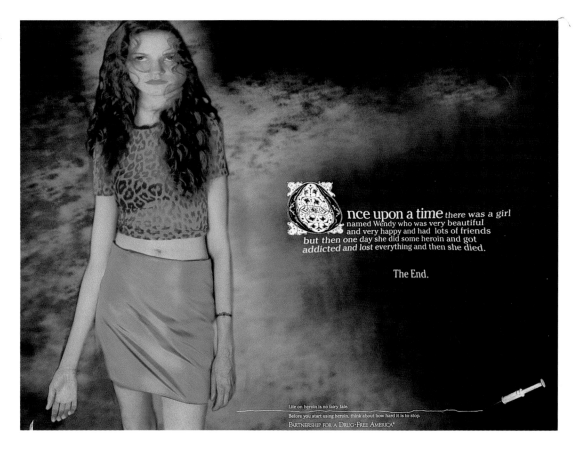

THE PARTNERSHIP FOR A DRUG-FREE AMERICA (PDFA) WAS FORMED IN 1986 WITH MONEY FROM THE AMERICAN ASSOCIATION OF ADVERTISING AGENCIES.

It is a private, non-profit coalition of professionals from the communications industry, best known for its national anti-drug advertising. The work focuses on unselling drugs to children by making drug use less glamorous and less acceptable. With some 600 ads donated to the Partnership, it represents the single largest public service advertising campaign in history. At any given time 30–40 different agencies are working on Partnership messages that have succeeded in generating unprecedented levels of *pro bono* media support. Early results were encouraging, and showed a dramatic reduction in the number of new triers and non-addicted users of illegal drugs in the USA. Since 1985, the number of cocaine users has fallen by 77 percent and the number of users of illegal drugs in general decreased 50 percent.

However, since 1991 media exposure for anti-drugs ads experienced a significant decline due to increasingly competitive market forces. In response, the PDFA – in conjunction with the White House Office of National Drug Control Policy (ONDCP) – embarked on the largest ever social marketing effort ever undertaken in the USA. Beginning in 1998, a national co-ordinated, consistent campaign ran in paid media for the first time thanks to nearly 200 million dollars appropriated by Congress. With media companies being asked to match purchased exposure with donations of broadcast and print exposure, the project commands as much exposure as many leading commercial advertisers.

This ad warning of the dangers of heroin addiction pre-dates the ONDCP initiative. Image manipulation is used to reflect the mind-altering effects of taking heroin. A hard-hitting 1999 TV commercial uses a similar strategy to illustrate the impact of drug abuse. Rachael Leigh Cook, leading lady in the teen romantic comedy movie *She's All That*, uses an egg to represent the brain and a frying pan as heroin. As Cook smashes the pan down on the egg the voice-over states: "This is what happens to your brain after snorting heroin". She then proceeds to wreck different parts of the kitchen as metaphors for family, friends, money, job, self-respect and future. "Any questions?"

THIRD WORLD DEBT

DATE: 1986.
CREATIVE DIRECTOR: David Trott.
DIRECTOR: David Bailey.
PRODUCTION COMPANY: Paul Weiland.

THE MEDIA HAS BROUGHT IMAGES OF MALNUTRITION INTO EVERYONE'S HOME AND PEOPLE HAVE BECOME HARDENED TO PATHETIC SCENES OF HUMAN TRAGEDY. THEY FEEL DETACHED FROM THE PROBLEM. YET RICH COUNTRIES ARE AS OFTEN AS NOT THE CAUSE OF THE PROBLEM AND CAN, EQUALLY, PROVIDE THE SOLUTION.

"In the last 12 months," says a disembodied voice, "Africa has paid out over four times as much in debt repayments as it has received in emergency aid."

The message is repeated as shrouded, shuffling figures move forward. Some mothers are carrying bandaged bundles. A crow picks at a discarded parcel. One mother lets her baby-sized bundle roll out of her arms. The camera takes a wide view to reveal a clutch of mothers dropping other tiny corpses into a giant piggy bank. And the slot through which they fall is shaped like an open grave. The phrase coined by David Bailey appears on the screen "Bury the debt, says the voice, not the dead."

"The commercial was made to increase public awareness of an iniquitous situation that has developed over several decades. Aid money is still important, but giving a donation is like putting a Band-Aid on a haemorrhage," says David Trott, who took up Oxfam's

invitation to publicize the issue. "A more far-reaching solution begins with the Western governments. But they will only start talking about it if they think people care about it."

TIBET

"TIBET IS SO REMOTE THAT MANY PEOPLE DO NOT KNOW THE COUNTRY IS FORCIBLY OCCUPIED BY THE PEOPLES REPUBLIC OF CHINA. ACCORDING TO INFORMATION SUPPLIED BY THE US CONGRESS, MORE THAN 1.2 MILLION TIBETANS HAVE DIED SINCE 1987 AS A DIRECT RESULT OF CHINESE COLONIAL POLICIES," SAYS CREATIVE DIRECTOR FRANK BODIN.

Created as a free ad for the Society for Swiss-Tibetan Friendship (GSTF), the Crosses campaign has grown, snowball-fashion, attracting high-profile international attention. The value of the coverage in newspapers and magazines, on radio and television, is estimated to be more than $20 million.

Initially, the simple, symbolic and highly charged black and white design was used in a variety of ways, ranging from large posters to direct response stickers. Later, the campaign was extended into a "statement campaign" featuring such personalities as Richard Gere, Oliver Stone, Naomi Campbell and the monk Palden Gyatso.

The full advertisement copy reads: "Tibet is occupied. By China. Which is systematically destroying Tibetan culture. With an agressive settlement policy. Torture. Forced abortions. Your interest can help Tibet survive. Society for Swiss-Tibetan Friendship (GSTF)." The copy on the poster (shown here) presents a condensed version of this message.

DATE: 1994.
AGENCY: Aebi, Strebel and McCann-Erickson, Geneva. CREATIVE DIRECTOR: Frank Bodin.

WATERMAN

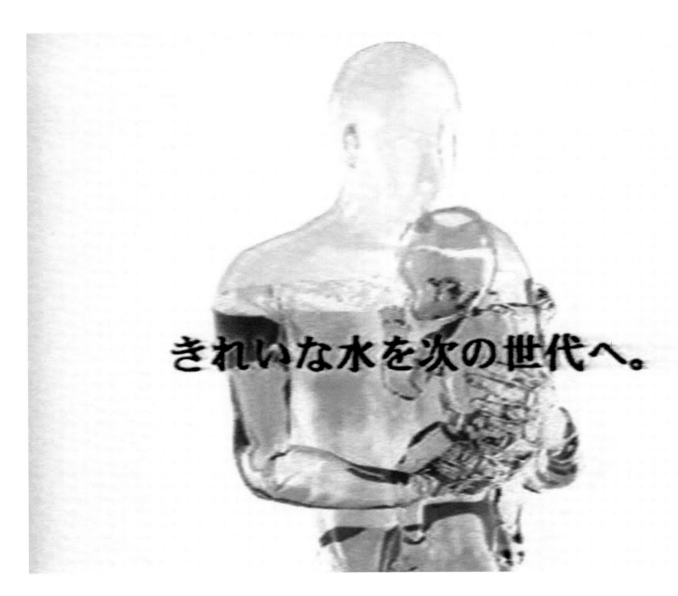

きれいな水を次の世代へ。

DATE: 1996.
AGENCY: Dentsu, Tokyo.
CREATIVE DIRECTOR: Kotaro Sugiyama.
ART DIRECTOR: Hiroshi Tashiro.
COPYWRITERS: Hiroshi Abe, Masako Okamura
and Shinya Aoyama.
DIRECTOR: Koji Matsuoka.

WHEN JAPAN'S ECONOMIC BUBBLE BURST IN THE EARLY 1990S, THE COUNTRY ENTERED A PERIOD OF RECESSION WHICH JOLTED THE MENTALITY OF A NATION USED TO RELENTLESS TECHNOLOGICAL GROWTH AND CONSPICUOUS CONSUMPTION. ENVIRONMENTAL PROBLEMS SUDDENLY TOOK ON A GREATER IMPORTANCE.

As the extravagant 1980s tumbled into the caring, sharing 1990s, men picked up babies, popped them into catalytically converted cars and drove off into an ozone-friendly sunset. Extravagance became unseemly and green became the favoured colour. In Japan, as in much of the developed world, a wave of public service announcements highlighted the dilemmas facing one of the world's most endangered species: human beings.

The Waterman commercial was aired simultaneously in the USA and Japan, as a joint campaign by the Advertising Councils of both countries, to promote awareness of water pollution. The concept was based on the fact that 70 percent of the human body is made up of water. By depicting the shocking consequences of water pollution, it stressed society's responsibility to the next generation.

WORLDWIDE FUND FOR NATURE (WWF)

WWF

"LET'S KEEP IT POSITIVE," SAID CREATIVE DIRECTOR PARRY MERKLEY TO HIS CREATIVE TEAM. "LET'S MAKE SURE THERE'S ENOUGH HOPE THAT PEOPLE DON'T GIVE UP, FEELING THE PROBLEM IS TOO BIG."

New York ad agency Ogilvy and Mather opted for an optimistic approach when it was asked to galvanize support for saving the Amazon rain forest. The aim was to symbolize the magic and majesty of the location, rather than decrying its destruction.

"It's an awe-inspiring place, yet very difficult to photograph well," says

Merkley. "We wanted a symbolic, rather than literal, portrait that captured the spirit of the place."

While the television commercial covered close-up views within the rain forest, the print ads had to show the broader picture.

Duncan Sim, who shot the stills, is a photographer who thinks in superlatives and relishes running the gauntlet for the sake of the image. "I don't want to go to a stunning location and make it look average," he says. "My brief was to come back with evocative, positive images, not burning stumps and men with chain saws."

The assignment was gruelling. Sim spent two months in the Venezuelan jungle near the Brazilian border during the rainy season, among the ants,

mosquitoes and leeches. On one occasion, he swam up river with water-proof camera cases tied to his legs; it was the only way to reach a little island in the middle of the river from which to shoot a place called Sleeping Indian, a rocky outcrop shrouded in mist and low cloud.

The photograph was used in the WWF Rain Forest Rescue Campaign that ran in *Life*, *Vanity Fair*, *Sports Illustrated* and *People*. "Publications usually feel obliged to run public service announcements only when they have space," says Art Director Lona Walburn, "but the magazines were actually asking for these."

DATE: 1990.
AGENCY: Ogilvy and Mather, New York.
CREATIVE DIRECTOR: Parry Merkley.
ART DIRECTOR: Lona Walburn.
COPYWRITER: Antonio Navas.
PHOTOGRAPHER: Duncan Sim.

VEHICLES

DE DION BOUTON

CARS WERE MADE for advertising. New models keep appearing. They are aspirational as well as functional. And because a number of manufacturers compete for customer loyalty, the sector is constantly revitalized.

Following the invention of the steam engine at the beginning of the nineteenth century, and the internal combustion engine in the 1860s, the pace of progress gathered momentum. The German inventors Daimler and Otto developed the four-stroke internal combustion engine; Frenchman Armand Peugeot moved to making cars instead of bicycles; and another Frenchman, Delamare, presented the first prototype of a motor car at Debotteville. In 1886 Benz introduced his gasoline tricycle capable of moving at 15/kph – generally recognized as the first true automobile. Ten years later Austrian Baron Zulien had his Peugeot stolen, marking the first recorded car theft in history.

America's intimate relationship with the automobile got into gear in 1893 when the Duryea Brothers of Springfield, Massachusetts, installed a one-cylinder, four-horse-power engine under the seat of a standard buggy. They created the first auto ad the following year, and added an illustration in 1895.

Numerous small manufacturers sprang up in Europe, especially in France where de Dion Bouton (p.173), Peugeot (p.184), and Renault (p.186) were built. Many early posters featured variants of the de Dion Bouton – one of the earliest commercially manufactured cars.

Motor cars quickly became a status statement and illustrations for them emphasized the glamour and exclusivity of motoring. This was initially an indulgence of the wealthy, who were depicted in high fashion, driving – or being chauffeur-driven – through attractive landscapes. The Cadillac, born in 1902, was the ultimate expression of luxury in the USA, and coined the slogan "Standard of the world" (p.172). As early as 1900 a variety of non-related advertisers – including Campari and Lux Soap – incorporated automobiles as symbols of prestige.

In 1908 Henry Ford produced the first Model T – the universal car for the common man.

Manufacturers invested heavily in advertising to attract enough customers to justify the assembly-line mass production that was needed to make a profit. In much of the early publicity, manufacturers made mileage out of their record-breaking feats. In 1903 the first car crossed America in 65 days. In 1911 the Grand Prix took place in Indianapolis over a distance of 800 kilometres. In 1915 Henry Ford built his millionth Model T and his 15-millionth in 1927, when it ceased production. The first 24-hour car race took place at Le Mans in 1923, and the Englishman Malcolm Campbell set a new land speed record – 333/kph – in 1928. By the 1930s one in five Americans owned a car.

Cars and motor accessories provided a vast and expanding canvas on which prominent artists could apply their art. Maxfield Parrish and Norman Rockwell created ads for the Fisk Rubber Company (p.176); Paul

SHELL

That's Shell –*That was!*

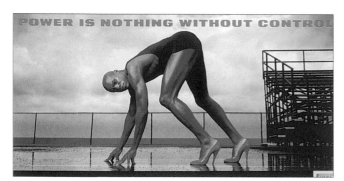

POWER IS NOTHING WITHOUT CONTROL

Nash, H.M. Bateman and many others were commissioned by Shell (pp. 188–89), Hans Rudi Erdt produced a classic image for Opel (p.181) and Paul Colins depicted "Speed" for Peugeot (p.184).

Poster artists began to appreciate the need to simplify designs if they were to catch the eye of passing motorists. As car speeds increased, the length of headlines decreased and images communicated directly and swiftly. Although there are some very successful exceptions, memorable posters now seldom include more than one picture and half-a-dozen words.

"With a poster you have to get it straight away – wallop!" say Mark Denton and Chris Palmer of the London ad agency Simons Palmer Denton Clemmow Johnson. "Posters have to be immediate – like a sledgehammer. You can't be too precious about it."

By contrast, press ads can be intriguing – with a clever headline that draws people into the copy. This can then be followed by a more substantial selling proposition, phrased for those who have already demonstrated their interest by reading the body of the text. Ads with long copy are typified by David Ogilvy's approach (p.187). He often used an irresistible headline with the picture, followed by text that seems long-winded by the standards of smash-and-grab posters.

Many manufacturers that have endured throughout the century owe their instant recognition to branding that has evolved as successfully as the product. Having toyed with various artistic styles, Esso hit on the symbol of the tiger which developed from a ferocious symbol of power,

speed and strength, to a cheery, helpful cartoon character to a protective friend with the consumers' interests at heart (p.174). The Michelin Man "Bibendum" drawn by cartoonist O'Galop, in 1898, has grown into a more rounded figure, but retained the same basic form for over 100 years (pp. 178–79).

During the 1940s and 1950s American advertising was dominated by airbrush paintings, then photographs portraying cars with exaggerated distortions and elongations and with suave drivers and admiring females. The artistic styles of Europe were considered "flat" by comparison.

Having virtually invented advertising and pioneered the hard sell, American ads then made a U-turn. At least, one element of the industry did. Bill Bernbach was the dynamo behind advertising's "Creative Revolution" of the 1960s, when the ad world enjoyed its biggest-ever shot of adrenaline. Founder of the New York ad agency Doyle Dane Bernbach, he advocated reducing ads to single, clear, relevant ideas. He also introduced the modus operandi of art directors and copywriters working together in teams to create a marriage of words and images. Two of Bernbach's early campaigns were for Volkswagen (p.190–91) and Avis (p.170).

His Volkswagen Beetle ads paved the way for endearingly honest, self-effacing advertising that addressed the reader as an intelligent friend. "You cannot sell to a man who isn't listening," said Bernbach. "Our job is to kill the cleverness that makes us shine instead of the product."

NISSAN MICRA

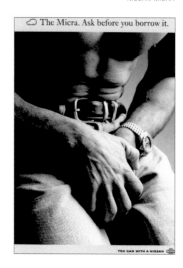

The Micra. Ask before you borrow it.

YOU CAN WITH A NISSAN

AVIS

DATE: early 1960s.
AGENCY: Doyle Dane Bernbach, New York.
CREATIVE DIRECTOR: Bill Bernbach.
ART DIRECTOR: Helmut Krone.

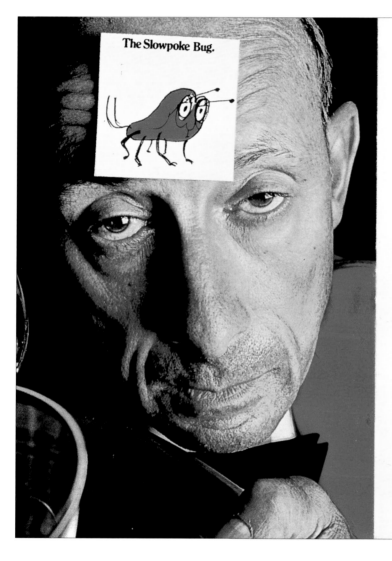

Are we living in a bugged society?

Wouldn't you like some small remembrance to leave the waiter who keeps you waiting an hour for a rare steak and then brings one well done?

And how about something for that nice TV repairman who doesn't make house calls?

Or that temperamental house painter you hired who paints only when he gets the inspiration?

The truth is, our society is being bugged unmercifully by lousy service. And Avis has decided it's about time something was done about it.

Here's our plan:

With every shiny new Plymouth you rent from us you'll get a set of bug stickers like the one on the left.

Of course, if anything bugs you at Avis, sock it to us. We'll knock ourselves out to make things right.

(If we're going to take the No. 1 spot in rent a cars, we can't have any bugs in our system.)

But be sure to keep the stickers when you leave the car. And use them wherever you think they'll do the most good.

If they work for Avis, why not the whole country?

We try harder.

Avis

AVIS WAS IN TROUBLE. THE CAR RENTAL COMPANY HAD BEEN SUFFERING FINANCIAL LOSSES FOR 15 YEARS AND WAS IN NEED OF A MAJOR OVERHAUL. THIS CAME IN 1962 WITH THE APPOINTMENT AS CHIEF EXECUTIVE OF ROBERT TOWNSEND, WHO TURNED TO DOYLE DANE BERNBACH, A YOUNG AGENCY WITH THE CREATIVE ENERGY AND DRIVE TO TAKE ON THE CHALLENGE.

The strategy was as bold as the agency's mould-breaking approach to the VW Beetle (pp.190–91). The campaign's big idea was daring: it not only acknowledged that Avis was number two to Hertz, it wholehearted embraced it and made a virtue of it, saying that Avis has to try harder. When you're number two you have to try harder … or else.

Helmut Krone created a totally fresh look that broke with convention. But people were sceptical. Why announce that you are not the best? And the design. Too much copy. Not enough photography or illustration. And the raw truths about the company were unpalatable to those seeking an approach to buoy up the company's fortunes. Yet Bill Bernbach had the courage to sell the idea to the client, who had the courage to buy it. "It's better to state our proposition with the kind of talent that will touch and move the reader than to bore them to death with the ordinary," said Bernbach.

The image of the hard-working underdog immediately won customer affection and loyalty. The public empathized with Avis's position. And in the first year of the campaign, Avis's $3 million loss was turned into a $3 million profit.

BMW

DATE: 1990.
AGENCY: WCRS Matthew Marcantonio, London.
CREATIVE DIRECTOR: Alfredo Marcantonio.
ART DIRECTOR: Simon Green.
COPYWRITER: John Dean.
PHOTOGRAPHER: Graham Ford.

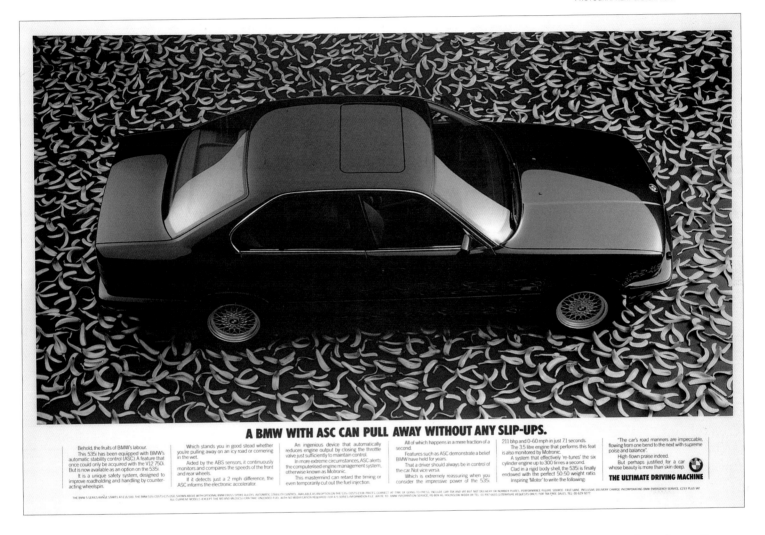

BMW IN THE UK HAS SUPPORTED CONSISTENT ADVERTISING OVER AN EXTENDED PERIOD, ACHIEVING A SUSTAINABLE, STRONG PERSONALITY FOR THE BRAND. BMW (GB) WAS ESTABLISHED IN 1979, WHEN THE AGENCY WCRS WAS APPOINTED. THE COMPANY'S OBJECTIVE WAS TO TREBLE VOLUME SALES WITHIN 15 YEARS, WHILE MAINTAINING HIGH PROFIT MARGINS.

The creatives visited the factory in Bavaria to ascertain the brand values: performance, quality, advanced technology and exclusivity. From these emerged the long-running campaign: "The ultimate driving machine", forming the framework for a progression of concepts. The bananas skins, for example, were driven by an advanced technology brief.

"The best advertising should encompass the essence of a product that cannot be transferred to another product. Then milk it forever," says Peter Harold who art directed many of the BMW ads. Although different models in the range appeal to different sectors of the market (targeted separately) all the advertising is underpinned by the shared BMW driving experience. The brand is chosen before the model.

"Many ideas are culture-specific," says agency partner Robin Wight.

"BMW tried to do pan-European advertising in the late 1980s, then realized they wouldn't get the best advertising for each market. We're all still quite national in our outlook. For an ad to work it has to relate to someone, and the more closely it can relate, the more effective it will be."

Within 15 years there were six times more BMWs on the roads in the United Kingdom.

CADILLAC

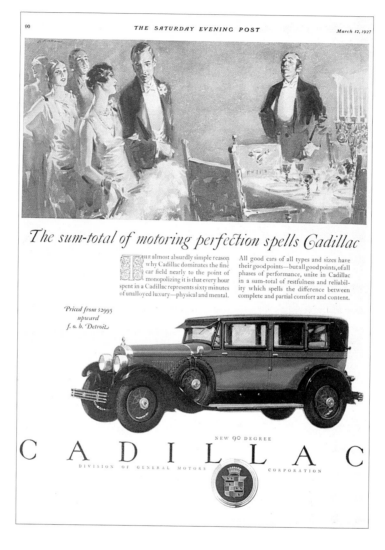

DATE: 1927.

THE CADILLAC BRAND WAS FOUNDED IN 1902 WHEN THE CADILLAC MOTOR CAR COMPANY IN DETROIT ROLLED OUT THE MODEL "A". ITS FOUNDER HENRY MARTYN LELAND WAS A MASTER MANUFACTURER OF PRECISION-BUILT, INTERCHANGEABLE MACHINE PARTS.

This American invention helped the US overtake European competition and established the Cadillac as a worldwide standard for quality in the burgeoning automotive industry.

The car soon developed a reputation for its state-of-the-art engines and design, and the name became synonymous with style, performance and luxury. Early models climbed steeper gradients and ran more smoothly than all its competitors. The Cadillac was seen as resilient and able to withstand adverse conditions. Early ads (1903–06) boasted the car's accomplishments. In 1906 the Cadillac adopted the slogan "Standard of the world" which was still in use 60 years later.

The Cadillac Motor Car Co was purchased by Detroit's General Motors Corp in 1909. In 1915 the V8 engine was introduced and, together with other technological and styling advancements, the Cadillac joined the Packard and Pierce-Arrow as America's finest cars. The advertising shifted towards the car's luxury status, and Cadillac's advertising director Theodore F. MacManus – founder of D'Arcy MacManus advertising agency – created "The penalty of leadership" ad. Although it appeared only once, its impact on the advertising world was as striking as that of Bill Bernbach's early Volkswagen advertising (pp. 190–91). Its long body copy echoed the chatty tone of other ads of that period, yet the Cadillac was never mentioned. Descriptions of adverse circumstances faced by leaders in various fields, by implication placed Cadillac at the pinnacle of automotive design.

By the end of the twentieth century, over a quarter of a million Cadillacs were being sold each year, representing over a quarter of the USA luxury car market.

DION-BOUTON

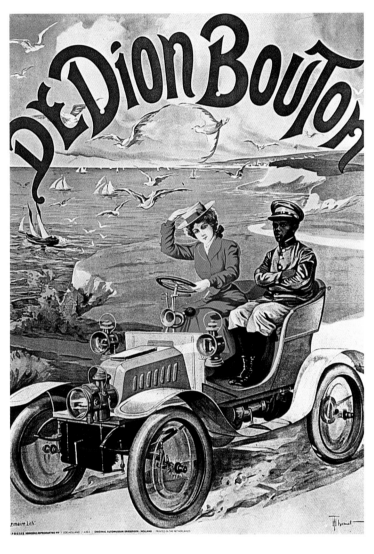

DATE: 1903.
ARTIST: H. Thinet.

FROM THE OPENING YEARS OF THE TWENTIETH CENTURY MOTOR MANUFACTURERS PROLIFERATED, ESPECIALLY IN FRANCE. ONE OF THE EARLIEST COMMERCIALLY MANUFACTURED CARS WAS THE DE DION BOUTON, PRODUCED BY COMTE (LATER MARQUIS) DE DION AND M. BOUTON. EARLY POSTERS USUALLY FEATURED VARIATIONS OF THIS ELEGANT AUTOMOBILE, EMPHASIZING THE GLAMOUR AND EXCLUSIVITY OF MOTORING.

In the early years of the golden age of motoring, cars were depicted as being sedately driven by fashionably clad figures. A chaotic exception was a 1899 de Dion Bouton poster that showed a medley of reckless driving, typifying the arrogant disregard of car drivers for other road users.

A popular theme at the time depicted a redundant chauffeur, supplanted by an aristocratic lady because she so enjoyed driving this car. It is a concept that was repeated in the 1990s by the advertising of several motor companies, notably Volkswagen. In its commercial, a young couple argue about who is going to drive to their friend's dinner party that evening – both preferring the pleasure of being behind the wheel to the pleasure of drinking.

De Dion Bouton was a successful exporter of proprietary engines of various capacities for vehicles ranging from lightweight motorcycles to middle-size cars. But by 1927 the company was suffering from inflexibility and was acquired by its old rival, Peugeot.

ESSO

DATE: 1965.
AGENCY: McCann Erickson.

BY ASSOCIATING AN ANIMAL WITH ITS PRODUCT, A MANUFACTURER CAN TAP INTO THE CONSUMER'S SUBLIMINAL REACTIONS TO THE ASSUMED ATTRIBUTES OF THAT ANIMAL.

The tiger was first seen promoting Esso Ethyl in the UK in the summer of 1936. But intensive use of the tiger was not made until the reintroduction of branded petrol in 1953. The ferocious leaping tiger pounced from posters as a symbol of energy and excellence, advertising the top grade of petrol, Esso Extra. A decade later a cartoon clone had assumed an infectious enthusiasm and appealing roar and has since appeared in slightly varying form in almost every country in the world, inextricably linked with Esso Extra.

Harrison King McCann became the oil company's ad manager in 1911, just before the US government ordered the breakup of Standard Oil. To retain continuity, he formed the agency H.K. McCann the following year and then merged with Albert Erickson in 1930. The same agency has handled the account throughout.

The tiger was originally drawn by Henry Hewitt, agency artist with McCann Erickson in London. The Netherlands affiliate of Esso came up with the slogan that freely translates as "Put a tiger in your tank". The line first appeared in English in 1959 in Chicago, above a trademark of the Oklahoma Oil

Co, later incorporated into Humble.

Some of the commercials portray the tiger as parts of a car. As the tyres, the tiger demonstrates its ability to cope with water – rapidly changing direction or stopping. As the engine, it charges up a steep slope or ploughs through snow. In reality the snow is

gypsum, found in a desert in New Mexico. It looks and drifts like snow, but is easier to work with.

"We always film the commercials in America because they have special wild animal ranches where the tigers are kept lean and slightly hungry," says Dennis Page, creative director with

McCann Erickson in London. "The tiger handler has a good rapport with the tiger and offers rewards of meat to encourage it to run or jump. We've never had a serious mishap, but the animal can get tired of all the repeats. It can be unnerving when a tiger's unblinking eye singles you out."

FORD

DATE: 1950s.

HENRY FORD WAS A RACING DRIVER AND SELF-TAUGHT MECHANIC WHO FOUNDED HIS COMPANY IN 1903. AT THAT TIME CARS WERE AN EXTRAVAGANCE ENJOYED EXCLUSIVELY BY THE WEALTHY AND GENERALLY DRIVEN BY CHAUFFEURS. INITIALLY FORD CATERED FOR THIS MARKET, BUT BY 1908 HE REALIZED THAT THE LUXURY CAR MARKET WAS SATURATED. HE THEN ANNOUNCED PLANS FOR A PEOPLE'S CAR. RUNNING ON FOUR CYLINDERS, THE MODEL T STOOD HIGH ABOVE THE ROAD FOR MAXIMUM CLEARANCE, WAS SIMPLE TO OPERATE AND RAN 30 MILES ON A GALLON OF PETROL.

Ford's assembly line allowed mass production at a vastly reduced price. By 1920 the Model T accounted for over half of all the cars in the world; seven years later, nearly all middle-class Americans owned a car. That year, when production of the Model T ceased, a total of 15 million had been sold – a record that remained intact until topped by the VW Beetle in 1972 (pp.190–91).

In the early years, Ford's advertising copy was generally long and outlined the car's attributes. By the early 1920s the more elaborate and appealing ads for General Motors' Chevrolet drove Ford to defend his cars more aggressively. A

IN 1903 WE MADE...

450 Model A's Ford Motor Company's first car. It weighed 1000 pounds, had 2 cylinders, 8 horsepower, ran at the fantastic speed of 30 miles an hour and cost $850. Trade-in price today about $5,000.

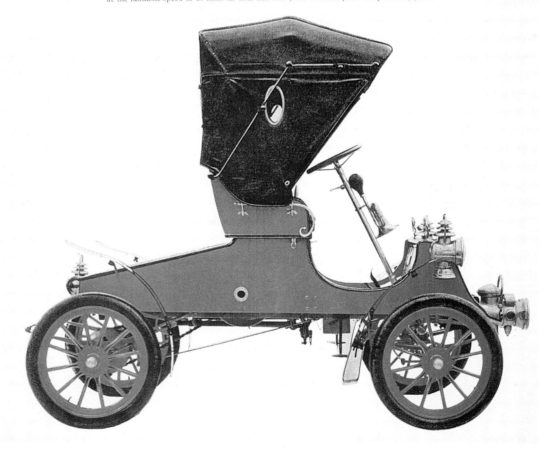

constant thorn in his side, GM's view that cars were a symbol of attainment, rather than a low cost mode of transport, was gaining wider acceptance. By the mid-1920s GM's new range of colours and the status perception began to undermine Ford's sell-line: "Any colour so long as it's black". The year the production of the Model T ceased, Chevrolet sales overtook Ford's. But the Ford empire continued to expand, extending to over 200 countries.

FISK RUBBER COMPANY

A ROUGH SKETCH IS THE SIMPLEST MANIFESTATION OF AN IDEA FOR A PRINT AD. ART DIRECTOR BURR GRIFFIN HAD TO PRODUCE LITTLE MORE TO CONVINCE THE FISK RUBBER COMPANY TO PRODUCE A POSTER, AND LATER AN ICON FOR THE COMPANY.

Like many of the best ideas, the elements of this narrative had been germinating in Griffin's subconscious for some time. They emerged spontaneously in the middle of the night and he dutifully drew a boy holding a tyre in his right hand and candle in his left. When the U.S. Rubber Company acquired Fisk in 1939, the original idea was considered strong enough to be kept intact.

In 1918, leading artist and magazine cover designer Maxfield Parrish created the ad, "Fisk – fit for a king". Parrish's studio incorporated a woodworking shop where he constructed models of his subjects to ensure that the shading and shadows he drew were accurate. As a result his paintings possess a photographic realism.

Norman Rockwell returned to Fisk's "Time to retire" theme in 1924 when he painted a snoozing hobo whose shoe soles had long since lost their tread.

DATE: 1925.
ARTIST: Robinson.

MERCEDES-BENZ SLK

DATE: 1996.
AGENCY: Leo Burnett, London.
CREATIVE DIRECTOR: Gerald Stamp.
ART DIRECTOR: Mark Tutssel.
COPYWRITER: Nick Bell.
PHOTOGRAPHER: Russell Porcas.

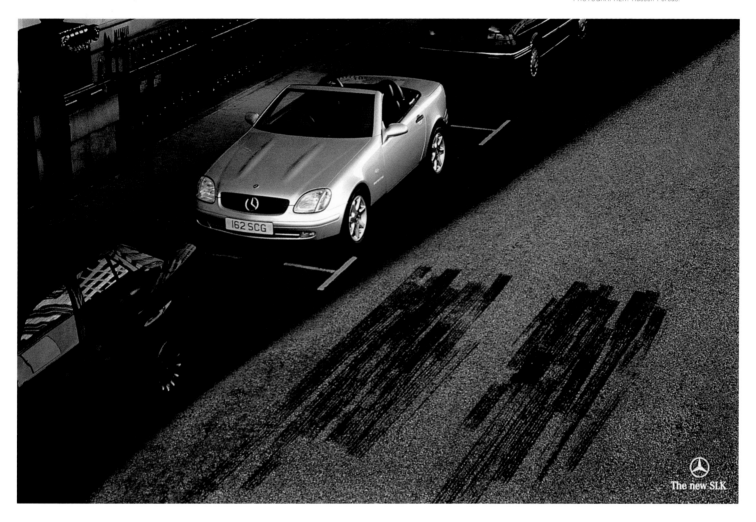

EVER SINCE BILL BERBACH ELEVATED CAR ADVERTISING ABOVE THE PROSIAC BY TREATING THE CONSUMER AS AN INTELLIGENT FRIEND, THE FIELD HAS BEEN WIDE OPEN FOR LATERAL APPROACHES THAT SHOULD BE WITHIN THE GRASP OF DRIVERS OF SUPERIOR MARQUES (PP.190–91).

Sophisticated and innovative advertising presents the product within an environment or scenario that reveals additional aspects of its character. As long as the image is pleasing, the different levels of meaning will hold the viewers' attention for longer, enabling them to decipher the message and respond to the wit and subtlty of the ad.

The approach requires input from the audience in order to complete the communication. Why the skidmarks? Deductive reasoning leads to the unravelling of the narrative.

Carl Benz built the first self-propelled vehicle powered by an internal combustion engine in 1885 – a 3-wheel Velocipede. In 1902 Emil Jellinek was one of the biggest and most demanding customers of Gottlieb Daimler and Wilhelm Maybach. He insisted that one of the manufacturer's new models was named after his daughter Mercedes. The competitors Benz et Cie. and Daimler-Moteren-Gesselschaft merged in 1926.

Since then Mercedes has stood for luxury, excellent engineering, comfort, style, heritage and, according to this multi-award winning ad, a high "Wow" value. The SLK roadster, launched in 1994, is sporty, light and small – a slick, modern departure from the more conservative, executive image of the company's earlier models.

MICHELIN TYRES

AN EMINENT SCIENTIST CALLED MACINTOSH DISCOVERED THAT RUBBER WAS SOLUBLE IN BENZENE. HIS NIECE, ALIZABETH DAUBREE, USED RUBBER TO MAKE BALLS FOR HER CHILDREN TO PLAY WITH. TWO COUSINS SEIZED ON THE INDUSTRIAL POTENTIAL OF VULCANIZED RUBBER, AND USED IT TO MAKE SEATS, BELTS, VALVES AND PIPES.

In 1889 the Michelin company was created in Clermont-Ferrand, France. Edouard and André Michelin took over the agricultural business founded by their grandfather. André was an engineer with a flare for publicity, Edouard a talented painter and gifted industrialist. In 1891, following a visit from a cyclist wanting "tyre repair equipment", Edouard decided to develop the tyre, making it easier to repair. He patented a removeable tyre and the company's future was sealed. Racing cyclist Charles Terront was the first and only competitor to use the new Michelin tyre in the Paris–Brest–Paris race. He won, and the following year 10,000 cyclists used Michelin tyres.

Bibendum – the Michelin Man – became the company's trademark as a result of an involved string of chance events. When discussing the pneumatique (air tyre) in 1893, André Michelin said, "The tyre drinks obstacles", meaning it absorbs shocks and jolts. The following year the two

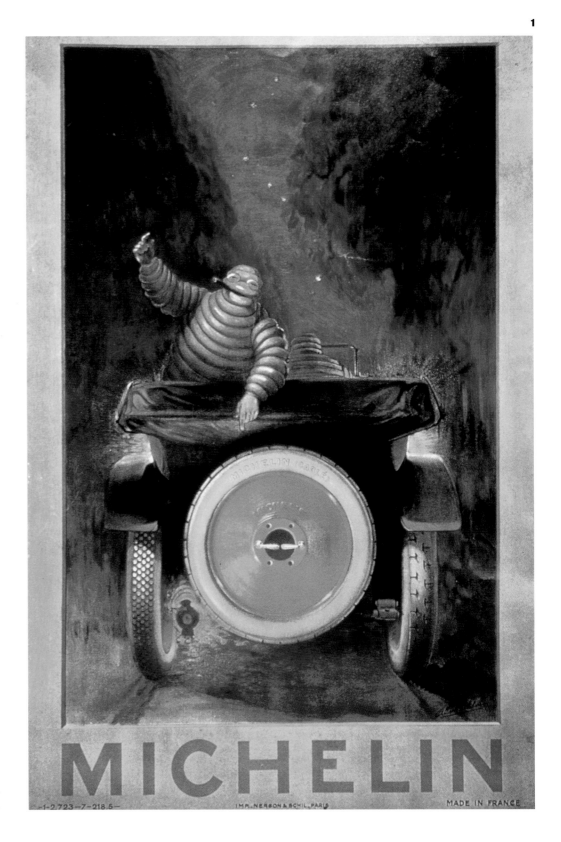

1. DATE: 1919.
ARTIST: Albert Philibert.

2. DATE: 1905.
Artist: Ernest Montaut.

brothers noticed a stack of different-size tyres on their display stand in Lyons, with an evocative silhouette resembling a human form. "If it had arms it would look like a man," remarked Edouard.

Four years later, the illustrator and cartoonist Marius Rossillon (pseudonym O'Galop) showed the Michelin brothers several publicity projects. Among them was a sketch for a brasserie showing a drinker raising his tankard, with the slogan "Nunc est Bibendum" – it's time to drink – after a verse from Horace. André remembered the phrase "The tyre drinks obstacles" and made the association between the fat Bavarian in the sketch and the pile of tyres. He commissioned O'Galop, who in 1898 created a poster of an imposing character composed of tyres. He is raising his glass filled with broken pieces of glass and nails, and offering a toast, declaring "Nunc est Bibendum", illustrating André's phrase "Michelin Tyres drink obstacles".

Soon afterwards, during a Paris–Amsterdam-Paris race, the driver Théry saw André Michelin pass by and cried out, "There's Bibendum!" The nickname quickly became inextricably linked with the Michelin Man. At the factory, workers still refer to him affectionately as Mr Bib.

Meanwhile, the excitement of the golden age of motoring was captured in an involving poster of a racing Panhard fitted with Michelin tyres. The car is outpacing the Flying Scotsman – a symbol of speed and class – between Edinburgh and London.

2

MICHELIN *Tyres.*

THE RAIL VANQUISHED BY MICHELIN TYRES.

The image, by Ernest Montaut – "Father of automobile art" – bursts with drama and activity, with scattered pebble and the puffing train.

Although modified over time, the Michelin trademark – Bibendum – has endured for over 100 years and represents the company in over 150 countries. Michelin has more than 80 factories in 19 countries on every continent, producing 830,000 tyres every day. Michelin has 18 percent share of the market.

NISSAN MICRA

NISSAN NEEDED A RADICAL RETHINK OF ITS UK MARKETING STRATEGY. AFTER TWO DECADES OF "PILE 'EM HIGH, SELL 'EM CHEAP", THE COMPANY RESPONDED TO INCREASING COMPETITION FROM EUROPEAN MANUFACTURERS BY SETTING UP ITS OWN DISTRIBUTORSHIP (OPENED IN JANUARY 1992).

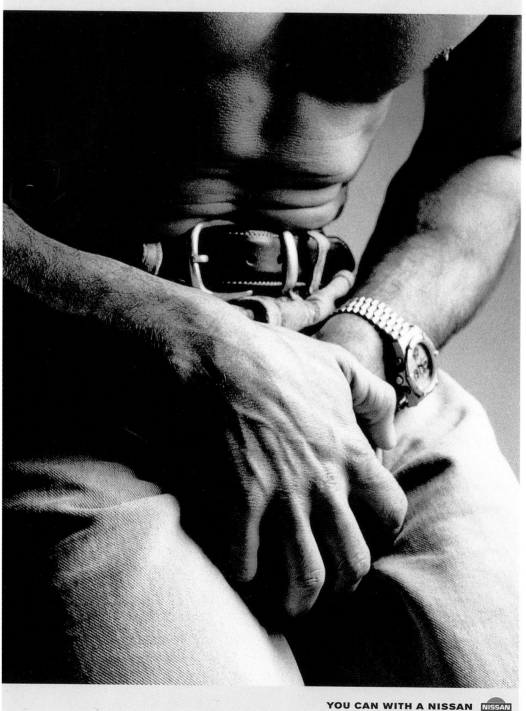

Nissan planned to reposition itself by producing cars that people actively wanted rather than chose mainly on the basis of price. In a radical departure from the company's heritage, the Micra was redesigned and launched later that year.

The new Micra was small, simple and driver-friendly, with good fuel economy and a distinctive shape. The advertising focused on the emotional as well as the rational attributes. The car's rounded outline conveyed a lively, appealing personality. This was best communicated using a simple "cartoon" graphic derived from some of the original concept drawings and from a symbol used in Japanese promotional material.

Despite a recession, a modest launch budget and a 20 percent price increase over its predecessor, sales targets were exceeded.

The graphic was retained as a diminutive icon when the concept was further developed in the 1994 campaign, targeting fun-loving women between 25 and 35. As in the early Dion-Bouton ads (p.173), a woman takes control and becomes possessive about her car. The campaign uses the Micra as a symbol of her independence, bringing freedom and status as an individual. In an amusing, if uncomfortable, series of ads, the line "Ask before you borrow it" warns her male partner of the dire consequences of taking liberties.

DATE: 1994.
AGENCY: TBWA, London.
ART DIRECTOR: Chris Hodgkiss.
COPYWRITER: Pip Bishop.
PHOTOGRAPHER: John Claridge.

OPEL

In Berlin before World War One, a group of designers worked for the lithographic printers Hollerbaum und Schmidt. They developed a new style of artistic expression that became known as *Sachplakat* or "Object poster".

Influenced by the Beggarstaff brothers, their minimalist approach portrayed only the essential objects in simple form, and the words were restricted to the brand name, with no verbal elaboration. The chief protagonists of this style were Lucian Bernhard, Ludwig Hohlwein (pp. 80, 146), Hans Erdt, Julius Klinger and Julius Gipkens.

An excellent example of Erdt's economical approach to design is seen in his poster for Opel cars. In a restricted range of flat colours he created an exceptional composition. The "O" of Opel forms a regular circle describing a tyre. It stands out prominently because it would normally have the same alphabet forms as the rest of the name – "pel" – thicker at the sides and narrower at top and bottom.

Erdt also produced German propaganda posters during World War One, including his classic "*U Boote Heraus!*" or "U Boats Out!"

DATE: 1911.
ARTIST: Hans Rudi Erdt.

PIRELLI TYRES

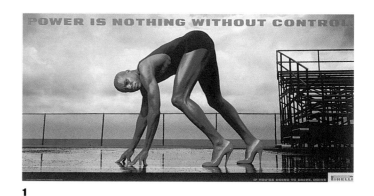

1

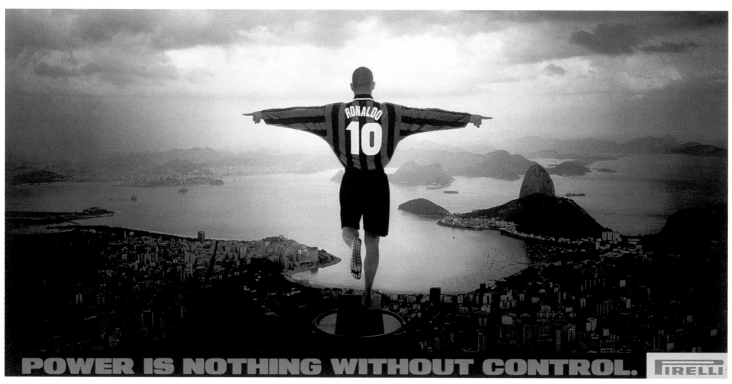

2

PIRELLI IS AN ITALIAN-CONTROLLED MANUFACTURER OF TYRES THAT HAS OPERATED IN BRITAIN VIRTUALLY SINCE MOTORING BEGAN. BUT PIRELLI ALSO MAKES CABLES AND SYSTEMS, AND PRODUCES INTEGRATED COMPONENTS FOR TELECOMMUNICATIONS AND POWER TRANSMISSIONS. THESE CREDENTIALS HAVE HELPED STRENGTHEN THE COMPANY'S STANDING.

During the final decade of the twentieth century, Pirelli was facing competition from cheap imports from the Far East, its tyre sales were falling and losses were accumulating. London agency Young and Rubicam took over the account in 1992 and decided to target the consumer in a market where the majority of people view buying tyres as a necessary and depressing chore and are led by retailers' recommendations.

Against this unpromising background, the agency set out to brand the Pirelli product as familiar and reassuring. Sharon Stone appeared in a commercial "Driving Instinct" and a tele-

vision/cinema and poster campaign featuring athlete Carl Lewis helped create an 18 percent increase in sales value, transforming Pirelli's fortunes from losses in 1992 and 1993 to profit in 1995.

The campaign was conceived and implemented for Europe as a whole, and showed that advertising can surmount cultural and market differences. The huge amount of media coverage generated by the campaign vastly increased the effectiveness of the advertising spend.

The annual Pirelli calendar has been part of the company's promotional communication since 1964. The calendar has taken the concept of the garage

pinup girl into a different league. Extravagant budgets have taken leading photographers and top models to lavish locations, with glamorous results. Brian Duffy went to the South of France (1965), Sarah Moon to Paris (1972), Uwe Ommer to the Bahamas (1984), Norman Parkinson to Scotland (1985), Clive Arrowsmith to France (1991) and Spain (1992), John Claridge to the Seychelles (1993), Richard Avedon to New York (1995 and 1997) and Bruce Weber to Miami (1998). Herb Ritts, the photographer for the 1994 calendar, was reselected for the 1999 shoot. To celebrate the close of the twentieth century, he photographed 12 different models, each evoking the mood and "look" of a different decade from the 1890s onwards.

3

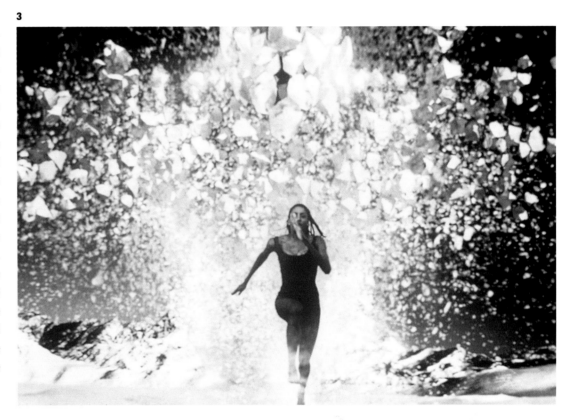

4

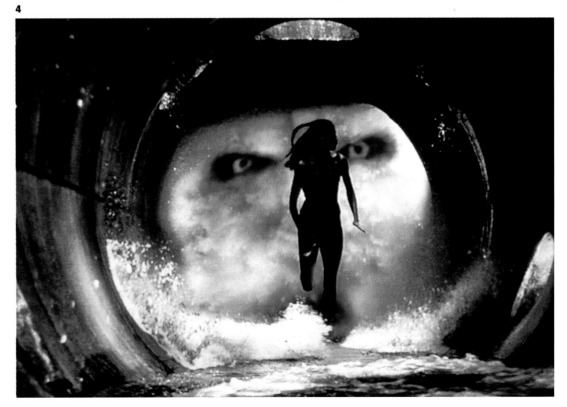

1. DATE: 1994.
AGENCY: Young and Rubicam, London.
CREATIVE DIRECTOR: Mike Cozens.
ART DIRECTOR: Graeme Norways.
COPYWRITER: Ewan Paterson.
PHOTOGRAPHER: Annie Leibovitz/Contact Press
Images.
MODEL: Carl Lewis.

2. DATE: 1996.
AGENCY: Young and Rubicam, London.
MODEL: Ronaldo.

3 & 4. DATE: 1997.
AGENCY: Young and Rubicam, London.
MODEL: Mary Jo Perek.

PEUGEOT

1. Date: 1935.
ARTIST: Paul Colin.

2. DATE: 1991.
AGENCY: Euro RSCG Wnek Gosper, London.

1

1935 Peugeot accélération

2

THE NEW PEUGEOT 405.

DESCENDED FROM A FAMILY OF MILLERS LIVING IN THE MONTBELIARD REGION OF FRANCE, THE PEUGEOT BROTHERS IN 1810 DECIDED TO TRANSFORM THEIR GRAIN MILL INTO A STEEL MILL. FIRST THEY PRODUCED SPRINGS FOR LOCAL CLOCK-MAKERS, THEN ADDED TOOLING DEVICES AND CORSET-MAKING MACHINES. BY 1840 PEUGEOT WAS PRODUCING COFFEE GRINDERS AND BY 1867, SEWING MACHINES.

When Peugeot started manufacturing bicycles, the business escalated. At the Paris Universal Exhibition of 1889, the Serpollet-Peugeot tricycle was a major attraction. The following year Peugeot adopted the internal combustion engine and manufactured a gasoline quadricycle, driven by a Daimler motor.

By the turn of the century Peugeot was a major automobile builder. In 1905 The Bébé was the first lightweight single-cylinder car to be launched on the market at a reasonable price, within reach of the middle classes. By 1913, Peugeot was building half of all French cars.

During the golden age of motoring, car racing was a popular showcase for the technical capabilities of the car manufacturers. The advertising often combined speed and streamlined design. Paul Colin's elegant poster "Accélération" in 1935 highlighted the freedom of the open road, a precursor of subsequent commercials that yearned for a return to carefree driving.

In 1974 Peugoet merged with Citroën, creating PSA Peugoet Citroën Group.

To capture the excitement of driving the Peugeot 405 in 1991, and to make the Peugeot driver feel special, a breathtaking television commercial shows the car racing through exploding fields of sugar cane. As walls of flame shoot up either side of the speeding car, the evocative strains of "Takes my breath away" embody the experience.

PORSCHE

DATE: 1993.
AGENCY: Jung von Matt, Hamburg.
CREATIVE DIRECTOR: Deneke von Weltzien.
ART DIRECTOR: Claudia Wriedt.
COPYWRITER: Mathias Jahn.
PHOTOGRAPHER: Uwe Düttmann

DR FERDINAND ANTON PORSCHE – SON OF A TIN SMITH – PREFERRED TINKERING WITH ELECTRIC MOTORS TO FOLLOWING HIS FATHER'S CRAFT. IN 1905 HE BECAME TECHNICAL DIRECTOR FOR AUSTRO-DAIMLER, AND LATER WORKED FOR DAIMLER IN GERMANY, WHERE HE DEVELOPED THE MERCEDES SSK IN 1924. IN EARLY 1930S HE DESIGNED A VOLKS AUTO THAT EVOLVED INTO THE VOLKSWAGEN BEETLE (P.190). THE PORSCHE AUTOMOBILE WAS NAMED AFTER HIS SON, FERRY, WHO INTRODUCED THE BRAND IN 1948.

The Porsche brand represents excitement and pedigree – speed and breed.

Advertising for Porsche perpetuates the legend, while also trying to extend it. The tone is superior without being arrogant and there's a knowing twinkle in the eye.

"We are driven by the desire to create conspicuous advertising," says Holger Jung, co-founder of the Hamburg ad agency Jung von Matt. "But we try not to be eccentric just for the sake of attracting attention. Our strategies must show our clients that we have a responsible and enduring approach to the business rather than being a crazy, fly-by-night hot shop."

Although the agency only opened its doors in 1991, its early work for Porsche was so accomplished that it was adapted for use around the world, excluding the UK and USA. Despite a public move towards more responsible driving, two of the successful print ads acknowledge "speed" as a major selling proposition – though with a gentle, confident wit. The headline reads: "You can linger longer over breakfast. You're home

earlier for dinner. Could there be a better family car?"

And, while advertising for convertibles often refers to the sun, Porsche's version sports a racy addition. "You can get a tan in other convertibles. But not as quickly."

Swiss copy guru Jean-Remy von Matt, marketing man Holger Jung and creative director Deneke von Weltzien each acquired valuable experience working for the prestigious Hamburg agency Springer and Jacoby before launching Jung von Matt. Within its first 15 months, the agency had notched up over 50 TV and cinema commercials, numerous print ads and an avalanche of awards.

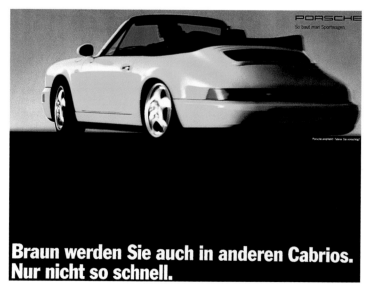

RENAULT CLIO

DATE: 1997.
AGENCY: Publicis, London.

IN MARCH 1991 THE CLIO WAS LAUNCHED AS SUCCESSOR TO THE LONG-ESTABLISHED RENAULT 5, WHICH HAD BEEN AROUND SINCE 1972. THE HOPE WAS THAT IT WOULD REVIVE THE COMPANY'S FORTUNES IN THE UK DESPITE AN OVERALL DECLINE OF 20 PERCENT OF NEW CAR SALES THAT YEAR – THE WORST ANNUAL FALL IN 17 YEARS.

The first Clio commercial introduced characters of Papa and Nicole, who personified the car's proposition: the small car with big-car refinement. It was a position that immediately broadened its attractiveness to include a wider age group than the Renault 5s.

Despite a recession, the commercial helped establish a personable and memorable image for the car.

After two or three years, the novelty of a new model usually wears off and sales decline. The challenge for the Clio advertising was to maintain its position

as the clear image leader in its sector, even after its product advantage had been matched by competitors – Peugeot 106 in 1991, Nissan Micra in 1992, Fiat Cinquecento and Vauxhall Corsa in 1993 and so on.

Led by television, but also through radio, posters and press, the Papa and Nicole saga developed, defying the normal market trend. The Renault Clio managed to sustain its price premium and held its position against bigger brands with larger networks. Sales and volume share increased every year,

nearly doubling from the launch to 1995.

The Clio's success is attributed largely to the relationship between the father and daughter. It exudes a potent and irresistible French charm that also provides a flexible framework within which to promote a series of product features and upgrades, adding sportiness and male appeal. The Provencal setting and relaxed lifestyle present attractive aspects of Frenchness, to which many British buyers aspire.

ROLLS ROYCE

The Rolls-Royce Silver Cloud—$13,995

"At 60 miles an hour the loudest noise in this new Rolls-Royce comes from the electric clock"

What __makes__ Rolls-Royce the best car in the world? "There is really no magic about it — it is merely patient attention to detail," says an eminent Rolls-Royce engineer.

1. "At 60 miles an hour the loudest noise comes from the electric clock," reports the Technical Editor of THE MOTOR. Three mufflers tune out sound frequencies—acoustically.

2. Every Rolls-Royce engine is run for seven hours at full throttle before installation, and each car is test-driven for hundreds of miles over varying road surfaces.

3. The Rolls-Royce is designed as an *owner-driven* car. It is eighteen inches shorter than the largest domestic cars.

4. The car has power steering, power brakes and automatic gear-shift. It is very easy to drive and to park. No chauffeur required.

5. The finished car spends a week in the final test-shop, being fine-tuned. Here it is subjected to 98 separate ordeals. For example, the engineers use a *stethoscope* to listen for axle-whine.

6. The Rolls-Royce is guaranteed for

three years. With a new network of dealers and parts-depots from Coast to Coast, service is no problem.

7. The Rolls-Royce radiator has never changed, except that when Sir Henry Royce died in 1933 the monogram RR was changed from red to black.

8. The coachwork is given five coats of primer paint, and hand rubbed between each coat, before *nine* coats of finishing paint go on.

9. By moving a switch on the steering column, you can adjust the shock-absorbers to suit road conditions.

10. A picnic table, veneered in French walnut, slides out from under the dash. Two more swing out behind the front seats.

11. You can get such optional extras as an Espresso coffee-making machine, a dictating machine, a bed, hot and cold water for washing, an electric razor or a telephone.

12. There are three separate systems of power brakes, two hydraulic and one mechanical. Damage to one will not affect the others. The Rolls-Royce is a very *safe* car—and also a very lively car. It cruises serenely at eighty-five. Top speed is in excess of 100 m.p.h.

13. The Bentley is made by Rolls-Royce. Except for the radiators, they are identical motor cars, manufactured by the same engineers in the same works. People who feel diffident about driving a Rolls-Royce can buy a Bentley.

PRICE. The Rolls-Royce illustrated in this advertisement—f.o.b. principal ports of entry—costs **$13,995.**

If you would like the rewarding experience of driving a Rolls-Royce or Bentley, write or telephone to one of the dealers listed on opposite page. Rolls-Royce Inc., 10 Rockefeller Plaza, New York 20, N. Y. Circle 5-1144.

AT THE BEGINNING OF HIS ADVERTISING CAREER, DAVID OGILVY LEFT SCOTLAND AND WENT TO AMERICA. "I WAS DRIVEN BY AMBITION AND AVARICE. THE SAME AMOUNT OF WORK PRODUCED THREE TIMES AS MUCH MONEY IN AMERICA. AND I WASN'T INDIFFERENT TO THAT," HE SAYS. "AT THE TIME AMERICA WAS ABOUT 30 YEARS AHEAD OF BRITAIN IN ADVERTISING TECHNIQUE.

That's no longer true. English advertising is just as good as American, and in some ways better. The British have a better sense of proportion."

Ogilvy was especially proud of the Rolls Royce account, which enabled him to create what he considered the best type of advertising – based on ideas. He lists his criteria: "Did it make me gasp when I first saw it? Would I have liked to have thought of it myself? Is the idea unique? Does it fit the campaign strategy to perfection? Could it be used for up to 30 years?"

Ogilvy lifted the headline for the Silver Cloud from a report by the tech-

nical editor of *The Motor* magazine in which he quoted a remark made by an engineer at the Rolls Royce factory: "Yes, we must do something about that clock".

"The first duty of advertising is to communicate effectively, not to be original or entertaining," says Ogilvy. "An ad that pleases because of its style is seldom the same as an ad that sells most products. When I write an ad, I want readers to find it so interesting that they will go out and buy the product."

Ogilvy's copy for Rolls Royce embodied the dream that led aristocrat and motor enthusiast Charles Stuart

Rolls and engineer Henry Royce to produce the best car in the world. But illustration and headline take precedence over copy. "I find that readers look first at the illustration, then at the headline, then at the copy, so the elements should be placed in that order. And don't be afraid of long headlines."

DATE: 1960s.
ART DIRECTOR/COPYWRITER: David Ogilvy.

SHELL

Shell's lack of a constant, rigid advertising strategy has allowed it to respond rapidly to topical events and changing tastes in a great variety of ways. An example of the versatility of Shell's approach is John Reynold's updating of one of Rex Whistler's 1928 series, "That's Shell – That Is!"

Whistler's single-headed man commenting on a passing car becomes a double-headed man – speed implied by the image and reinforced by a suitable change of tense in the copy line.

The two heads idea was sent in by a member of the public, a Mr Horsefield, who was originally paid two guineas, though this was later increased to £100 when the success of the idea was appreciated. Shell was not the first company to view art as a useful tool in corporate image projection, but it was a significant one.

Art has been used in advertising since the nineteenth century. In 1886 Sir William Ingram purchased John Everett Millais' painting of his grandson William James blowing bubbles, in order to reproduce it in the *London Illustrated News*. He then sold *Bubbles* to A & F Pears Ltd who used it to advertise soap. In many cases advertising has played patron of the arts, encouraging new artists and providing lucrative outlets for established painters

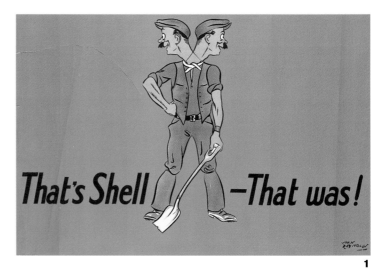

1

and, later, photographers. The benefits are reciprocated when the product gains credibility and respectability from the unstated endorsement of the artist.

As advertising manager from 1932 to 1939, Jack Beddington elevated Shell's advertising by commissioning a prestigious collection of work by leading British artists, including Graham Sutherland, McKnight Kauffer, Barnett Freedman, Paul Nash and Duncan Grant. Their work appeared in the

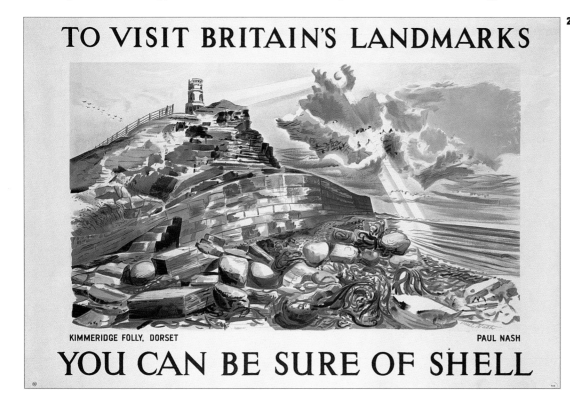

2

TO VISIT BRITAIN'S LANDMARKS

KIMMERIDGE FOLLY, DORSET PAUL NASH

YOU CAN BE SURE OF SHELL

1. DATE: 1930.
ARTIST: John Reynolds.
COPYWRITER: Horsfield.

2. Date: 1937.
ARTIST: Paul Nash.

3. DATE: 1937.
ARTIST: Graham Sutherland.

4. DATE: 1924.
ARTIST: H.M. Bateman.

press, on posters and on the sides of delivery lorries.

Like Frank Pick at London Transport (pp.202–3), Beddington created a personality for Shell, taking in British landmarks, institutions, events, curiosities and activities, while drawing on expressionism, cubism, surrealism, constructivism, symbolism and romanticism.

Although a more contiguous style might have given Shell's advertising greater coherence, it would have straitjacketed individual expression. Shell ads display a confidence worthy of a corporate statement. They assume the role of brand leader, set above the need to hard-sell individual products. Shell is portrayed as the gateway to free movement – the freedom to explore anywhere in the country – a theme that was repeated in 1955 when Independent Television was launched, and again in a print campaign in 1991.

3

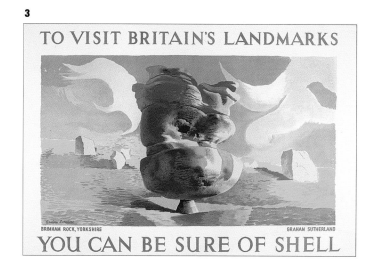

4

VOLKSWAGEN

FERDINAND PORSCHE WAS AN ELECTRICAL ENGINEER WITH A LOT OF GOOD IDEAS. AT 25 HE PRODUCED A REVOLUTIONARY HUB TRANSMISSION SYSTEM FOR ELECTRIC CARS AND WON THE GRAND PRIX AT THE PARIS EXPOSITION IN 1900. BY 1906 HE WAS TECHNICAL DIRECTOR AT THE AUSTRO DAIMLER CAR COMPANY, AND BY THE EARLY 1930S PORSCHE HAD LAUNCHED HIS OWN INDEPENDENT DESIGN "BURO". HIS DREAM OF PRODUCING AN INEXPENSIVE CAR, COINCIDED WITH ADOLF HILTER'S VISION FOR A PEOPLE'S CAR. THE TWO MEN MET AND THE FUHRER AGREED TO FINANCE THE CAR'S DEVELOPMENT.

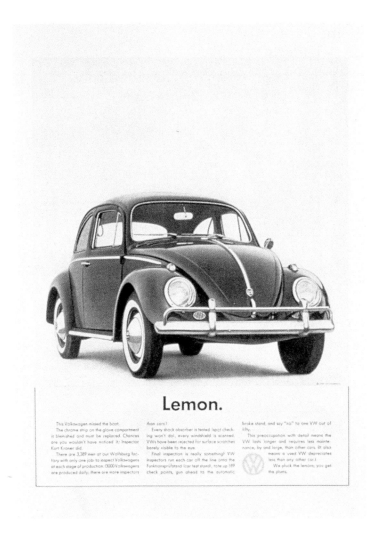

1

1. DATE: 1960.
AGENCY: Doyle Dane Bernbach, New York.
CREATIVE DIRECTOR: Bill Bernbach.
ART DIRECTOR: Helmut Krone.
COPYWRITER: Julian Koenig.
PHOTOGRAPHER: Wingate Paine.

2. DATE: 1985.
AGENCY: BMP DDB Needham, London.
CREATIVE DIRECTOR: John Webster.
DIRECTOR: David Bailey.
MODEL: Paula Hamilton.

3. DATE: 1999.
AGENCY: BMP DDB Needham, London.

Porsche designed the Beetle with a rear-mounted 986cc air-cooled engine capable of 60mph and 40mpg. At the Berlin Motor Show in 1939 Hitler announced the new Volkswagen which he renamed the "KdF Wagen" or "Strength through joy car". As a government-controlled venture, the manufacturer had no selling or advertising costs, a guaranteed market, no need to show a profit to shareholders nor give a discount for agents.

It wasn't until after the war when the British took over the factory in Wolfsburg that the Beetle actually went into production for the first time (and continued until 1978). Yet it was Detroit man Heinz Nordhoff who managed the plant from 1948 and escalated production.

With no water-filled radiator to freeze or boil, the air-cooled engine soon earned the name "motorized tortoise" and reputation of being reliable, as well as being a good antidote to the gas-guzzling monsters being disgorged by Detroit. By the end of the 1950s, Beetle sales in the States had topped 150,000 a year – with a six month waiting list, despite no help from advertising. But competition was looming. The three Detroit giants – Ford, General Motors and Chrysler – were introducing small cars to challenge increasing European imports. VW's Carl Hahn chose to advertise to maintain sales of the Beetle.

In the meantime, Bill Bernbach and Ned Doyle left Grey Advertising and joined a small agency run by their friend Mac Dane in New York. In 1959, the decade-old agency, Doyle Dane Bernbach (DDB), was awarded the VW account. Other car ads of the period were honed and sanitized by consensus. They featured flashy air brushed models or sleek photographs with wide angle lens distortion. Bernbach rejected this collective wisdom. "Imitation can be commercial

2

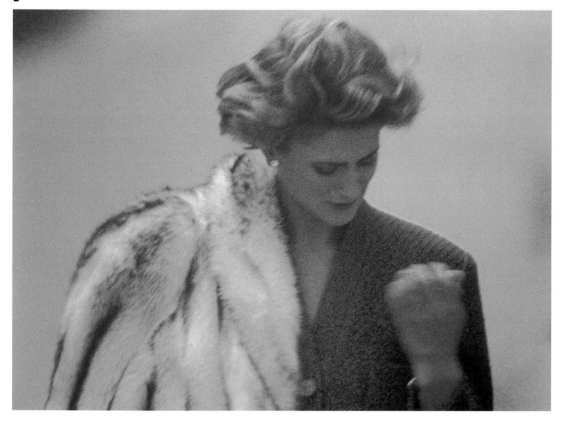

everything was as reliable as a VW". In a TV commercial directed by David Bailey, a lady storms out of the house, discarding all the trinkets bestowed on her by her partner – fur coat, jewellery etc – but (on second thoughts) not the car keys. After all, the VW is reliable, even if he isn't.

Reliability means high mileage. A print ad produced by DDB in Paris shows the kilometre reading turn over to "etcetc" after 999,999. And you can almost hear the knowing sigh in the tone of voice.

In Chinese, the name Volkswagen – *da zhong* – translates as "the mass of the people".

The tone of voice of VW advertising was – and is – warm and human. VW has become a friend with whom the consumer can share a gallery of jokes. The People's Car (and its offspring) is uniquely loved by the people. And so is the advertising.

suicide. It's not just what you say that stirs people. It's the way that you say it," he said. "I wouldn't hesitate for a second to choose the plain looking ad that is alive and vital and meaningful, over the ad that is beautiful but dumb."

In 1960, together with Helmut Krone and Julian Koenig, Bernbach created the first VW campaign, with a promise in every ad. It not only changed car advertising, but revolutionised the approach to advertising in general. In the face of all the hype and exaggeration, Bernbach showed the Beetle for what it was. This was the opposite to aspirational advertising, the antithesis to the American dream. VW ads were disarmingly honest, thought-provoking and talked to the reader as an intelligent friend. "Lemon" and "Ugly is only skin deep" were two of the early headlines.

Helmut Krone established a simple format for the ads: large photograph, clear headline, then the copy. The design was a breakthrough when it was introduced, and is the basis of many ads today.

Charlie Piccarillo was assistant to Krone. "Our aim was to simplify the message, get down to the core. VW advertising was characterised by the three 'Ss' – Simple, Surprise and a Smile. We used intuition a lot. Now we use research." Rephrasing the well-known dictum, he adds, "Clients want to get more information into an ad, but the more we put in, the less everybody takes away."

Garry Walton, one-time art director on the VW account at DDB's London office, says, "The format of VW ads doesn't get in the way of the message. We want people to notice the vehicle, not the ad. If it's not simple, people become involved in reading the design, at the expense of the message."

"It is a clever approach in a marketplace where people have stopped believing ads. Even I don't believe ads,

and I make them," says John O'Driscoll, one-time creative with DDB in London. "We never went to glamorous locations to photograph the car. And we used a simple, self-effacing, not self-congratulatory approach which only worked with a car that was as funny looking as the Beetle."

The cold weather provided DDB with a perennial opportunity to emphasis its reliability. As the car was not water-cooled, it did not freeze up. Hence the classic ad: "How does the snowplough driver get to the snowplough?"

Reliability led to the proposition created in the UK in 1985: "If only

3

I'M GROWN-UP

I'M GOING DOWN THE SHOPS

VOLVO

A 17 YEAR-OLD VOLVO AND TWO OF ITS CONTEMPORARIES.

The Volvo has an average life expectancy of 17.9 years.

According to the Swedish government, who keeps records, that's longer than any other car.

Longer than Volkswagen. Longer than Mercedes.

In fact, in Sweden 47% of the Volvos registered in 1961 are still on the road.

Which makes them nineteen years old.

Of course, not everyone wants to keep a car that long but a car that's built to last seventeen years or more has certain short-term advantages too.

Check the re-sale value of a 6-year old Volvo and you'll begin to see our point.

A Volvo that cost £2,155 new in 1974 can still command £2,050. (Parker's Car Price Guide.)

And as you'd expect, a car that's built to last is also built well.

In survey after survey, the Volvo emerges as one of the most trouble-free cars on the road.

So whether you plan to keep your car for 2 years or 17, no car will keep better than a Volvo.

Please send me the 1980 edition of 'Volvo Facts.'
To: Volvo Concessionaires Ltd., London W13 9JQ.
Name_____
Address_____

VOLVO. A CAR WITH STANDARDS.

PRICES FOR THE NEW 1980 200 SERIES START FROM £5,995 (DELIVERY & NUMBER PLATES EXTRA). ALL PRICES CORRECT AT TIME OF GOING TO PRESS. SALES TEL: HIGH WYCOMBE (0494) 33444. SERVICE TEL: IPSWICH (0473) 72026. PARTS TEL: CRICK (0788) 82 3511. SOURCE: SWEDISH MOTOR VEHICLE INSPECTION CO. 1977.

1

THE FIRST VOLVO – NICKNAMED JAKOB – LEFT THE PRODUCTION LINE IN GOTHENBURG, SWEDEN, IN APRIL 1927. FOUNDED BY BUSINESSMAN ASSAR GABRIELSSON AND ENGINEER/DESIGNER GUSTAF LARSON WHO HEADED THE COMPANY UNTIL THE MID-1950S, VOLVO (LATIN FOR "I ROLL") GREW TO BECOME SCANDINAVIA'S LARGEST INDUSTRIAL ENTERPRISE.

When the London agency Abbott Mead Vickers took over the account, it created a Volvo look in which the ad lines worked off the pictures. It was a technique popularized by the early VW Beetle ads in the early 1960s. (pp.190–91) Without the line, the picture conveys very little, and vice versa.

In 1959 the Volvo P120 and PV544 became the first cars in the world to offer safety belts as standard. Since then, safety, reliability and durability have been recurrent themes in Volvo advertising. "They last longer" was turned into

an ad with graphic impact by showing an ageing Volvo next to two scrapped contemporaries.

"The original concept grows from the client's brief", says art director Ron Brown. "It's up to the art director and copywriter to single out one advantage of the product on which to focus their thinking. When I first start thinking about a concept, my mind fans out in many different ways, though I'm only looking for one idea. A good brief helps speed up the process. Sometimes it's a question of juggling the material around, sometimes an idea will come

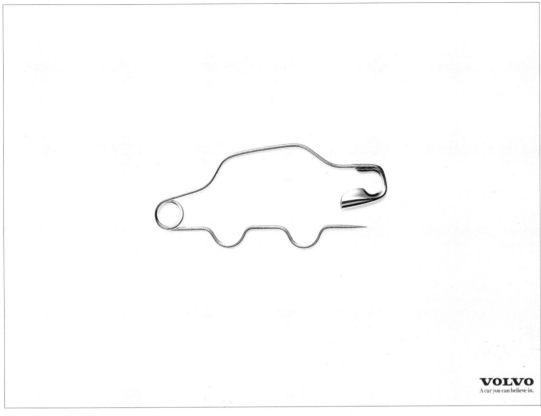

2

out of the blue, a phrase stored in my memory may suddenly come leaping through."

The strong protective frame of the Volvo was demonstrated by New York agency Scali McCabe Sloves in a 1988 commercial in which a truck was placed on the roof of one. The voice-over asked, "How well does your car stand up to heavy traffic?"

Perhaps the simplest, most graphic illustration of safety was created in 1996 by Masakazu Sawa in Japan. "I thought it would provide more effective communication if the readers themselves were able to equate Volvo with safety merely by seeing the safety-pin visual. Conveying a strong message with just a visual is an ideal method in advertising. Following the newspaper campaign, sales increased by 20 percent," says Sawa.

The trouble with safety, reliability and durability is that they sound boring – or

at least conservative. And by the 1990s most cars had developed similarly impressive specifications. To counter the uninspiring image, AMV/BBDO devised a strategy based on the concept of "Intelligent Risk", focusing primarily on user image and backed up by the core brand attributes. The aim was to use the Volvo 850 to communicate different, exciting and appealing through three dramatic TV commercials, "Stuntman", "Photographer" and "Twister" – adventurous situations, requiring the dependable safety of a Volvo. Authentic scenarios separated these from the flash, self-conscious imagery of some other car advertising.

The campaign repositioned Volvo as the car for doctors who rock climb and mothers who windsurf, projecting excitement built on solid foundations: intelligent risk. After 18 months, sales had risen 27 percent and market share increased from 10 to 17 percent.

3

1. DATE: 1980.
AGENCY: Abbott Mead Vickers, London.
ART DIRECTOR: Ron Brown.
COPYWRITER: David Abbott.

2. DATE: 1996.
AGENCY: Dentsu Young and Rubicam, Tokyo.
ART DIRECTOR: Masakazu Sawa.
COPYWRITER: Minoru Kawase.
PHOTOGRAPHER: Megumu Wada.

3. DATE: 1995.
AGENCY: Abbott Mead Vickers, London.
CREATIVE DIRECTOR: David Abbott.
ART DIRECTOR: Walter Campbell.
COPYWRITER: Tom Carty.
DIRECTOR AND PROCUCER: Tony Kaye Films.

TRAVEL

MONACO GRAND PRIX

JAPAN RAILWAYS

THE CENTURY STARTED WELL with a promising advertisement that appeared in the London *Times* in 1900. It presented no guarantee or glorification of the benefits, and certainly no glossing over the potential pitfalls.

Placed by Polar explorer Ernest Shackleton the ad, which was short, had a tone of voice that the public found irresistible: "Men wanted for Hazardous Journey. Small wages, bitter cold, long months of complete darkness, constant danger, safe return doubtful. Honour and recognition in case of success – Ernest Shackleton."

The enormous response to Shackleton's frank, no-nonsense approach might have convinced advertisers in the early years of the century that you don't have to be dishonest, untruthful or indecent to sell products and services. You can tell it like it is. Yet disarming honesty was only adopted by a brave few and it wasn't until Bernbach's Volkswagen Beetle ads embraced such philosophy in the 1960s – with huge success and lasting impact – that advertisers more generally sat up and took notice (p. 190–91).

The advertising industry has always had to guard against truth decay; humility runs counter to the selective approach that most agencies feel they must adopt to woo an audience. "If I'm proposing to a girl, I don't feel called upon to tell her that I have this unfortunate habit of picking my nose!" says David Ogilvy. "There are often some negatives, but I think we have the right to put our best foot forward."

Travel and tourism advertising in the twentieth century has taken many imaginative steps to inspire people to move around the world. As modes of transport flourished, especially in the early decades, posters played a key role in increasing public awareness of what was available.

The first Zeppelin flew in 1900, followed three years later by the first powered flight by the brothers Roville and Wilbur Wright. In 1911 Calbraith P. Rodgers completed the first transcontinental flight across the United States, from New York City to Long Beach, California, in 3 days, 10 hours, and 14 minutes. Alcock and Brown flew across the Atlantic in 1919, then in 1924 two US aviators made the first flight around the world, taking six-and-a-half months. The earliest aeronautical posters advertised air shows and exhibitions.

In 1927 Charles Lindbergh's solo flight from New York to Paris in the Spirit of St Louis took him over the Atlantic in 33 wave-hopping hours. In 1930 Amy Johnson flew solo from London to Australia in just under 20 days. By 1935 airlines were offering flights around the world. Next came Frank Whittle's first jet engine in 1937, and then Pan American Airways' regular commercial flights between the US and Europe in 1939. The emerging commercial airlines, such as

BOAC, BEA and Pan-American, began to feature from the 1930s, and flourished in the 1950s and 1960s when air travel became more readily accessible. Photography did not play a big role in transport advertising until the late 1950s, from which time it has been used extensively.

Art Nouveau arrived in the ad world in the 1890s, at about the same time as the popular magazine was introduced. Many early travel posters adopted the Art Nouveau style, with its elegant lines and solid blocks of colour. France, in the vanguard of poster design, appreciated it particularly.

Early posters were illustrated versions of the companies' schedules and rates. As tourism grew in importance, posters proliferated for the means of transport as well as the destination resorts and the sport and leisure activities that they offered (p.199).

During the 1920s, Art Deco emerged from the trend for simplification. The new style featured parallel lines, repeated shapes and a crisp, clean look. Russian-born A.M. Cassandre replaced the decorative frills and prancing nymphettes of Art Nouveau with stark, graphic lines and unusual viewpoints. His work was characterized by the angularity of the designs and dramatic use of typography. He produced numerous railway and shipping posters during the 1920s and 1930s for British

and French companies. One of his best-known posters was for the great French passenger ship, the *Normandie* that crossed the Atlantic in the record time of four-and-a-half days (p.207), winning the Blue Riband.

Railway posters first appeared around 1900 in Europe and flourished for the next three decades. They enjoyed their heyday in Britain between 1923 and 1947, after which the nationalization of the railways helped bring about their gradual demise. Railroad and steamship lines were among the first in the USA to use advertising.

Like advertising in all other sectors, holiday and travel advertising presents the product's best face; and if the realities don't always live up to the promises, this is one sector where people don't altogether mind – they enjoy anticipating the break from their day-to-day lives too much. "It's hard for advertising to be a positive addition to someone's day," says Anthony Easton who art directed some of the British Airways ads for Saatchi and Saatchi (p.196). "But if you can get people to feel good about the ad, they will like the product."

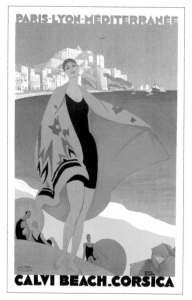

BRITISH AIRWAYS

At the beginning of the 1980s British Airway's claim, "We'll take more care of you", had a hollow ring to it. In 1981–82 the company was running at a loss of £541 million. Staff cuts had deflated an already low morale, and the company was considered a poor investment.

In 1982 Lord King and Sir Colin Marshall were brought in to turn BA around in preparation for privatization. That year Saatchi and Saatchi was appointed to help create an inspiring advertising campaign. The brief was to capture BA's new corporate vision to become the best and most successful international airline in the world, and to attract consumers willing to pay a premium.

The corporate goal was translated into the slogan, "World's favourite airline", positioning BA as the airline that more people chose to fly. This claim was based on the fact that the airline carried more passengers internationally than any other airline.

Advertising around the world played a key role in building BA's image. High-profile directors, including Hugh Hudson (*Chariots of Fire*), were given large budgets to produce grand, blockbuster extravaganzas. In the period 1983–85, commercials such as Manhattan focused on the size, stature and internationalism of BA. The 1985–87 commercials concentrated on the improved service, while privatization was also highlighted. In 1989–94 the campaign refocused on a wider public, reaffirming the warmth and humanity of BA's personality: We bring 24 million people to other people all around the world every year.

In the face of strong competition from major international airlines, building the brand always took precedence over increasing sales. The cost of the advertising was small relative to the value it created. Over 10 years, BA spent £400 million on advertising, while the premium price and growing market share over the same period was worth over £5 billion. Largely through television and cinema advertising, BA was transformed from a loss-making company into the world's most successful airline, both in terms of perception and profitability.

DATE: 1990.
AGENCY: Saatchi and Saatchi, London.
ART DIRECTOR: Graham Fink.
COPYWRITER: Jeremy Clarke.
DIRECTOR: Hugh Hudson.
PRODUCTION COMPANY: Hudson Films.

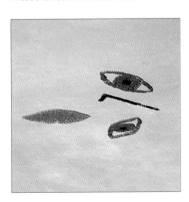

CLUB 18–30

DATE: 1995.
AGENCY: Saatchi and Saatchi, London.
ART DIRECTOR: Dave Hillyard.
COPYWRITER: Ed Robinson

CLUB 18–30 IS A UK TOUR OPERATOR SPECIALIZING IN PACKAGE HOLIDAYS TO THE MEDITERRANEAN FOR YOUNG PEOPLE. THE COMPANY GAINED A REPUTATION FOR CATERING TO THE SEXUAL EXCESSES OF THE YOUTH MARKET. THE CORE GROUP OF 18–24 YEAR OLDS ARE UNATTACHED, HAVE FEW COMMITMENTS AND THEREFORE HAVE A RELATIVELY HIGH DISPOSABLE INCOME.

After a turbulent patch in the early 1990s, with the collapse of its parent company, IPG, Club 18–30 had to change its name to "The Club" and operate on a meagre budget. When the original brand name was reinstated in 1995, the company returned to mainstream consumer advertising with a controversial campaign that raised its profile to cult status.

The ad agency aimed to increase awareness of the Club 18–30 experience and reclaim its lead position in the youth holiday market. At the same time, the objective was to ensure that the message was sufficiently clear to discourage inappropriate applicants.

In effect, the brief was an invitation to air sexual innuendoes and be as explicit as the creative team could get away with. This was achieved by exposing the naked truth about the brand in order to heighten expectations. Being humorous, irreverent, even outrageous came with the territory as it reflected the mindset of the target market – both male and female. "Summer of 69" is perhaps the neatest application, sending a clear message to the initiated. While non-members are musing nostalgically about their holidays three decades ago, those in the know smile knowingly at the shared allusion.

A full multimedia campaign from 1995–97 used press, posters, cinema and radio. As it progressed, outdoor posters directed the target audience to new, more risqué ads in the specialist press, thus reducing the offence to those outside the club.

Inevitably the campaigns sparked great controversy, with the resultant barrage of media coverage that multiplied the effectiveness of the advertising spend. Bookings grew by 35 percent at a time when the overall market declined by 5 percent.

CONDOR AIRLINE

Ihr Wecker sagt, wann Sie
aufstehen sollen. Ihr Freund
sagt, was Sie kochen sollen.
Und die Wetterkarte sagt Regen.
Also fliegen Sie mit Condor
nach Gran Canaria und sagen
selber mal, wo es langgeht.

Condor
Die Ferienflieger der Lufthansa

DATE: 1992.
AGENCY: Michael Conrad, Leo Burnett, Frankfurt.
ACCOUNT MANAGER: Kai Salein.
ART DIRECTOR: Peter Austenfeld.
PHOTOGRAPHER: Michael Ehrhart.

"AS CONDOR IS DAUGHTER COMPANY OF LUFTHANSA, PEOPLE ALREADY HAVE CONFIDENCE IN THE TECHNOLOGICAL ASPECTS OF THE AIRLINE," SAYS ACCOUNT MANAGER KAI SALEIN. "PEOPLE GOING ON HOLIDAY DON'T WANT TO KNOW ABOUT THE SIZE OF THE SEATS IN THE AIRCRAFT, THEY WANT TO BE INSPIRED BY MAGIC HOLIDAY MOMENTS."

Being light-hearted and entertaining was not typical of German advertising up to this time, but the more daring agencies and their clients were showing signs of moving from a solidly informative approach towards a more subtle and amusing one that credited the audience with intelligence and invited participation. The Condor campaign is a good example.

In their dreams people want to be different, and the photograph demonstrates that holidays with Condor are spectacularly different from the average holiday. The agency brief to Frankfurt photographer Michael Ehrhart was to shoot amusing, zany vacation photos in the Seychelles.

Ehrhart notes that the freedom he enjoyed on that shoot is still the exception in German advertising. "Clients and agencies rely on market research in an attempt to safeguard the success of their advertising campaigns," he says. "Creative directors have difficulty pushing their own ideas through because the clients are reluctant to give them a free hand."

Art director Peter Austenfeld agrees that the transition from prosaic to poetic advertising has met considerable resistance – ads that present sound, logical reasoning sit more comfortably with the German psyche. "Everybody in German advertising looks to England, not America or France," says Austenfeld. "We like English advertising, though it is hard to sell the more progressive ideas to our clients."

DESTINATION POSTERS

As EARLY AS THE 1880s, POSTERS BEGAN TO APPEAR ADVERTISING FASHIONABLE SPA AND COASTAL TOWNS.

Adopting the flowery Art Nouveau style prevalent at the time, they depicted detailed landscapes and elaborately attired figures. Many were commissioned by the railway companies – the early posters were simply decorated train timetables.

Advances in modes of transport brought leisure destinations within reach of the masses in the early decades of the twentieth century. Posters, especially in Britain, France and Switzerland, were widely used to promote the attractions of the destinations. Many, such as Dorival's rendering of the French resort Entretat, featured sports, notably golf and tennis. Winter sports – mostly in French and Swiss mountain resorts – also provided dramatic subjects. A series of five posters by Mangold spelt out the letters of the winter resort Davos.

Calvi Beach, Corsica, by Rogers Broders, a leading travel poster designer of the 1920s & '30s, epitomizes the elegance of Art Deco style. His simplified designs rely on clean lines, bright colours and a minimum of lettering. Many posters of the Art Deco period revel in fashionably clad, elongated figures – and now provide insights into dress and social conventions.

DATE: 1920s.
ARTIST: Rogers Broders.

FRENCH GOVERNMENT TOURIST BOARD

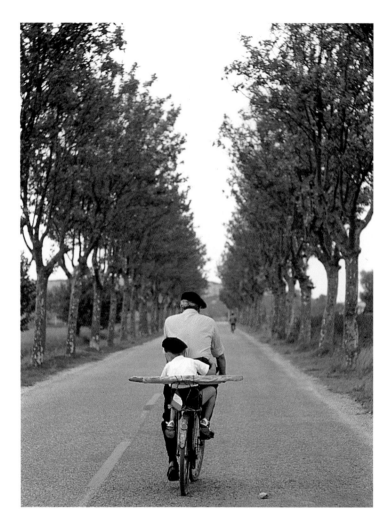

DATE: 1960s.
AGENCY: Doyle Dane Bernbach, New York.
CREATIVE DIRECTOR: Bill Bernbach.
PHOTOGRAPHER Elliott Erwitt.

DAVID OGILVY SINGLES OUT THIS PICTURE AS "THE BEST PHOTOGRAPH IN THE HISTORY OF TRAVEL ADVERTISING — THE ABSOLUTE ESSENCE OF FRANCE."

Elliott Erwitt photographed a series of ads for the French government over a period of years. Most of the time he was given a free hand. "Fortunately a lot of the early travel stuff was not prescribed," he says. "For example, Bob Gage at Doyle Dane Bernach called me in and said 'Why don't you go to Jamaica and take some snaps?' So there was the Jamaica campaign. I've done a similar campaign for Australia, again without a brief. Personally, I think that's the right way to work. These are people who have confidence in you. You're free to use your imagination and you perform better because it's more of a personal effort."

Erwitt became a member of Magnum Photos in 1953, six years after it was founded, joining Robert Capa, Henri Cartier-Bresson, Werner Bischof and Ernst Haas. Like his colleagues, Erwitt was a storyteller, who could initiate, shoot and edit his own stories. Yet he did not consider himself above commercial work. "I don't resist commissions where they have a drawn layout," he says. "I'm a taxi driver. If someone flags me down for a job, and if I think I can do it, then I do it. But when a picture has been researched to death, that takes the fun and spontaneity out of it.

"The Frenchman on a bicycle has been copied a lot. The one time that I was hired to copy my own picture was when the agency Lowe Howard-Spink asked me to parody that shot for a Heineken ad."

JAPAN RAILWAYS

DATE: 1993.
AGENCY: Dentsu, Tokyo.
CREATIVE DIRECTOR: Hiroshi Sasakai.
ART DIRECTOR: Tetsu Goto.
DESIGNER: Yoshihsa Ohura.
PHOTOGRAPHER: Katsuju Takasaki.

THE BULLET TRAIN — OR SHINKANSEN — RUNS BETWEEN TOKYO AND OSAKA. IT IS CLEAN, EFFICIENT AND FAST, ZIPPING ALONG AT 210 KM/PH (130 MPH). IT STOPS AT KYOTO, THE FORMER CAPITAL OF JAPAN AND ONE OF ITS BEST-LOVED TOURIST DESTINATIONS. THE CENTRAL JAPAN RAILWAY COMPANY WAS LOSING BUSINESS PASSENGERS TO THE AIRLINES, SO DECIDED TO LAUNCH THE "YES, LET'S GO TO KYOTO" CAMPAIGN ON THE 1,200TH ANNIVERSARY OF THE CITY BECOMING THE CAPITAL. THE POSTER FEATURES KIYOMIZU TEMPLE.

The campaign was based on the premise that people had only a vague idea of the Kyoto shrines and temples from textbooks, postcards or school outings. The idea was to contrast this vague, formal and possibly boring memory with something more dynamic. This was achieved through creative camera angles and an inventive soundtrack that used the song "My Favourite Things" from the Rogers and Hammerstein musical, *The Sound of Music*. And by dubbing footsteps and the sound of wind over the images, the viewer feels involved in the scene, although nobody actually appears.

The campaign captured the hearts of young Japanese, who are not usually attracted by Kyoto's past glories.

The ad agency, Dentsu, was founded in 1901. It pioneered many innovative moves within Japanese advertising and became, in 1973, the world's largest ad agency in terms of billings.

LONDON TRANSPORT

1

1. DATE: 1913.
ARTIST: Tony Sarg.
2. DATE: 1929.
ARTIST: Manner.
3. DATE: 1939.
ARTIST: Man Ray.

LONDON TRANSPORT POSTERS DATING FROM THE EARLY YEARS OF THE TWENTIETH CENTURY ARE AMONG THE MOST INNOVATIVE, ENTERTAINING AND ARTISTICALLY VARIED ADS EVER PRODUCED.

Posters were introduced on London Underground stations by publicity manager Frank Pick when he was trying to improve the service's poor image; they illustrated the destinations reached by the trains and integrated bus services. Pick was effectively a patron of the arts and commissioned many young artists, including Frank Newbold and Terence Cuneo, to extol the virtues of Kew Gardens, Regent's Park Zoo and other popular attractions. Tony Sarg's bird's eye views, populated with animated cartoon vignettes and packed with anecdotal detail, promoted Richmond Park, Hampstead and Southend.

In 1916 Pick commissioned Edward Johnson to create a new typeface for his posters. The result was the first san serif type of the twentieth century.

Although Manner was a little-known designer, he created a striking image of umbrellas – "No wet, no cold" – to illustrate the unattractive alternative to travelling in the shelter of the Underground.

The American surrealist painter and

2

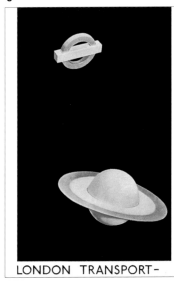

photographer, Man Ray, worked in Paris. While making contact prints from large plate negatives, a sheet of unexposed light-sensitive paper became mixed up with a batch of paper being developed. "As I waited in vain a couple of minutes for an image to appear, regretting the waste of paper, I mechanically placed a small glass funnel … and the thermometer on the wetted paper," he wrote. "I turned on the light; before my eyes an image began to form, not quite a simple silhouette of the objects, but distorted and refracted by the glass more or less in contact with the paper and standing out against a black background." Man Ray refined the process and developed what he called Rayographs or camera-less photographs. He used his unique style in fashion magazines during the 1930s and also created two posters for London Transport. His futuristic image of Saturn with an orbiting London Transport logo introduced surrealism to a wider British audience.

3

LOUIS VUITTON

1

Chawda.

Celles qui voyagent dans l'âme éprouvent le désir d'atmosphères étranges, de lointains légendaires, d'horizons sans fin, où tout ce qu'elles regardent est digne d'être aimé. Pour elles, Louis Vuitton, malletier à Paris depuis 1854, a créé de nouveaux instruments du voyage en Cuir Epi. Pureté des formes inspirées, séduction du cuir le plus précieux, profondeur des couleurs, ils invitent aux voyages dans l'élégance et le raffinement.

Louis Vuitton. L'âme du voyage.

LOUIS VUITTON
MALLETIER A PARIS

MAISON FONDÉE EN 1854

Louis Vuitton dans ses magasins exclusifs à Paris et dans les principales villes du monde.
En Europe: Londres · Copenhague · Berlin · Düsseldorf · Francfort · Hambourg · Munich · Kampen · Vienne · Zurich
St. Moritz · Milan · Rome · Florence · Venise · Madrid · Barcelone · Lisbonne · Koweit
Paris, 78 bis avenue Marceau, 57 avenue Montaigne · Nice, 2 avenue de Suède · Cannes, 44 La Croisette
Deauville, rue du Casino · Strasbourg, 18 place de la Cathédrale
Monte-Carlo, 6 avenue des Beaux Arts · Bruxelles, 25 avenue Louise
Genève, 40 rue du Marché · Lausanne, 30 rue de Bourg · Crans-sur-Sierre, rue du Prado

IN 1837, 16-YEAR-OLD LOUIS VUITTON WALKED TO PARIS FROM HIS HOME IN THE JURA MOUNTAINS OF EASTERN FRANCE. HE BECAME AN APPRENTICE PACKER AND TRUNK-MAKER AND BY 1854 HAD SET UP SHOP AT NO.4 RUE NEUVE DES CAPUCINES. HIS FLAT-TOPPED, CANVAS-COVERED TRUNKS WERE WELL SUITED TO THE EMERGING RAIL TRAVEL AND SOON SUPERSEDED THE HEAVY, DOMED LUGGAGE USED BY STAGE-COACH TRAVELLERS.

By 1920 his factory was turning out functional yet stylish orders for Coco Chanel, the Aga Khan and the President of the French Republic, as well as Indian maharajahs. It was an era in which people travelled with up to 50 pieces of luggage so they could combine the art of living with the art of travel.

In 1980, after 40 years without advertising, Louis Vuitton launched an extravagant campaign to bring traditional luxury luggage back into vogue by evoking the ultimate in aspirational travel. The company's director of design was Françoise Jollant Kneebone. "In the luxury business you are selling a dream as well as an object," she says. "This is reflected in our advertising, which focuses less on the product than the idea – the soul of travel."

Jean François Bentz, who had recently founded Le Creative Business in Paris, set out to create great images of epic voyages conducted in the lavish style worthy of hand-made, *haute couture* luggage. Bentz later moved to the larger agency, RSCG, taking the account with him. "I wanted to embrace the subjective, emotional aspect of Vuitton as well as the objective, physical qualities of the product," he says. "The bags or cases should be recognizable in the pictures, without being dominant. Too strong a

2

Ganganagar.

LOUIS VUITTON
MALLETIER A PARIS

MAISON FONDÉE EN 1854

Louis Vuitton dans ses magasins exclusifs à Paris et dans les principales villes du monde.
En Europe: Londres · Copenhague · Berlin · Düsseldorf · Francfort · Hambourg · Munich · Kampen · Vienne · Zurich
St. Moritz · Milan · Rome · Florence · Venise · Madrid · Barcelone · Lisbonne · Koweit
Paris, 78 bis avenue Marceau, 57 avenue Montaigne · Nice, 2 avenue de Suède · Cannes, 44 La Croisette
Deauville, rue du Casino · Strasbourg, 18 place de la Cathédrale
Monte-Carlo, 6 avenue des Beaux Arts · Bruxelles, 23 avenue Louise
Genève, 40 rue du Marché · Lausanne, 30 rue de Bourg · Crans-sur-Sierre, rue du Prado

Ⓥ Les voyageurs dans l'âme pensent,
vivent et voient au-delà des seules apparences.
Aussi, jusque dans le choix de leurs bagages,
recherchent-ils l'empreinte de l'authenticité.
Malletier depuis 1854, Louis Vuitton a créé
pour eux de nouveaux instruments de voyage:
les «Nomades» en cuir naturel.
Modèles fonctionnels, formes essentielles:
la simplicité n'est-elle pas le plus beau des
luxes?

Louis Vuitton. L'âme du voyage.

presence would dilute the image ... the dream. People are buying a piece of legend."

Bentz hired leading Paris still-life photographer Jean Larivière to translate the personality of the product into stunning visual images. He used his previous cinematic experiences and his earlier memories to capture a romantic, nostalgic vision of travel. "In my pictures I am trying to tell a continuing love story," says Larivière. "I keep finding intriguing visions which have been hiding in my head since childhood."

Framed within the cropped "widescreen" viewfinder of his Hasselblad, Larivière methodically built up each element of the picture, much as a child might construct a castle of bricks, yet the elegant fantasies of the photographs belie the often painful logistical reality experienced by his valiant support team. "There is never a problem in Vuitton travels; it's always been a royal way to travel," says Larivière, who entered into the spirit of the dream by employing an entourage of helpers to lug the luggage, hold the reflectors or pick out thousands of unsightly weeds from a lake.

Unwillingness to compromise helped create one of the most coveted campaigns of the 1980s.

DATE: 1980s.
AGENCY: Le Creative Business, Paris.
CREATIVE DIRECTOR: Jean François Bentz.
PHOTOGRAPHER: Jean Larivière.

MONACO GRAND PRIX

Tʜᴇ ᴀᴅᴠᴇʀᴛɪsɪɴɢ ᴀɴᴅ ᴀᴜᴛᴏᴍᴏᴛɪᴠᴇ ɪɴᴅᴜsᴛʀɪᴇs ʜᴀᴠᴇ ɢʀᴏᴡɴ ᴛᴏɢᴇᴛʜᴇʀ, ᴇᴀᴄʜ ꜰᴇᴇᴅɪɴɢ ᴛʜᴇ ᴏᴛʜᴇʀ. Eᴀʀʟʏ ᴍᴏᴛᴏʀɪɴɢ ᴘᴏsᴛᴇʀs ᴏꜰᴛᴇɴ ʀᴇꜰʟᴇᴄᴛᴇᴅ ᴛʜᴇ ᴘʀᴇᴏᴄᴄᴜ-ᴘᴀᴛɪᴏɴ ᴡɪᴛʜ ʀᴀᴄɪɴɢ. Tʜᴇʏ ᴘʀᴏᴠɪᴅᴇᴅ ᴀɴ ᴏᴘᴘᴏʀᴛᴜɴɪᴛʏ ᴛᴏ ᴄʀᴇᴀᴛᴇ ᴅʀᴀᴍᴀᴛɪᴄ ᴅᴇsɪɢɴs ᴄᴏɴᴠᴇʏɪɴɢ ᴘᴏᴡᴇʀ ᴀɴᴅ sᴘᴇᴇᴅ. A ʙᴜʀɢᴇᴏɴɪɴɢ ᴘᴀssɪᴏɴ ꜰᴏʀ ᴄᴀʀs ᴀɴᴅ ʀᴀᴄɪɴɢ ᴡᴀs ᴇᴄʜᴏᴇᴅ ʙʏ ᴀɴ ɪɴᴛᴇʀᴇsᴛ ɪɴ ᴀᴜᴛᴏᴍᴏᴛɪᴠᴇ ᴀʀᴛ.

International car racing effectively began in France in 1902. The country's importance was reinforced by the French Grand Prix in 1906. French posters during the subsequent Art Deco period developed strong linear designs and flat areas of colour. Graphic portrayal of major racing events attracted the sponsorship of both manufacturers and tourist agencies keen to endorse cars and destinations. The Monaco Grand Prix poster is typical of the lithographs by the prominent artist of the era, Georges Hamel, who signed himself Geo Ham or sometimes Geo Matt.

Besides motor manufacturers, posters were designed for motoring clubs and driving schools, as well as for the manufacturers of accessories, such as Michelin and Pirelli (p.178, 182).

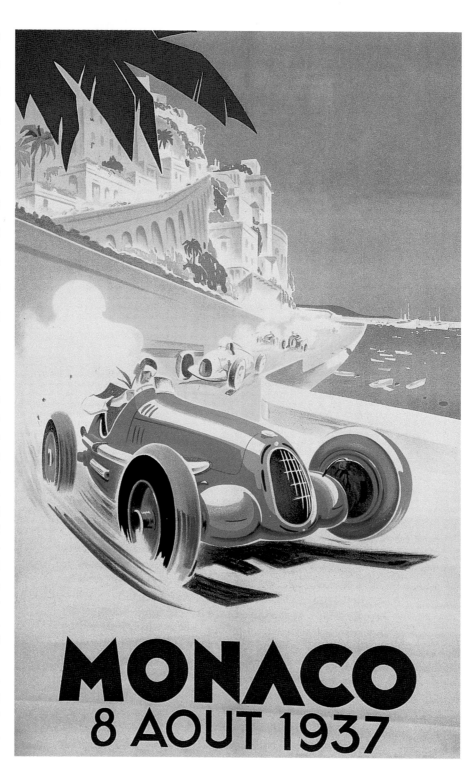

DATE: 1937.
ARTIST: Georges Hamel
(Geo Ham).

NORMANDIE

DATE: 1935.
AGENCY: Alliance Graphique, Paris.
ARTIST: A.M. Cassandre.

It was the fastest and most luxurious liner in the world. The palatial art deco *Normandie* left Le Havre in France on 29 May 1935, with 3,500 passengers on board. It arrived in New York on 3 June, having broken the record for the North Atlantic crossing.

Prominent poster artist Cassandre – real name Adolphe Jean-Marie Mouron – was born in Ukraine in 1901. He applied the conventions of the formal art movements to advertising posters, recreating the effect of montaged photographs in his graphic designs. Besides being commissioned by the railways, most notably Nord Express and Etoile du Nord in 1927, he was commissioned by all the major shipping companies.

Earlier posters had used a lot of lettering and detailed illustrations; Cassandre developed simpler outlines with powerful geometric forms. His stylish and evocative designs, displayed in travel agencies and booking offices, emphasized luxury, power and speed. He viewed his work in commercial terms, describing the poster as an announcing machine.

After several unsatisfactory attempts to capture the grandeur of the *Normandie*, Cassandre visited Le Havre for a closer encounter. He took to a little rowing boat and gazed up at the immense hull of the ship from the viewpoint that provided the angle and perspective for his poster.

NEW HAVEN RAILROAD

A LATERAL APPROACH IS OFTEN VASTLY MORE EFFECTIVE THAN A DIRECT ONE, ESPECIALLY IF PITCHED AT A SUITABLE EMOTIONAL LEVEL. IN THE 1940S, THE PSYCHOLOGY OF ADVERTISING WAS IN ITS INFANCY – AT AN INTUITIVE STAGE – WHEN THIS POIGNANT ADVERTISMENT REACHED OUT TO THE NATION'S CONSCIENCE.

At a time when the USA was suffering shortages and poor service because of World War Two, Nelson C. Metcalf had to write ads asking users of the New Haven Railroad to be patient.

After several entreaties had failed to win widespread support, Metcalf decided to aim for the heart strings. His personal, human tale appealed to people's patriotism, humanity and compassion. Cynics and doubters warned that it was too corny or slushy and the ad was nearly pulled. The copy was long, the message oblique and the theme unashamedly sentimental, yet the boy in the top bunk on a troop train appeared in the *New York Tribune* and made people feel ashamed to complain about the service. A huge readership response led to the ad being read by celebrities on radio, made into a song and reproduced free in leading magazines and newspapers. MGM even made the story into a movie short. Against the background of war people found it so moving that it won the highest award for advertising copy in 1942.

DATE: 1942.
COPYWRITER: Nelson. C. Metcalf.

PUERTO RICO

DATE: 1950s.
COPYWRITER: David Ogilvy.
PHOTOGRAPHER: Elliott Erwitt.

Pablo Casals is coming home – to Puerto Rico

THIS SIMPLE ROOM is in his mother's home at Mayaguez. The first concert Casals ever gave in Puerto Rico was from the balcony of this house last year—just beyond that fanlight.

While his mother's kinsmen listened from the street, Casals played her lullaby, smoked his pipe and wept.

The back of that armchair bears an inscription in Casals' own handwriting. "Este es mi sillón." This is my rocking chair.

Here are gentle thoughts from the world's greatest cellist—on Puerto Rico, the sea and himself:

"The first time I was aware that I was alive, I heard the sound of the sea. Before, I would have said that the most beautiful sea was the one I had in front of my Spanish house. But now I must confess that the sea I am looking at this moment is even more beautiful."

Of his plans for the future, Pablo Casals had this to say:

"The natural thing that occurs to me, is to come back to Puerto Rico and to do for this country everything within my power. I will be back for the festival I have planned for this coming Spring."

PUERTO RICO'S GREAT NEW MUSIC FESTIVAL IN SAN JUAN

The Casals Festival in San Juan opens on April 22nd and will continue through May 8th. Pablo Casals will conduct or perform at each of twelve concerts.

The Festival Orchestra brings together fifty-four of the world's most talented musicians. Principal performers include: Mieczyslaw Horszowski, Eugene Istomin, Milton Katims,

Jesus María Sanromá, Alexander Schneider, Rudolf Serkin, Gérard Souzay, Maria Stader, Isaac Stern, Joseph Szigeti.

Two chamber music concerts will feature the Budapest String Quartet.

For further details, write Festival Casals, P. O. Box 2672, San Juan, Puerto Rico; or to 15 West 44th Street, New York 17, N. Y.

Commonwealth of Puerto Rico, 579 Fifth Avenue, New York 17, N. Y.

Living room of the house where Casals' mother was born—in Mayaguez, ▶
Puerto Rico's third largest city. Photograph by Elliott Erwitt.

"I DID NOT FEEL 'EVIL' WHEN I WROTE ADVERTISEMENTS FOR PUERTO RICO. THEY HELPED ATTRACT TOURISTS TO A COUNTRY WHICH HAD BEEN LIVING ON THE EDGE OF STARVATION FOR 400 YEARS," SAYS DAVID OGILVY, CO-FOUNDER OF OGILVY AND MATHER.

This ad posed a particular problem. The aim was to promote a music festival in San Juan by announcing the homecoming of Pablo Casals. The obvious solution would have been to show Casals playing the cello, but he was not available. So Erwitt took a photograph of an empty room – in Casals' mother's home in Mayaguez – with a cello leaning against a chair.

"That's an immortal photograph. It has this magic element I call story appeal," says Ogilvy. "You wonder what it's all about; why is that an empty room? And that draws you into reading the copy. My greatest boast is that I was the first person ever to use Elliott Erwitt in advertising."

Erwitt is perceptive, observant and ready to take a lateral view. "I get really, really bored shooting to a formula. I don't like to do anything on a steady diet," he says. "But whatever I've done for commercial clients, I've done with their needs and the needs of their brief in mind."

RAJASTHAN

In Udaipur the Lake Palace Hotel is an intricately carved iced cake of white marble adorning Lake Pichola, which is usually a seductive shimmering blue. However, Claridge arrived just before the Monsoon broke and the lake was half empty and surrounded by mud. Yet his photograph evokes the mystical romance of enigmatic enchantment, and the hotel was soon submerged with bookings, as people bought into the dream in the headline: "Live like a king for £7.20 a night".

"Solving these sorts of problems has always been exciting as long as the end result is aesthetically pleasing," says Claridge. "I do very little studio work now. It drives me crazy being inside. I have to see things happening … see the light changing."

Another shot on the same trip required a trio of elephants in full regalia. As they were being herded across a marshland into position, ominous Monsoon clouds were gathering. "We had to get everything set up before this thing hit," says Claridge. "The elephants were getting in a mess,

legs crossed, grabbing each other's tails and starting to sink into the mud. When the Monsoon struck I knew I'd lose them. I had about five minutes to get the shot, then total chaos errupted. The elephants were stumbling around in what became a huge river." The illusion of fantasy frequently belies the logistical hoops through which creatives have to jump to achieve their visions.

DATE: 1979.
AGENCY: Cherry Hedger Seymour, London.
ART DIRECTOR: Graham Cornthwaite.
COPYWRITER: Geoff Seymour.
PHOTOGRAPHER: John Claridge.

SIA CARGO

DATE: 1996.
AGENCY: Ogilvy and Mather, Singapore.
ART DIRECTOR: Thomas Low.
COPYWRITER: Steve Elrick.
PHOTOGRAPHER: Thomas Herbrich.

Whether it's flying fresh salmon to the deserts of the Middle-East, or orchids to the Arctic, there's one company displaying the innovation that makes it happen. •With the largest fleet of the most advanced cargo freighters in the world - the B747-400 Mega Arks. •One of the world's most modern and efficient cargo terminals at Singapore Changi Airport - Singapore Airlines Superhub, certified to ISO 9002. •Globalised state-of-the-art EDI technology systems. •The unrivaled expertise of dedicated cargo professionals. •And a network now stretching across 5 continents to more than 75 cities in over 40 countries.

FROM ITS INAUGURATION IN THE EARLY 1970S, SINGAPORE AIRLINES CARGO HAS SHOWN IMPRESSIVE GROWTH, RISING TO BECOME ONE OF THE TOP 10 AIRLINE CARGO COMPANIES IN THE WORLD.

Its advertising has focused on the company's practical and emotive strengths, including the size and sophistication of its fleet and network and its eagerness to take on challenges. The sign-off line – "We've got what it takes" – signifies attitude as well as capability.

Since the 1970s, the advertising has evolved to reflect developments in the market and build on its own well-established brand awareness. For this campaign, the aim was to cut through the clutter of cargo advertising by introducing a fresh approach that communicated the airline's competitive edge – its passion to deliver solutions, whatever the task. SIA Cargo has got what it takes to deliver Salmon to the Sahara Desert, Orchids to the South Pole, Fibre Optics to the Paddy Fields of Southeast Asia or Electronic Chips to the Amazon.

The masterful and imaginative execution of the brief typifies the values of the brand. The model-making and computer technology were handled in Germany, in conjunction with the work of a photographer who relishes the creation of grand fantasies.

TOKYO OLYMPIC GAMES

THE OLYMPIC GAMES WERE REVIVED AND INAUGURATED IN THE SPRING OF 1896, LARGELY THROUGH THE EFFORTS OF THE FRENCH SPORTSMAN AND EDUCATOR PIERRE DE FREDI, BARON DE COUBERTIN. THROUGHOUT THE TWENTIETH CENTURY THE GAMES HAVE PROVIDED A CATALYST FOR UNITING NATIONS AROUND THE WORLD — AT TIMES HELPING TO HEAL THE WOUNDS OF CONFLICT.

The 1960s was an era in which Japan acknowledged the "individualization of expression" – an approach contrary to Japanese traditional values. It resulted in rising technology, economic growth and the strengthening of Japan's position on the global stage. But it also made some people see the country as an insensitive economic force. Winning the bid for the 1964 Games, the first to be held in Asia, was a vehicle for changing this perception.

Poster designers for the Games incorporated cultural, spiritual and aesthetic elements into their work in an effort to project a human function beyond the sales message. By using the simple, minimalistic visual language of universally recognized symbols, the poster with the Japanese "sun" and the linked rings of the Games transcends the language barrier and reinforces the image of co-operation. Japanese posters have gained greater international recognition since.

The potential showcase for Japanese posters differs from the billboards of many western cities. Japanese conurbations are festooned with tangles of fly-overs, wires, poles and street signs – and neon signs dominate the outdoor advertising. In contrast, railway stations and their warrens of corridors provide a vast gallery of display space, some sites passed by over three million passengers a day.

DATE: 1964.
AGENCY: The Design Committee for the 18th Olympic Games, Tokyo.
ARTIST: Yusaku Kamekura.

SKEGNESS

BRITAIN HAS BEEN NOTED FOR THE
HUMOUR OF ITS ADVERTISING SINCE
THE BEGINNING OF THE CENTURY.
WHILE EARLY TRAVEL POSTERS IN
MAINLAND EUROPE DISPLAYED A
STYLISH SOPHISTICATION, THEIR
BRITISH COUNTERPARTS OFTEN
TOOK A MORE LIGHT-HEARTED
APPROACH.

While the artistic merits of the friv-
olous examples may not compare
favourably with the work of Cassandre,
Hohlwein, Cappiello, Dudovich et al,
they possess a vibrancy of spirit suited
to the subject matter.

It has been said that John Hassall
translated into the English idiom the
styles of Jules Chéret and Toulouse-
Lautrec. Like the work of H.M.
Bateman and John Gilroy, his designs
explode with vitality and have great
popular appeal.

His best-known poster, from 1908,
advocating the attractions of Skegness,
is of an oil painting bought by Great
Northern Railway for £12. The illustra-
tion was later acquired by the town itself
and a few minor alterations made, such
as the removal of the clouds. Hassall was
made a freeman of Skegness in 1934,
which prompted his first ever visit.

DATE: 1908.
ARTIST: John Hassall.

ENTERTAINMENT

SOME OF THE MOST INDIVIDUALISTIC ARTISTS of the century devoted their creative energies to promoting the entertainment business. The unique styles of Jules Chéret, Leonetta Cappiello, Norman Rockwell and Ronald Searle at times surpassed the talents of those on the stage or in the movie that they helped to advertise.

As the twentieth century opened, the Belle Epoque in Paris was already reflected in, and enhanced by, the ebullience and joie de vivre of designs spearheaded by Jules Chéret's theatre and circus posters. Most of the striking posters to appear on the streets at this time – especially in France – were those for music-halls, popular theatre, circuses and carnivals. When cinema was born, its early posters evolved from designs for live shows. Chéret created the first pre-cinema posters, for Emile Reynaud's Optical Theatre, starting with the Pantomimes Lumineuses in 1892, depicting the Pauvre Pierrot film.

In Paris in 1894 Louis Lumière viewed moving images, peep-show fashion, in Thomas Eddison's Kinetoscope. Inspired by this, Lumière and his brother Auguste then developed the Cinématographe that combined camera and projector. Auzolle's poster for the Lumière brothers' film, shows an audience viewing *L'Arroseur Arrosé*, and is judged to be the first poster promoting a fiction film. Subsequent film posters show a beam of light from the projector to distinguish them from posters for theatrical productions. To endorse the films' respectability, some of the audiences drawn on the posters included members of royalty.

At the height of the Art Nouveau period, poster design

studios flourished under the patronage of film makers such as the Pathé brothers and Leon Gaumont, and a pool of talented designers and printers converged on Paris. France continued to dominate the international film scene until the industry crumbled during World War One. Until then Charles Pathé alone was distributing twice as many films in the USA as all the American companies together.

For the first 12 years of the American film industry, activity was concentrated on the East Coast. Then, in 1909, Colonel Selig opened the first major West Coast studio near Los Angeles.

Early movie posters focused on the action and title, using colour to promote black and white films. Then, as the concept of the movie star emerged with Mary Pickford, actors began to be featured on the posters along with their names. Sometimes larger print was used for directors likes D.W. Griffith and Cecil B. De Mille.

By 1912 an average of five million Americans went to the cinema every day. And by 1920 Hollywood had become the centre of the film industry, turning out about 800 films a year, each with its quota of posters. At first, the film cameraman shot publicity photographs during filming; later, artists and designers were employed, but their work was anonymous – they were not permitted to make a name for themselves. Several different poster designs would have been issued for major releases such as *The Kid* (p.227). Talking pictures were born in 1924, although they did not effectively start replacing silent films

A CLOCKWORK ORANGE

until 1929. During the years of the Depression, American cinema responded to people's thirst for glamour and escapism. The 1939 epic *Gone with the Wind* (p.224) is perhaps the quintessence of this genre.

Other countries had thriving film-making industries. The Russian film industry received an enormous boost in 1919 when nationalized by the government to provide a visual means of serving political ends. Private film companies disappeared and the Proletkino was formed in 1923 (renamed Sovkino in 1926). The artist-designer Yakov Rukhlevsky, head of the Sovkino poster department, employed designers such as Alexander Rodchenko and the Stenberg brothers to advertise their films.

The Russian Constructivist movement founded by sculptor Antoine Pevsner and his brother Naum Pevsner Gabo evolved from the belief that art should be functional and not elitist – a philosophy reflecting that of the Russian Revolution. Photomontage was frequently used, with an emphasis on geometric lines and mechanical shapes.

After World War Two, Italy and Poland experienced an artistic resurgence free from commercial considerations. Italian neo-realism emphasized truth and reality as a reaction to the deception of Mussolini, while Polish cinema evolved its own idiosyncratic style.

The annual film festival in Cannes was inaugurated in 1946 to boost the interests of the international film industry. Yet, as the cinema continued to upgrade the movie-going experience with wide-screen, Technicolor and improved sound, television sets began to infiltrate the home, a ubiquitous entertainment medium that threat-

ened the viability of both stage and screen productions. Audiences retreated to their "boxes" and cinemas closed in droves. In the vanguard of the sixties revival were spy thrillers such as the James Bond movies (from 1962), accompanied by action-packed posters. With the introduction of more efficient and sophisticated photographic printing techniques in the same decade, movie posters began to be dominated by photography.

Popular music, too, was experiencing a major resurgence. Bill Haley and Elvis Presley produced the early rumblings of a cultural earthquake that The Beatles carried into the 1960s. With its roots in San Francisco, the alternative society gave rise to a separate outbreak of artistic expression that found its showcase in rock and pop posters and album covers. Artists such as Milton Glaser, Peter Max and Martin Sharp led the exploration into new modes of expression, sometimes with a little help from mind-expanding drugs. Their psychedelic posters frequently echoed forms and styles of the Art Nouveau period. The sensations evoked by the image were as important as the message, which was often hidden in flamboyant floral lettering.

Although posters, film trailers and other promotional material perform a similar function to mainstream advertising, they have evolved quite differently. Advertising in the entertainment field has essentially never progressed beyond the basic presentation of its main attributes – the names and dramatic highlights. Celebrities and music bands could benefit from the brand-building approach of a consistent campaign.

LA DOLCE VITA

BATTLESHIP POTEMKIN

THE FILM, *BATTLESHIP POTEMKIN*, DIRECTED BY SERGEI M. EISENSTEIN IN 1925, IS ONE OF THE EARLIEST AND MOST SIGNIFICANT FILMS TO EMERGE FROM THE SOVIET UNION.

Covering the Russian Revolution of 1905, it focuses on the mutiny aboard the Potemkin at Odessa, an episode that became a symbol for the entire uprising.

Among the most innovative and versatile of the new poster artists in the 1920s, Georgi and Vladimir Stenberg brought fresh visual imagery to film advertising. In this case they concentrated on the pivotal scene in the film, involving a man overboard. Using minimal key elements – the two sailors and the opposing diagonals of the massive extended guns – the Stenberg brothers created a graphically powerful and dynamic embodiment of the event. Eisenstein, once a student of architecture, used recurring diagonal patterns etched against the sky to epitomize the conflict within the drama. Other posters for the same film were produced by Anton Lavinsky and Alexander Rodchenko, but this remains the most striking.

During the 1920s the Soviet government saw film as a means to disseminate information, and supplied the cinema with generous financial backing. Lenin himself had stated, "Of all the arts, for us the cinema is the most important".

DATE: 1927.
ARTISTS: Georgi and Vladimir Stenberg.

THE BEATLES

DATE: 1964.

EARLY BEATLES POSTERS ARE RARE AND MUCH SOUGHT AFTER. BILLS PROMOTING PERFORMANCES BY NEW ROCK BANDS WERE NOT CONSIDERED COLLECTIBLE AT THE TIME; THEY WERE INVARIABLY TORN DOWN AND DISCARDED AFTER A SHORT LIFE.

The earliest Beatles' posters promoted the group's 100 plus gigs in Hamburg in 1960, just weeks after they had settled on the name "Beatles" and when their first recording was still two years away. Early performances were unpolished, like the hand-printed bills. There was a raw excitement to the plain, simple, direct lettering that needed no embellishment.

The Beatles phenomenon began in 1963 with the release of two albums – *Please Please Me* and *With The Beatles* –

and an appearance on the top TV show "Sunday Night At The London Palladium". "Beatlemania" was born.

Following their appearance on the Ed Sullivan Show in New York at the beginning of 1964, the Beatles started work on their first movie, *A Hard Day's Night* directed by Dick Lester, which premiered at the London Pavilion on 6th July. The film was originally viewed as a vehicle to help sell the album, yet it earned 30 times its production costs, as well as

helping the soundtrack reach No. 1 in both America and Britain.

Apart from the title track, none of the songs relate to the plot of the film – the story of the Beatles' rise to fame. The title – coined by Ringo Starr – emerged after a particularly hard day and night's work. It reflected the frenetic pace of their lives at the time and captured the mood of the movie.

JULES CHÉRET

DATE: 1900.
ARTIST: Jules Chéret.

JULES CHÉRET IS CREDITED WITH BEING THE GRANDFATHER OF THE POSTER. HE BROUGHT "ART" TO COMMERCIAL PRINTING AND PRODUCED A COLOURFUL ALTERNATIVE TO THE ENDLESS WALLS OF TYPOGRAPHY PRESENTED BY CONTEMPORARY POSTERS.

Chéret studied at Beaux-Arts in Paris while working as a lithographer's apprentice. He lived in London during the early 1860s, designing book covers and posters for concerts and circuses. In 1866 he began producing colour lithographic posters from his own printing press in Paris, financed by Eugène Rimmel, for whom he created brochures and showcards.

His success stemmed from his enthusiasm for embracing new technology. By drawing straight onto the lithographic stone, he extended the use of colour lithography from a purely reproduction process to a medium for direct artistic expression.

Chéret's work was influenced by the eighteenth-century Rococo style of paintings of Giovanni Tiepolo, Jean-Honoré Fragonard and Antoine Watteau. His 2,000 or so designs advertised a wide variety of products from theatrical performances to drinks. He had a feel for the popular idiom and utilized the visual language of popular folk art as used to decorate circus programmes. His favourite model was a Danish actress and dancer, Charlotte Wiehe – popularly called La

Cherette. In his posters she invariably appears irrepressibly happy, dancing, laughing and irresponsible.

Chéret's vivacious posters proved very popular, though some people were shocked by the explosion of colour and exuberant sensuality that they brought on to the city streets. Chéret was an important source for the Art Nouveau movement.

His use of black as a colour and his interlocking flat shapes were developed by Henri de Toulouse-Lautrec and Pierre Bonnard.

A CLOCKWORK ORANGE

DATE: 1971.
WRITER: Anthony Burgess.
DIRECTOR: Stanley Kubrick.
ARTIST: Philip Castle.
ACTOR: Malcolm McDowell.

FOLLOWING THE RELAXATION OF CENSORSHIP LAWS IN THE 1960S, A SERIES OF SHOCKINGLY VIOLENT MOVIES REACHED THE SILVER SCREEN. FOREMOST AMONG THESE WAS STANLEY KUBRICK'S NOTORIOUS FILM VERSION OF THE CONTROVERSIAL NOVEL BY ANTHONY BURGESS, *A CLOCKWORK ORANGE*.

Kubrick's crisp, stylized direction choreographs the exploits of a drug-fuelled gang of teenagers in a futuristic Britain. A key moment in the plot is when the gang break into an author's home. The book he is writing – *A Clockwork Orange* – argues that aversion therapy turns people into clockwork oranges, "Orang" being Malaysian for "Man", as in Orang Utan – old man of the forest.

The gang's charismatic leader Alex de Large (Malcolm McDowell) is caught by the police after an attack that results in murder. He agrees to try a new aversion therapy that involves being brainwashed into good citizenship, rather than remaining in prison for life. By chosing freedom he denies his future freedom of choice because he is conditioned into having mechanical Pavlovian reactions to sex and violence.

The design of the poster and soundtrack album conveys the air of sinister menace that surrounds Alex and the nightmare fantasies he perpetuates. Its sharp, stylized portrayal of sex and violence echoes the movie's graphic treatment of the subject.

Being the adventures of a young man whose principal interests are rape, ultra-violence and Beethoven.

STANLEY KUBRICK'S
CLOCKWORK ORANGE ⊗

From Warner Bros W A Warner Communications Company
Released by Columbia-Warner Distributors Ltd

DIAMONDS ARE FOREVER

POSTERS FOR BRITISH FILMS HAVE ALWAYS TENDED TO FOCUS MORE ON THE DRAMA THAN THE STARS THEMSELVES – EVEN WHEN THEY ARE AS "BIG" AS SEAN CONNERY.

Bond movies give great scope for a colourful backdrop of spectacular action. When the British government suspect the existence of a worldwide diamond smuggling operation, Agent 007 is called in to investigate. He travels to Las Vegas where a millionaire casino owner Ernst Stavro Blofeld is discovered to be behind the deception. A satellite laser, high speed chase, floating fortress and obligatory explosive climax provide a wealth of visual drama with which to promote the film.

Like many of the James Bond movies, *Diamonds are Forever* had the highest box office takings of all films that year.

DATE: 1971.
WRITERS: Ian Fleming (novel), Richard Maibaum (screenplay).
DIRECTOR: Guy Hamilton.
ACTOR: Sean Connery.

WALT DISNEY

Joseph M. Schenck
presents
WALT DISNEY'S
MICKEY MOUSE
MICKEY'S
NIGHTMARE
UNITED ARTISTS PICTURE

DATE: 1932.

TODAY THE WALT DISNEY CO. IN BURBANK, CALIFORNIA CONTROLS AN INTEGRATED EMPIRE OF THEME PARKS, FILM STUDIOS, RECORD LABELS, STORES, HOTELS AND A TV CHANNEL. IN 1928, WHEN MICKEY MOUSE WAS BORN, ALL THIS WAS JUST A DREAMLAND FANTASY.

Walt Elias Disney was born in Chicago in 1901. While still a teenager he worked for the Kansas City Slide Co. (later called the Kansas City Film Co.) producing rudimentary animated films and making cinema commercials. By 1922 he was employed in the Newman Laugh-o-Grams office turning out comics. Together with Ubbe (Ub) Iwerks, he created the cartoon character Oswald the Lucky Rabbit, resulting in Disney's first experience of merchandise tie-ins, that he later developed into a multi-million dollar sideline. Oswald bore more than a passing resemblance to Mickey Mouse, who was introduced to the public in the 1928 movie *Steamboat Willie*. By this time Disney had moved to Los Angeles to set up a tiny animation studio with his brother.

Disney himself was not a remarkable draftsman and stopped animating even before Mickey Mouse was created. Yet, from 1923 when he launched his own business, Disney's imagination and personality has suffused all the ventures achieved in his name, even after his death

in 1966. The development of the animated feature film is attributed to Disney, who proceeded to create several classics of the genre, as well as producing live-action films. He expanded the concept of amusement parks and developed the first integrated theme park - Disneyland near Los Angeles.

The organization, one of the most prosperous in Hollywood, enjoyed a resurgence in the 1980s. Michael Eisner, who became chairman and CEO of Walt Disney Productions in 1984, had a flare for promotion, marketing and advertising. He expanded the company's motion picture production, theme parks and merchandising, with each element contributing to the overall value of the brand. He steered the merger with ABC and created an even larger multimedia force.

Besides advertising Disney products, the company issued lucrative licenses for its characters to be used in merchandising other brands. For example, until 2002, only Nestlé has the rights to use Disney characters on branded foods in Europe and seven other countries.

LA DOLCE VITA

DATE: 1960.
WRITERS: Federico Fellini and Ennio Flaiano.
DIRECTOR: Federico Fellini.
ARTIST: G. Olivette.

IN THE MIDDLE DECADES OF THE TWENTIETH CENTURY AMERICAN MOVIE POSTERS WERE GENERALLY CREATED WITHIN THE FILM STUDIOS, WHILE EUROPEAN FILMS OFTEN USED LEADING ARTISTS AND ILLUSTRATORS TO DESIGN THEIR POSTERS.

Described as an example of Italian film-making at its zenith, *La Dolce Vita* was an artistic masterpiece and commercial success, with a host of sensational themes suitable for inclusion on the poster.

Made in Rome, the movie drew on real-life tabloid headlines of a statue of Christ carried over Rome by helicopter in 1950, a murdered girl washed up on a beach in 1953, and two teenager girls who claimed to have seen the Madonna in1958. The film's most controversial scene was based on a striptease adapted from a similar display at a party in 1958 for American millionaire P.H. Vanderbilt.

The film follows seven aimless days and nights in the life of Marcello Rubini (Marcello Mastroianni) – a world weary gossip columnist and would-be serious writer. He is entangled in the flotsam of decadent society in which he flounders in pursuit of shallow values in a contrived world of hollow pleasures. The events were considered shocking and made a great impact at the time the film was first released. The poster remains a popular collectors' item.

BOB DYLAN

MILTON GLASER WAS A FOUNDER MEMBER OF PUSH PIN – A CALIFORNIAN STUDIO OF ART ASSOCIATES WHOSE *ALMANACK* WAS FIRST PUBLISHED IN 1954. TOGETHER WITH CO-FOUNDERS SEYMOUR CHWAST, EDWARD SOREL AND REYNOLDS RUFFINS, HE DEVELOPED A TASTE FOR THE VISUALLY BIZARRE, DRAWING ON A VARIETY OF ART FORMS FOR INSPIRATION.

The group specialized in book jackets, record sleeves, posters and magazine illustrations. They produced the monthly magazine *Push Pin Graphic* to promote the studio's work. Their styles were characterized by bright colours, a freedom from graphic conventions and a willingness to experiment. Glaser's poster of Bob Dylan became a graphic icon of the 1960s.

Glaser was president of Push Pin Studios until 1974 when he established Milton Glaser Inc. in New York. In 1983 he and Walter Bernard launched WBMG – a publications design firm. Glaser designed *Paris Match*, *L'Express* and *Esquire*. His work extended to corporate identity, packaging, exteriors, interiors and exhibitions.

DATE: 1967.
ARTIST: Milton Glaser.

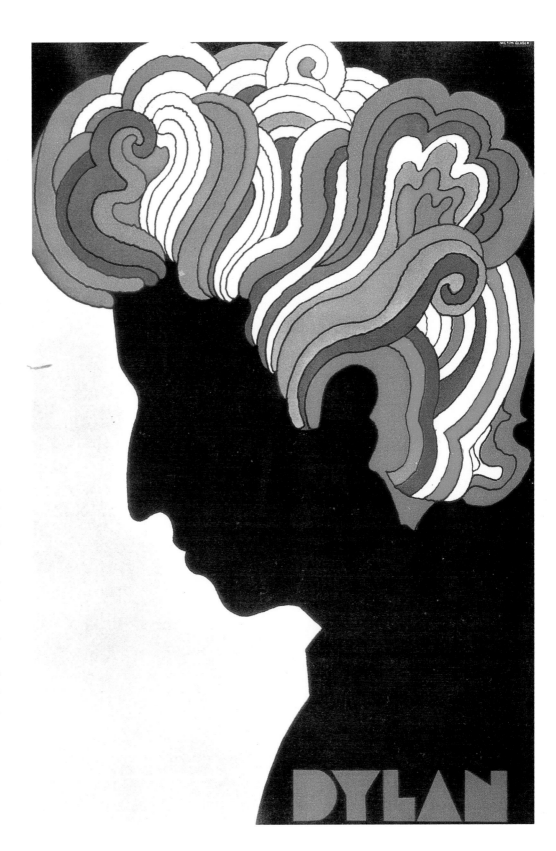

GONE WITH THE WIND

SINCE THE END OF WORLD WAR ONE, FILMS – AND THEIR POSTERS – APPEALED TO A GROWING DEMAND FOR ESCAPISM. POSTERS DEPICTED GLAMOROUS STARS IN EXOTIC LOCATIONS AND OFFERED A RICH MIX OF ACTION AND EMOTION. DESCRIBED AS THE MOST MAGNIFICENT PICTURE EVER, THIS IS AN EPIC STORY OF DEVOURING PASSION SET AGAINST A BACKGROUND OF THE CIVIL WAR IN THE SOUTHERN STATES.

The roguish and virile Rhett Butler, and wilful minx Scarlett O'Hara are spirited, arrogant, self-centred and amoral. Their relationship is destined to be a passionate clash of personalities – surging between attraction and rejection.

With a running time of 3 hours 40 minutes, David O. Selznick's film was one of Hollywood's longest movies. It won nine oscars at the 1940 awards ceremony, and from then until 1965 it held the record for the film with the highest gross earnings.

DATE: 1939.
WRITERS: Margaret Mitchell (novel) and Sidney Howard (screenplay).
PRODUCER: David O. Selznick.
DIRECTOR: Victor Fleming.
ACTORS: Clark Gable and Vivien Leigh.

HAIR

DATE: 1968.
DESIGNER: Natoma Productions.
ARTIST: Rúspoli-Rodríguez.

THE OUTBREAK OF PEACE AND LOVE IN THE MID-1960S PROPAGATED A FERTILE CROP OF WILD, COLOURFUL POSTERS.

With roots in San Francisco and inspired in part by British rock music, the emerging artform drew on an eclectic mix of styles from the early years of the century.

A flourish of liberating designs blossomed in the wake of Robert Welsey "Wes" Wilson – one of America's leading psychedelic poster artists, who designed posters for the 1965 and 1966 rock concerts at San Francisco's Fillmore Auditorium.

Poster designers claimed the images recreated the visual sensations and hallucinogenic effects experienced while under the influence of mind-altering drugs, especially LSD. The colours were as loud as the music, often with repeated or mirrored images, and using photographic negative and solarization techniques.

The stage show *Hair* and accompanying poster epitomized the underground movement of the time. It provided a banner for the anti-establishment attitude of the young people of the sixties who took an alternative social and political stance to the status quo. In America it was allied with the Hippie culture, peace and environmental movements. The counter-culture was further fuelled by the Vietnam war, and the antagonistic reaction to the threat of being drafted provided the backdrop to the plot of *Hair*.

JIMI HENDRIX

DATE: 1968.
ARTIST: Martin Sharp.

So-called mind-expanding drugs were legal in California until 1966. Hallucinogenic narcotics provided the catalyst for much of the development of psychedelic art, fashion and music in the USA and Britain between 1965 and 1970.

Many posters mimicked the stroboscopic light shows at concerts, with dazzling, alternating colours creating an optical vibration in which the swirling lettering was almost illegible. At odds with the clear, concise message most designers tried to convey, the psychedelic poster absorbs its message within a decorative flourish reminiscent of the Art Nouveau styles of the 1880s and 1890s. The ambiguity aimed to appeal to the senses rather than reason. People began to "see" without reading. The medium was the message. The style became the signature of Flower Power, and immediately attracted a cult following.

The Australian Martin Sharp was the artist on the satirical and psychedelic magazine *Oz* started by Richard Neville in Sydney in 1964. Sharp went on to energize the renaissance of poster design in Britain. His striking designs and use of vivid colour are best seen in his silk screen prints of Jimi Hendrix, Bob Dylan's *Mister Tambourine Man* in 1967, and the album cover for *Disraeli Gears* by Cream also in 1967.

THE KID

IN THE EARLY YEARS OF THE TWEN-
TIETH CENTURY, HOLLYWOOD LED
THE WORLD OF FILM PRODUCTION.
THE INITIAL FLURRY OF ENTHUSIASM
FOR THIS NOVEL FORM OF ENTER-
TAINMENT MEANT THERE WAS LITTLE
NEED FOR ELABORATE PUBLICITY.

The earliest film posters appeared
around 1909, and soon most cinema
posters used photographs illustrating key
moments in the action. American films
were invariably accompanied by photo-
graphic posters commissioned by the
studios, but many British and continental
posters were mainly typographical.

As the leading actors evolved into
stars, movie posters used them as the
focus of attention. Charlie Chaplin
began to stand out as a leading talent as
early as 1910, and his image dominated
his movie posters from 1914. By the time
The Kid appeared – written and
directed by Chaplin and produced by
First National – his was one of the best
known faces in Hollywood.

The poster – one of several different
designs – portrays the touching rela-
tionship that develops in the film
between and abandoned child (Jackie
Coogan) and a tramp (Chaplin).

DATE: 1921.

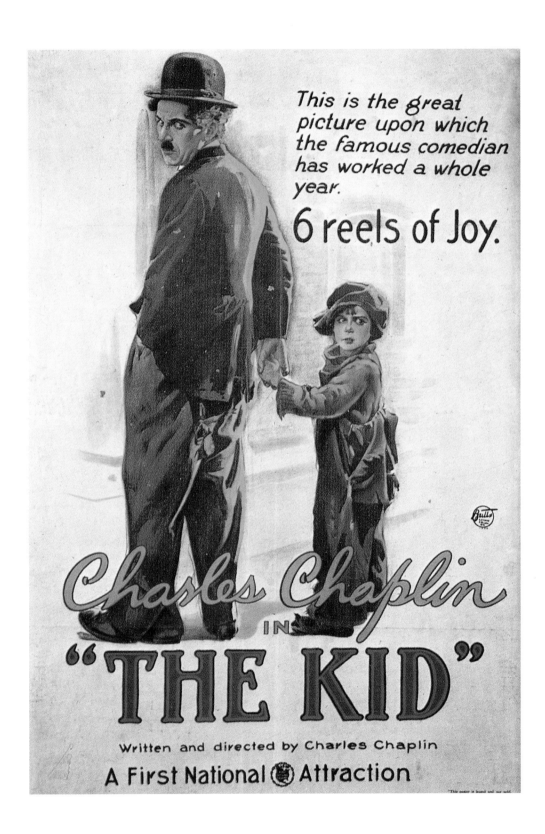

ROLLING STONES/ BEGGARS' BANQUET

DATE: 1968.
ART DIRECTOR: Mike Peters.
PHOTOGRAPHER: Michael Joseph.

"THE STONES COMMISSIONED ME TO SHOOT THE ALBUM COVER AND POSTER FOR THE BEGGARS' BANQUET BECAUSE MY PORTFOLIO CONTAINED THE MOST ORGIASTIC SCENES," SAYS MICHAEL JOSEPH WHO, WITH OVER 3,500 ADVERTISING ASSIGNMENTS TO HIS NAME, RATES AMONG THE WORLD'S LEADING ADVERTISING PHOTOGRAPHERS OF THE SEVENTIES AND EIGHTIES.

"They were already a bit plastered when I arrived at 11 in the morning. They were rather disturbed because they'd been raided by the police not long before. Two weeks later Brian Jones committed suicide and there was a dilemma about whether or not to use the picture."

The Rolling Stones had their own ideas about how they wanted to look and Joseph had to manipulate them gently to do things that would make the shot work – a skill he had started to learn at the age of 18 when he went to work for the *Johannesburg Tatler* and was exposed to the theatre and high society.

"At the end of the session, for my own amusement, I knocked off some black and whites in two minutes with the Hasselblad and superwide," he says. "Then I spent the night in the darkroom printing them on Kodalith paper – amazing contrast. Mick Jagger was so knocked out by the 16 x 20-inch sepia enlargements that he didn't even look at the 10 x 8 colour transparencies. It's often the spontaneous image that wins the day rather than the posed portrait."

VERTIGO

Saul Bass was one of the lead-
ing American poster designers
of the twentieth century. He
created film title sequences
and promotional pieces for
many Hollywood movies
collaborating most notably
with Otto Preminger (*The Man
with the Golden Arm*) and
Alfred Hitchcock.

Apart from designing the titles
for *North by Northwest*, *Psycho*
and *Vertigo*; he is also rumoured to
have directed *Psycho*'s infamous shower
sequence.

 Vertigo was described as Hitchcock's
richest, most obsessive and least
compromising film. Hitchcock based the
title on the situation that precipitates the
story. This, in turn, led to the graphic
interpretation of the poster design.
Based on a Boileau-Narcejac novel,
with a screenplay by Samuel Taylor, the
film was shot in northern California and
at Paramount Studios. James Stewart
plays "Scottie", a San Francisco lawyer-
turned-detective who discovers his
pathological dread of high places
during a rooftop chase. His acrophobia
is manifested by vertigo, producing
dizziness and a sensation of floating in
a spinning void. The poster uses this core
element of the plot as the essence of the
design.

DATE: 1958.
ARTIST: Saul Bass.

MONEY AND MEDIA

CONSUMERS KNOW that all advertising is a careful presentation of any product's best attributes, but they are perhaps more wary of the claims made for financial services than for any other generic stream. People erect protective barriers against its seductive messages. Ironically, the belief that they are not being affected ultimately makes them more vulnerable: when they accept a ceaseless selling proposition they even assume credit for their evolving attitude.

CHELTENHAM AND GLOUCESTER BUILDING SOCI-

Confidence in financial products is frequently nurtured by personal recommendation. While Zoë Ball increased the credibility of Egg (p.236), a long string of celebrities indirectly endorsed American Express by allowing themselves to be commended by the company, rather than vice versa (p.232). Celebrity endorsement can also be given vicariously by a leading photographer or prominent artist who creates an ad. By implication, Annie Leibovitz and Norman Rockwell condone the products they promote (p.232, p.239).

Ads are more than the sum of their parts – words, images, music, sound effects. "In print ads, the idea develops out of dialogue between the visual and verbal," says Andy Rork, creative director of Granfield Rork Collins. "The copy doesn't always have to say the same thing as the picture. It shouldn't just be a caption, it should make the audience work a bit."

A headline alone may seem disconnected and incomprehensible, a picture alone may seem baffling or inconsequential. Why is a man with a pig's head being used to advertise a woman's magazine (p.238)? How does a toddler on a racetrack (p.237), or horse's blinkers (p.241), relate to a newspaper?

By asking the questions the consumer is allowing himself to be drawn into the ad. But the time between the question and answer must be short. The mystery should be solved by the copy revealing the relevance.

Branding brings reassurance. It establishes and helps maintain a relationship with the consumer. At the beginning of the century Claude Hopkins, copywriter with Lord and Thomas agency, established the philosophy of brand image as the soul of the business. He also introduced "reason why" copy, product comparisons and product demonstrations.

The *Economist* magazine (p.235) is a model of product branding, its consistent and distinctive appearance promoting instant recognition. Any advertising that digresses from the brand image by removing some of the brand's building blocks is in danger of forfeiting that recognition. The *Economist* has established a reputation for smart, succinct and often incisively witty copylines. Many of its ads illustrate the advertising maxim: derive maximum meaning by minimal means. The less said the better: a simple picture of a fly on a wall speaks volumes about inside information.

The use of symbolism not only helps strengthen

THE SUNDAY TIMES,
SOUTH AFRICA

a product proposition, it builds a bridge between product and consumer. Good ads require the reader to finish – or respond to – the train of thought. A row of drills with a single pen nib means little until the viewer contributes his own experience and knowledge (p.234).

Symbolism is taken a stage further and becomes an allegory in the fairytale underwater commercial for Cheltenham and Gloucester Building Society (p.233). The agile boy who outwits cumbersome divers and finds the treasure is so beautifully filmed, the fantasy is irresistible. There is credibility in fantasy. Viewers can extract what truth they want from it, and put the rest down to harmless make-believe. Fantasy is safe because it is not real. The audience can enjoy it without fear of being accosted by an aggressive selling proposition.

Many European countries have a cosmopolitan appreciation of pictures that incorporate subtle humour, puns and symbols rather than words – a boon to advertisers. But the most successful ads in every culture are those that are tailored to local attitudes and beliefs.

While many brands are successful globally, their advertising may not export quite so seamlessly: possibly because idiosyncratic campaigns are developed for particular times and cultures, or because the perception of a product varies between cultures – although this is less true of superbrands with a global identity.

In China, as the communist state was drawn towards a market economy, new home-grown agencies sprang up with an advantage over the multinational agencies, as they understood the local idiom and could, more intuitively, blend ideologies of East and West.

Since the 1960s the substance of what is said has become less important than how it is said. The medium is the message – with a danger of the medium flourishing at the expense of the message. This is especially true of the Internet where many are caught up with the excitement of new technology.

When the Internet first looked like becoming a viable marketing vehicle, advertisers made varied guesses about how best to use the medium. A lot of money was thrown after misguided suppositions and, by the end of the century, few companies had found effective ways of using the Net for anything other than ensuring their presence on it. "We have to remain open to new ideas, especially as the Internet is evolving at a pace not seen in other media," says Rob Holloway, vice-president of global marketing for Levi Strauss, which disseminates information across the globe but which also tailors itself to local situations using local servers.

ROLLING STONE MAGAZINE

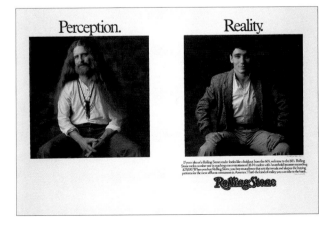

AMERICAN EXPRESS

DATE: 1994–96.
AGENCY: Ogilvy and Mather, London.
ARTIST: David Hughes.

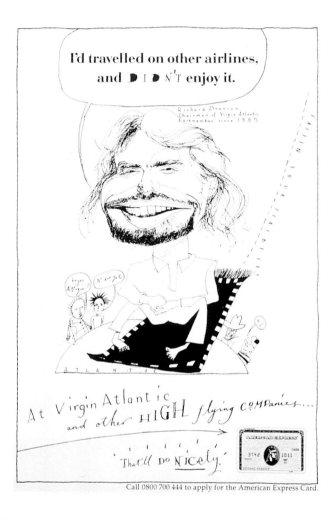

Call 0800 700 444 to apply for the American Express Card.

AMERICAN EXPRESS – THE LARGEST TRAVEL ORGANIZATION IN THE WORLD – WAS BORN IN 1850 AS AN EXPRESS FREIGHT COMPANY. IT BEGAN UNDERWRITING MONEY ORDERS IN 1882 AS A SAFER MEANS OF TRANSFERING MONEY, AND IN 1891 THE COMPANY ISSUED THE WORLD'S FIRST TRAVELLER'S CHEQUES. ITS FAMILIAR GREEN CHARGE CARD WAS INTRODUCED IN 1958 AND IS NOW RECOGNIZED IN AROUND 160 COUNTRIES.

One of its long-running advertising campaigns for the charge card turns the product endorsement formula around by paying tribute to the card members, instead of asking them to compliment the product.

The concept was conceived by Parry Merkley, then creative director with Ogilvy and Mather in New York. "While the creative team was in California shooting the American Express commercial, the client asked me to come up with a print campaign compatible with it," says Merkley. "I didn't want to do a celebrity campaign as such, because I felt that people would be paid a lot of money to say 'Use this card', and the product's credibility would suffer. Instead, I avoided written testimonials and simply showed the impressive group of people you'd be joining by using the card."

Merkley turned first to photographer Annie Leibovitz who could create visual interviews with the personalities. "I wanted the photography to be candid – almost voyeuristic, and Annie had a way of showing the real side of people. The pictures have a larger-than-life, almost legendary quality that Annie calls heightened reality."

The campaign was a huge success and built up a vast photographic hall of fame. Although Leibovitz photographed many of the celebrities around the world, the different regions also used local personalities and photographers or artists to produce images compatible with the strategy of the campaign.

CHELTENHAM AND GLOUCESTER

TEAMS OF INTREPID UNDERWATER FILM-MAKERS ARE CONTINUALLY PRODUCING BREATH-TAKING FANT-ASIES OF SURREAL BEAUTY. SEVERAL STARTLING TELEVISION/CINEMA COMMERCIALS HAVE DIPPED INTO THE SUBAQUATIC REALM IN THE SEARCH FOR WAYS TO PROMOTE EVERYTHING FROM JEANS TO GAS.

In a commercial designed to illustrate the financial flexibility of the Cheltenham and Gloucester Building Society, a simulated ancient ruin was constructed 6 metres (20 feet) below the surface at Egypt's Ras Mohammed nature reserve, where the water is warm and clear and the coral and fish life abundant. The storyline involved an agile 12-year-old boy swimming down between cumber-some divers wearing leaden boots. He reaches the prize – a pearl – ahead of his heavily weighted rivals – demonstrating

the advantage of nimbleness and versatility.

Michael Portelly has photographed and directed a string of innovative, award-winning ads and commercials that harness the unique qualities of the ocean. "The single most important quality a director must have is 'vision'," says Portelly. "He must be able to 'see' the finished film in his mind's eye, then communicate this vision to the creative team."

Having selected his aquatic studio, Portelly orchestrates the support crew.

Timing is everything, especially as communication underwater is difficult and repeated retakes are tiring. "When filming underwater, it is most important that the models trust me and the support crew completely, because they are putting their lives in our hands."

DATE: 1997.
AGENCY: K Advertising, London.
ART DIRECTOR: Susie Henry.
COPYWRITER: Judy Smith.
DIRECTOR: Michael Portelly.

DE VOLKSKRANT

DATE: 1990s.
AGENCY: PPGH/J. Walter Thompson, Amsterdam.
ART DIRECTOR: Pieter van Velsen.
PHOTOGRAPHER: Hans Kroeskamp.

de Volkskrant
HET MEEST INFORMATIEVE OCHTENDBLAD VAN NEDERLAND

VISUAL SYMBOLS ARE USED IN ALL CULTURES AS A FORM OF SHORTHAND. MANY ADS INVOLVE THE READERS BY DRAWING THEM IN WITH INTRIGUING SYMBOLS WHICH THE HUMAN BRAIN CANNOT RESIST TRYING TO INTERPRET. READING THE AD BECOMES A GAME OF HUNT OF SYMBOL, AND THE PRIZE IS THE ENJOYMENT GAINED FROM CRACKING THE CODE.

A pen nib was one of 50 symbols put forward to denote "journalism" in a Dutch campaign for *de Volkskrant* newspaper. Keyboards and screens lacked the same creative allure. The headline reads: "The best informed morning newspaper in the Netherlands". The drill is the symbol for a tool used to bore into sources of information. Other allusions employed by the campaign to indicate the penetrating nature of good journalism included keys to unlock "closed doors"; an electricity plug to connect with sources of power; and an alarm clock to denote that only the early bird scoops the worm. Similar symbols were used in a campaign for the British newspaper *Financial Times*: a nutcracker to break open hard cases, a windsock to discern the way trends are blowing and an arctic ice-breaker ploughing through pack ice.

Hans Kroeskamp, a photographer adept at handing nuances of light, was chosen to represent investigative journalism. Models are often constructed larger than life size to make them easier to light, but the drills here were normal size. "The lighting was more difficult because I had to work in such a small area," says Kroeskamp. "But it gave the photograph a more realistic look".

THE ECONOMIST

1

1. DATE: 1988.
AGENCY: Abbott Mead Vickers BBDO, London.
CREATIVE DIRECTOR/COPYWRITER: David Abbott.
ART DIRECTOR: Ron Brown.

2. DATE: 1999.
AGENCY: Abbott Mead Vickers BBDO, London.

> ## "I never read The Economist."
>
> Management trainee. Aged 42.

THE ECONOMIST IS A WEEKLY PUBLICATION CONCENTRATING ON SERIOUS NEWS AND ANALYSIS. DURING A PERIOD OF RECESSION, SIMILAR PUBLICATIONS CLOSED OR SUFFERED HUGE LOSSES, WHILE SALES OF THE ECONOMIST GREW. THIS WAS ATTRIBUTED ALMOST TO ENTIRELY TO THE STRIKING, COHERENT AND RELEVANT ADVERTISING CAMPAIGN.

The highly visible press and poster campaign is immediately recognizable. This branding arises from the tone of voice and consistent typeface that echoes the distinctive red of the magazine logo. The approach embodies a level of wit appropriate to the target audience that comprises business people, especially those with international interests. Embedded within the strategy is the proposition that success comes from reading *The Economist*. Those who don't read it, don't succeed.

The strategy emerged from consumers' comments. Qualitative research among business people illustrated that readers gain a cachet, a sense of being in the know, that gives them an edge in business over non-readers.

Besides taking prime sites in the quality national press, the campaign ran on the most prominent outdoor sites around London and major regional cities. Awareness of the campaign was far in excess of any other newspaper. The many headlines resonate with those in the know: "Top desk publishing", "Hello to all our readers in high places" – printed on the top of a red bus, and only seen from high offices. Another simply showed a fly … for the reader to add the wall it is on.

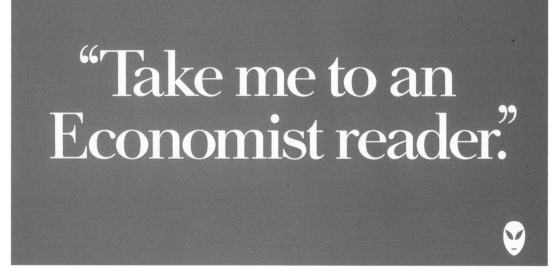

> ## "Take me to an Economist reader."

2

EGG

DATE: 1998.
AGENCY: HHCL and Partners, London.
MODEL: Zoe Ball.

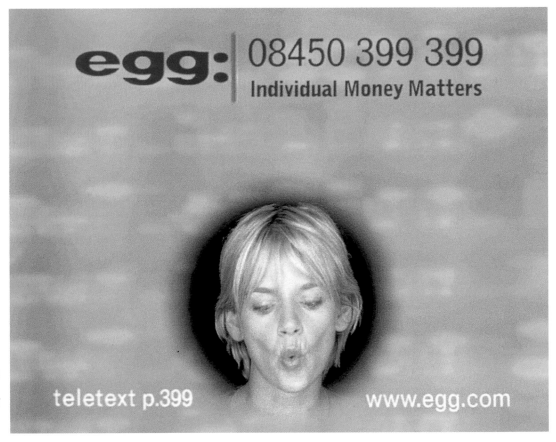

CELEBRITY ENDORSEMENT CAN BE POWERFUL – AS LONG AS IT IS BELIEVABLE.

To introduce a new direct financial services company, the Prudential had to find ways of breaking through consumer resistance to advertising and overcome people's apathy and inertia. The target group comprised 24 to 45 year-olds who were affluent, open-minded and technology-literate – but cynical. They distrusted financial services companies and their advertising claims.

The agency, HHCL and Partners, had to position "Egg" as a genuinely new kind of organization, providing flexible savings accounts, loans and mortgages, tailored to the individual. Being a direct company with no high-street outlets, Egg needed a strong media presence to build the brand and act as a shop window.

In an integrated media campaign, TV, press, radio and teletext advertising, as well as Internet banners, were all linked by the same brand "personality" and the same proposition – "created for the individual". If traditional companies were seen as inflexible and condescending, Egg was modern, open, realistic and convincingly honest.

The strategy was to use real people to demonstrate the brand promise: celebrities on television, ordinary customers in the press, and genuine Egg employees on radio. The television commercials treated the celebrities as individuals – you see the person, not the celebrity.

To overcome audience cynicism and build credibility, a polygraph lie-detector was used on Zoe Ball by a real FBI agent who asked her personal questions – "Have you ever cheated in exams?" – and finished with: "Isn't that just a load of advertising waffle?" To which Ball gave an unprepared reply and endorsement: "It works!"

However genuine an advertiser's attempt to present an authentic product or service, sceptics will view it as a confidence trick designed to prize open their wallet. Yet the popularity and perceived honestly of the celebrity, coupled with the moment-of-truth treatment, prompted a consumer response of 100,000 phone-calls and nearly a million website hits within two weeks of the launch, and 60 percent brand awareness among the target audience two months later.

EXPRESSEN

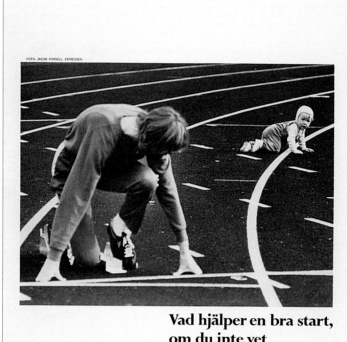

FOTO: JACOB FORSELL, EXPRESSEN.

Vad hjälper en bra start, om du inte vet vart du ska springa?

Läs Expressen.

DATE: 1989.
AGENCY: Alinder and Co., Stockholm.
CREATIVE DIRECTOR/ART DIRECTOR: Mats Alinder.
COPYWRITER: Johannes Göransson.
PHOTOGRAPHER: Jacob Forsell/*Expressen.*

THE SWEDISH TABLOID NEWSPAPER *EXPRESSEN* WANTED TO CELEBRATE ITS FORTIETH ANNIVERSARY WITH A CONSPICUOUS ADVERTISING CAMPAIGN. BO STRÖMSTEDT, THE PUBLISHER AT THE TIME, WAS AN ENLIGHTENED LIBERAL THINKER WHO GAVE THE AD AGENCY THE FREEDOM TO EXPLORE AND DEVELOP ITS OWN IDEAS FOR THE ADVERTISING STRATEGY.

The small creative hot shop Alinder and Co discovered a tone of voice that was fresh and original for Swedish advertising in the late 1980s. A series of over 100 press and poster campaigns that spanned nearly three years began with arresting headlines and no picture: "Follow the world's destruction day by day in *Expressen*", "*Expressen* sees everything. Think of that God" and "God sees everything. Think of that *Expressen*".

This was followed by a photo-caption campaign that aimed to position the paper as being smart as well as sympathetic to human needs, rather than being banal and superficial. "We felt that a newspaper should have an almost human relationship with its public," says creative director Mats Alinder. "We wanted to encourage people to view the paper as an understanding friend."

Photographs were drawn from the newspaper's files, depicting real life situations full of humour and humanity. "I prefer the immediacy and potency of real life photographs, as opposed to advertising photographs that often lack energy and realism," says Alinder.

The caption here reads: "What use is a good start if you don't know where to run?" The tone of voice of the advertising resonnated with consumers and journalists on the paper, resulting in an improved reputation and higher sales.

FREUNDIN

DATE: 1992.
AGENCY: Jung von Matt, Hamburg.
CREATIVE AND ART DIRECTOR: Deneke von Weltzien.
COPYWRITER: Matthias Jahn.
PHOTOGRAPHER: Uwe Düttmann.

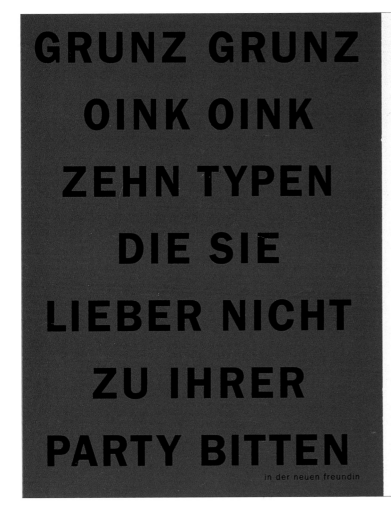

THE HAMBURG AGENCY JUNG VON MATT WAS BORN IN JULY 1991. IN A COUNTRY KNOWN MORE FOR ITS PRECISION AND PROFESSIONALISM THAN ITS EFFERVESCENT WIT AND HUMOUR, THE AGENCY'S INNOVATIVE APPROACH MET WITH RESISTENCE ON A NATIONAL LEVEL, BUT GREAT ACCLAIM INTERNATIONALLY.

"German print advertising tends to be more straightforward than most," says creative director Deneke von Weltzien. "It tries to get the message across very directly and not so artistically."

Ads that present sound, logical reasoning sit more comfortably with the national psyche, but are rather too staid for the young target audience of *Freundin* magazine, published by Burda Verlag. Yet, by the final decade of the twentieth century, German advertising was showing many signs of entering a

more subtle, soft-selling phase in which the audience is credited with intelligence and invited to participate in the communication.

The headline on this advertisement reads: "Grunt Grunt Oink Oink Ten types of men you're better off not inviting to your party."

"The only way to achieve good advertising is to approach it with a sense of fun," says partner and marketing man Holger Jung. "In our agency there exists no formalities, no hierarchy and no politics."

Jung von Matt's stated aim is to create an abundant flow of spectacular and effective campaigns without imposing an agency look on the work. "Each problem demands its own solution," says von Weltzien. "And consumers must not feel that the ads are talking down to them or selling to them in a cheap way."

MASSACHUSETTS MUTUAL

DATE: 1920s.
ARTIST: Norman Rockwell.

Norman Rockwell trained at the National Academy and the Art Students League in New York and went on to become the best-known American illustrator of the twentieth century.

Rockwell drew his first advertisement in 1914 and went on to illustrate 322 covers for the *Saturday Evening Post* between 1916 and 1963.

In his early advertising work Rockwell would paint the picture then a designer added the selling text. When advertising agencies rose to prominence in the 1920s, Rockwell viewed them as a mixed blessing. While providing a lucrative outlet, their big budgets threatened the integrity of the artist's work.

Rockwell viewed J. C. Leyendecker as his role model (p. 76), yet developed his own distinctive style that was infused with humour and humanity. He clearly had a heart for his subjects that existed in an idealized setting of small-town America. The public grew to recognize and trust his work and, by association, this generated a sympathetic response from the viewer towards the product being advertised. The celebrity endorsement in this case comes from the respect commanded by the artist.

Rockwell's evocative images served the war effort well during World War Two and his illustrations appeared in several leading magazines including *Life*, *Colliers* and *Look*.

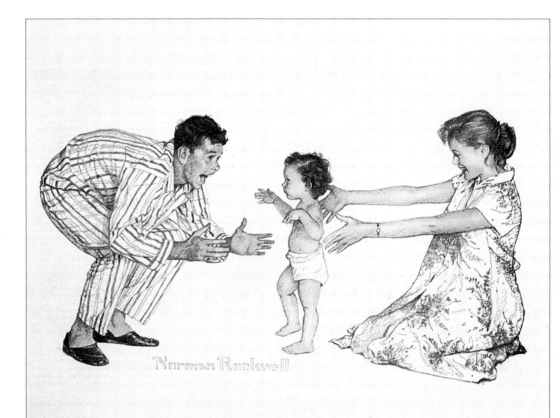

Standing on his own two feet? Well, almost!

He still needs you to encourage him — or to catch him if he falls. And in the years ahead too he'll be counting on you to stand behind him . . . to give him confidence, to assure his future.

Massachusetts Mutual can help you make sure you'll be able to give him that kind of backing when he needs it most . . . and guarantee that your plans for him will be carried out, even if you can't be here. We can also help you spread a major expense (like his education) over the years . . . and, at the same time, assure you steadily growing cash reserves to help in case of an emergency.

A good idea would be to talk it over with a Massachusetts Mutual man soon. *Call him — or our General Agent —* listed under Massachusetts Mutual in the phone book.

Massachusetts Mutual
LIFE INSURANCE COMPANY
ORGANIZED 1851 SPRINGFIELD, MASSACHUSETTS

ROLLING STONE MAGAZINE

DATE: 1987.
AGENCY: Fallon McElligott, Minneapolis.
ART DIRECTOR: Houman Pirdavari.
COPYWRITER: Bill Miller.
PHOTOGRAPHER: Marc Hauser.

Perception.

Reality.

If your idea of a Rolling Stone reader looks like a holdout from the 60's, welcome to the 80's. Rolling Stone ranks number one in reaching concentrations of 18-34 readers with household incomes exceeding $25,000. When you buy Rolling Stone, you buy an audience that sets the trends and shapes the buying patterns for the most affluent consumers in America. That's the kind of reality you can take to the bank.

IN 1985 THE MUSIC MAGAZINE *ROLLING STONE* WAS SUFFERING FROM AN IMAGE PROBLEM AMONG MEDIA DECISION MAKERS. THIS WAS LIMITING ITS ADVERTISING SALES AS POTENTIAL ADVERTISERS PERCEIVED IT AS APPEALING SOLELY TO THE IMPOVERISHED COUNTERCULTURE.

In reality the magazine had evolved into a slickly produced mainstream publication read by relatively affluent 18–34 year old single males who were employed full-time in managerial and professional careers.

With a small budget, the Perception/Reality campaign aimed to improve the "selling climate" for the magazine by establishing a viable and distinctive long-term position for *Rolling Stone* in the trade and advertising communities, showing that it delivers a large number of high spending young adults. It emphasized specific categories – apparel, automotive, grooming and alcohol – by featuring appropriate examples.

The campaign successfully challenged and transformed people's outdated perceptions by portraying conflicting icons that typified misconceptions alongside the realities of the readership profile.

Although young adults have unpredictable and varied interests, a common thread binds them together – music. Their commitment to pop music and personalities affects their personal spending habits, particularly in relation to fashion and entertainment. *Rolling Stone* was regarded by this segment as the publication that keeps them in touch with contemporary music.

While many advertisers relied on consumer advertising to bolster their trade advertising, *Rolling Stone* had no direct consumer advertising. Instead, the ads reached both the advertisers and the agencies by running in key advertising trade publications, notably *Adweek*, *Advertising Age* and *Marketing and Media Decisions*.

After the first year of the campaign *Rolling Stone*'s advertising revenue increased 40 percent. After seven years and 55 executions this figure rose to 230 percent. At the same time awareness and familiarity with the magazine's reader profile was greatly improved.

SUNDAY TIMES

DATE: 1989.
AGENCY: McCann Erickson.
Durban.
ART DIRECTOR: Les Broude.
COPYWRITER: Merlin Grant.

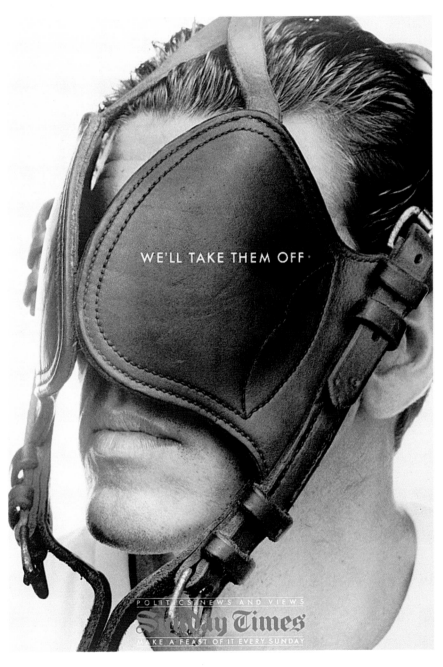

WE'LL TAKE THEM OFF·

ADVERTISING AGENCIES IN SOUTH AFRICA ARE HOMEGROWN, ARMS OF INTERNATIONAL NETWORKS, OR MERGERS OF THE TWO. BEFORE APARTHEID WAS OFFICIALLY DISMANTLED AND THE AFFLUENT SEGMENT OF THE BLACK MARKET GREW, MOST OF THEM OCCUPIED THEMSELVES SOLELY WITH THE WHITE MARKET. "MUCH OF THE TIME YOU PRODUCED ADS FOR THE TOP 5 PERCENT OF SOCIETY AND FORGOT ABOUT THE OTHERS," SAYS LES BROUDE.

For the *Sunday Times*, Broude created 36 rough ads, of which eight actually ran. "In my ads I always like to ask the reader to make a mental jump; he has to work a little bit," says Broude. "Then, once he's made the link between the visual and the headline, he feels good about it."

For example, an ad in the business section of the paper had the headline: "Read the signs". Astute readers immediately identified the bull and bear prints in the sand.

One of the more contentious ads, which ran while apartheid was starting to crumble, showed a man wearing horse-blinkers, with the headline, "We'll take them off". Another – which was considered too politically "hot" to appear – characterized the times, showing three hands symbolically expressing the contrasting attitudes in the country: as a fist, making a peace sign, and with fingers crossed.

In the late 1980s, the majority of South African art directors already took their lead from British approaches to advertising, but Broude said at the time, "Removing sanctions is going to make an immense difference. We are going to be able to work with guys in London and America, and more expertise will be able to flow in."

PROPAGANDA

US RECRUITMENT POSTER, WORLD WAR ONE

US RECRUITMENT POSTER, WORLD WAR ONE

RUSSIAN ANTI-IMPERIALISM POSTER

WAR HAS SUCH A PROFOUND effect on society that a whole nation's psyche and outlook shifts – and the advertising with it. Factory workers switch to feeding the war machine with armaments that don't need to be advertised. Existing products are reassessed and often re-presented in the light of the changed conditions and attitudes. Some mistimed ads find themselves stranded with embarrassingly inappropriate assertions. This ad promoting German tourism appeared in 1938: "You will be charmed by everyone's eagerness to make you happy and comfortable. You will want to come back to Germany."

The opening years of the twentieth century marked the first time that advertising played an important role in documenting social behaviour and attitudes during war. Advertising was not only tightly controlled but rationed, with restrictions on sizes of posters and press ads. Consumer, as opposed to propagandist, advertising was drastically reduced, but those ads that did appear depicted their products as providing comfort or vitality to those on active service and reassurance to those at home. The tone was collaborative and supportive, or offered humorous relief.

Bovril was promoted in the Boer War and both world wars as an energy booster (pp.10–11). In a letter home during World War One a soldier wrote: "Be sure to send Oxo" (pp.26–27). In World War Two the Oxo cube was pictured on the wing of a fighter with the headline "On a plane by itself"; and the Guinness zookeeper became a member of the Home Guard (pp.44–47). All this is itself a form of propaganda.

By the outbreak of World War One, governments of the leading powers had realized the potential role of advertising in the dissemination of information and the rallying of support. Posters were the primary medium of mass communication and many artists and designers were called on to reverse their usual role of promoting products and use their persuasive talents to encourage the public to spend less and to conserve resources. The creative process required was much the same, but the sense of urgency that war brings created a crop of innovative ideas and high-quality artwork that was frequently copied and had a major effect on later advertising. Alfred Leete's 1914 poster "Your country needs you" (p.248) was adapted for America by James Montgomery Flagg (p.249) and was resurrected repeatedly in different guises.

Guilt was often the prime emotional lever used to galvanize people into action. The 1915 poster "Daddy, what did YOU do in the Great War?" was designed to shame eligible but reluctant men into doing the "right thing". The same year a single poster touched a collective nerve and together with the event it portrayed – the sinking of the *Lusitania* by a German U-boat attack – acted as a catalyst in America's decision to enter the war. The Boston Committee of Public Safety published Fred Spear's

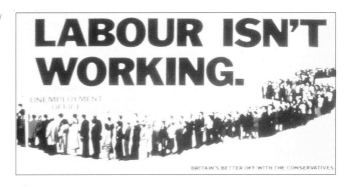

evocative image of a drowning American mother and child, harnessing the shock wave that spread across the country. The tragedy, the single word "Enlist" and the two figures under the sea aroused strong responses fuelled by feelings of outrage and patriotism.

Yet the sinking of the *Lusitania* was widely used for propaganda on both sides. The British public interpreted it as a premeditated attack on women and children; a German medallion commemorated the event, correctly claiming that the ship had been carrying munitions.

Contrasting approaches to propaganda statements often reflect vastly different levels of confidence and political stability between countries. While America chuckled over Howard Chandler Christy's frivolous 1917 recruiting posters of the Christy Girls declaring "Gee! I wish I were a man. I'd join the Navy", pronouncements by Chairman Mao during the Chinese Cultural Revolution accompanied images of sincere, resolute people drawn from popular folk art: "Imperialism oppresses us in such a way that we must deal with it seriously. We need to have not only a strong regular army but also establish a military force by the people. By doing so, when imperialism wants to invade our country, it will be difficult for them to move forward."

This Russian exhortation appeared in 1919 showing women prisoners looking beseechingly through camp barb wire: "USSR – All our hope lies with you red warriors!"

After the glamour of the 1920s and 1930s, World War Two brought advertisers back to the themes of sacri-

fice and patriotism. While Joseph Goebbel's Reichsministerium Volksaufklärung und Propaganda (Ministry for People's Enlightenment and Propaganda) spread its influence throughout Germany, Britain launched its Ministry of Information and the USA its War Advertising Council, to help enlist public support. During World War Two, poster and radio propaganda played a significant role which, in Britain, exhorted everyone to save, make do and salvage, to avoid careless talk and, most famously, to "Dig for Victory".

Propaganda is not restricted to wartime. Governments turn to the advertising creators in times of peace, too. Political propaganda is not so different, either, though the "enemy" is within and the consequences are less deadly. Such advertising again targets public opinion, but rather than generating recruits, selling bonds or underwriting relief programmes, the message involves rejecting the political opposition. The battle for votes is often so fierce – employing the full armoury of persuasive techniques – that the resulting ads are among the most effective ever produced. In 1910 the UK Labour Party's poster "Workless", depicting the unemployed of London, raised hackles and votes. In a clever counterattack – albeit nearly 70 years later – the Tories replied with the damaging wordplay: "Labour isn't working", followed by "Labour still isn't working" (p.245).

PARLIAMENTARY
RECRUITING
COMMITTEE

DEATH TO WORLD IMPERIALISM

DATE: 1919. ARTIST: Dmitri Moor.

DMITRI STAKHIEVICK MOOR, WHOSE REAL SURNAME WAS ORLOV, WAS BORN THE SON OF A COSSACK IN 1883 IN NOVOCHERKASSK, A TOWN IN SOUTHERN RUSSIA.

He spent two years in the Physics and Maths faculty of Moscow Univeristy, before changing to Law. Moor read Marxist literature in 1905–6 and took part in the revolution that was sweeping the country. During the Moscow uprising in December 1905 he belonged to a group of insurgents, took part in demonstrations and erected barricades.

Late one night in the Mamontov Printing Works where Moor was working, he began to make sketches of Tsarist ministers. The editor of one of the newspapers printed there saw the sketches, and gave Moor his first commission. This encouraged him to take his interest in illustration more seriously, using it as a political weapon.

By 1916 he had became one of the editors of *Budilnik* magazine. Some of his work was incisively satirical. His disrespectful caricature of Tsar Nicholas II, published five days after his abdication, caused a scandal. Throughout this turbulent period in Russia's history Moor was one of the few Soviet poster artists prepared to risk his life by continuing to sign his work. For a time he used the pseudonym "Dor", from the first letter of Dmitri and the first two letters of Orlov. He later changed this to "Mor". This coloured lithograph shows workers fighting a green monster with the headline "Death to World Imperialism".

СМЕРТЬ МИРОВОМУ ИМПЕРИАЛИЗМУ

CONSERVATIVE PARTY

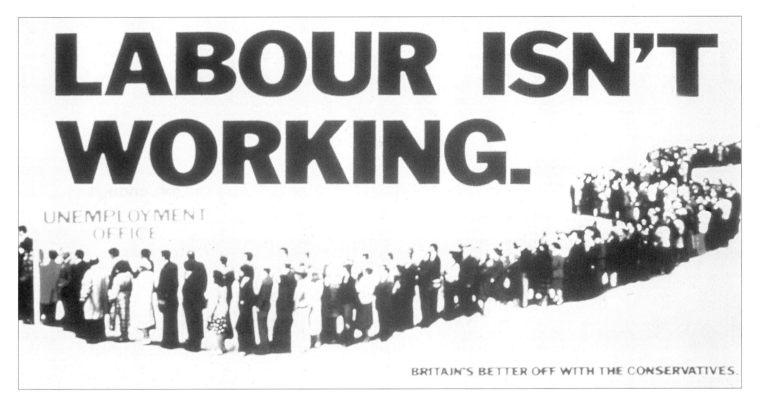

DATE:1979.
AGENCY: Saatchi and Saatchi, London.
ART DIRECTOR: Andrew Rutherford.
COPYWRITER: Martin Walsh.
PHOTOGRAPHER: Bob Cramp.

HOWEVER SINCERE OR PASSIONATE A POLITICIAN SOUNDS ON TELEVISION, AN INCREASINGLY CYNICAL ELECTORATE DISREGARDS MOST OF THE MESSAGE. ADVERTISING IS OFTEN A MORE EFFECTIVE TOOL IN SHAPING AND TURNING PUBLIC OPINION. DURING THE 1970S AND 80S, THE ADVERTISING AGENCY SAATCHI AND SAATCHI WAS PROBABLY THE CONSERVATIVE PARTY'S MOST FORMIDABLE ALLY.

Within the advertising arena, political ideas have become as sophisticated, subliminal and insidious as any, and Saatchi's "Labour isn't working" is one of the most compelling. It is clever, simple, graphic, memorable – and it has teeth. The poster gave vivid visual expression to an existing groundswell of opinion and helped to undermine confidence in the Labour government.

Brazenly, the poster leads with the name of the client's main rival in large bold letters, the three-word headline hitting home. It is a very neat, succinctly expressed pun, evoking the image of an out-of-work labour force – and an impotent government. The photograph of a long dole queue reinforces the message, before a sign-off solution.

Echoing the evocative 1910 poster by Gerald Spenser Pryse "Workless" by the Labour Party, "Labour isn't working" debunked its target, attacked its Achilles' heel – whether real or perceived – provided a headline for journalists and party activists, and set the tone for the entire political campaign.

The ad helped pave the way for 20 years of Tory rule.

CARELESS TALK COSTS LIVES

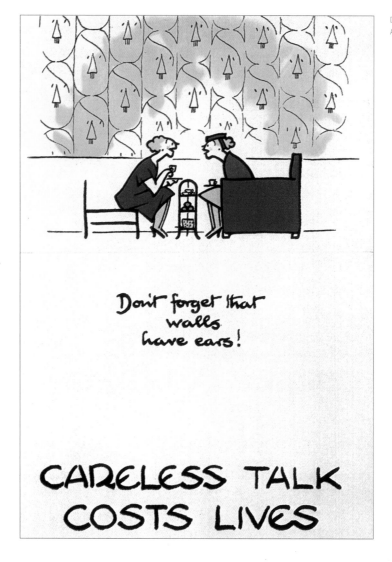

DATE: 1940.

ARTIST: Fougasse (Cyril Kenneth Bird).

CYRIL KENNETH BIRD "FOUGASSE" WAS ART DIRECTOR FOR *PUNCH* MAGAZINE AT THE OUTBREAK OF WORLD WAR TWO. HIS CONTRIBUTION TO THE WAR EFFORT WAS TO PROVIDE HIS PROPAGANDA MATERIAL FREE OF CHARGE.

A skilled cartoonist, illustrator and poster designer, Fougasse was best remembered for his series of posters for the Ministry of Information warning of the dangers of indiscreet gossip. His cartoons presented a welcome antidote to the dismal formality of early, expensive yet unsuccessful government attempts to communicate with the public. Humour was needed to help people cope with the disruption and turmoil of war and cartoons in the popular idiom provided the most effective tool.

In response to public reaction against costly government advertising, the space to display posters had to be provided free. The posters therefore had to appeal to owners of factories, shops and restaurants. At the time Fougasse wrote, "Quite apart from the relative merits of tragedy and comedy in conveying this somewhat grim message – they had to present it in such a way that people with space to give would not recoil from it."

Fougasse understood that fear closes the mind, whereas humour can open it. His so-called "formula" figures did not bear resemblance to real, specific people, but they allowed the viewer to identify with them, as did his scenes from everyday life. Small captions drew the viewer closer – an act of involvement that reinforced the message of each poster.

The "Careless talk costs lives" campaign re-emerged throughout the war, with contributions from several artists and in several forms – posters, films and broadcasts.

YOUR TALK MAY KILL

ABRAM GAMES WAS BRITAIN'S
ONLY OFFICIAL WAR ARTIST BETWEEN
1941 AND 1946. ALTHOUGH A
PHOTOGRAPHER'S SON, HE SELDOM
INCLUDED PHOTOGRAPHY IN HIS
WORK. UTILIZING THE EUROPEAN
MODERNIST PRINCIPLE, HE COMBINED
TYPOGRAPHY AND PICTURE TO
CREATE AN INTEGRATED MESSAGE.

An especially effective example comes
from the "Careless whispers" campaign
for the War Office designed to alert the
public to the "enemy within". In a
graphic portrayal, he depicted circulat-
ing gossip literally stabbing the
servicemen. Standing out in white letter-
ing are the words "Talk may kill". The eye
is then drawn to "Your" in orange and
"your comrades" in yellow.

The unsettling impact of the image
stems from the blunt and vividly
displayed consequence of careless talk.
Few propaganda posters risk the demor-
alizing effect of showing the death of allies.

Before the war Games created
images for Shell-Mex, the Post Office and
London Transport. He also designed – on
a bus ticket – the famous Guinness
advertisement with a large red "G" form-
ing a man's face.

Games's prolific postwar output
included posters for BOAC (later British
Airways), Truman Beer, Metropolitan
Police, British Petroleum, the *Daily
Telegraph*, the *Financial Times*, Murphy
Television, Jersey, the World Health
Organization and the Orient Line.

DATE: 1942.
ARTIST: Abram Games.

YOUR COUNTRY NEEDS YOU

DATE: 1914.
AGENCY: Caxton Advertising, London,

COPYWRITER: Eric Field.
ARTIST: Alfred A. C. Leete.

Propaganda posters during World War One presented the conflict as a crusade. The three-fold aim was to recruit volunteers, solicit money as war loans and expose the atrocities of the enemy.

At the beginning of the war, before conscription was introduced, the British were reluctant to volunteer for service: the fighting was seen as a job for the existing professional army and navy. There was strong resistance to advertising, so the task of recruitment posters was doubly difficult.

It was Lord Kitchener, the Recruiting General, who proposed the "Lord Kitchener needs you" poster. He had been impressed by small ads put out by the army before the war, with the headline "Your king and country need you" and the end-line "God save the king". He proposed changing the heading to "Lord Kitchener needs you."

A wave of national responsibility answered Kitchener's call – he was, after all, the archetypal wartime father figure. His pointing finger and uncompromising eye contact triggered a wave of national responsibility. The image may have been crude, but it was the most powerful, haunting and enduring of the time – of all time. When America entered the war three years later, James Montgomery Flagg adapted it for his equally imposing "I want YOU for U.S. army" (opposite).

I WANT YOU

THIS IS PROBABLY THE MOST FAMOUS POSTER EVER TO HAVE BEEN PRODUCED IN THE USA. JAMES MONTGOMERY FLAGG DREW HIMSELF IN THE MIRROR AS UNCLE SAM, IN A POSE INSPIRED BY ALFRED LEETE'S POSTER OF LORD KITCHENER.

In 1917, when America was drawn into World War One, the government created a Federal Committee of Public Information to inform, encourage and cajole the public. The artist Charles Dana Gibson formed a division of pictorial publicity and engaged some of the country's leading illustrators.

At the age of 12 James Montgomery Flagg was already contributing to *St Nicholas* magazine. He went on to study at Art Students League in New York. He created this design for the cover of *Leslie's Weekly* magazine. More than 4 million posters were printed during World War One. Some sources say a further 5 million copies were produced during World War Two.

The original Uncle Sam really existed. Samuel Wilson was a respected provisions merchant who supplied the US army during the 1812 war. The "US" stamped on his shipments – meaning "United States" – came to be referred to as "Uncle Sam". And the term soon embraced a personification of the United States itself.

Flagg depicted Uncle Sam, not as the comic cartoon character he had become in popular publications, but as a handsome, dignified figure sternly commanding attention. The figure was so successul that he featured in many other posters.

His Uncle Sam poster became such an icon and symbol of America that it provided the ideal subject for parody and satire. The 1971 anti-Vietnam poster "I want OUT" was a part of a popular protest against the US involvement in the war, through the "Unsell the War" campaign. It featured the familiar Uncle Sam now crushed and broken by years of conflict, his strong rallying call transformed to a plea for release.

Flagg executed 46 posters for various war agencies and organization. His 50 year career was prolific and he produced more than 300 illustrations a year at his peak.

FOR THE CONQUERED

Date: 1940.
Artist: Edward McKnight Kauffer.

EDWARD MCKNIGHT KAUFFER WAS BORN IN MONTANA IN 1890. HIS FATHER WAS GERMAN, HIS MOTHER SWEDISH. WHILE KAUFFER WAS TRAINING AS A PAINTER, PROFESSOR JOSEPH E. MCKNIGHT AT THE UNIVERSITY OF UTAH TOOK A GREAT INTEREST IN HIS WORK. HE SO BELIEVED IN KAUFFER'S POTENTIAL THAT HE GAVE HIM A LOAN TO ENABLE HIM TO STUDY. IN HOMAGE, KAUFFER ADOPTED HIS PATRON'S NAME.

Kauffer moved to London in 1913, aged 25. He remained in Britain until the outbreak of World War Two, producing some 250 posters for British advertising.

Greatly influenced by the poster art of Ludwig Hohlwein (pp.80, 146), Kauffer's geometrical style joined elements of Cubism and Surrealism with the decorative qualities of Art Deco, to produce a strikingly original approach. In the late 1920s his work moved towards Modernism, with greater emphasis on photomontage.

In the 1930s Frank Pick, of London Transport, and Jack Beddington, advertising manager for Shell-Mex, commissioned Kauffer to design posters, providing high-profile outlets for his work. Other clients included American Airlines, Lincoln Continental, Ford, Great Western Railways and Eno's. He produced anti-Nazi propaganda for the Ministry of Information before returning to America.

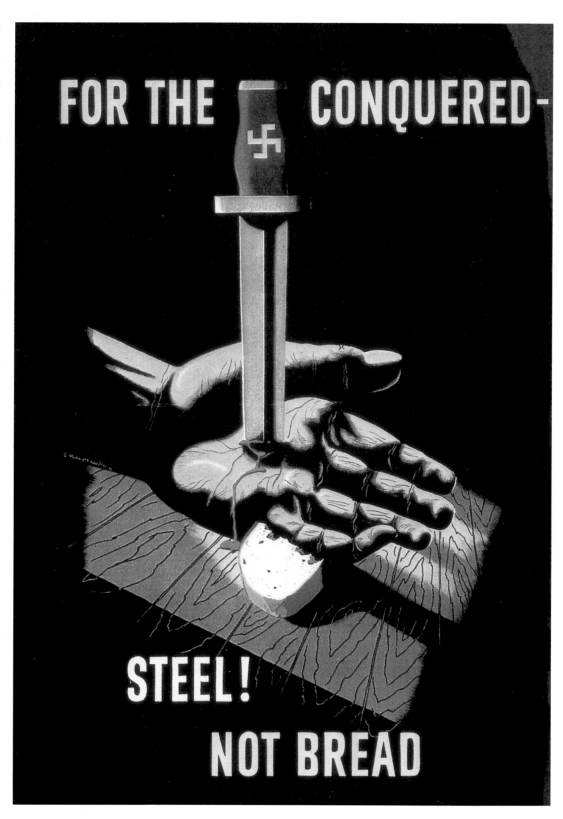

ON LES AURA!

In a rallying call to boost morale and increase patriotic fervour, the beckoning soldier is calling out "On les aura!" – "We will get them!" The declaration was popularized by General Pétain during the Battle of Verdun and revived in World War One.

Jules Abel Faivre was born in Lyons, where he studied at the Ecole des Beaux Arts. He then worked in Paris in the studio of Benjamin Constant and became a well-known cartoonist for magazines such as *Le Journal* and *Echo de Paris*. This is the best-remembered of the posters Faivre contributed for all the campaigns that were run for French war loans.

Faivre took the soldier's stance from the sculptured group by François Rude on the Arc de Triomphe in Paris, but he had some difficulty finding a soldier to pose for him. He tried to find appropriate models among the troops arriving at the Gare de L'Est, but the men were self-conscious about what onlookers would say. The final result justified Faivre's efforts, and the poster was frequently copied. An Italian version appeared in 1918, then the Americans recreated the pose during World War Two, with the headline "We have only just started to fight!"

DATE: 1916.
ARTIST: Jules Abel Faivre.

INDEX

BIBLIOGRAPHY

Advertising in America – The First 200 Years, Charles Goodrum and Helen Dalrymple, Harry N. Abrams Inc, New York, 1990.
Advertising Outdoors – Watch this Space, David Bernstein, Phaidon Press, 1997.
Advertising – Reflections of a Century, Bryan Holme, Heinemann, 1982.
Advertising's Ten Best of the Decade 1980–1990, The One Club, New York, 1990.
Art of our Century – The Story of Western Art, 1900 to the Present, Jean-Louis Ferrier, Longman, 1988.
The Art of Walt Disney – From Mickey Mouse to the Magic Kingdom, Christopher Finch, Virgin, 1995.
The Bolshevik Poster, Stephen White, 1988, Yale University Press.
The Book of Guinness Advertising, Brian Sibley, Guinness Books, 1985.
The Book of Guinness Advertising, Jim Davies, Guinness Publishing, 1998.
Cadbury World Souvenir Brochure
Chiat/Day – The First Twenty Years, Stephen Kessler, Rizzoli, New York.
Cocoa and Corsets, Michael Jubb, HMSO, London, 1984
Creative Directors Sourcebook, Nick Souter and Stuart Newman, Macdonald Orbis, 1988.
Drinka Pinta, Alan Jenkins.
Excellence in Advertising – The IPA Guide to Best Practice, ed. Leslie Butterfield, Butterworth-Heinemann, 1997
Fantasy in Advertising, Dave Saunders, B.T. Batsford, 1997.
The First Hundred Years Coca Cola, Anne Hoene Hoy, The Coca Cola Company, Atlanta, Georgia, USA, 1986.
First World War Posters, Joseph Darracott and Linda Loftus, Imperial War Museum, 1972.
Graphic Design – A Concise History, Richard Hollis, Thames and Hudson, 1994.
Graphic Design Source Book, Liz McQuiston and Barry Kitts, Macdonald Orbis, 1987.
A Handbook of Advertising Tehniques, Tony Harrison, Kogan Page, London, 1987.
The Hidden Persuaders, Vance Packard, Penguin Books, 1957.
The History of Bovril Advertising, compiled by Peter Hadley, for Bovril Ltd, 1970.
How it all Began – The Story Behind those Famous Names, Maurice Baren, Smith Settle, 1992.
Humour In Advertising, Dave Saunders, B.T. Batsford, 1997.
The 100 Greatest Advertisements – Who Wrote Them and What They Did, Julian Lewis Watkins, Dover Publications, New York, 1949, 1959.
The International Film Poster, Gregory J. Edwards, Columbus Books, London 1985.
Man Ray – The Photographic Image, ed. Janus, Gordon Fraser, 1980.
E. McKnight Kauffer – A Designer and his Public, Mark Haworth-Booth, Gordon Fraser, London, 1979.
McLuhan Hot and Cool, Penguin, 1967.
McLuhan, Jonathan Miller, Fontana, 1971.
Miller's Collecting Prints and Posters, Janet Gleeson, Miller's, Reed International Books, London, 1997.
Motoring – The Golden Years, compiled by Rupert Prior, Tiger Books, 1994.
Nike Culture, Robert Goldman and Stephen Papson Sage Publications, London, 1998.
Ogilvy On Advertising, David Ogilvy, Orbis, London, 1983.
Over my Shoulder – Graphic Design, A. Games, Studio Books, 1960.
Posters – A Concise History, John Barnicoat, Thames and Hudson, London, 1972.
Posters in Tokyo, Bertrand Raison and Philippe Benoit, Nathan, Paris, 1989.
Posters of the First World War – selected and reviewed by Maurice Rickards, Evelyn Adams and Mackay, 1968.
The Power of the Poster, ed. Margaret Timmers, V & A Publications, 1998.
Professional Advertising Photography, Dave Saunders, Merehurst Press, 1988.

Revolutionary Soviet Film Posters, Mildred Constantine and Alan Fern, 1974, Johns Hopkins University Press.
Schweppes – The First 200 Years, Douglas A. Simmonds, Springwood Books, 1983.
Sex In Advertising, Dave Saunders, B.T. Batsford, 1996.
The Shell Poster Book, introduction by David Bernstein.
Shock In Advertising, Dave Saunders, B.T. Batsford, 1996.
Taking Stock – Over 75 years of the Oxo Cube, Penny Vincenzi, Willow Books, 1985.
The Thames and Hudson Encyclopaedia of Graphic Design and Designers, Alan and Isabella Livingston, Thames and Hudson, 1992.
Thirsty Work – 10 years of Heineken Advertising, Peter Mayle, Macmillan, London, 1983.
Thirty Years and a Century of the Campari Company, Davide Campari, Milan, 1990.
Tiger in your Tank – The Anatomy of an Advertising Campaign, Brian Ash, Cassell, London, 1969.
Understanding Media – The Extensions of Man, Marshall McLuhan, Signet, 1964.
When Advertising Tried Harder – The Sixties the Golden Age of American Advertising, Larry Dobrow, 1984, the Friendly Press, NY.
The World's Best Advertising Photography, Dave Saunders, B.T. Batsford, 1994.
The World's Greatest Brands, ed. by Nicholas Kochan, Interbrand, Macmillan Press, 1966.
The World's 100 Best Posters, Rob Morris and Richard Watson, Maiden Outdoor/Open Eye Publishing, 1993.

ADVERTISING EFFECTIVENESS AWARDS: PAPERS PUBLISHED BY THE INSTITUTE OF PRACTITIONERS IN ADVERTISING (IPA), LONDON:

Chris Baker, Saatchi and Saatchi, 1986, Castlemaine XXXX Lager.
Merry Baskin, J.Walter Thompson, 1996, DeBeers.
Janet Brades, GGT, 1990, Nurofen.
Tim Broadbent, WCRS, 1994, BMW.
Jim Carroll, Bartle Bogle Hegarty, 1993 and 1995, Levi Strauss.
Cathy Clift, Lowe Howard-Spink, 1992, Irn-Bru.
Clive Cooper, Louise Cook and Nigel Jones, BMP DDB Needham, 1990, PG Tips.
Guy Murphy, Bartle Bogle Hegarty, 1994, Boddingtons.
Andrew Crosthwaite, Euro RSCG Wnek Gosper, 1996, Kaliber.
Michael Ellyatt, Publicis, 1996 Renault Clio.
Angus Fear, Allen Brady Marsh, 1990, Tango.
Colin Flint, McCann Erickson, 1996, Nescafe Gold Blend.
Susanna Hailstone, TBWA, 1994, Playtex Wonderbra.
Bruce Haines, Young and Rubicam, 1980, Smirnoff.
Martin Hayward, Ogilvy and Mather, 1990, Guinness.
Tim Lindsay, Bartle Bogle Hegarty, 1988, Levi Strauss.
Giles Lury and Paul Hackett, J.Walter Thompson, 1992, Oxo.
Fiona MacGill and Kara Gnodde, Saatchi and Saatchi, 1994, British Airways.
Laura Marks, Abbott Mead Vickers/SMS, 1992, *Economist*.
Paul Meyers, TBWA, 1994, Nissan Micra.
Guy Murphy, Bartle Bogle Hegarty, 1994, Boddington's.
Amelia Reynolds, Saatchi and Saatchi, 1990, Lanson.
Charlie Robertson, Leith Agency, 1994, The Health Education Board for Scotland.
Alan Setford and Crispin Reed, Leo Burnett, 1990, Perrier.
Mary Stewart-Hunter, Davidson Pearce, 1990, International Wool Secretariat.
Rosie Wilson, Leo Burnett, 1986, Perrier.
Jeremy Williams and Russell Seekins, Abbott Mead Vickers/BBDO, 1994, Pepsi Max.
Jeremy Williams, Abbott Mead Vickers/BBDO, 1995, Pepsi.
Kathy Wood, Stuart Smith and Tim Broadbent, Young and Rubicam, 1996, Pirelli Tyres.

thanks

I would like to thank the vast raft of people who contributed to this book.

Thanks to the creatives who put together all the ads presented here, and especially to the quoted contributors. Please note: all contributors are quoted as being with the agency they were in at the time. Thanks, too, for their various contributions:

Nancy Adam
Francoise Assere
David Bailey
Josefin Bergén-Lilja
Frank Bodin
Anita Bourne
Tracie Carlson
Matthias Claude
Catherine Costelloe
Karin Eggenberger
Penny Foulkes
Mark Glover
Tessa Gooding
Jan Greenwood
Gail Harvey
Gary Hellmer

Veronique Humbert
Paula Ismael
J.John.
David Keane
Frances Kelly
John Kendall
Sarah Larter
Gwenn Lee
Stephanie Luxat
Jan Maagaard
Y. Masuyama
Jean McArthur
Walter Merz
Mimi Minnick
James Moffatt
Yoshifumi Nakashima

Brett Netherton
Simon North
Hilaire O'Loughlin
Chris Pinnegar
Bob Prior
Jacqueline Reid
Richard Reynolds
Tim Rich
Nora Roach
Denys Saunders
Marcello Serpa
Wendy Shadwell
Kay Southgate
Philip Spink
Sabine Toennissen
Dave Trott

Heidy Vonaesch
Ryuta Watanabe
Katherine Wilkinson

Particular thanks are due to the following organizations:

Advertising Archives
The Advertising Association
D&AD (Design and Art Direction)
The History of Advertising Trust
IPA (Institute of Practitioners in Advertising)
The Smithsonian Institute

picture credits

The publishers would like to thank the following sources for their kind permission to reproduce the pictures in this book:

Artwork courtsey of **Absolut/TBWA GGT Simons Palmer**/Steve Bronstein 32, 33tl/Graham Ford 33r, **The Advertising Archives** 10-11, 13, 14, 21, 23t, 29, 43t, 59, 61-2, 64tl, 67, 74-6, 79, 83, 92-4, 105, 107, 110-12, 116, 117, 120, 126-7, 129-31, 136-7, 143-4, 152, 170, 172, 174-6, 181, 184, 187, 232, 239, 245-6, 249, 251/Delaney Fletcher Bozell Ltd. 100-1/Graham Ford 132/MGM Selznick International 224/UA/CIP 225/ Jospeh M Schenck/United Artists Picture 221, **AECC Spanish Cancer Association/Delvico Bates**, Barcelona/Ramon Serrano 154, **Amnesty International**/JBR, Oslo/Roger Fredericks 153, © **Apple Computer Inc./TBWA Chiat Day**, Los Angeles 104, Artwork courtesy of **Boddingtons/Bartle Bogle Hegarty/David Gill** 34, **Benson & Hedges/Collett Dickeson Pearce**/Graham Ford 125t /Chris Lovell 125b/Jimmy Wormser 124, Photograph courtesy of **BMW (GB) Ltd./WCRS/Paul Bevitt** 171, **Bridgeman Art Library**, London/Collection Kharbine-Tapabor, Paris, France *Poster advertising 'La Reine Indigo', music by Johann Strauss (1804-49) c.1900 (litho) by Jules Cheret (1836-1932)*, Photographs courtesy of **British Airways/M &C Saatchi** 196, **British Egg Information Service** 12, Artwork courtesy of **British Gas/Centrica/Young & Rubicam**, London 106, Photographs courtesy of **Britvic Soft Drinks/HHCL & Partners**, London 66, Photographs courtesy of **Cadbury Ltd.** 15Artwork courtesy of **Campari International S. A. M** 36-7, Photographs courtesy of **Castlemaine XXXX/Saatchi and Saatchi**/Peter Lavery 35, **Cheltenham & Gloucester/K Advertising**, London 233, **Christie's Images** 199, 212, Courtesy of the **Archives of The Coca-Cola Company** 38-41, **Colgate Palmolive/Young & Rubicam Ltd.** 138, Artwork courtesy of **Condor Airline/Leo Burnett**, Frankfurt/Michael Ehrhart 199, **Club 18-30/Saatchi & Saatchi**, London 198, **DeBeers/J Walter Thompson**, Tokyo/Tetsuro Takai 141/**N. W. Ayer**, New York/Albert Watson 140, Reproduced by permission of **Department of Health and Social Security/Yellowhammer**, London/Clive Arrowsmith 157, Photograph courtesy of **Diesel S. P. A./Paradiset DDB**/Peter Alendahl 77, Artwork courtesy of **The Economist/Abbot Mead Vickers BBDO Ltd.** 235, Photograph courtesy of **Egg/HHCL & Partners**, London 236, **ET Archive** 244, **Expressen/Alinder & Co.**, Stockholm/Jacob Forsell 237, **By Fallon McElligott**, Minneapolis/Hush Puppies. All Rights Reserved./Rick Dublin 82, **By Fallon McElligott**, Minneapolis/Timex. All Rights Reserved. 99, **By Fallon McElligott**, Minneapolis/Windsor Canadian. All Rights Reserved./Craig Perman, Dave Jordano 68, **By Fallon McElligott/Rolling Stone Magazine By Straight Arrow Publishers Company, L.P. All Rights Reserved. Reprinted by Permission** 240, Photograph courtesy of **Family Planning Association/Saatchi & Saatchi**/Alan Brooking 155, **Federal Express/Ally & Gargano** 108, **Marc J. Frattasio, New Haven Railroad Historical and Technical Association** 208, Photograph courtesy of **Fuji Film/Dentsu**, Tokyo 109, Photographs courtesy of **General Mills Flour** 17, Photograph courtesy of **Gold Blend/Dentsu**, Tokyo 43b, **Ronald Grant Archive**/Warner/Polaris 219/Archive/UA/Eon/Danjaq 220/ Riama/Pathé Consortium 222/First National/Charles Chaplin 227/ Paramount 229, **Guinness Archives**/S H Benson, London/John Gilroy 45, 46/J Walter Thompson Company, London 47tl/Ogilvy and Mather, London 47cr, 47b/Euro RSCG Wnek Gosper, London/Dan Tierney 52, **Häagen Dazs/Bartle Bogle Hegarty**/Nadav Kander 19tl/Barry Lategan 18b/Jeanloup Sieff 18tr, **Häagen Dazs/J. Walter Thompson Company**, Tokyo/Megamu Wada 19r, Photographs courtesy of **Heineken/Lowe Howard-Spink** 48-9, **Hamlet/Collett Dickenson Pearce**, London/Paul Bewitt 128, Artwork courtesy of **Hartmarx Corporation/Edward Penfield** 78, **Health Education Board for Scotland/The Leith Agency**/Mike Parsons 156, **History of Advertising Trust** 20, 63, 81, 173, 206, **Imperial War Museum** 248/A Games 247, **India Tourist Board/Cherry Hedger Seymour**, London/John Claridge 21, **International Poster Gallery**, Boston/A M Cassandre 207, Photograph courtesy of **Japan Railways/Dentsu**, Tokyo/Katsuju Takasaki 201, **Michael Joseph**/Rolling Stones/Beggars' Banquet/Decca 228, **Jung von Matt**, Hamburg/Uwe Düttmann 185, 238, **Kadu Shorts/Andromeda**, Sydney/Simon Harsent 87, Photograph courtesy of **Kaminomoto/Wella Pacific Hair Care/The Ball Partnership**, Singapore/Willie Tang 147, Photographs courtesy of **Kellogg's Marketing and Sales Company/J Walter Thompson Company Ltd.**, London 22, 23b, Photographs courtesy of **Kibon Fruttare/AlmapBBDO/Solk/Freitas** 16, Photograph courtesy of **Kit Kat/Nestle Rowntree/J Walter Thompson Company Ltd.**, London 24, **Knight Leach Delaney**, London/Paul Delaney 150b, **Kobal Collection** 216, **The LaGuardia and Wagner Archives, LaGuardia Community College/The City University of New York**/Steinway & Sons 118, **Lanson Black Label/J R Phillips and Co./Saatchi and Saatchi**, London /Andreas Heumann 53, **Lego UK** 113, **Levi Strauss/Bartle Bogle Hegarty** 90bl, 90tr, 91cr/Richard Avedon 91tl/Levi Strauss STA-PREST® 91b, **Levi Strauss/Foot, Cone and Belding**, New York 91tr, **Levi Strauss/McCann Erickson**, Milan/Graham Ford 88-9, Artwork courtesy of **The Leith Agency on behalf of A. G. Barr**/Photography by Euan Myles 50, **Loctite/Super Glue-3/Ogilvy & Mather**, Paris 119, **London Transport Museum** 202-3, Photographs courtesy of **Louis Vuitton/Euro RSCG Wnek Gosper**/Jean Lariviére 204-5, **Lynx**/Yellowhammer, London/David Bailey 158/Respect For Animals/David Bailey 159, **Lynx Body Spray /Bartle Bogle Hegarty**, London 145, **Magnum Photos/Elliot Erwitt**/French Government Tourist Board/Doyle Dane Bernbach, New York 200/Puerto Rico 209, Photographs courtesy of **Marmite/BMP DDBO Ltd./Andy Barter** 25, Artwork courtesy of **Martell/Ogilvy and Mather**, Hong Kong 54, **Maxell/Scali McCabes Sloves** 114, Photograph courtesy **McCann-Erickson Geneva, for Society for Swiss-Tibetan Friendship (GSTF)** 165, **Metropolitan Police/Collett Dickenson Pearce**/Don McCullin 160, Photograph courtesy of **Mothers Against Drunk Driving (MADD)/Clarity Coverdale Fury Advertising, (Minneapolis, MN)**/Steve Umland 161, Photograph courtesy of **Mercedes-Benz/Leo Burnett Ltd.**, London 177, Artwork courtesy of **Michelin** 178-9, **National Canine Defence League/TBWA GGT Simons Palmer**/Leon 162, **National Dairy Council** 55, Photograph courtesy of **Nissan/TBWA GGT Simons Palmer** 180, **Nynex Yellow Pages**/Chiat Day, New York 121, **Olympus/Collett Dickenson Pearce**, London 115, **Oxo by kind permission of Van den Bergh Foods reproduced from originals in the care of Unilever Historical Archives** 26-7, **Partnership For A Drug-Free America/Hill Holliday Connors Cosmopulis**, Boston/Matt Mahurin 163, Photographs courtesy of **Pepsi/AlmapBBDO Ltd.** 57/**Abbott Mead Vickers BBDO Ltd** 56, Pictures reproduced courtesy of **Perrier and Publicis Ltd.** 59l/John Turner 58, **PG Tips by kind permission of Van den Bergh Foods reproduced from an original in the care of Unilever Historical Archives** 60, **Pirelli Tyres Ltd./ Young & Rubicam** 183/Annie Leibovitz 182, **Pretty Polly Ltd.** 95, Picture reproduced courtesy of **Renault UK Ltd and Publicis Limited** 186, **Round the Clock hosiery/Romann & Tannenholz**, New York/Horst P. Horst 96, **Jonathon Sceats/BAM/SSB**, Sydney/Michael Corridore 86, **The Shell Art Collection at the National Motor Museum Beaulieu** 188-9, **Silk Cut/M & C Saatchi**/Graham Ford 132/Francois Gillet 133t/Nadav Kander 133b, Artwork courtesy of **Singapore Airlines Cargo/Ogilvy & Mather**, Singapore/Thomas Herbrich 211, Photographs courtesy of **Smirnoff/Lowe Howard-Spink**/Alex Buckingham 65/Andy Green 64br, **Stadtmuseum München**/Ludwig Hohlwein 146, Photograph courtesy of **Sunday Times/McCann Erickson**, Durban 241, **Swatch/Barbella Gagliardi Saffirio**, Milan/Nicola Graziani 97, Photograph courtesy of the **Swedish Egg Council** 28, **TAGHeuer/BDDP**, Paris/Guzman 98, **Third World Debt/ David Trott**/Walsh Trott Chick Smith 164, **Unilver/J Walter Thompson Company, London** 142/Terence Donovan 143, Photographs courtesy of **United Colors of Benetton/Oliviero Toscani** 72-3, 151, **United Distillers & Vintners** 51, **The Vintage Magazine Company Ltd.** 42, 80, 213, 217, 223, 226, 250, Photographs courtesy of **De Volkskrant/PPGH/J. Walter Thompson Company, Amsterdam**/Hans Kroeskamp 234, Photographs courtesy of **Volkswagen UK/BMP DDB** 190-1, Photographs courtesy of **Volvo/Abbott Mead Vickers BBDO, London** 192, 193br/**Dentsu**, Tokyo 193tl, Artwork courtesy of **Waterman/Dentsu**, Tokyo 166, **The White House, Cape Town**/Franco Esposito 150tr, **The Woolmark Company**/Brian Griffin 85/Michael Joseph 84, Photograph courtesy of **Worldwide Fund For Nature (WWF)/Ogilvy & Mather**, New York/Duncan Sim 167, Photograph courtesy of **X. O. Beer/Ogilvy & Mather**, Singapore/Han Chew 69

Every effort has been made to acknowledge correctly and contact the source and copyright holder of each picture, and Carlton Books Limited apologises for any unintentional errors or omissions which will be corrected in future editions of this book.